University

of

New

Mexico

Press

Albuquerque

PHOTOGRAPHY
AT BAY

Interviews,

Essays,

and

Reviews

JOHN
BLOOM

Library of Congress Cataloging-in-Publication Data
Bloom, John, 1948–
Photography at Bay: interviews, essays, and reviews/John Bloom.
—1st ed.
p. cm.
Includes bibliographical references.
ISBN 0-8263-1412-0 (cloth). —ISBN 0-8263-1413-9 (pbk.)
1. Photography. 2. Photographers—
Interviews. 3. Photography—California—San Francisco Bay
Area. I. Title.
TR185.B46 1993 *93-20394*
770—dc20 *CIP*

All of the interviews and reviews included in this collection
(except as noted below) were first published in *Photo Metro*
magazine and are reprinted with permission. The essays "From
Magic Lantern to Modern Form," "Daredevils and Falling
Horses," and the book review "Photography Until Now," were
published in *San Francisco Camerawork Quarterly*. The reviews
"The Turbulent 60's," "Lorie Novak: Interiors," and "Foto-
grafie Aus Berlin," were published in *Afterimage*. The intro-
duction, the review "Lee Friedlander," and the curatorial essays,
"Sitter's Dream" and "Nature and Culture" are published here
for the first time.

Introduction:
 The Technology of Modern Wonder/1

v

A photograph is a dead image of a living imagination. This is no small twist of logic. The still image marks a death ritual driven by an assumed capacity to know the world through picturing it and the further assumption that the camera's model of vision resembles optical sense perception. But, the camera portrays something other than what we see. The world is simultaneously literal and figurative, material and spiritual, multivalent. It has been photography's mission, amongst all the arts, to render these facets of the world indistinguishable from one another—to homogenize realities into a single valence of appearance. Further, the limitations of the medium, its insistence and dependence upon a projective space, whether in cameraless work with light-sensitive materials or in camera rendering, trivialize the true dimensionality of thought. Though a photographer may, a camera cannot work with multiple sets of rules and concepts simultaneously. The sense of knowing that the photograph conveys is disconnected from the reality portrayed, from that which existed prior to its image. It is a lifeless knowing—abstract in the extreme, cleverly masked in the recognizable.

Its limitations also place photography, of all the still visual media, closest to being purely conceptual. Its substance lives in the translation of light phenomena into patterns that imitate or approximate apparent reality—patterns that have extraordinary powers of suggestion about that reality with virtually no physical substance beyond a thin chemically treated stratum. Ironically, photography is a latter-day ally of illusionistic

art, the hallmark of overachieving materialistic cultures. Photography's illusion is mechanistic, ruled by the mathematics of lenticular perspective. In apposition to the painted illusion, the photograph lacks candid evidence of its maker's presence. Its process, its trick so to speak, is, as Fox Talbot so aptly understood, the direct transcription of nature without the aid of the artist's hand.

The absent hand has an apt substitute in the form of mind-presence, given the ascendancy of a machine aesthetic for which the overriding context is replication and reproduction within a remarkably consistent set of materials. Mind-presence is photography's equivalent to painting's handwork—evidence of play ordered in concept.

Such playfulness could only emerge in photography when photographers and the culture of audience ceased taking the medium's illusionistic function as incontrovertible evidence and recognized instead its inherent relativity, its ofness, its counterflux, and finally its disconnection from knowing. The first hints of this awakening came with the advent of the hand camera. The camera was at least then connected to human conditions, one small step away from the frozen gaze of the onlooker, one toward evidential participation. Once the image was properly located in the field of consequences, that is as an object distinctly separate from its more or less obvious source, photography could be closer to thinking and conceptualization than to science and observation. This is a late-twentieth-century vantage point, one taken or made while observing and participating in the medium's transubstantiation from light-based to electron-based, from photography to pixelography. If images are to have a meaningful life, to be reinvested with living thought, they must be reckoned with as part of a genealogy of the present.

Taken and made at specific moments in the time-flow of sensibility, photographs are records of the perceivable and metaphors of perception. Beyond their function as illustrators of history, they constitute a history unto themselves, a repository of fragmentary visions, temporary imaginations turned permanent by technicality. Retired in archives with their contextual origins in suspense, they inform contemporary thought as surrogate imag-

inations. They are part and parcel of consciousness and conscience, indicate at least something of the knowable, and delimit, in sociocultural terms, the acceptable.

Images dot the map of history, points along a mythic narrative. Conscience and consciousness are the substance of that history and a higher function of imagination. They, unlike imagistic constructions, are the living mediators of experience, the bridge between outer worlds and inner.

Photography is certainly a special case within the history of image-making. Its own history is short if construed on a technical basis and might even be considered as having come to its conclusion. Just as image-making had no direct physical dependence on light prior to photogenic drawing, neither do electronic imaging systems. It served the modernist sensibility to define photography as a medium unto itself, it made for an easier defense. But the separatist model, with technology at its heart, no longer serves. In its stead has come a search for a broader definition of the photographic medium as one connected to cultural streams, political dialogue, art ideas, and biographic expression.

This assemblage of interviews and critical writings represents that kind of search. Beginning with the examination of photographic history and historical constructions in the words of two of its noted architects, the text flows into a more detailed look at modernism. The interviews are in many ways countertext, in the sense that they articulate an already established point of view. My voice, such as it is, is directed toward serving the voice of the interviewee and the thinking behind the words. The other writings serve several purposes: the illumination of the work examined, the exploration of the language necessary to accomplish that, and, if there is a pattern to that language, perspective on a medium which may have run its course before being fully understood.

Following the passages on modernism are three sections which explore aspects of the modernist model: "Notations as Fact," "The Poetic Imagination," and "Aspects of the Psyche." Journalism and documentary work have found new interest among audiences in the last decade which itself has been marked by political and economic disaster. There can certainly be a case

made for an inverse relationship between the state of the human condition and its poignancy as a prime subject for photography. The camera's exacting descriptive power is compelling.

While description at its best is a literal process, it can also create an obstacle to figuration. "The Poetic Imagination" examines work that attempts to transcend the literal through the literal, by creating picture contexts which develop meaning through an associative process. Meaning thus becomes a linguistic concept—relational, self-explanatory in its generative logic, yet arbitrary from its beginning. The picture sequence refers to a concept other than that which is present in the pictures. What sustains the otherness is the degree of the viewer's faith both in the work's intention and his or her capacity to experience it. "Aspects of the Psyche" addresses a world that centers on and flows out of a solely inner-driven vision. The images and photographers discussed in this section use signs and symbols intoning soul darkness, doubtful gazes, memoric landscapes. Historically, these last three sections reflect developments of late modernism, the fully elaborated expressions of those impulses whose roots can be seen in the early modern period.

The final section, "Culture and Cultural Constructs," recognizes that photography's provincial borders have dissolved within the broader issues of image-making and its culture. The syndesis of photography and conceptuality signifies photography's role as servant to idea. It has been photography's emblematic and linguistic achievement to be nothing more or less than *representation*. Its inflections are solely rhetorical style.

And we are fascinated with the idea of culture, its identity, politics, ideologies, and, quite simply, the permission to address it as something constructed with a degree of intention and consciousness. If postmodernism is a convenient term to hang on this process of reexamination, then so, too, is the notion that the process is one of research for an appropriate spiritual basis or generative principle for picture making as we approach the next millennium. Since it has taken about seventy years (a full human life cycle) to unfold some of the spiritual impulses behind modernism, to see beneath its more acknowledged accomplishments, one can only respond to hints and desires for the future in recent work. The pattern is one of reconnection, between

language and image, self and world, concept and feeling—all through a desire for consciousness in action. The idea is to move meaning out of the constraints of the photograph, out of the realm of death ritual and closer to the living imagination. By engaging multiple modes of working and senses, recent work in the recombinant mode engages the viewer more as participant in the work's meaning than as the passive detached onlooker.

While the text of this collection considers an historical unfolding, the overall texture should convey a sense of photography in the San Francisco Bay Area. With few exceptions, the interviews were done with individuals who were in the area because of exhibitions—often the first publication coincided with the event. And, the vast majority of the exhibitions discussed were held in museums or galleries from the area. Beginning in about 1980, San Francisco moved from its relative provinciality toward center stage and international recognition as a center of photographic activity. Its earliest claim was with Group f.64 whose sole group exhibition was held in 1932. Those photographers pretty much defined the photographic aesthetic in Northern California for decades. However, the San Francisco Museum of Modern Art under the curatorial directorship of Van Deren Coke, began in 1979 exhibiting and collecting in depth with two particular directions. The first was to collect, research, and exhibit the full spectrum of modernist photographic work particularly as it related to the other visual media. The second was to exhibit and collect the work of younger contemporary photographers. The museum's exhibition program progressed at breakneck speed, generating excitement amongst the local constituency and commanding attention from the national and international media. The wide range of active photographic institutions—including the Ansel Adams Center and "alternative" spaces such as San Francisco Camerawork—continue to contribute to and benefit from the energy of this renaissance. Though this assemblage of writings does not present a complete picture of the spaces actively exhibiting in the Bay Area, I would hope that it remains as a timely historical impression of place and concept.

John Bloom
SAN FRANCISCO 1991

History

and

Historical

Constructions

With the publication of *A World History of Photography*, Naomi Rosenblum has been recognized as one of the preeminent historians of the medium. Her vision of its 150 years of practice portrays human values foremost and then addresses the larger social, cultural, and economic issues from that standpoint. As evidenced in this interview, Dr. Rosenblum's historical perspective is guided by a very practical and accessible philosophy.

One of the exclusive wonders of photography is that its history is very short, at least relative to a more inclusive history of picture-making. A period of 150 years seems encompassable. However, with the advent of the camera-film image, the accessibility, production, and consumption (the last of which doubles as a disease) of images changed drastically. Photography accelerated the rate of picture production to such an extent that one could view a year of photography as equivalent to 50 years of painting. As counter to that notion, a curator in New York once stated that photography was born whole— that is to say that nothing new has emerged since its incipient years.

Whether one agrees with either case, 1989 marks the sesquicentennial celebration of photography's official announcement as the artistic medium of the future. Photography made its debut in an appropriately modern and ironic way when the new medium was released in France with Daguerre's name and patent attached, but freely distributed by the purchase and will of the government. Imagine an artistic medium kept secret, while others raced for prior disclosure—a true

example of historical self-consciousness and commercial self-interest. In England, Talbot's patent came as a failed afterthought to information published in the spirit of free inquiry.

The photographic medium is not a natural outgrowth of human behavior such as drawing or forming, but rather is grafted from and to the intellect rather like geometry. The photograph's ability to express arises from its pictorial or linguistic nature rather than from its physical quality—it is, in a sense, a pre-mediating medium. Thus the portrayal of the medium's history is as much a conceptual exercise as it is chronological. The history of photography, how it has been constructed and written will be much looked at in the coming year.

But first, one should hear from one of its principle authors, Dr. Naomi Rosenblum. Dr. Rosenblum received a bachelor's degree in fine arts from Brooklyn College, New York in 1948. Thirty years later she was awarded a Ph.D. in Art History from the Graduate Center of the City University of New York, where her dissertation topic was *Paul Strand, The Early Years: 1910–1932*. Her concerns with Strand's work, which has been recognized as key to the development of modernism in photography, and her continued interest in photographers such as Lewis Hine are a reflection of her having grown up in the depression and her awareness of the social and artistic impulses of that time. Her historical interests have included such topics as a history of *Women in Photography* and more recently researches into photography in China and Latin America. Dr. Rosenblum is a thoughtful and engaging historian whose insights are based upon careful research and a broad perspective of the arts.

JB: How did you go about structuring and organizing *A World History of Photography*? This is a historiographic question, because, it is about how you tell the story of history. You have certainly taken a different approach than Beaumont Newhall.

NR: I decided not to use what I call a topical approach, in which one goes through the theory, inventors, and practitioners of the medium and jumps from one to the other. I wanted to tie the technical material (I think you can't really discuss photography

Lewis Hine, *Little Spinner in Mill, Augusta, Georgia. Overseer said she was regularly employed,* 1909, gelatin silver print. Courtesy International Museum of Photography at George Eastman House, Rochester, New York.

without it) into what was happening sociologically and culturally—that is, discuss it in terms of movements in the other visual arts. I felt it necessary to touch on photography's economic base, too.

JB: Economics in what sense?

NR: In the sense of which groups of people became interested in photography. Were photographs different when done by people of different classes? How did different groups of people in the economic structure use the medium and regard it? What kinds of photographs did they prefer to make or look at? At the same time I didn't want to make it too theoretical or didactic; I wanted a wide readership to find it intelligible.

Interview with Naomi Rosenblum 13

The first thing I thought about was chronology. This made me realize that many events were happening at the same time. Photographs were made of certain things, for certain reasons, and I had to figure out a way of dealing with concurrent activities which I felt were related to one another. So I divided the work by subject matter, and later, approach. As you say, any way you divide history is arbitrary.

JB: Except that you engender a certain mood or set of values when you cut it any particular way.

NR: That's right. The overriding idea was to try to relate photography to other aspects of culture—to scientific, sociological, and aesthetic developments, yet allow it to keep its character as a distinctive entity.

JB: What you've done is actually tracked the development of ideas in photography as a reflection of everything that was going on contemporaneously in the culture.

NR: I've had a background in the arts, but I've also been interested in the way the visual arts relate to social and economic factors. This comes partly from having grown up in the depression. That's when I first took art classes; I learned to paint while attending WPA [Works Progress Administration] classes. The first artists I knew were all connected with the WPA, and most of my later friends were artists and art historians who had been involved with the social movements of the 1930s. Walter [Rosenblum] was in the Photo League in New York City. This may account for my interest in Lewis Hine and Paul Strand, although in later years Strand was plucked out of that context and made into an artist interested more in abstraction than in social issues.

JB: One would have to divide Strand's work into early and later periods to come to some clarity about that, no?

NR: His early work fits that description better, but from the

time I knew him in the late 1940s, he was greatly involved with political ideas.

JB: This is clearly reflected early on in his filmmaking.

NR: He even felt that some of his early work was "political," although people don't readily see that character in it. But to return to my *History,* because of my background I concluded that making art and making social statements are not mutually exclusive. One can produce artistic objects with "social significance," that old-fashioned phrase that hasn't been used for a long time. I am amused when I read that people who make documentary images should not be making art because documentation makes a social statement and art arouses emotions—pity, for example.

Do people really believe these elements to be separate? Significant works of art make social statements, symbolical statements, psychological statements. Why should we demand of social photographs that they give us only information about how something looks or how we should think instead of how we should feel? Feeling and thinking should be integrated rather than separated.

JB: In terms of the history of photography, do you think it's important to draw a significant distinction between the nineteenth and twentieth centuries?

NR: I don't think that's a bad distinction to make. Actually, I teach a course in the History of Photography in two semesters, from the beginning up until 1890, and then to the present.

JB: Up to the Pictorialist movement?

NR: Yes, up to the invention of small cameras, dry film plates, and independent processing. Up until its expansion into a popular medium. And up until the point when halftone reproduction became possible. Because, after that photography took off in many other directions. At its beginning—the so-called primitive

era—photography had different techniques and a different sensibility. Then, through its popularization, other impulses became important. People were able to experiment and to project ideas more clearly. For instance, before 1890, a small number of individuals such as Rejlander, Robinson, and Cameron felt photography could be art, high art. And shortly afterward an art movement with different ideas was led by Emerson. But it really was not until Pictorialism in the 1890s that the art movement in photography became serious and widespread. Amateur groups and camera clubs appealed to large numbers of people in the United States.

JB: And internationally?

NR: Yes, it was an international movement, but I think the art idea was more popular among photographers here. People in Europe couldn't afford to photograph so extensively. The United States had a larger middle class, which meant that one could think of getting a camera and plates, and of spending the time. In Europe, there was an upper class, and artist-bohemians, some of whom thought of photography in this way; but, peasants, workers, and craftspeople really could not afford the medium.

JB: You have mentioned that some of the nineteenth-century photographers borrowed from the hallowed grab-bag of nineteenth-century art. So, there already was an impulse to recycle imagery, or at least choose good models to base things on. Though this idea seems so current, it is interesting to note that ideas do trip easily from one century to another.

NR: I've always felt that a strong relationship between all the visual arts exists. This relationship might derive from an art idea and affect the style of works in different media. If one is just training the camera out the window to make a record of something without much thought, then such ideas might not have any effect, but if one is conscious of art culture, then prevailing styles will impinge and will be visible in one's photographs.

However, from its beginnings, photography was thought to

be a stepchild of the arts. There were ongoing arguments about whether photography could be art. You are familiar with Baudelaire's famous statement that photography should consider itself the handmaiden of art—should be used like a typewriter, so to speak. Since many nineteenth-century photographers were aware of this kind of argumentation, they felt that the way to give the medium more prestige was to imitate the traditional visual arts.

I don't think that is true any longer. The relationship between the media has changed completely since the 1920s. The Bauhaus in Europe and later in the United States encouraged experimentalism, which became more widely accepted. Artists were able to do all kinds of things with photography and with painting. Historians should be open to the fact that distinctions between media had historical origins and were important in the past, but are not any longer appropriate.

JB: Do you think there are national styles and tastes in photography? For example, you have researched Latin American photography. Does it have distinguishing characteristics?

NR: I've recently started to look at Latin American photography, mainly in publication, but also in the original. I do find a different sensibility, even though there is also a kind of international consistency about photography. For one thing, the photographer is constrained by the mechanism and the process. But the sensibility—what one chooses to photograph and the way one uses the light, for example—I think, has to do with one's origins and the purposes for which the photographs are made. And, one's visual history is significant, too. For instance, in Latin America, there have been few artistic photography movements such as Pictorialism. There were few people who could afford to be involved, and few that thought of photography as an art commodity. So photographs have come to be considered as useful in commercial, documentary, or photojournalistic contexts, rather than as art.

Since the 1950s, photographers in Latin America have become more aware of the different movements in photography. They

have tried to incorporate some of the ideas from the United States with their own historic sensibilities, but the results do not look the same as the photographs made here. The United States is quite exceptional in that its photographic expression is so rich— we've explored so many directions. We've enabled so many people to photograph, by setting up schools for example. When I traveled around Europe in the early 1970s, there were few schools of photography in most of the places I visited—in Rome, in Paris, for example.

JB: I assume there were clubs.

NR: There were clubs, but the technical schools where one learned to make photographs in the service of something were more important. A place like San Francisco Camerawork, for example, did not exist then. And in Eastern Europe, the work I saw was mainly photojournalistic. People almost never made photographs for reasons of personal expression, like Strand or Weston. Their work always seems to have some useful application like illustration.

The purpose for which the images are made and the photographer's culture determine, in a sense, a sort of national character for the work. But at the same time, almost everyone has access to photo magazines and books from all over. For instance, back in the 1920s, Japanese photographers looked at American and German magazines; they knew what was going on in the avant-garde. They did montages, and all kinds of experimental work, and took over the German ideas of "new realism." In consequence, international ideas and style become superimposed over the individual and the national sensibilities.

When we were in the People's Republic of China to install the Lewis Hine show in Beijing, we made it our business to look at the work of Chinese photographers; we also showed them lots of slides of photographs from the United States and Europe. We looked at exhibitions and at their photo magazines and noticed that they had been isolated for so long that ideas current in the West had not penetrated their culture. Artistic photography consisted of landscapes—mountains, cliffs, branches—derived from

centuries-old painting styles. On the print the Chinese photographer might calligraph a signature or poem. Other kinds of photographs looked as if they had come straight out of 1950s travel magazines—*Holiday,* for example. Bright blue skies, fields of grain and rice paddies, workers standing, holding implements, and smiling up at the camera.

JB: They really just treated photography as illustration.

NR: Yes, essentially. And not very interesting illustration, visually or sociologically.

JB: Have you done much curating?

NR: No, that's one area I am not usually involved in.

JB: Is it that you feel it's important for an historian to stay out of that area?

NR: No, if someone were to offer me an interesting deal, I would like to organize a show. The first show I worked on was a section of an American art exhibition called *The Modern Spirit* that went to England. The photography part was highly acclaimed because almost nobody in Great Britain had seen the photographs, and few were aware of the caliber of work that was being done in the United States between 1908 and 1935. Then in 1977, I did the Lewis Hine show with Walter and Barbara Millstein of the Brooklyn Museum; it was to be a large show and we tried to organize it with prints in different sizes and techniques—sepia toned, for instance—so it would not be deadly in its visual appearance.

JB: Some of the material that you used to illustrate your lecture on "Women in Photography" was fascinating. Could that become an exhibition eventually?

NR: Perhaps that will happen, I don't know. The lecture may have been interesting because I showed images made as art and

Lewis Hine, *Power Mechanic*, ca. 1923, gelatin silver print. Courtesy Walter and Naomi Rosenblum.

others made for a variety of purposes—as commercial work, as documentation—a mixture that has diversity and offers an idea of what was going on when people working in the same time period have different objectives and points of view.

Toby Quitsland reconstructed a show of the work of forty-two women photographers that Francis Benjamin Johnston had taken to the Paris Exposition in 1900. It was an important thing to do even though the works had the same tenor and are too genteel for today's tastes; however, if in addition one were to include the work of Alice Austin or Jessie Tarbox Beals, and even of Johnston herself, the show would have a broader range. One might see then how women dealt with different social and cultural aspects of life around the turn of the century.

JB: Do you feel that documentary photography has changed very much over the last 150 years?

NR: I think documentary photography has changed in some ways and not in other ways. Wendy Watriss's projects concerning *Agent Orange* and the *Vietnam Veterans' Memorial* are similar to classical documentation. That is, the images are meant to arouse feeling in the viewer. That's what Riis and Hine, and Lange and the other FSA people intended. They did not want to make just file pictures for [Roy] Stryker's expanding file, which would provide information about the kinds of buttons on clothing or knobs on cabinets and radios. Photography may be a good way to accumulate such information, and it certainly is within the meaning of documentation. But it's a literal way of looking at documentation. Riis, Hine, and the others had different ideas; they wanted to touch the viewer, to translate what they felt into visual form so the viewer might share their feelings. I think there's room for both these ways of working. Intellectuals seem to like dispassionate documentation, but in the past people have been moved by visual images. I don't see why photographs shouldn't continue to do that. It is one thing they do very well. Not very many people do it well, but when they do, it's marvelous.

Then there's another problem. One can't make arguments with pictures.

JB: But isn't propaganda, argument?

NR: Not really. When I said argument, I meant a conceptual argument, in which you establish a logical train of thought from which one can understand, for example, that the economic system is responsible for such and such result, or some other weighty idea. I don't think photographs can do that in any way. They can be moving and perhaps even awaken ideas that one can then begin to think about, but the photograph itself is not creating the ideas—they come from one's whole background.

If one looks at a photograph from Wendy Watriss's *Agent Orange* series, for instance, without knowing a thing about the Vietnam War, about chemicals, or anything that went on ten years ago, one sees in the picture someone on the verge of death. Something has gone on: there's an affective relationship between two people—one is saddened by it. But unless one knows from experience, or is driven to read about it, there's no way of knowing about the problems or arguments surrounding Agent Orange.

JB: I'd like to return to the question of whether documentary has changed.

NR: It has changed because the perception of what documentation means has become more acute. There's much discussion about the need for text, and for the pictures to have a relationship to one another. It's changed also because of the way documentation has been used in photojournalism; that development has led some people to look upon documentation as dishonest or corruptive.

JB: Do you feel that we've developed a cynical attitude toward the document?

NR: Many people have a cynical attitude—or a mistrust of the manipulation of photographic images as they appear in magazines, or in other contexts. A number of photographers and critics distrust the fact that documentary photographs have an emotional element or content. They feel that the viewer is being

manipulated by appeals to emotion, rather than to rationality. Some participants in today's documentary movement feel that all images that parade as documentary should have texts and should be distanced—concerned only with fact—which I think makes for rather dull photographs. If one needs to intellectualize, why use a visual image in the first place? If one demands that the image be cerebral, be informative only, make all the connections clear, and so on, why not write about the matter instead? Didactic images have their purpose, but I would not want them to supplant the kind of documentation that displays some feeling and inner expressive energy.

JB: In your historical researches have you found evidence of spiritual impulses that have surfaced at different times?

NR: Yes, photographers often were concerned with symbolism or other realities. Throughout history, some artistic photographers wanted to keep their work quite distinct from commercial or documentary kinds of images and sought avenues that would elevate their images. Spiritual concerns are one of the avenues that keep the image from appearing too mundane. This interest occurs differently at different times in history. One might say that Julia Margaret Cameron was concerned with the spiritual in her portraits and especially in her allegorical works; one reason for the lack of sharpness in her work was her wish to avoid great exactness. As a profoundly religious person, her spirituality took the form of dressing up sitters as Biblical characters. Today, some find these images laughable in their sentimentality while others find them acceptable and even moving, and follow a similar course.

Another wave of concern with the spiritual led to the Pictorialist movement. The photographers involved wished to elevate photography from a record of what is to an expression of more rarified feelings or ideas. All the visual arts of the time were involved with similar ideas—that is, with symbolism.

JB: In Pictorialist photographs, a crystal sphere was a recurring element.

NR: That's an obvious symbol of the spiritual idea—reflective, insubstantial, suggestive, without beginning or end. Pictorialism died out but returned again in a different form again after World War II, with Minor White, Wynn Bullock, and Paul Caponigro, to mention a few. I think that such movements appear in waves, and photography partakes of the same waves that affect all the visual and performing arts.

JB: Do you feel that that impulse has been a part of any of the documentary work that's gone on?

NR: No, not really. I've never thought of it that way.

JB: What about Walker Evans's images?

NR: Reality provoked Evans to make the images. He may have wanted to intensify the experience, but not remove it from its roots, which seems to me to be White's intention—to remove the image from its tie to reality and send it up to float around in a stratosphere of shapes, forms, and feelings.

JB: You mentioned that as a historian, you can't really take on issues of contemporary work.

NR: I don't have the necessary perspective. One has to look at things over and over; what sometimes seems very significant when ideas are in flux can often lose intensity, energy, or validity when times change. I have to let things sit for a while, mull over them.

For instance, if I were to do a show today of contemporary women photographers, I would be selecting the works on the basis of taste. I think historians have a different problem; taste has to be not so much corrected as tempered by time.

During the interview with Weston J. Naef, curator of photographs at the J. Paul Getty Museum in Malibu, one highly significant phrase kept recurring in the back of my mind. It emerged as a leitmotif throughout our lengthy conversations over two days; and, the concept—difficult, problematic, rich with possibilities—points toward the idealism which infuses Naef's approach to and understanding of the medium and its images. *Ut pictura poesis*—as is painting so is poetry— encodes a philosophical stream that not only parallels the visual and literary arts, but also accepts a shared analogy. That resides in the power of words to create pictures, and conversely, the construct meaning, in the linguistic sense of sign and symbols, through the picture.

Photography, as Naef portrays it, has a long-standing connection with the literal and the literary, and as a medium holds a rather special place in the visual arts. The photographic image represents, and therefore, harbors the issues of likeness and interpretation; yet the photograph is also a crafted object. As is clearly conveyed in the interview, Weston Naef is highly attuned to both aspects. His perspective, which holds as ideal the interrelatedness of representation and language, is refreshingly rendered with a faith in the unattainable.

Prior to his curatorship at the Getty which was coincident with the museum's commitment to collecting photography in 1984, Naef was curator of photography at the Metropolitan Museum in New York City. During his tenure there he put together such major exhibitions as: *The Painterly Photo-*

25

graph (1971); *Era of Exploration: The Rise of Landscape Photography in the American West 1860–1885* (1975), which was accompanied by an influential publication of the same name; and, *Counterparts: Form and Emotion in Photographs* (1982), also accompanied by a book about which we speak in the interview.

Since arriving at the Getty, Naef has mounted several exhibitions based upon the strengths and depth of the collection. Most recently, he has produced a series of exhibitions under the general title of *Experimental Photography*. In sequence they constitute his construction of photographic history and much of the discussion that follows hinges upon them. They are: *Discovery and Invention; The First Golden Age, 1851–1889; The Painter-Photographer; The Machine Age* (done by associate curator Judith Keller); and most recently *The New Subjectivity*, which opens December 1990.

Naef, first as consultant then as curator, has been a principal architect of the extraordinary collection of photographs acquired by the Getty. The collection, put together with the commitment of John Walsh, director of the museum, and the expertise of Daniel Wolf, the noted New York dealer, was born whole with near simultaneous purchases of several major private collections, most notably those of Arnold Crane and Sam Wagstaff, and extensive holdings from individual sources and archives. The Getty's announcement of the inception of a Department of Photographs in June of 1984 was carefully timed—it surprised the photographic community—to capitulate all the quiet purchasing which made the Getty one of the most important photographic collection and research centers in the United States virtually overnight. Suffice it to say that few institutions command the resources available to the Getty.

The museum has also made a commitment to making the photographic collection accessible to scholars, researchers, and, by appointment, to virtually anyone who knows what they want to look at by the name of the maker. The Photography Department actively engages curators, historians, and critics as consultants to the collection, in order to help authenticate work, to form exhibitions from the holdings, and to contribute to published material about the collection.

JB: Are you writing a history of photography for the sesquicentennial?

WN: I'm in the process of preparing a survey of our collection, focusing on interlocking bodies of work. This is a particular strength of our collection at the Getty. I'm producing what we hope to be a two-volume work, one volume devoted to the nineteenth century, and one volume devoted to the twentieth century, which will consist of essentially multiple monographs in suites of ten pictures. I've chosen a unit of ten to be a symbol for the relative strength of each of the individuals in the broader historical context. I will be including between forty and fifty photographers in two fairly substantial volumes that will be their own form of a history, in the sense of establishing the canon. This roster of names will reflect the course of picture making in the nineteenth and twentieth centuries. The suites will be accompanied by a text in which I address the most important aesthetic contribution that each particular photographer made.

JB: On what terms are you defining an aesthetic contribution?

WN: Let's start with Carleton Watkins, somebody I've been looking at recently. I am treating Watkins as a genius for having invented, pretty much single-handedly, and throughout his body of work, photographs that are addressed to the problem of perception as a human capacity that can be uniquely expressed in a photograph. Through his compositional structures, he signaled that he was thinking about definable issues such as the role of the edges versus the center of the picture, the role of the incidentalnelements playing off of the more visually prominent elements, and reversing the roles of certain elements by allowing exaggerated foregrounds to dominate a nominal subject. So I've chosen a few of Watkins's photographs in which the clues indicating these strategies are unambiguous. I'm going through each photographer's work to establish the ways in which they have signaled to us what they wanted to do, what they were doing in their work. And it's been frustrating, because sometimes I think . . . I feel it much more strongly than I say it. The book

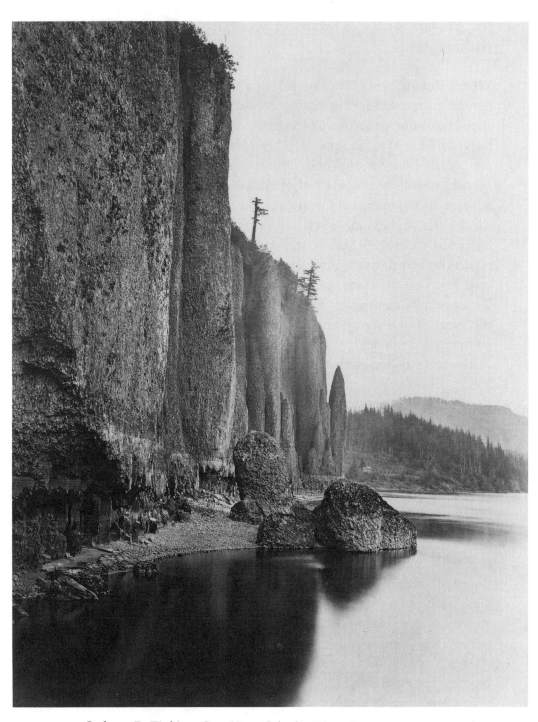

Carleton E. Watkins, *Cape Horn, Columbia River, Oregon*, 1867, mammoth-plate albumen print. Courtesy Fraenkel Gallery, San Francisco.

has been very slow in materializing because I've had to go through and rewrite in order to define what I meant about these.

JB: One major problem is defining what you mean just in terms of the language. And it seems to me you run into the problem between the way things are seen and then what is seen.

WN: Keeping them separate has been my chief problem—but without eliminating biographical details, because I really did not want to become formalist about it. I was trying to weave certain thoughts about the nature of content in photography. There are some ideas I believe in very strongly, and sometimes these ideas came into conflict with the narrative structure I was trying to create.

One of those ideas is the role of the photograph as a picture poem. It is constantly frustrating to articulate the poetic element of the photograph itself when you address it from that very bold, direct, head-on point of view. And poetry seems to be something that wants to become a sort of emergent quality rather than a major prominent subject.

JB: Like trying to define in concrete terms the process of evocation.

WN: Yes, exactly.

JB: In looking back through a number of important exhibitions that you put together, including *The Era of Exploration,* which rekindled an interest in the topographic photographers of the nineteenth century, there is a recurring idea of exploring and experimenting.

WN: There's no question that "Era of Exploration" and the thinking that went into creating that book, which attempted to identify the intellectual undercurrents that surrounded the making of pictures, is still my chief concern. That is to say, the pictures that interest me most are those that were made within a matrix of intelligent observation rather than academic repetition. There's a definite connection because the work that I did

on "Era of Exploration" brought me very close to five photographers who were each experimenting in different ways, with different methods of addressing more or less the same question.

My eyes opened to certain aspects of visual style, and the degree to which one needs to concern oneself with the intention behind the photographer's making of the picture—even to question the whole problem of intentionality in art and art history, and how it relates to the same question for photography. Photography may be an exception to the philosopher's rule that intention cannot be considered. Because the photograph is such a piece of circumstantial evidence. It is a piece of evidence that betrays the intention of the maker.

JB: You mean that the photograph is somehow or other a piece of the photographer's thought?

WN: Exactly. It goes so directly to the mind. The photographer's intention is much more evident than it is in literature or poetry where you always have layers of language that are still between you and the mind of the person. It took me a long time to realize that that rule does not hold for the art of photography. It's one of the most fundamental aspects in which the art of photography differs from the other arts. Many people have talked about how photography differs from painting or drawing or sculpture or architecture. And it may be as simple as the fact that so much of the art of the photographer's thinking is so unambiguously, directly indicated in the picture itself.

And how can a work of art be anything but the work of a single consciousness? If you go through the whole roster of expressive media, poetry has a genuinely direct power. Reading Shakespeare's sonnets, you realize how unfettered he was in his sense of communication. The medium is only limited by the imagination of the person who is working with the words. I think of poetry and painting as these two princely characters where there is pure plasticity. I just find so many limitations which constrain all artists in one way or another. But photography seems no more no less.

JB: Do you think there is a Shakespeare in the history of photography, at this point?

WN: Good question. Very good question. Of course, there *has* to be a Shakespeare. But, Shakespeare only exists for those who read Shakespeare. And when you've read Shakespeare or looked at Rembrandt's paintings, you realize why they are so absolutely extraordinary. The problem with the history of photography is that so few people have looked at the bodies of work to have a large enough number be in accord over what it is they have actually seen. This mainly has to do with the youthfulness of the materials.

Since you asked me who are my Shakespeares in photography, Julia Margaret Cameron in England had a genius that is universal, and her pictures will be looked at as long as people are looking at pictures. Carleton Watkins comes up again and again. When I look at his work, I'm just astonished at the perfection of his vision, of how he transformed a disorganized, chaotic world into a place where everything seemed right and correct. Through his power of vision, he created a kind of inner perfection, a visual utopia that is really, for me, about the same as the kind of utopia that Shakespeare created in the best of his sonnets.

JB: If you look at some of the industrial landscapes that Charles Sheeler and other Precisionists were painting, they portrayed a clean utopian vision. Does Sheeler, as a photographer, qualify?

WN: That's a very interesting comparison. He does, but the problem with Sheeler, of course, is his body of work in photography is relatively limited. But he made twenty of the greatest pictures ever done. Edward Weston is a name that I've talked about because his work gets better after each looking. There seem constantly to be pictures surfacing that we didn't know existed. His work is so diverse and full of emotion. Paul Strand stands way up there in the pantheon of creativity. If you think about the question of early genius, it is absolutely staggering to think that Paul Strand, at the age of nineteen or twenty years,

created some of the most powerful works, photographs, that have ever been created in the history of the medium.

Unfortunately, Gustave Le Gray and Roger Fenton had careers of only ten years. It is a highly personal measuring stick that, to be really in the highest pantheon, you have to have a career that goes beyond a certain decade. Consequently, I look at those photographers who have had really long and prolific lives. Watkins fits in there because he had a forty- or fifty-year span. But it tends to eliminate Timothy O'Sullivan. It certainly causes you to want to look at the dinosaurs of the twentieth century like Imogen Cunningham, Harry Callahan, and Alfred Stieglitz. Given my background and my enormous respect for him, Stieglitz should be decreed by a chorus of voices as a Shakespeare of photography. But Stieglitz was a little bit like Michelangelo in having personal crises that paralyzed him during long spans of his creative life.

JB: How did you become interested in photography? Were you inspired by William Ivins at the Metropolitan Museum?

WN: Ivins had left the Metropolitan Museum long before I arrived. He was an intellectual mentor rather than an actual one. My love of photography began as a result of work that I'd been doing with nineteenth-century French painting and printmaking. I had done quite traditional art history graduate studies. I was also very interested in the sixteenth century because it was the century of Dürer and some of the great advances in seeing and optics that led to photography as we know it. And representation had always interested me enormously as an idea. I never became very—in a scholarly way—interested in Dutch painting, but I was always a great admirer of it. But, to answer your question, I was a student of nineteenth-century painting and printmaking and began to see remarkable resemblances between the drawings, for example, of Honoré Daumier and the photographic representations of Nadar. I marveled at how Daumier could draw the world so tellingly, so accurately, and yet not be a realist, so to speak. On the other hand, he wasn't really a caricaturist, because the drawing was so truthful in a sense. Through the study, sim-

Gustave Le Gray, *Brig on the Water,* 1856, albumen print. Courtesy J. Paul Getty Museum, Malibu, California.

ply, of representation I began to look at photographs as varieties of representation. And the only way I can describe it is simply falling in love with a subject.

I can vividly remember the first time I saw Edward Weston's *Pepper No. 30.* I thought it was the most beautiful thing that I had ever seen in my life. At the same time I saw Dorothea Lange's *Migrant Mother* at the Museum of Modern Art in 1961 or 1962. Those two pictures were the ones that really were absolute evidence that this was a great art with extraordinary expressive potential. It may also have been because as a student of French art and artists around Daumier in Paris of the 1830s and 1840s, I noticed an absence of strong emotional positions on the part

of the artists toward the subjects they were rendering. But in the photographs, I sensed a deep commitment not only to the subject, but the way the subject itself was represented. This particular aspect suited my own temperament; it simply touched a chord that I really wanted to explore. And as a result, I spend a lot of my time looking at photographs and trying to find those pictures that touch the spirit, the human spirit, in a way that is general and classic, rather than hermetic or part of a mystery that one has to be introduced to without seeing it first, without a code.

JB: Was that really the basis of your exhibition and book *Counterparts*?

WN: Exactly. *Counterparts* was the result of having to cope with an exceedingly limited situation; the idea was to create a book, a publication, out of a group of pictures that had come together as a result of a corporate donation, and a purchase fund that had been established along with a gift of photographs. It had to be a collection that was shaped on a premise that the individual works should be of great quality, and each should have a strong power of arrest. The company that sponsored this was Warner Communications. I was intrigued by the image of Warner Communications as the mass media company. I was trying to appeal to a kind of public sense, sensibility, without admitting that I was doing so! *Counterparts* was the result. I decided to put these pictures together that *I saw* as having connections, and with the text tried to explain why I felt those connections.

I go back to the book a lot and see some comparisons I wouldn't probably make today. In doing the show that's coming up next, *The New Subjectivity,* I have, as I did with *Counterparts,* started the essay with Alfred Stieglitz. *The New Subjectivity* is, in a sense, a re-deployment of the idea of *Counterparts.* In fact, I'm calling the new subjectivity something which bounces off of Pictorialism and the Photo-Secession. That is the first period of subjectivity in which the photographers were governed, first and foremost, by the requirement of making a beautiful picture, rather than ventilating emotional states. The great transition came when Alfred Stieglitz began to photograph clouds that were intended

to be nothing more than expressions of inner being. In *Counterparts* I put forward a formalist emotional sensibility.

JB: That seems self-contradictory!

WN: But the experience of feeling strongly about a purely non-objective work because of the beauty of the inner formal relationships that have been created by the mind of the artist is one form of satisfaction. For anyone who is initiated in the experience, it is a form of visual utopia. So the counterpart I was trying to work with was: what happens when you go from abstract and formalized work which has underlying it a strong emotional quality based on the intelligence of the mind creating it and the relationships that are created, to something which appeals to emotions more humanistically, more referentially through the subject.

The New Subjectivity goes more directly to the heart of the issue and can do so because it follows a show called *The Machine Age*. In *The Machine Age,* I presented the concern for concrete, formal relationships of a very powerful sort that anyone could respond to. People really love abstract art, obviously. The real questions in my mind are: how will *The New Subjectivity* strike the same people? Will the Josef Sudeks and Gene Smiths seem somehow sentimental and insincere?"

JB: In making a connection between *Counterparts* and *The New Subjectivity,* you seem in agreement—and correct me if I'm wrong—with one of the basic tenets of Modernism, and that is the Equivalent. Do you still agree with that notion?

WN: Well, I don't believe any less that the greatest photographers were either consciously or unconsciously creating metaphors rather than illustrations. When you use the word *metaphor* as the objective, that is, the picture stands for something that cannot be seen on the surface, then the word *Equivalent* has to be invoked. Consequently, the photographs that I like best are damned hard to explain.

For example, Bernd and Hilla Becher are among the small

number of contemporary photographers that we have in the collection. We have not for the time being acquired any contemporary photographs by purchase. I always say that as an aside because I hope that one day soon we will be addressing contemporary photography in a very aggressive and professional way, which it deserves.

JB: If you track the chronological order of exhibitions that you've done, it must be coming fairly soon.

WN: I know very few people who do not like to look at the Bechers' work; it's absolutely charismatic. The perfection of the way they're arranged has a kind of sonnet-like appearance. They've spent such an enormous amount of time editing the groupings of pictures and composing the individual ones to an errorless perfection that is attractive to even the uneducated eye. For the life of me I could not create words that were as perfect as the photographs. I began to make some connections about their selection of such very obvious and accessible subjects and treating them in a way that no one else had treated them, and what degree of imagination that took.

The success of these photographs simply overshadowed my ability to put into words why they were such powerful equivalents of some emotional attachment, the Bechers' own emotional attachment to those industrial structures that they photographed out of a sense of deep, abiding love. So I continue to find the concept of equivalency a very important one, because it really does mean that we're asked to feel something about the picture, when we look at it, that the photographer is supposed to *feel* something about his/her subject when the picture is made, and that the union between the viewer and the photographer is when the feeling about the subject is perceived. That is the equivalency that we're talking about. The difference between commercial, "hack" or amateur photography and poetic photography is probably the degree of the feeling that goes into the picture.

JB: In your structuring of the history, where do you fit people like John Heartfield, whose work is clearly politically motivated?

WN: I think photography is an essentially political tool, a fundamentally political medium, so inherently political that I don't even usually consider the politics of a picture as an issue that concerns me in my analysis. Heartfield proved the power of the camera to implement social change. He is a kind of Daumier or Goya of the camera. And he proved that the photograph could have a literary barb to it that is as powerful as any of the caricatures made for political purposes in the past. And I applaud that, I think it's wonderful.

JB: When you think of photographs as inherently political, in what way?

WN: I should refine that and say it's principally twentieth-century photography that is inherently political. When highly portable cameras, as used by photojournalists, became available, photography immediately became a political tool. So it doesn't really go back to the nineteenth century. However, if you examine some of the underlying premises of the great photographs of the nineteenth century, you will very often find a political agenda. For example, Pierson's portraits of the Countess Castiglione in the era of Napoleon III are clearly representations by someone who deeply admired the politics of the person, and the style of those people.

JB: So in some senses representation of something is an affirmation of its political values.

WN: Right. There are exceptions to that, but I think, particularly in the nineteenth century, it's very unusual for someone to point the camera at something that they genuinely did not like. One could also go through an entire body of work, and subtract things that were not photographed by a photographer and come up with a corollary alternative agenda.

JB: Could you give an example?

WN: Atget never, as far as we know, photographed the Eiffel Tower, the Opera, or the great public and political buildings of Paris.

Eugene Atget, *Street Fair Booth,* 1925, gelatin silver print made by Berenice Abbott, ca. 1954. Courtesy J. Paul Getty Museum, Malibu, California.

JB: Neither did he embrace any of the contemporary technology available to him. That must have been a condemnation as well.

WN: We have to say that Atget's photographs must have an unwritten political agenda detectable in what he chose not to photograph as much as what he chose *to* photograph.

JB: In your capacity as a curator, what is the role of intuition and taste?

WN: Intuition is absolutely essential to the task of curating because so much of what a curator is able to buy, he or she has

never seen before. Most of the objects that we are presented with are new to the nonauction market. The auction marketplace tends to be the opposite by making available mostly things that are known about or seen before. The point is that vendors know we will take seriously work that they present as new to the museum, new to the marketplace, or new to the history of the medium. Sam Wagstaff, for example, loved to be the arbiter of taste over judgment.

It's a question of his intuition as to whether the person involved was really a major figure. I can give you a specific example. There was a man named Quigley, a Philadelphia photographer who experimented with photograms and some X-ray photography in the 1920s. Sam bought an enormous amount of Quigley's work, most of which went to Robert Mapplethorpe. Of the body of works, which totalled about fifty or sixty pictures, we have maybe ten or twenty in our collection. It's hard for me to say whether Sam thought those were the best, or whether they were the worst! Robert ended up having the best of his work. This was recently sold from his estate in New York. And I hope what was sold will get to us eventually through the workings of the marketplace. But in any event, the taste that was expressed, or the intuition, between these two people about a name that is totally unknown, for the most part, except to really true specialists, is an interesting phenomenon. I don't think of Quigley as a major figure; it's the work of a sincere amateur. They belong in a museum collection, but it's work over which there is still either taste or intuition to be levied. I'm not sure which it is.

JB: I can't help thinking they might be called Quigleygrams. On a more serious note, I wonder how you determine lasting value?

WN: By looking at the work again and again. For me, the great example is Paul Strand. And up until about 1980, I had seen the five prints that the Metropolitan Museum had through Alfred Stieglitz. Wonderful images, such as *Wheel and Mudguard* and *Blind Woman*. The marketplace would produce Strand pictures

of uneven print quality. They did not seem to demonstrate his passion for creating objects of extraordinary craft. However, I was invited by the Paul Strand Foundation to look at the entire estate. I was just astonished at the consistent beauty and greatness of these prints that had apparently not ever been seen by the public. When I saw how many of them existed, I realized that he was, indeed, a master of the highest possible order to the very end of his life, as fastidious as anyone, any person ever working in this medium could be. It was a kind of opening of the eyes, such a wonderful experience to recognize the sheer genius that the man had. And as a result, we acquired a collection of over one hundred of Strand's most beautiful prints.

JB: How would you present the case for the significance of nineteenth-century photography for contemporary sensibilities?

WN: I would make the argument on the consciousness of perception itself, the process of perception, which is the first step toward Modernism. The second ground would be the medium's power to infuse content, literary content, into pictures in ways that are really quite traditional. I would point to Julia Margaret Cameron for the way she brought literary sources, simply made pictures that were so full of traditional literary content that you learn a lesson about how to work by looking at the work itself. And it is relevant to anyone who is working today, because if content ever becomes irrelevant in art, then we might as well throw up our hands.

Perception will always be a key issue in all of the arts, particularly the art of photography. If perception is at the heart, say, of a concept like Postmodernism, then in order to comprehend the roots of where you've come from and what it means to be dealing *not* with content, but with perception, you have to start with the nineteenth century. In nineteenth-century work like Watkins's or Cézanne's, you can see the roots of a poetic consciousness that is the overshadowing source for how we think about art. They were simply dealing with the issues directly, because they were the first to be there. That really is key to their

greatness. They carved out areas of primacy that can be easily identified.

JB: Do you sense that there was an innocence that the nineteenth-century photographers brought to the issues of representation? Julia Margaret Cameron applied an art consciousness to making pictures, but that seemed separate from representational issues. Is that true of others as well?

WN: No. But you are right about the innocence of perception.

JB: And at what point did that fall away?

WN: That fell away in about 1880. The five shows that we will have presented this year are a quiet attempt to redefine the structure of the history of photography. The structure is that you have the moment of discovery and invention, the time of true innocence during which some of the basic possibilities, potentials were established for the first time, and models that unfolded later were established. You have the first Golden Age, which is the moment at which all of the principal possible materials and strategies and places to be photographed were fully established. At that point the result of the photographer's work, the quality of it was totally dependent on his or her ability to create, to imagine, to invent.

In everything before that time, there was always a technical struggle, the fact that all of those people, if nothing else, were the first to be doing what it is they're doing. And there is, of course, a historical destiny to that early period. The second period is so important because, for the first time, the photographer can do anything, practically anything, with the exception of representing color faithfully, that the imagination permitted. And therefore, in the first Golden Age, you have photography beginning to get very close to painting and ideas of painters at the time.

Where I differ in the structure from many of the existing history books is that I consider the third period not a period of

naturalism or Pictorialism, but a period of the painter/photographer. For the first time, painters, such as Degas and Eakins, came into a developed field and exercised naive imagination. They used the materials in fresh ways that bypassed all of the rule books that had been written in the decades before. Since my history is forward-looking, I had to create a substitute for Pictorialism, because Pictorialism was essentially reactionary. Those who began to deviate from the rule books were the ones who we have to look to as the pattern setters for the next decade, the decade when Alfred Stieglitz abandoned Pictorialism after 1910.

Photography is all about the power simply to apprehend the perception. And so it's this particular strain that happens to interest me enormously enough. I love it. The first decade, particularly, because these people were perceiving the world through the camera's eye, for the first time. And that is, by definition, perception. When Talbot made those first photographs, he was expressing a deep emotional experience, the power of this invention to record.

JB: But, camera perception was already current in artistic culture, because of the camera obscura. So there's something other than just the camera. . . .

WN: I think of the camera pictures made at that time as more or less subordinate to the cameraless pictures. They are more compelling because they confront so directly the conflict between truth and beauty. They are both the reflection of the thing and a poetic statement about the thing simultaneously—they were perfect manifestations. The camera photographs inevitably bring in imperfected technique.

In regard to the cameraless images, Anna Atkins stands as one of the great geniuses. You get into her biography and you realize how deeply immersed she and her father were in poetry. Although one first thinks of her work as scientific, her cyanotype photograms were more likely manifestations of the spirit of Coleridge and Wordsworth. The work never proved to anyone to have a real scientific value. That means they were a classic example of useless projects. The only projects I have known that

are perfectly useless are those that are created by the government and those that are created by artists!

JB: You cite the cameraless pictures as essential and critical to understanding the birth of photography. A similar fascination with cameraless imagery occurs in the late teens and early 1920s with Schad, Moholy-Nagy, and Man Ray. Do you see that node as equally important?

WN: The earliest cameraless photographs have practically nothing to do with those of the early twentieth century. For me, the first cameraless photographs by Talbot, Atkins, and Bayard strove for representation in the most utterly truthful and faithful way of a subject that was otherwise very difficult to represent. If you interpret the earliest cameraless photographs as they interpreted them, as absolute counterparts of that which created the picture, then the earliest photograms are a part of that truth-seeking line of photography that finally comes to fruition in the 1920s, not with Man Ray, Moholy-Nagy, and Schad, but rather with Albert Renger-Patszch, August Sander, and Walker Evans. I see this concept as the fundamental stepping stone to the present for a very different reason than most historians. It is a very personal interpretation that I have not articulated in any really thorough way in writing or in a lecture, but I would like to have the opportunity to do so at some point in time.

JB: So your sense is that nonobjective images from the early twentieth century were solely about art ideas?

WN: Yes. The real difficulty is in confusing, at the earliest moment of photography, art with poetry. Most of the early photographers came from literary backgrounds, up to the time of Julia Margaret Cameron, who was the last of that great tradition. Look at Talbot's motivations. He was basically a philosopher, a person involved in semantics who will finally be remembered for the gift of description that he had in his own writing, and for the pictures that he made that were translations into visual language of what he was thinking in words. We are indebted to

Mike Weaver who really led us into a new understanding of Talbot and Cameron.

JB: How much of nineteenth-century photography was commercially rather than artistically motivated?

WN: The answer to the question is, we don't really know, for sure, until you get to the 1880s, when advertisements appealing to a broad audience begin to appear. Before that time, I think the issue of commerciality is really a red herring in the history of photography. For example, Samuel Bourne working with his partners in India, Felice Beato working in China and Japan, or even Carleton Watkins, working in San Francisco, all sold pictures; they had enterprises, but that was secondary to their photographic concerns.

Of all the organizations that you could really describe as "commercial," in the sense that there was a thriving business with a clientele that responded to their advertising or to their appeals, or to the need for the product, there are really only two that stand out. One of them was Adolphe Braun in northern Europe. He identified a very specific market that photography could satisfy better than any other known means—to record works of art. That was truly commercial. I believe that until the invention of photomechanical printing, the advent of the picture postcard in the 1880s, and the chromolithograph, even the most commercial photographers were still operating like artists. They were still going out to make the best picture they possibly could, in places that they respected and actually enjoyed being at the moment. There's also a commercial aspect to carte-de-visite portraiture. But you see how well composed and lighted they were in comparison with the later cabinet portraits.

JB: So you don't think that even though they were works of art, that commercial interest fostered a lot of innovations in photography?

WN: I don't think that commercial motivation has spawned any of the innovations that concern me. For the most part, the history

of photography that is most interesting is not very much connected to the history of processing. And this is, of course, the point at which John Szarkowski and I may differ. When his exhibition and book [*Photography Until Now*] come out in 1990, we'll all have a clear view of his particular position on this issue. John is, I think, going to argue that process and materials are fundamental to an aesthetic of photography.

My objection to that is, when you have somebody as majesterial in their accomplishment as Gustave Le Gray, Carleton Watkins, Julia Margaret Cameron, or Roger Fenton, there is something in the pictures that goes beyond technique. It is not albumen on glass that makes the picture what it is. Each of their images has a signature that starts at the cortical level of the human brain. It's all about perception, and it is the perception that allowed them to make pictures that were ravishingly beautiful using materials that were more or less common to all four of them.

JB: What followed the period of the painter/photographer?

WN: The biggest gap in my chronology is the great era of Pictorialism. A practical reason for that might be that it is not a strength of the Getty Collection. But a more important answer is that Pictorialism is not part of the forward momentum that I'm trying to describe in my history. If they contributed anything specific, it had to do with transforming the photograph into a beautifully crafted consumable object for delectation and collection. I equate Pictorialism with the images produced by portrait studios in the 1880s. Their products were for the middle class. In Pictorialism, the images were simply better products.

JB: They were, theoretically, for a higher-class audience.

WN: I am treating Pictorialism in what some might feel an unfair way, but I must say that my credential for doing so is having studied the period probably more carefully than I have studied any of the others. These small sequential exhibitions have a very personal air about them, they can be much more personal and tentative. The small scale and intimate nature of the shows have

permitted me to make some arguable decisions about the un-folding of the history of photography.

JB: Are you are taking the painter/photographer period right up through World War II?

WN: Well, I say that is the momentum. It started with Eakins and Degas and has moved straight up in an unbroken line through, well, I'd like to say the present day, up to Andy Warhol.

JB: It seems that it's not just representation or presentation, but also authorship, that is central to your vision and the way you've put the Getty Collection together.

WN: Absolutely. The author, for me, is all. The maker of the picture is a person who is sacred in their position.

JB: Where does Postmodernism fit with your notion of historical development?

WN: I'm not sure I really have a good definition of what Post-modernism is in photography. But much contemporary work, that for example strives for large scale, has aspects in common with a period that would be pre-Modern in its inception. If Postmodernism means not a revised state of Modernism but rather the opposite, a reaction to Modernism, going back to another axiom, then, yes, Postmodernism follows a line estab-lished in the 1850s and 1860s that was generally nondocumentary in its character.

JB: You are portraying history as a kind of pendulum.

WN: The history of photography seems to be a pendulum that swings continuously between facts and interpretations, objectiv-ity and subjectivity, mechanism and romanticism. Postmodern-ism as we see it is really a neo-Pictorialism of an odd kind. It doesn't have a great deal to do with radical Modernism.

In its rudimentary state, projection is interrupted light; its presence is, in a sense, *in absentia*. Shadows were probably the earliest form of observed projection, and belief in their magical powers was connected to their sun-origin and their ability to evoke significant form. The shadows, dancing on the cave walls, had a life of their own. They fascinated because they engaged the imagination in an auto-constructed believable world. The shadow's condition of simultaneous presence and absence was the basis of Plato's "Parable of the Cave" in *The Republic*. In elevating the shadow to primary reality, the denizens of the cave substituted the projected image (shadow) for the substance itself. This substitution was the first condition of a nonobjective reality and still serves as a paradigm for forms of projection. To understand a perception or construct based on projection, one must first establish its objective basis and/or accept its subjective and illusive nature. C.G. Jung noted: "In general, emotional ties are very important to human beings. But they still contain projections, and it is essential to withdraw these projections in order to attain to oneself and to objectivity."[1] Plato's parable continues to inform human consciousness in its struggle with objectivity—in discriminating between appearance and significance.

In the realm of photographic media (including film, video, and still photography), shadows are an integral part of its objects. For example, in photograms light is given objective form and one reads that abstraction through the physical properties of reflection. In an essay discussing photographic

FROM MAGIC LANTERN TO MODERN FORM: SOME HISTORICAL NOTES ON A MAVERICK MEDIUM

For us there must be projection, and the question for the twentieth century is whether it is to be projection of nothingness or a projection of the sun-spirit, the spirit of light.
OWEN BARFIELD

47

A magic lantern, engraving, 17th century.

theory, Dennis Grady points out that the photograph's "paper-thin surface is literally an interface between projection and reflection."[2] It is this same principle of reflection which can allow a photograph to make the leap from abstract light-marks to representational imagery. The film records the subject's modulation of light through the lens. From the apposition, the image-object has a mimetic appearance because the patterns of light and shadow *approximate* the imprint or mental image of the original experience (real or imagined). Thanks to Plato's admonition and a heightened media consciousness, we know how to unravel the syntax of approximation. We are free to contemplate and enjoy images, projected or reflected, as if they were shadows dancing

on the walls of the cave, provided our perception is informed rather than veiled by this syntax. The poetic of camera-generated imagery imbues the image with equal reference to origin (reflection) or idea (projection). The former is quantitative, explicable by examination of the physical properties of the imaging system; the latter happens through the imagination and is conceptual and magical.

As our ancient cultures devised uses for the projected shadow, they intuitively understood the dichotomy between the functions of origin and idea. On the one hand, as early as 2500 B.C. the shadow clock marked the passage of time, breaking the sun's (origin) movements into discrete units. On the other, abstracted or silhouetted shapes and writing cast as shadows upon a translucent paper screen were the mechanism for a theater of movement and fantasy.

It is ironic that the two individuals credited with the invention of the magic lantern were both scientists—but not scientists in the contemporary sense. They tinkered with the inner workings of what in the mid-seventeenth century was considered the Divine creation. The lantern itself represented but a small facet of their *oeuvres*. According to photo-historian Josef Maria Eder, Athanasius Kircher, a German Jesuit scholar, described a rudimentary projection technique in 1646. Kircher, who later coined the term *magic lantern,* placed a condensing lens in front of a mirror on which words or pictures were drawn.[3] The lens focused the light reflected from the mirror. The actual development of a projection mechanism, however, Eder credits to the Dutch physicist Christian Huygens shortly before 1662. Huygens used a light source (usually a candle or oil lamp) directed by a concave reflector. The light passed through one lens, then through the hand-painted glass slide, then through the second focusing lens and on to the screen.[4]

Within a short time, the educational value of the mechanism was noted, but instead (perhaps because the potential lecturers were not artistically inclined to produce their own transparent materials) the magic lantern was used primarily for entertainment purposes. Artists (magicians) were most successful at producing engaging visual imagery, which sometimes verged upon ghost-

like apparitions, for the new machine. And it was they who used it to excite their audiences, playing upon their innocence and unfamiliarity with projective syntax. In order to sustain the apparent magic of the projections and perhaps to approximate more closely a realistic experience, the syntax increased in complexity. Sound effects and live music accompanied the shows. Indeed, by 1839 the practice of "dissolving views," the use of multiple integrated projections, had been established. Eder notes that the intense luminosity of the calcium light source discovered in 1822 (and colloquially referred to as "limelight") was the key to the success of the dissolve technique.[5]

This technique, now called multi-image, dovetailed irrevocably with the inception of photography and its later offspring, film. Lantern slides, which had previously been entirely hand-originated, were photographically generated with the wet-plate process by the early 1850s. The ghost-apparitions disappeared in favor of the more fascinating illusionistic photographic image. The instinct for entertainment, and, more specifically, an appetite for pictorial inebriation that had been satisfied by the visual fantasies proffered by the magic lantern, was easily transferred to the more information-oriented photographic transparency. The camera could assimilate and translate any pre-existing imagery into projectible form through rephotographing. For example, one could view, through a sequential projection of rephotographed illustrations, Columbus discovering America. There were, also, hand-tinted magic lantern slides of the American Civil War produced in the 1870s. Also in 1870, Henry R. Heyl of Philadelphia used a projector mounted with a disk holding a series of small lantern slides to create the appearance of waltzing figures to which music was synchronized.[6] Slide projections were frequently used in vaudeville theaters from the 1880s through the 1920s, and they illustrated the Chautauqua lectures through the first decade of the twentieth century. In the 1890s, Jacob Riis, the Danish-American reporter and photojournalist, accompanied his social reform presentations with lantern slides made from his own photographs of slum and tenement conditions in the Lower East Side of New York City.

The new century brought with it some radical changes in

approaches to knowledge. Cubism shattered the convention of the picture window and Relativity changed the perspective of time and space. With the advent of Freud and psychology, the inner life of soul and dreams was given analogical parameters. The restructuring of human experience provided ample latitude and subject matter for artists to utilize projection media in newly emerging forms. Within the art of projection (including the close kinship between still and moving projection), the manipulation of logical time and space presented no obstacle. Both media depended upon memory and immediate experience to convey their message—but there was an important difference between them. Film images, based upon a narrative logic, had to be projected at a fixed rate in order to create the illusion of movement, and it was the consequent deception which was of critical importance. A middle ground between still and film projection was occupied by the film strip, developed and marketed by the Dusquesne Corporation of Minneapolis, Minnesota, in the 1920s. Adopting comic strip narrative to the time control of still projection produced an ideal and easily disseminated instructional medium. Still slide projection benefited immensely by its departure from film. As painting was freed from perspective-correct representation by the evolution of camera photography, so slide projection was freed from discursive illusion by film.

Two experiments with projected light in the early twentieth century explored its expressive and spatial aspects in a theatrical context. Wassily Kandinsky began work on a stage composition called *Der gelbe Klang* (The Yellow Sound) in 1909. Proposed for performance at the Munich Artists' Theater in 1914, the piece "consists of a series of six 'images' with an introduction. The characters are designated as 'co-workers,' and include five 'giants,' 'indefinite creatures,' a child, a man, people in loose drapery, people in tights and, behind the stage, one tenor, and a chorus. There is no apparent plot or dialogue in the ordinary sense. The action consists solely of changes in color and light, and in the movement of objects and figures, singly and in groups."[7] Kandinsky used light and space for the creation of a carefully structured abstract mood through performance. A much more free-form experience was created by British stage designer Thomas

Wilfred's "clavilux" or light organ constructed in about 1921. In his instrument light emission was substituted for sound from the keyboard.[8] Both treated projection as abstraction and as non-objective form; for Kandinsky projection served idea, for Wilfred, magic. The concerns of Laszlo Moholy-Nagy and Gyorgy Kepes, who worked with light and projection at the Bauhaus in the 1920s, were similar.

Analytical Cubism marked the inception of a general movement toward dematerialization and conceptualization within the arts. In his masterwork *The Great Glass,* Marcel Duchamp was one of the first artists to use transparency as a way of integrating the object with its surrounding space. Transparency reduced the material presence of the object and shifted the focus toward content and conception. Max Ernst's work with chance in his frottage pieces and his ability to synthesize portentous, if ambiguous, photomontages moved art and photography toward ideation and the ethereal. Duchamp and Ernst were key figures for the Conceptual art movement in the 1960s and early 1970s.[9] Mirroring its use in the formative Modernist period, performance became a viable form of art presentation in late Modernism because art and the art-idea did not require a residual precious object for its authentication.[10] The parallel cultural moods could support the value and supremacy of experience over object, the multiplex over the singular. Thus it is not surprising to see a renewed activity with slide projection art in the 1960s and 1970s because of its nonobjective and performance aspects.

Two new products marketed by Eastman Kodak in the early 1960s made multi-image production more readily accessible and easily distributed. The Carousel projector was available by 1963. It was followed shortly by a programmer, a dissolve control unit, and, in 1965, a sound synchronizer.[11] In combination, they formed the common denominator for slide projection art, though since the 1960s equipment has become more diversely manufactured and increasingly sophisticated through computer technology.

Dave Heath, whose work in the slide projection medium has been a seminal influence for other's work in the 1970s and 1980s, produced his first show *Beyond the Gates of Eden* in 1961. A simple two-screen show, it provided the groundwork for three-screen

Le grand ALBUM Ordinaire completed in 1973. The *ALBUM* is one of the masterworks of the medium. The show "pursues the theme, 'we are all of a common herd' (Montaigne), by organizing in a semichronological sequence popular photographic imagery from 1840 to the present, with the material drawn from my own extensive collection of photographs and the music of the Beatles."[12] *An Epiphany,* an autobiographical study consisting of photobooth self-portraits juxtaposed with art reproductions (completed in 1971), was programmed along with *ALBUM* into the ninety-minute piece *Carnival of the Selfe,* which premiered in Toronto in 1973 and was shown in several places across Canada and the United States. Heath's last slide show *Ars Moriendi* was completed in 1980.

In the late 1960s, William B. Giles, then in Rochester, New York, experimented with two-projector shows which, because the dissolve was hand-controlled, were responsive to the accompanying music and also the mood of the audience and photographer. These moods were reinforced by the carefully sequenced, nonnarrative imagery. Thomas Porret, working in Philadelphia, produced two major slide shows *Made in USA* (1969) and *Cycles* (1973). A third, shorter (and final) show *My Funny Valentine* was completed in 1979 before he turned to work with computer-generated imagery. *Made in USA* was an impressionistic view of American society in late 1960s presented in sound, altered photographs, and film. Porret reached a high degree of technical and conceptual sophistication in *Cycles,* which had four parts. The "Prologue" was entirely audio. The second section, "Beginnings," was an eight-screen matrix with sound that held childhood as its theme. The third section, "Journeys," was switched to a three-screen format and traced the growth and maturation of an individual. The fourth and most foreboding section, "Mysteries and Terrors," treated dreams as nightmares and included a series of complexly altered images of a physical conflict.

Slide projection along with installations, film, video, and performance were presented collectively in an exhibition at the Walker Art Center in Minneapolis in 1974. "Projected Images" included work by Peter Campus, Rockne Krebs, Paul Sharits, Michael Snow, Ted Victoria, and Robert Whitman. Martin Friedman's

introduction, "The Floating Picture Frame," and several important essays included in the catalogue discuss the theory and aesthetic of projection. Though this exhibition was not specifically concerned with straight slide shows, it did help open other museum and gallery doors to projection art.

With the ascendancy of Conceptual art in the 1970s, slide shows provided a vehicle for presenting events along with narration or commentary. *Points of View,* a collection of slide shows summarizing Jim Melchert's work with events and prescribed approaches to subject matter (done between 1970 and 1974), was shown at San Francisco Museum of Modern Art in 1975. The exhibition included such pieces as *Location Projects* (1970), *Faces* (1972), and *Points of View Series: Taking Turns Taking Pictures* (1973), among others.[13] Other artists were working in a conceptual mode in the mid-1970s: James Petrillo (Berkeley) staged events in the landscape specifically for slide presentation, Carol Law (San Francisco Bay Area) continues to combine slide art with sound performance, and Robert C. Morgan (Rochester, New York) completed his first piece, *Hands Against the Land/ Hands Against the Sky,* in 1974. Morgan has continued to work with the medium, producing some thirteen shows; the most recent is *The Swimming Lessons* (1980–86).

The increased accessibility of computerized projection equipment and video, coupled with a rising interest in hybrid or intermedium forms, has led to a surge in innovative presentations. George Coates, working in collaboration with photographer Ted Heimerdinger, directed his first slide performance piece, *The Way of How,* at the New Performance Gallery in San Francisco in 1981. In this piece the performers in interacting with the slides also functioned as moving projection screens. Coates has continued work with slide performance in *are are* (1983), and more recently in *Rare Area* (1985) in which the projections created a sophisticated spatial illusion with translucent floating curtain-like screens. Beginning in 1982 with the production of the slide show *I Saw Jesus in a Tortilla.* a fictional recount of a New Mexican woman's vision, Jeanne C. Finley has worked in installation format and toward translating slide shows into video for broader distribution. Among her other slide shows are: *Deaf Dogs Can*

Hear (1983); *Beyond the Times Forseen* (1984); and *Risks of Individual Actions* (1985), which incorporates "live" video.

Leslie Bellavance, inspired in part by the Walker Art Center exhibition, curated *Projections* at West Hubbard Gallery, Chicago, in 1982. Consisting of a spectrum of presentations and techniques including holograms, installations, laser projection, and others, the show included twelve artists' work.[14] One of the points of this exhibition is that nonobjective forms of expressive presentation are absolutely within the purview of the contemporary gallery, despite the extraordinary technical coordination that it requires. Such shows as this, and the more recent *A Passage Repeated* held at Long Beach Museum of Art in 1985, serve as focal points for the broad-based concerns with projective media.[15] In the latter show, only Perry Hoberman's "3D" *Forced Stops (& False Stops)* was entirely based on slide projection accompanied by audio. Another of Hoberman's "3D" shows, *Out of the Picture (The Return of the Invisible Man),* and Nan Goldin's *Ballad of Sexual Dependency* were included in the 1985 Whitney Museum Biennial.

In his essay "Ernst Machs Max Ernst," Guy Davenport wrote: "What we understand of an event is very little compared to our ignorance of its meaning. The greater our sensibility, the sharper our skepticism, the more we are aware of the thinness of the light that is all we have to probe the dark."[16] The projection of a slide is but a momentary probe and slide shows are events to be experienced as much through memory (absence) as through presence. The slides and the audio track give themselves up as objects for the sake of experience which the audience receives much as Plato's denizens encountered the shadows. In any projected art, the experience of the piece is sustained through memory. As the memory reconstructs that experience, it develops an imaginary constellation (projection-idea) within which the information (reflection) resides. The flexibility of the slide projection medium as it has been exercised throughout its history has contributed significantly to the language of expression and to the breadth of audience imagination. The challenge for the medium is to reflect its roots in entertainment without sacrificing its complexity of ideation.

Notes

1. C. G. Jung, *Memories, Dreams, Reflections* (New York: Vintage, 1963) p. 296.

2. Dennis Grady, "The Portrait," *U-Turn Monograph 2* (Los Angeles, 1985) p. 7.

3. Owen Barfield, in the essay "The Harp and the Camera," in *The Rediscovery of Meaning, and Other Essays* (Middletown: Wesleyan University Press, 1977), offers some important insights concerning Kircher and the development of the magic lantern and the camera obscura.

4. For a carefully documented discussion of the invention of the magic lantern, see J. M. Eder's *The History of Photography* (New York: Dover, 1978, reprint of 1945 edition), Chapters 7 and 8 (revised), pp. 46–55. The above noted information is from pp. 51–52.

5. *Ibid.*, pp. 53–54.

6. Robert Taft, *Photography and the American Scene: A Social History, 1839–1889* (New York: Dover, 1964) pp. 408–9. In a footnote on p. 409, Taft cites the precedent of a movable element placed in front of a still projected image to create the appearance of movement. Like shadow play, this must have been a pleasant form of entertainment.

7. Kandinsky's *Der gelbe Klang* is discussed in detail in Peg Weiss, *Kandinsky in Munich: The Formative Jugendstil Years* (Princeton: Princeton University Press, 1979), pp. 96–102.

8. For a specific description of Wilfred's Color Organ see James Enyeart, *Bruguière: His Photographs and His Life* (New York: Knopf, 1977) pp. 57–58. The light organ is also an early precedent for the free form of Joshua's Light Show and its ilk in the 1960s.

9. Critic Lucy Lippard (with John Chandler) discussed the relationship between Duchamp's work and that of the Conceptualists in the 1960s in "The Dematerialization of Art," *Art International* 12, no. 2 (February 1968).

10. Writing about the slide projection shows included in the Whitney Museum Biennial, Andy Grundberg concluded that "the present groundswell of interest in projecting photographic images is fueled by a fundamental dissatisfaction with the physical presence and esthetic efficacy of photographs as prints." The article was titled "Beyond Still Imagery," *New York Times*, April 7, 1985, p. 24.

11. The Carousel was actually preceded by a linear projector called The Cavalcade (1960–63) which was available with a dissolve unit. I am indebted for this and the noted information to Phiz Mezey. She authored, *Multi-Image Design and Production* (Stoneham, Mass.: Focal Press, 1988).

12. From Dave Heath's unpublished program notes. For a more extensive discussion of his work, see Charles Hagen, "Le grand ALBUM Ordinaire: An Interview with Dave Heath," *Afterimage* (February 1974): 2–6, 13.

13. See also Suzanne Foley (curator), *Jim Melchert: Points of View, Slide Projection Pieces* (San Francisco: San Francisco Museum of Modern Art, 1975), exhibition catalogue.

14. The twelve artists included were: David Belle, Cathey Billian, John

Boesche, Agnes Denes, Edward Dietrich, Dieter Froese, Liz Lamont, Abby Robinson, Miroslaw Rogala, Susan Smith, Alex Sweetman, and Anita Thatcher.

15. The eight artists included in this exhibition were: Judith Barry, Barry Gerson, Doug Hall, Perry Hoberman, Nan Hoover, Thierry Kuntzel, Bill Lundberg, and Paul Sharits.

16. This essay is from Guy Davenport, *The Geography of the Imagination* (San Francisco: North Point Press, 1981), p. 378.

SITTER'S DREAM: EARLY PHOTOGRAPHIC PORTRAITS

at the Ansel Adams Center, San Francisco, January 23– April 1, 1990

[The following is the brochure and wall text for an exhibition of nineteenth-century portraits. I was asked to guest curate the exhibition as part of the center's honoring of photography's sesquicentennial. With two exceptions, the works included came from Bay Area collections. The show consisted of pieces by historically noted portrait makers such as David Octavius Hill and Robert Adamson, Julia Margaret Cameron, Nadar, and Roger Fenton, as well as anonymous daguerreotypes and painted tintypes from the American Civil War period.]

Within the history of representation, portraits reign as some of the most direct, engaging, and problematic images. On one hand they describe a public presence, on the other the best of them seem to penetrate appearance into the domain of inner reality. With the advent of the photographic portrait in 1839, painted portraiture was eclipsed by the camera's power of light-generated depiction, a power that quickly became associated with truthfulness and accuracy. The fleeting moment of exposure had, to mid-nineteenth-century eyes, an aspect of divine revelation.

Photography also brought the dream of having one's portrait made within the reach of an unprecedented number of people from across the socioeconomic spectrum. The dream was given cogency by portraiture's *a priori* association with wealth and power, and was driven by the instinctual desire to leave behind a material tracing of one's presence. A photograph was, after all, incontrovertible proof of one's existence. While the new

Unknown artist, *Post Mortem,* ca. 1850, daguerreotype. Courtesy Robert
Harshorn Shimshak.

medium made portraiture popular and affordable, its scale and packaging made those images attractive, easily transported, and, perhaps more important, transferable.

By 1854, with the promulgation of the carte-de-visite, the notion of replicating and broadly distributing a portrait became a reality and a highly significant cultural impulse. Family albums and the concatenation of images that they typify were presaged by Goethe in a letter of 1799: "Every well-off man of sensibility should have portraits of himself and his family at various stages of his life. Strongly characterized by a clever artist and on a small scale, they would take up little room, and thus he could collect all his friends around him, and his posterity would always find a place for such a gathering."[1] In addition to family albums, portraits of noted figures of the day were actively marketed and collected, much in the vein of baseball trading cards. The early phase of portraiture ended by the late 1870s as the photographic process became more accessible and the domain of visual record-keeping shifted from the hands of artistically or commercially motivated studios to the individual household.

Who were the early portrait makers? They ranged from painters such as Jean-Baptiste-Camille Corot, a member of the Barbizon group who experimented with *cliché-verre* and light-sensitive materials, to artists working collaboratively with technicians, as in the case of Hill and Adamson, to highly literate amateurs such as Julia Margaret Cameron, to entrepreneurs who saw a market and livelihood in the culture of the mid-nineteenth century. John Plumbe, for instance, had traveled to Washington, D.C., to promote the development of a transcontinental railway, found himself short of cash, and learned instead the development of the daguerreotype plate at Alexander S. Wolcott's commercial photographic studio, the first of its kind. Plumbe turned his promotional gifts into a very successful chain of studios along the eastern seaboard.

The vast majority of the early portraitists, however, remain unnamed or unknown. It was commonplace for the town barber, who was also the dentist and doctor in the leeching days of medicine, also to be a daguerreotypist. It made commercial sense for clients to be healthy and well-groomed for their portraits. In

the United States, itinerant daguerreotypists traveled with their equipment through towns too small to have a resident studio.

Unattributed images account for much of what we postulate about personal and cultural history as well as historical figures. The photographic image takes on a life of its own and conveys information and meaning for which no conceptual intention or biographical context can be established. Though we are free to see all images as part of visionary history, unattributed pictures hold a special place as artifacts of the present. Lacking an author, we authorize them. Wright Morris wrote of this special aspect: "In the anonymous photograph, the loss of the photographer often proves to be a gain. We see only the photograph. The existence of the visible world is affirmed, and that affirmation is sufficient. Refinement and emotion may prove to be present, mysteriously enhanced by the photographer's absence. We sense that it lies within the province of photography to make both a personal and an impersonal statement."[2]

It seems the provenance of the early photographic portrait to engage us not only in the dialogue between art and artifact but also in the most profound questions of identity. In early portraits, one can find the roots of the modern view of the self as image, as something that could be both quantitatively and qualitatively pictured. Having one's portrait made in the first years of the medium became a significant cultural activity that had about it ritualistic aspects and a desire for self-conception.[3] What emerges from the ritual is a quality of humility which was later transformed as photography became a household practice.

Sitter's Dream: Early Photographic Portraits includes a range of techniques used in this early phase of photographic history. Though 1839 is the most commonly cited date for the invention of photography, its discovery (there are extant pictures from the 1820s) was really a multistaged struggle to make a permanent record of the magical and realistic image projected on the ground glass of the camera obscura. The struggle resulted in several processes based on silver or asphaltum discovered within a few years of each other by Louis Jacques Mandé Daguerre, Joseph Nicéphore Nièpce, and Hippolyte Bayard in France, William Henry Fox

Talbot in England, and Hercules Florence in Brazil. Of these, Daguerre's and Talbot's techniques received the most attention, though they were radically different in material quality and visual aesthetic.

What would become the finished daguerreotype, with its highly resolved image floating on a polished silver surface, was exposed directly in the camera. Therefore, each image is unique. The calotype or salt print was made on a paper base over which the silver sensitizer was brushed. The negative image was absorbed in the paper fiber, giving the image a lack of sharpness and tonal gradation. The paper negative was translated into a positive one by printing onto another sensitized sheet of paper. Because Talbot's process was negative-positive and could render multiple prints from a single negative, it has traditionally been proclaimed the true forerunner of modern photography.

For the first twenty years of the medium's existence, these two processes were used with equal success. The year 1851 marked Daguerre's death and Frederick Scott Archer's introduction of the collodion wet-plate process. This process was cheaper and easier to produce, making it attractive to the entrepreneurial portrait artists. It also contributed a high-resolution, high-transparency glass negative to the negative-positive system. Though the collodion emulsion was also used to produce ambrotypes and tintypes, cheaper imitations of the daguerreotype, it spelled the end of the daguerrean era by 1862 and marked the ascendancy of reproducible photography.

Although the daguerreotype has no contemporary offspring, its obsolescence guaranteed it sanctuary in the history of photography. The polished plate with its image composed of silver-mercury amalgam, embodies the mercurial aspects of time and space; that the vaporous image can burst forth into a fully rounded illusionistic projection when viewed from the right angle is analogous to experiencing moments of intense recognition and revelation.

The exposure time necessary to make a daguerreotype portrait was between five and ten seconds, a long period to hold still and to confront the camera. The daguerrean artists took two approaches to solving this problem. Physically, they used iron stands

with a U-clamp to support the neck and head. To overcome self-consciousness, subjects wore professional garb or held materials emblematic of their profession or status—mothers held their children, children held their toys or pets. Such inclusion of emblematic subject matter was already a well-established practice in northern European portrait painting.

Ambrotypes and tintypes share the same scale and packaging as the daguerreotype, but have a unique tone scale and quality of their own. They were both wet-plate collodion processes. The ambrotype had a base of glass while the tintype, as the name implies, was based on a black lacquered sheet of tin. Tintypes were the last of the unique direct-plate processes. Because they were quite inexpensive and considerably less fragile than the glass-plate ambrotype, they were often treated to heavy doses of "retouching." Lady Eastlake praised this treatment of the photograph in her 1857 review:

> Portraits, as is evident to any thinking mind, and as photography now proves, belong to that class of facts wanted by numbers who know and care nothing of their value as works of art. For this want, art, even of the most abject kind, was, whether as regards correctness, promptitude, or price, utterly inadequate. These ends are not only now attained, but even in an artistic sense, attained far better than before. The coloured portraits to which we have alluded are a most satisfactory coalition between the artist and the machine.[4]

However well the technique worked in the trained hand of the miniature painter, the more frequent untrained application of tinting and overpainting has left us with a legacy of photographically derived images that look more like artifacts of folk culture than artistic portraits.

The calotype or salt print looks more like a conventional photograph in surface, scale, and texture than its unique counterparts. As a process it was regarded as more artistic than the daguerreotype because it emphasized broad areas of tone and mass rather than the microscopic detail found in the polished silver surface. These images are particularly fugitive, sensitive to changes in light and humidity. Consequently, many early paper

photographs have been lost due simply to chemical attrition and overexposure to the elements. There were as many variations on the salt print as there were inventive photographers, but all were based on the same basic principles of the reduction of silver salts by the action of light and development and second-step negative-to-positive printing.

In combination with the wet-plate collodion negative, the advent of the albumen print brought photography to its first golden age. Photographers could achieve a clarity and brilliance in the images nearly equal to that of the daguerreotype, yet benefit from the infinite reproducibility of the negative-positive process. It was the albumen print, with its egg-white sheen and rich sulfur brown tones, that stocked the shelves of the Victorian picture cabinet and filled the pages of family, travel, and promotional albums. Here, the albumen print demonstrates the heights of artistic portraiture.

One of the most fascinating things about early portraits is that they imply wonderful stories yet remain fixedly ambiguous. As Max Kozloff wrote:

> No matter how physically faint, a photograph involuntarily whispers of something exquisitely carnal. The weeks, the years, whatever stretches of time separating our present from the photograph's retire into the transparence of the shot and seem to be erased by it. We have almost to shake ourselves to overcome the feeling that we peer out at the other place, in that different age. Yet we are always aware of this illusory dislocation, for such is the ambiguity, in principle, that seduces us over and over again in the photographic experience.[5]

Portraits, in particular, are unfailing in their power to fascinate us. Whether done out of artistic or commercial intent, these photographs from the medium's earliest period indicate some of the significant techniques and styles used by photography's pioneer practitioners. The wish to map the human visage, to plumb its depths, or treat its surface cosmetically has melded artistic intention with commercial interest. It allows us, with the distance

of time, to experience the artifacts as equals of differing character and pretension. Beyond style and technique, the images become and reflect figures from our collective imaginary history, a history constructed from empathy and identification with the portrait subjects and that same instinctual desire to partake of the records of a past. The images in *Sitter's Dream* make beautifully stated and highly persuasive arguments that the objects of time past, and the portrayals they present, are valuable guides to understanding not only what has been gained in our collective character, but also what has been lost.

In a passage from *The Past Recaptured,* Marcel Proust came as close to analogizing the experience of looking at photographs from the medium's early history as any words I have read:

Yes: if owing to the work of oblivion, the returning memory can throw no bridge, form no connecting link between itself and the present minute, if it remains in the context of its own place and date, if it keeps its distance, its isolation in the hollow of a valley or upon the highest peak of a mountain summit, for this very reason it causes us suddenly to breathe a new air, an air which is new precisely because we have breathed it in the past, that purer air which the poets have vainly tried to situate in paradise and which could induce so profound a sensation of renewal only if it had been breathed before, since the true paradises are the paradises that we have lost.[6]

Notes

1. John Gage, ed., *Goethe on Art* (Berkeley: University of California Press, 1980), p. 34.

2. Wright Morris, *In Our Image,* 1978, reprinted in Vicki Goldberg, *Photography in Print* (New York: Touchstone, 1981), p. 540.

3. Ralph Waldo Emerson took a rather humorous view of the portrait ritual: "'Tis certain that the Daguerreotype is the true Republican style of painting. The artist stands aside and lets you paint yourself. If you make an ill head, not he but yourself are responsible, and so people who go Daguerreotyping have a pretty solemn time. They come home confessing and lamenting their sins. A Daguerreotyping Institute is as good as a national Fast" (cited in Richard Rudisill, *Mirror Image: The Influence of the Daguerreotype on American Society* [Albuquerque: University of New Mexico Press, 1971], p. 191.)

4. Lady Elizabeth Eastlake, *London Quarterly Review, 1857,* reprinted in Alan

Trachtenberg, *Classic Essays on Photography* (New Haven: Leete's Island Books, 1980), p. 67.

5. Max Kozloff, "The Territory of Photographs," *Artforum* 13, no. 3 (November 1974):64.

6. Marcel Proust, *The Past Recaptured* (New York: Vintage, 1971), p. 132.

I remember as a young child witnessing a man across from me at the table recount what appeared to be a story of serious content. His expressions remained rather restrained, and I was surprised that at the completion of the tale all the adults burst into laughter. Clearly I had missed or misunderstood something of the language and the gesture. When I asked my mother what it was all about, she responded that "his delivery is deadpan." That phrase, with its ominous overtone, disquieted me for many years. I associated it with the deception which I had greeted with an automatic trust—both in the gestures of the speaker and in the literal logic of my perception. Though the obvious and mundane moral of this story is that things are not always what they seem, a more important notion is that deception can be a brilliant rhetorical device.

Many of the photographs in *The Insistent Object* recalled into a new context the question that emerged from that juvenile experience. How were the adults sensitized to the irony of the delivery, of its purposeful restraint? Language and gesture. And, by analogy, how are we, as image consumers, sensitized to the import of an image which seems on the surface guileless? In its primary form, the camera photograph is a record of appearance rather than substance. The medium's objective qualities are as neutral and gestureless as a sheet of paper with markings on it, and a photograph is particularly limited by the structural and chemical necessities of its production. The exposed and developed emulsion is nothing more than a pattern of the light reflected from the orig-

THE INSISTENT OBJECT

at Fraenkel Gallery, April 1987

67

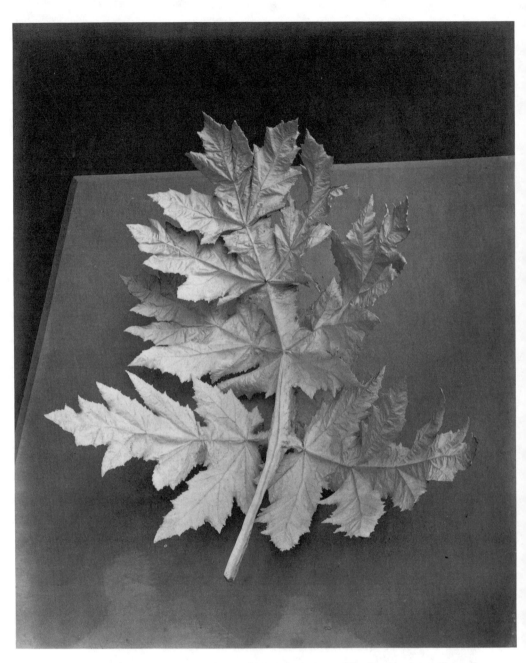

Charles Aubry, *A Study of a Leaf* (*Heracleum Longefolium*), ca. 1864, albumen print from wet-collodion glass negative, from the exhibit *The Insistent Object*. Courtesy Fraenkel Gallery, San Francisco.

inal subject—a pattern which *approximates* that subject. The photograph's means of approximation are remarkably spare in comparison to the powers of representation ascribed to it. Its substantive qualities are apprehended or evoked rather than inherent. Approximation is thus camera photography's rhetorical device, the basic element of its deceit.

Jeffrey Fraenkel wrote in his introduction to *The Insistent Object* (accompanied by a beautifully produced catalogue of the same title) that the exhibition is organized around the notion that "[the photographs] reiterate one of photography's oldest lessons—that there is nothing so mysterious as a thing clearly described." With the "thing" (the deceit) as its recurrent visual leitmotif, the show is also roughly chronological in its layout and is divided about equally between images from the nineteenth and twentieth centuries. Fraenkel thus seems to be dealing with two separate but equally significant points: that photographs are able to convey something of the essence of objects, and that one can create a meaningful historical argument through thematic context. The first is philosophical, the second historiographic.

The issue of what an image conveys lies at the heart of photography, as one of its primary reasons for being was to make accurate, unencumbered, marginally mediated visual records. John Szarkowski has been an insistent spokesman for this position and its stylistic tropes. In defining the documentary style, he commented upon Walker Evans in *Looking at Photographs:* "Sophisticated photographers discovered the poetic uses of bare-faced facts, facts presented with such fastidious reserve that the quality of the picture seemed identical to that of the subject." Whether or not pictures can be equivalent to the objects pictured is one of the issues raised by this exhibition (though as an issue it lacks urgency). Fraenkel argues further in his introduction that the "bare visual facts often take on a stronger, more vivid, more emphatic presence than if the actual object was there to contemplate before us." This argument implies that photographic vision is somehow more cogent than human vision. If it is more cogent it is because images, regardless of what they are pictures of, regardless of how deceptively fact-like they seem, are mediated fictive worlds apart from human perception.

The thematic context is pure curatorial invention, an invention which in *The Insistent Object* loses clarity and perhaps purpose when bound to the logic of historical order. The sense of progression through time is actually negated by deeper examination of the pictures. The resultant fused context homogenizes radically divergent philosophies and blurs important distinctions between nineteenth- and twentieth-century photographs as well as between photographers.

Fraenkel states: "Photographs of this kind [of objects] appear so frequently throughout the history of photography, beginning in fact with Fox Talbot's earliest pictures, that they constitute a solid yet unacknowledged tradition." The tradition to which Fraenkel refers is actually two philosophical streams whose origins long preceded the advent of photography into the history of picture-making—the materialistic and transmaterialistic. These two streams (which are not necessarily in opposition) are perhaps best seen in two images included in the exhibition, Adolphe Braun's *Still Life with Wild Fowl*, c. 1865, and Robert Frank's *Bar—New York City*, c. 1955. It is difficult to imagine a context other than their picturing objects that would bring together images which, except superficially, are worlds apart. The Braun picture is a celebration of the material. Its attention to sensual textural detail and the iconographic configuration of the hunt make the image a kind of surrogate trophy and an ironic comment upon nature-morte. The object pictured is so discreetly dissected or isolated from the world that one cannot look beyond the picture frame for context. The scale of the carbon print is unusual for the mid-nineteenth century, though it approaches that of similar genre oil paintings of the time—a genre which served as a reminder of the rites and rituals of the aristocracy.

Frank's picture is also iconographic in its portrayal of a jukebox, but the image is suffused with a different spirit than Braun's. Texture and form (as two indicators of solidity) are barely visible. Instead light emanates from the jukebox, reducing its material qualities to suggestion. The same is true with the figures in the background and the out-of-focus arm in the foreground. What is present is there by implication rather than explication. The

picture is not as much about the object, though it serves as an instinctive point of focus, as it is about mood and experience— two key words often used to describe the effects of art which aspires to the transcendental. Frank was not striving for effect; instead, he responded to a constellation of signs, symbols, event, space, light, and moment that could convey his vision in pictorial form.

Frank's picture is decidedly more modern than Braun's, though not all the more recent images in *The Insistent Object* make such a clear distinction. Robert Mapplethorpe's *Carnation,* 1978, and Nicholas Nixon's *Cambridge (apple),* 1986, mirror Braun's materialism. On the other hand, one can readily find examples of implicatory imagery from the early years of the medium. Ideas in photography do not seem located in a particular time; its history is still too brief.

Fraenkel has accepted for this exhibition a delimitation of the medium which emerged almost concurrently with its birth—that photography was to be a recording medium of the perceptible world. The photograph is thus both an object (record) and a constellation of information. Photographers have become increasingly interested in content and its message; photography or photographic imaging have been incorporated into virtually all the other art and performance media to the extent that traditional divisions between media are irrelevant. Given this current devolution of photography, *The Insistent Object* seems almost a preservationist argument for the value of the straightforward photographic object as a discreet delectable collectible entity. Regardless of the context, many of the images, especially those from the nineteenth century, are pleasurable, even refreshing to look at.

It is interesting in itself that a commercial gallery such as Fraenkel has adopted this historical-curatorial approach to exhibiting, though it is not the first to do so. In addition to creating a forum for representing an approach to photography, the exhibition and catalogue serve a double purpose of a sophisticated marketing strategy. The concern that arises here is: are we now headed in the arts where science has been for quite some time—where the

spirit of free inquiry has a necessary commercial component? This may seem like too hasty a conclusion based on this exhibition, but not if one is also aware of the turmoil over corporate funding in the museum community.

History, or at least the writing of it, is a late descendent of myth and legend. As a discipline, the former reflects a conscious knowledge of the world in a form that parallels myth's connection to the spiritual realm. History remains a story for the telling, an embodiment of the currents of biography, larger social forces, shifts in perception, and the wheels of commerce. As the construction of history has recently come under attack, its tendency has been for its preservers to return it to its ancestral origins—a form of counter-myth in which all tellings are self-justifying.

The history of photography is a special case within this broader historiographical context. Interestingly enough, Hegel was proclaiming the end of art for the last time (1828), in about the same year that Nièpce complained that it took eight hours to catch a faint impression on his light-sensitive plate. Photography was born virtually complete in its conceptual basis, but not as fully incarnated in its physical (lens/chemical) appearance. Its history has been a technological evolution toward clarity and verification of its original hypothetical purpose–a recording mechanism so sensitive to the visual world that its presentation brings us to a heightened sense of reality as identified by the photographer and defined by the lens and film. So it would seem, as the story is narrated by John Szarkowski.

The structure of the narrative in *Photography Until Now* starts with the emblematic camera obscura, the function of which was to render the world in perspectival form on a two-dimensional plane. The existence of

PHOTOGRAPHY UNTIL NOW

by John Szarkowski[1]

73

the camera and the mind set (Szarkowski's term) which came to expect the world to look rendered that way necessitated the invention of photography. While several individuals, Daguerre, Nièpce, Talbot, and others struggled or raced to bring the new medium to fruition, Szarkowski argues that it inevitably would have been invented anyway. From Szarkowski's standpoint, Talbot's paper process was the most important, not only because of its replicable matrix, but also because it afforded its user a degree of spontaneity unobtainable with the studio bound daguerreotype process. Departing from that point, he takes the history as stages in which the technology and aesthetic of the medium are inextricably bound, and the photographs as reflecting the mind set of the progressively larger audiences they both reached and served.

The turning point in Szarkowski's even-handed narration is the advent of the gelatin dry plate (late 1870s) and the Kodak No. 1 (1888). He lavishes much attention on their development and importance to Western culture. With the accessibility of this recording mechanism, photography departed the domain of professionals who served a clearly scribed marketplace. Instead, the new camera imparted to photography an aesthetic determined as much by the mechanism itself as by those who could afford its pleasures. From this basis, Szarkowski argues with the artistic pretenses of the international Pictorialist movement and its American principal, Alfred Stieglitz. It is as if, as a narrator, he cannot wait until the Modernistic aspect of the camera aesthetic in which the photographer's hand is hidden within the camera-image complex, can resurface in that fertile period following World War I.

This early Modernist period has been widely discussed as a time in which artists and photographers, including many who criss-crossed camps, shared in and gave expression to a rich pool of ideas connected to social renewal, a theoretical subconscious, and the politicization of aesthetics. Szarkowski handles this period and the unfolding of Modernism over the next two decades under a brilliant rubric, "Photography in Ink." It is his most challenging, problematic, and innovative chapter. He manages to convey the significance and depth of photography's reach into

culture under the eyes of corporate authorship (the editors rather than the photographers) and the breadth of photographic practice (montage and graphic design) that was homogenized through the bed of the press. This is an important perspective to hold. It pays homage to the mechanism, consistent with the story's leitmotif and metaphoric framing.

However, Szarkowski fails to recognize the impact which many of these artists and, more particularly, the actual objects they made (not the reproductions) would have on the next generations which followed under his heading "After the Magazines." In this section all pretenses of even-handedness vanish, reflected, for example in the following passage:

> Qualities intrinsic to photography's visual vocabulary . . . were adopted and adapted by many painters and printmakers during the 1960s . . . It was also discovered that photographs, or bits of photographs could be silk-screened or lithographed or cut and pasted onto pictures made essentially by hand . . . to the picture's possible benefit. In historical practice it has proved more difficult to reverse the process, to improve good photographs by painting on them, or by cutting them into pieces and rearranging the parts, although one can by these methods make interesting pictures out of boring ones. Photographs are made not essentially by hand but by eye, with a machine that records with unforgiving candor the quality of mind informed by that eye. Second thoughts that veil that candor do not often make the picture better (pp. 272–73).

Rather than finding a story line that remains inclusive as in "Photography in Ink," "After the Magazines" casts the end of the story, as it began, with a few intrepid individuals in search of authorship and a *raison d'être*. One finds this ending neatly reflected in Szarkowski's opening section on "The Daguerreotype and the Calotype" and succinctly restated by him in the flyer accompanying the exhibition: "Photography was not invented to serve a clearly understood function. There was in fact widespread uncertainty, even among its inventors, as to what it might be good for." Szarkowski clearly applies this characterization to recent practitioners of the medium—a mechanism whose

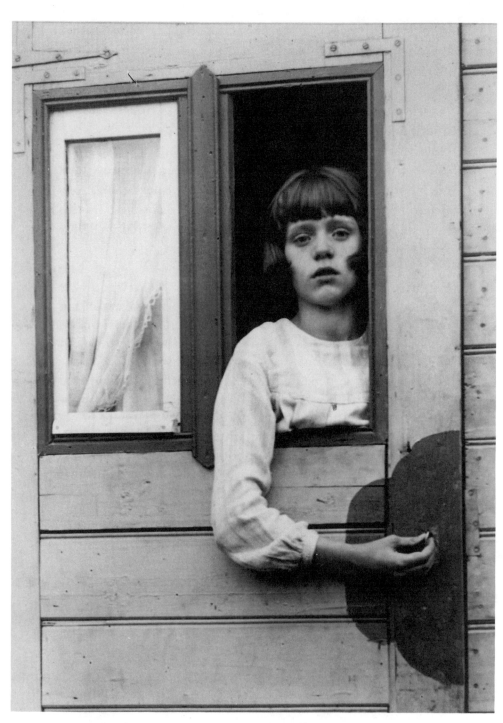

August Sander, *Young Girl in Circus Caravan*, from the series
"People of the Twentieth Century, Itinerants," 1932, gelatin silver print.
Courtesy Museum of Modern Art, New York.
Copyright © August Sander Archive, Cologne.

perpetual motion was bound to organic principles of decay. *Photography Until Now* fails to account for the notion that the majority of contemporary photographic imagery has sought renewal outside the domain which Szarkowski has so skillfully defined.

The camera, which he embraces as the essence of photography and as an essential metaphor for understanding its progeny, is a tool of the onlooker consciousness, a consciousness which he quite correctly understands no longer serves a purpose. In its stead, contemporary work arises from a participatory consciousness, that very impulse that stands behind painting a photograph or making the image part of a broader sociopolitical agenda or critique.

Photography Until Now is a late arrival and important contribution to the historical dialogue which emerged in force during the medium's sesquicentennial. From its cover which presents August Sander's image of a young woman reaching through the window frame to open the door, to its conclusion, the assumptions about visual presentation which emerged in the Renaissance—the necessity of perspectival space and the attendant picture window—and the democracy of image accessibility are played out through a brilliantly told history. The book, for all its failings, is filled with interesting asides and lucid perceptions. It constitutes a fitting testament to Mr. Szarkowski's important career, to his capacity to speak and write about photographs, and to his role as an arbiter of taste. It can only be fortuitous that his closing remarks begin on page 291, a number rich in modern art associations and key to the Modernist mind set.

Note

1. Museum of Modern Art, New York, 1989, 343 pages hardbound; includes illustrations with the text, complete partially illustrated checklist of the exhibition, and index of names.

Modernism

The Modernist era is loosely marked by the beginning of World War I and the end of the war in Vietnam. From the present vantage point of Postmodernism, this period has to be viewed with some historical distance, a distance which encourages revision of the relative importance of events and the development of new contexts within which to place those events. The aerial view of the landscape serves as an analogy for this kind of historical vision because it presumes a certain distance from its subject and a perspective which causes prominent features of the landscape to play point and counterpoint to the abstract patterns formed by the clusters of less distinct subject matter. New perspectives and an emphasis on structure were very much a part of the Modernist vision. Photographs, along with paintings and literature, became anamorphoses in which dreams could be given a structure or analyzable form. However, the experience of perception was perhaps most deeply explored through the medium of photography. The *new vision* extended our awareness of what and how things could be seen and has, through its permeation in public media, consequently conditioned contemporary vision. This conditioning is one of the central concerns of Modernist art. *Photography: A Facet of Modernism* is a condensed look at the topography of Modernism through the viewfinder of its photographs and to find within it previously unseen connections among the individuals, objects, and events of that time. The exhibition and catalogue expose some of the richness of Modernism in photogra-

phy and provide a basis for clarity in the myopic view of the Postmodern present.

The curators/authors of the exhibition and book, Van Deren Coke (noted director of the Department of Photography at San Francisco Museum of Modern Art from 1978 to 1988) in collaboration with Diana C. du Pont (assistant curator and project manager) have approached the development of Modernist photography as an integral part of Modernist picture-making, and as a reflector of the ideas and philosophies prevalent in twentieth-century art. Through careful research and thoughtful historianship, they have reconfigured photography's role in the Modernist landscape by reassessing some of its prominent features (major photographers and photographic works) and identifying its patterns (association of photographic works with art historical categories). The four categories or headings are Formalism, Surrealism, Expressionism, and Pluralism. The first three are already established as constituents in the mainstream of Modern art. Two of Coke's earlier exhibitions at the museum, *Photography's Response to Constructivism* (1979) and *Form, Freud, and Feeling* (1985) reflect his ongoing concern with the relationship between photography and the other expressive "mainstream" media. The last category, however, is somewhat of a catchall for the diverse works made in the past decade—works which, because of the context of this exhibition, reflect aspects of their predecessors. They are Postmodern in their time and function as an historically untested bridge from Modernism to the present.

As Coke points out in this interview, Modernism had much to do with simplification or reduction to functional essentials—thus the noted Bauhausian apothegm, "less is more." Consisting of sixty-six images by sixty-seven photographers, the exhibition is itself a Modernist exercise in how much can be accomplished with limited means. The images were collected by Coke for the museum and chosen for this exhibition because of their historical and aesthetic significance. But, it is through the introductory essay and extensive textual notes accompanying each image in the exhibition catalogue that one can come to a fuller understanding of the broader historical and sociocultural import of the

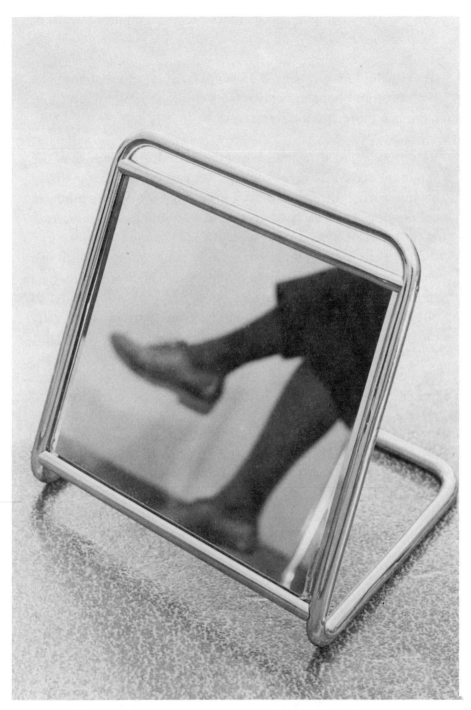

Hans Finsler, Untitled, ca. 1922–23, gelatin silver print. Courtesy San Francisco Museum of Modern Art.

images. The catalogue also includes brief biographies of each of the photographers.

JB: How did *Photography: A Facet of Modernism* come about? The exhibition and book are drawn from the collection, but certainly there is a more specific framework.

VDC: We decided, when we had the Fiftieth Anniversary of the San Francisco Museum of Modern Art coming up, that it would be appropriate to pick out fifty prints that we had acquired in the previous five years and give them star billing as an indication of the range of pictures that we had added to the collection. The show we envisioned, however, actually could not open until this December, because of its period of gestation and the fact that we contracted for a very handsome book that took a long time to publish. We decided to add to the text and reproductions, brief biographies with portraits of each photographer. Assembling this material required an awful lot of time for researching and editing. We also came to realize that we just couldn't be bound by the limitation of fifty images. It seemed an artificial restriction once we got beyond the Fiftieth Anniversary year.

We decided upon sixty-six pictures by sixty-seven photographers. Then we focused on links with Modern art since this was to be a didactic exhibition to a larger extent than usual. We could have just taken sixty-six super pictures from the collection, put them on the walls and say that they represent our view of photography's importance as an art form, but we didn't. We thought in terms of what we could select from our collection that would represent some of the facets of Modernism—Modernism as it has come to represent a new vision, a new look, and new attitudes to both art and life.

JB: Could you define Modernism more clearly? It's one of those terms that has been used rather broadly.

VDC: It is difficult to give a succinct answer, but Modernism denotes a different attitude toward our surroundings. It began as a recognition of the changes in society and attitudes that took

Martin Munkacsi, *Children, Kissingen, Germany,* 1929, gelatin silver print.
Courtesy San Francisco Museum of Modern Art.

place as a result of World War I—particularly the changes in the relationship between the machine and mankind. If you recall, the Europeans went into the conflict in 1914. At that time, early aircraft were nothing more than motorized kites. By the time the war was over in 1918, the SPAD fighter plane could move at 175 mph and was such a precision instrument that it was possible to fire its machine guns through the propeller without hitting it. This was an extraordinary advance in engineering technology in four years. If you have seen the early pictures of the armies going to war in 1914, you will recall all the guns and most of the goods were moved by horse-drawn vehicles of one kind or another. By 1917, there were armored tanks that could, with the help of complicatedly geared engines, move over everything and disregard roads. After the war, those kinds of technological developments fed into the peacetime world and meant that huge lorries and trucks were able to move merchandise across the continents of Europe and America. And, the airplane became a commercially viable means of transportation.

As a result of the Russian revolution, there was a revolution in attitudes towards man's management by his fellow man. As soon as there seemed to be a weakness in the old Czarist system in Russia, the revolution signaled a welling up of concern for man that after the war very quickly spread into Germany and would have spread further if American and English bankers hadn't come along and backed the Weimar Republic. When that took place the Germans settled into a semisocialist state which ended up with an educational system much different than in the days of the kaiser. A lot of people, from families in which no one previously had had the opportunity, went to college. There developed a much better educated and more extensive cultural base in the German population.

That population developed an interest in things outside their own towns and villages. They felt that the past was not something they wanted to dwell on due to the defeat in 1918. Things that were new and connected with the future were symbols of hope. We had the Bauhaus, the *Folkwang schule,* and other schools that began to teach design largely as simplification and linked applied art with fine art.

JB: Was it a reductive vision?

VDC: The instruction was concentrated on getting away from the frills, because the frills were an elitist adjunct to both communication and architecture. After the war, decorative handwork became a symbol of the past. There was much more interest in clean lines, and machine products, whether they were glass, steel, or wood finished in different ways than it had been in the past. Plastics entered into the picture. There was a different kind of environment created as a result of technical advances. A new breed of photographers met the need for new kinds of product illustration and a new kind of communication. Before WW I, most product illustrations in magazines were hand-drawn and were, therefore, aggrandized. After 1918, such pictures took on connotations of falsity. Photographs made with clarity began to be preferred by advertisers because consumers felt that the photograph didn't lie and therefore what you saw in an advertisement is really what you got. Such images took on psychological as well as political meaning. Repetition of forms and sharply focused geometry symbolized both consistency of quality and optimism about the future. Therefore advertisers involved with brochures and posters, as well as magazines, turned more and more to photography.

In those days they did not have the team approach that we have today in which the photographer does little beyond punch a button. Today, others do specialized things such as lighting and make up. In the 1920s, editors and art directors gave a problem to the photographer and the photographer solved it. As a consequence he was much more like a director of film who had to keep the various elements in mind. The photographer made the artistic and technical decisions. The problems solved in many cases were related to design and were solved with photographs used in conjunction with bold but simple graphics.

Photographers became more involved with formalism. They drew, to a large extent, upon Constructivism while tipping their hats to Cubism. It was a very natural development in Germany because El Lissitzky, who spoke German and went to school in Germany, was feeding information from Moscow to Berlin where

Moholy, his friend, was formulating applied uses of geometry. The Bauhaus was the main school for these new ideas. Located in Weimar, not far from Berlin, this school combined design, craft, and fine arts. The great Art Deco show in Paris, in the late 1920s, must not be overlooked for it demonstrated what happened when the surface look of Constructivism was turned into an applied art. Everything the Art Deco designer treated, from plastic to glass to concrete, became geometric. Photographers were called upon to reflect this quality in their pictures made for advertisements and to be in tune with the broader-based movement.

JB: At what point in time did Modernism hit photography?

VDC: I have taken a position in this exhibition that is somewhat revisionist. I think that Modernism as it applied to photography began, not in Europe, but in New York City, in 1916, fostered by the presence there of Picabia and Duchamp. The focal point was Stieglitz's 291 Gallery, and the two people who exemplify the new ideas were Man Ray and Paul Strand. Stieglitz, while he was the father of Modern photography, was certainly not the father of Modernism. He always had one foot in the nineteenth century. When you look at the date of his birth this makes sense. He was making real waves in the 1890s, and it was remarkable that he had fresh ideas up into the 1930s. He was, however, the man who gave Strand his break by introducing a portfolio of his geometric photographs in the last two issues of *Camera Work*. Man Ray was also close to Stieglitz. This is generally not recognized, but Man Ray was known to and stimulated by Stieglitz, and was a member of the Stieglitz circle—though not the intimate circle.

Because of these historical circumstances, 1916 is the year that we start our exhibition. We have a very fine Strand, done in 1916, that represented quite a break from his earlier work and is obviously indebted to ideas about abstraction that were being explored in New York and Europe by painters. The first Man Ray we show is a 1922 Rayograph done in Paris—a fine example of early twentieth-century cameraless photography. We wanted to have a transition from Dada into Surrealism, so we chose this

signed, dated, and unique, Man Ray piece made at the time the Dadaists were beginning to turn toward Surrealism. Man Ray was at the core of New York Dada because of his association with Picabia and Duchamp. He produced Dada paintings and photographs before he moved to Paris in 1921. He later became part of the group that orbited around André Breton and Surrealism. The pictures chosen to represent things going on in the Modern art movements in the 1920s range from Ralph Steiner's and Francis Bruguière's to an artist like Theodore Roszak's, whose extraordinary abstract photograms of the 1930s are as close to his geometric painting and sculpture as you can get and still deal with photography. These photograms, absolutely abstract, grew out of a knowledge of Moholy's work, but are little known and have rarely been shown in photography circles.

We have selected things that are not often seen even though they are by major photographers. Among the sixty-seven photographers, we've also introduced a number of photographers who are little known or spoken of in the histories of the medium. One of our points is to show the nature of this collection which is quite different from any other collection of photography in the world. I came here in 1978; the department of photography as a separate entity was established in 1979. At that point the institution and the person I saw as our natural rival, John Szarkowski at the Museum of Modern Art in New York, were in a weak position because his museum was getting ready to build a large new building. I knew they were going to be virtually out of business for at least three or four years except for exhibitions of a modest scope mounted in small spaces. This was also a time when John was almost totally involved with the Atget project. I thought that would give us about four years to establish this new department and the museum's commitment to photography. This was the plan carried out to get the San Francisco Museum of Modern Art into a position of strength.

JB: That sounds political!

VDC: It was very political! I knew that we didn't have enough money to acquire the many fine nineteenth-century works that

MOMA has. We tackled the problem of money by limiting our emphasis to twentieth-century photographs that are linked in form or concept with the mainstreams of Modern art. John, for his own reasons, has had a tendency to separate photography from the traditional arts, rather than work with the very obvious links.

JB: Wasn't that a consequence of some of the stated intentions of Modernism? It was Stieglitz and Strand who said let's find the aesthetic of photography, let's find its separate identity.

VDC: The idea of establishing a separate identity came out of a sense of inferiority on the part of photographers. I have felt that Steichen, when he took over from Beaumont Newhall at the Museum of Modern Art after World War II, thought that the way you should call attention to photography was to use it as illustration. He had come out of the commercial world of Condé Nast where he did illustration, fashion photography, and portraits that were pitched to an upscale, but not necessarily sophisticated, audience that read *Vanity Fair, House and Garden,* and *Vogue.* Steichen saw photography as a means of illustrating a subject, rather than creating metaphors in philosophic terms— the aim of most serious artists.

Our aim has been to give this collection a somewhat pedagogical caste. I have been a professor of art history and have taught the history of photography from original photographs for many years. We have such an active center here in Northern California where there are dozens of colleges and universities teaching photography, and thousands of students currently active with the camera at a serious level, that we have an audience of considerable sophistication. I thought that *Facets* would open up some avenues, perhaps prick the imagination of a large number of viewers. That's the intention anyway.

The next stage in the show is the influence of Surrealism. It was apparent to some avant-garde photographers in the late 1920s, soon after André Breton published in Paris the Surrealist manifestos, that the aims of his group were close to theirs. We have a number of instances of how even advertisers, certainly by the

early 1930s, picked up on the Surrealist attitudes and their ideas about the dream state. They saw photography as a means of attracting a more sophisticated audience to buy products, whether they were women's clothes or cosmetics.

JB: Are there other themes or leitmotifs in addition to Formalism and Surrealism?

VDC: A third is Expressionism, which deals with emotion. Sometimes the pictures in this group tap the emotion of the photographer himself or herself; sometimes the photographer records something with a very charged emotional content, knowing that that moment will convey something very special to a large audience and touch them through their own experience or imagination. We have a good many examples, some of them very dramatic, others more subtle.

JB: Did Expressionism in photography find its origins back in the late teens and early twenties as well?

VDC: If we think of Van Gogh as one of the progenitors of Modern art, he was one of the great expressors of emotion. Next would be Munch, who worked into the early twentieth century. In the twenties and thirties, I can't think of anyone who would be more expressive than Soutine, or Beckmann. One can't imagine Soutine without Van Gogh, and Beckmann was deeply indebted to Cubism in the way his paintings are put together. Surrealism and Constructivism have waxed and waned, but I think that Expressionism has such a grip on us that it seems a natural and continually evolving direction for artists to follow.

JB: When was the earliest Expressionist photograph?

VDC: In the nineteenth century there were a lot of them.

JB: In photography?

VDC: Of course. We have, for instance, Rejlander's work.

JB: Then how does Expressionism surface in photography?

VDC: Rejlander and Robinson working in England, for example, were emulating the romantic, expressionistic painters of the time. There was also a lot of expressionism in France in the paintings of Courbet and Millet. At the time they were thought to be socialistic, but they were also highly expressive of aspirations of the human soul—of being something other than just a clod out there planting and digging potatoes. One of the pictures we have included in the Expressionism section is by Roy DeCarava. It's a very strong image of a black man coming up out of a subway station in Harlem. It is beautifully put together, as Roy's things usually are, from a formalistic standpoint. But one really understands that picture as emblematic of what blacks in America have been up against, in the sense of coming up into a world that is not very receptive. That's a highly expressionistic, charged picture with which one could find parallels in the paintings of Ben Shahn, for example.

JB: I wonder about the definition of the categories because Surrealism is connected to Freudian psychology, and we usually associate expressionism with psychological overtones as well. But you are giving it a different basis, more political or social content.

VDC: I think that is right to a certain extent, because we include at the end of the Surreal section Joel-Peter Witkin, who I think is somewhat of a small "s" surrealist and also a very strong expressionist. We're not trying to restrict our categories to eliminate anything, or to restrict the meaning of any of the work. Witkin is involved with dramatic emotional content, but frequently that content is related to fantasy and dreams, visual versions of the unconscious. August Sander, for example, had a very expressionistic philosophical content in mind when he took the hundreds and hundreds of portraits of all kinds of people in Germany. His idea was to make a profile, almost from an anthropological approach, of the German people in the area around Cologne where he lived. He used formal devices, as all artists

do, to give a sense of coherence to his statements. The subject of the one we chose, a schoolmaster who happened to look very much like Hitler, predates Hitler's coming to power in 1933. This man conveys a quality of Germanness like we find in Christian Schad's *neue sachlichkeit* paintings. Both are highly expressive of class structure and discipline with a degree of pompousness, but also convey surreal overtones as well. The only reason we made the category of Expressionism was to call attention to the relationships between the ideas being explored by photography and the ideas that had already been accepted as a category in Modern art.

Photographs have been more successful in conveying to people emotional content than most paintings have. People look at a photograph that is of a truly tragic subject and the tummy rumbles. They may break out in a cold sweat, so "real" is the image. What may have taken place fifty years ago in one-fiftieth of a second still has immediacy in the present. That is one of the greatest strengths of photography.

Where we got into trouble, when we decided to categorize, was the period from 1970 to the present. We got beyond the three categories and moved into the area of Postmodernism or Pluralism. Don't ask me to define Postmodernism. I think of it as being like the mouth of the Mississippi River. It is a whole lot of streams that are borrowing from a whole lot of directions, some art, some literature, some pop culture. The notion of "drawing upon" seems to be what it is about to a large extent. It's not so clearly defined as Constructivism. Constructivism, when we look back on it, seems extraordinarily homogenous— whether it's Dutch or French, American or Russian, German or Swedish Constructivism. But today there is little consistency even within national boundaries. This is what led us to call the fourth category Pluralism.

JB: Are you saying that the earlier movements, such as Expressionism, arose out of a consensus of what the purposes of art were to be?

VDC: Art was being directed to a much smaller audience. Many

of those to whom it was directed were going right along with the philosophical ideas that were underpinning these movements. Sustained by written articles, curatorial support, and purchases, certain directions were considered to be avant-garde, the cutting edge. Now we've got this extraordinarily broad spectrum of people who are involved with buying, looking at, and writing about art because of the great number of people who have been exposed to art in universities and the new role that art has taken on in our society.

I don't think you can divorce Surrealism from Expressionism or Constructivism or Cubism from Expressionism entirely. It seemed much clearer to the practitioners and the advocates at the time than it does in retrospect. It was hard to pick out one Moholy-Nagy image for the exhibition because he cuts across the three categories. We finally picked one that he made of Oscar Schlemmer's childrens' dolls. Moholy and Schlemmer, a fellow teacher at the Bauhaus, went on vacation to Italy with their families. On that occasion, at one of the northern Italian lakes, Moholy photographed two dolls on a balcony. The framework is very Constructivist, but one of the dolls is missing a leg, which carries the connotations of the dolls found in proto-Surrealist and Surrealist paintings. Even Moholy recognized that he was into a "strange new mystery" with this subject. He said of this subject that he was open to ideas other than Constructivism beginning about 1926. If you had to think of a Constructivist photographer, Moholy would come to mind, but this image shows that he is not a clear-cut case. The overlaps are important and show how art grows out of the ether of ideas at a given time.

JB: What seems more important, though, is the way the pictures are connected. When one sees an exhibition like *Facets* and compares the treatment of the images with the way Newhall uses them in his history, the images take on a new meaning because of the new context.

VDC: We have so few histories, and the histories we do have have been written by people not much concerned with Modern art. There were only three histories in English—Newhall's, Rob-

ert Taft's, and Helmut Gernsheim's—until last year with the publication of Naomi Rosenblum's book *A World History of Photography*. The older histories were books with text of a factual nature supported by illustrations. They contained very little aesthetic evaluation. The authors set down a sequence of events, bringing the spotlight onto a limited number of photographers. I've always felt that there was a need for photographers to connect with what was going on in painting, because that is the way a serious creative photographer usually thinks, just as does a painter. As you deal with the chronology of twentieth-century art, you begin to see many connections. The other evening I was reading a book on Arthur Dove's work. We usually associate amorphous shapes in his paintings with fog on Long Island Sound, or having to do with clouds over a field with cows. I turned to work of the years 1916 and 1917, and there reproduced in this new catalogue were some drawings. Lo and behold, what are the drawings of? Details of gears, done exactly at the same time and with a similar approach that Strand was taking while photographing details of the front wheel of an automobile. Dove and Strand knew each other—the common denominator was 291 Gallery and Alfred Stieglitz. The painter and the photographer are dealing with the same body of ideas that are in the air. To separate the painter from the photographer at the conceptual level in any kind of exclusive way, I feel, has been a great mistake.

JB: Is that one of the points of contention between the Museum of Modern Art in New York and what you are trying to do here? Is that the basis of the East/West dichotomy?

VDC: I think that's very true. However, I think that we must recognize that Szarkowski had a totally different problem than I had when I came to the San Francisco Museum of Modern Art. He became director of the photography department following Steichen. Steichen, when he stepped down, maintained his office in the department and was there very frequently as a sort of overseer. Szarkowski was largely trained as a photographer. His finest contribution in that field were his pictures of Louis Sullivan's architecture in Chicago—a magnificent book. This was

the highest kind of documentation with sensitivity to the subject. The other book he did was a journalistic look at people in Minnesota. Because it was a people book, Steichen probably thought Szarkowski was the right kind of person to succeed him. When Szarkowski took over at MOMA he had to be very careful about what he did for photography as it had been defined in the museum under Captain Steichen. Szarkowski looked at photography with his own background and prejudices and soon began to define photography more clearly as a separate medium. He probably felt that he would be gobbled up by the other very strong departments if he did not do so. I think Szarkowski had a genuine feeling that the roots of photography could be found in directions other than the traditional arts. He turned instead to the snapshot as a kind of folk art, just as Picasso did with African Art in 1906 and 1907. I understand that when Szarkowski did *Mirrors and Windows,* he borrowed from the print department mixed-media images that they were collecting to fill out the aims of that exhibition. Remember he was not a painter or a Modern art historian.

JB: Do you think that Walker Evans's work informed Szarkowski's aesthetic?

VDC: Exactly, but you have to turn that around as well. When you see twenty or thirty of Walker Evans's early photographs from 1929 and 1930, you begin to realize that he and Charles Sheeler stand side by side. They were as formalist as you could get in 1929. Then we had the tremendous depression in this country. Walker Evans was a literary-poetic-humanist type. He began to see that that kind of formalist structure was quite necessary, but form must not be the sole content. Gradually in 1932–35, his content reflected the political scene at the time; the emotional content often began to override the formalistic concerns of his early years in photography.

You have to recognize that the photographers were often using the same structures in their pictures as painters. Cartier-Bresson is a perfect example; he was trained as a Cubist painter by André L'hote, the best teacher of Cubism in France. You could from

the very beginning see how Cartier-Bresson structured his photographs based on Cubist principles. The *decisive moment* is certainly a good term for his way of working. But the success of that moment is dependent upon a scaffolding or structure to make the images work pictorially.

JB: Tim Gidal said, when I interviewed him, "The decisive moment? Nonsense!" because he felt that the images were all prestructured. Cartier-Bresson chose the location, the moment—that's formalist. He simply waited for the event to happen.

VDC: I absolutely agree with Tim. But, on the other hand, Cartier-Bresson had the most extraordinarily instantaneous eye to see how images could be put together in such coherent arrangements. His early work was also Surreal.

JB: I don't think I've heard his work discussed in that context.

VDC: All you have to do is look at the dates. When he started in 1930–31, who was one of his closest friends? Louis Aragon, the Surrealist poet. That's where one has to look for the connections with Surrealism. Cartier-Bresson was trained as a Formalist/Cubist, but through Aragon he was cheek to jowl with the Surrealists. The works he did in Spain, during 1931–33, are so surreal—they fit absolutely all the canons of Surrealism. He sat in Paris at Le Dome Cafe and talked about Surrealism with the group that was so involved with Freud and the dream state. The picture that we have chosen by him is the man at the door of the bullring. His camera caught a reflection off one of the lenses of a man's glasses; he also included a big number 7 painted on the large wooden door and a young man half concealed in the shadows to form a most ambiguous image. The image has spatial confusion and even a dreaminess. It is truly eerie, so much so that you could put it right along side one of the greatest Surrealist images we have in the whole show, which is by Dora Maar. The image shows a strange group of people in a tunnel-like space. Maar was a member of the Surrealist group in the same years as Cartier-Bresson. Maar did her Surreal photography

in 1933–35, Cartier-Bresson worked in a Surreal manner 1932–35, so they overlapped and they were both in Paris seeing many of the same people. Once you are aware of these connections, you say "why sure, Cartier-Bresson's work does look Surreal." What's always interested me is that however you talk about Surrealism, it deals with a mental process which is based on accepted principles. The photographers who were interested in ambiguity as an aim, just like the painters, the poets, and the writers, found in incongruous forms connections with that mysterious world of daydreams and nightmares. That's why I have always worried about photography being kept as a separate medium, as if it had attributes that made that imperative. It seems like a terribly artificial separation.

JB: Does this exhibition and book, with its lengthy essay, function as a summary of the work that you have done here at San Francisco Museum of Modern Art or of ideas that started before you arrived here?

VDC: One doesn't just arrive here and start from scratch! Many of these ideas were germinating years ago. They came largely out of the fact that I was a practicing photographer and was teaching the history of twentieth-century painting and sculpture. I began to realize that these analogies were not just occasional links. As the photographers became better educated in the formal sense, especially after WW I, they became aware of a wider range of intellectual inquiry. They began to challenge assumptions. As a consequence, they made different kinds of pictures than the nineteenth-century photographers. This applies most directly to the pluralist group in this exhibition; they are all university trained, and have had experience with more and deeper connections with avant-garde art of all media. Their work has become richer and richer as more layers of meaning have been built into their images. And, I think they have high expectations that people who look at their work are sophisticated and can follow their clues. They are dealing at an idea level that is in every way comparable to what one might expect from paintings, and they interact with painters, socially as well as intellectually. This is very important

to realize. That is what I have tried to call attention to in exhibitions and catalogues. I think this concept is much better understood now. I don't pretend to be a leader of intellectuals, but I do think that if we are going to make any progress in our understanding of human problems and issues, we are going to have to depend more on the head, rather than on machines. That's the kind of message that photography should convey if it's going to have much impact on our complex and anxiety-ridden world.

AN
INTERVIEW
WITH
AARON
SISKIND

Providence,
Rhode Island,
August 12, 1986

One of the pleasures of speaking with an artist who has been deeply immersed in the creative process and the politics of its products for over fifty-five years is that he no longer distinguishes art from life. In a more abstract sense, the being and the deed are no longer separable, are equally infused with the same dualistic impetus—tension and resolution. That is what I most strongly sensed while interviewing Aaron Siskind. One cannot explain either the evolution of his pictures, or the individual images by examining his biography. And, conversely, one cannot draw biographical inferences from the images. They constitute a language of form in themselves, yet concomitantly suggest aspects of his psyche through metaphor. Since his major shift from social documentation to abstraction in the early 1940s, his picture-making has centered on form and the mark, and embraced the human soul through them.

One of the terrors of speaking with an artist of Siskind's stature and experience is that it seems virtually impossible to ask him a question which he has not already answered in any number of forums. At least that is the challenge Siskind presented to me as we began our introductory remarks. Momentarily taken aback by this probable truth, I realized that statements and interviews from different times in an artist's career make possible comparison of changes in attitude, philosophy, and nuances of expression. The present and the past are equals in the realm of history. Taken in sum, this interview reflects Siskind's present mode of operation and *credo*. He makes no direct attempt to explain the pictures—in fact he avoids the

issue—but rather gives a deep sense of what he seeks in and through the work.

In 1956, Siskind wrote the following as part of the catalogue statement for his retrospective exhibition at the George Eastman House, Rochester, New York: "When I make a photograph, I want it to be an altogether new object, complete and self-contained, whose basic condition is order—(unlike the world of events and actions whose permanent condition is change and disorder)." The following is from an interview published in *Afterimage,* March, 1973: "To me, in a deep sense, it's the purpose of art that a work of art is something that's composed, it's orderly, confined, it's within bounds, you can comprehend it. That gives you an incredible sense of pleasure because the things that take away our pleasure are apprehension, disorder, discomfort." From the present interview: "The main thing that a work of art has to give you is *order.* It takes all this mess of ours, which is so wonderful and so disturbing, and puts it together for us so that we can contemplate it. It removes you from life so that you can live your life."

Though the three selections represent a spread of thirty years, it is clear that order has remained one of Siskind's central concerns. However, the most recent quotation indicates a far more resolved relationship between the image and the chaos and flux of everyday life. Order is no longer "self-contained" or "unlike the world of events," but rather, it actively embraces or incorporates the "mess of ours." Though this is perhaps a subtle distinction, it is nevertheless an important one as it indicates a resolution of the tension between the image and its contents and form.

Throughout his career, Siskind has worked within the limitations of photography as a medium of translation and transformation. Subject matter, which he has always found (rather than fabricated), serves as a vehicle of expression, as evocator, embedded within the formal matrix of the straight black-and-white print. It is extraordinary how much he has been able to express and evoke within these self-imposed strictures. But, what appear as restrictions may actually reflect a higher purpose. Paul Valéry, the French poet and critic, commented upon the signif-

icance of such a limited vocabulary when he wrote: "It seems to me that the soul, when alone with itself and speaking to itself, uses only a small number of words, none of them extraordinary. This is how one recognizes that there *is* a soul at that moment, if at the same time one experiences the sensation that everything else—everything that would require a larger vocabulary—is mere possibility."

Siskind was born in New York City in 1903. After studying literature and music at City College of New York, from which he graduated in 1926, he went on to teach English in that city's public schools. He became seriously interested in photography in the early 1930s and subsequently joined the Film and Photo League in New York. While associated with that group, whose primary interest was social documentation, he produced several important bodies of work. Of these, *The Harlem Document* is perhaps the best known and most accessible. The early 1940s marked a major turning point in his career. Siskind, who died in 1991, was an influential teacher and an inspiration to two generations of younger photographers. I began the interview with a discussion of the detailed and extensive biographical study on him, *Aaron Siskind: Pleasures and Terrors,* written by Carl Chiarenza, published by New York Graphic Society in 1982.

JB: It is extraordinary that such an extensive and detailed biography has been written about you as a photographer. How did that come about?

AS: I think it was a matter of coincidence that a book of that sort was written. Carl Chiarenza is a photographer, as well as a photographic and art historian. His main interest in art happened to be one of the chief influences in my life, the Abstract Expressionists. He thought my work was very important and had a good many facets, and these coincided with his own personal interests. He liked that kind of art, he liked my kind of photography, I had a real juicy existence to work on—so it was a coincidence. There was nobody else who would have done such a book.

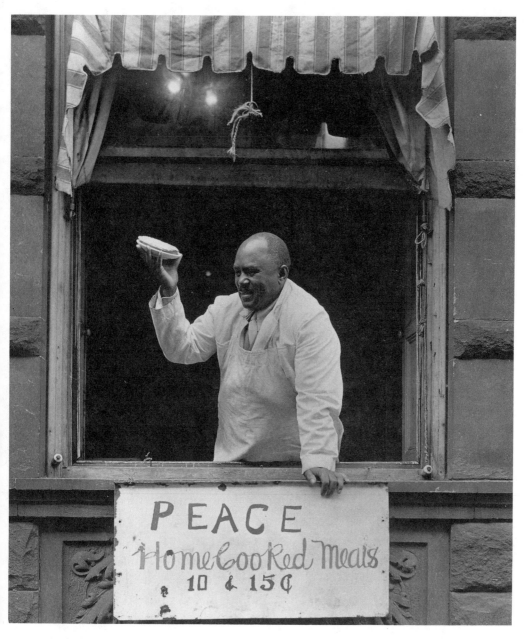

Aaron Siskind, *From Harlem Document,* 1936, gelatin silver print. Courtesy Museum of Modern Art, New York. Copyright © 1993 by the Aaron Siskind Foundation.

JB: The book feels as if it were written from the inside out.

AS: It was, because it was the result of endless, endless research, endless talking—we talked together for weeks. We went away on a photographic trip together. Every night in the motel we talked for hours and hours, besides talking during the day. All of this was taped. I made many of my personal friends accessible to him, artists living in New York. He interviewed them. Since I taught at the Institute of Design, I had a lot of former graduate students that he could interview as well. We had my archives, which I had given to Nathan Lyons [at the George Eastman House], to refer to.

He began to work on it in the late 1960s as a doctoral thesis. He was lucky enough to convince Harvard to let him do it on a living photographer. Fortunately, there were a couple of guys up there who know me and are partial to my work, so they let him go ahead. I had enormous numbers of pictures in my own personal archives to work with because I've been so productive over so many years—so later on when we had the problem of producing the book or even illustrating the thesis, he had endless stuff to choose from.

The point about my biography was that it was supposed to be a study in picture-making aesthetics. The whole problem, however, was that my life itself, the kind of guy I was, was very interesting to Carl. His philosophy was that pictures come out of your life. All the meaning of my pictures would emanate largely from my life, my personality, so forth . . . he also understood that the images came out of picture-making too. But, he stressed the biographical aspect—that was the big battle I had with him. He stressed what he thought was interesting stuff, my love affairs, etc. I'm a social person, I need people, so I get involved with them. One of the troubles with the book, to me, is that it emphasizes too much the relationship between the person and the picture. What I've always been trying to say is that the whole drive to make a picture is to create something that is different from your life. I've said that many times, I don't like to be academic about it, but I know that that is the essential drive behind my work.

JB: So the image transcends the personal?

AS: Yes, *its* basic nature is quite different from *our* basic nature. I'm just trying to define what it is, and I know what it is that moves me. For instance, when I listen to music, my whole relationship to it is different from my relationship to you or anybody else. It does different things than people do to each other. For a truly religious man, the contemplation of God is something quite different than the contemplation of his wife.

JB: Does the essay which Henry Holmes Smith wrote about your work get closer to it?

AS: Sure. Henry Smith was probably the best writer on photography that we've ever had. He was always trying to get at what a picture says, what it means. He tried to do it almost scientifically. There's an awful lot of nonsense written about the meaning of pictures, that's why we have the cult of the truth. I was participating in a discussion once when one fellow held up a photograph by W. Eugene Smith. He proceeded to say that Smith was an ideal photographer because Gene Smith was revealing the truth. To me that's utter nonsense, because the last person in the world to tell what the truth was was Gene Smith— he was too passionate and prejudiced a man to be concerned with such an abstraction. Besides photography can't do that any way. Photography can state the facts but the meaning is something else. Truth has to do with meaning. Henry Smith was always trying to find out what there was in a picture, what people saw in it. When he wrote about photographs, he was writing about pictures, where they came from, what they mean, and what is in them. His essay in the 1965 monograph on my work [*Aaron Siskind: Photographer,* George Eastman House, Rochester] was full of real insights.

My whole philosophy is that picture-making is like a lily coming out of the earth, but the lily is one thing, it ain't the earth (laughter). It has its own genes, it has its own past. The earth is what nourishes it, that's all. The book was published almost ten years after the thesis was complete. When they decided to do

the book, Carl had to do ten more years of research on me. More interviews, more pictures, more studying. I read over every word with him after he wrote it. He insisted on it and wanted me to do it. I had to struggle with him on the aesthetics, because with some of the pictures he began to analyze them as if they were paintings. A photograph is a little different. We don't put it there, we select it, we find it.

JB: One can't consider the surface of a photograph the same way one analyzes the surface of a painting.

AS: That's interesting because people are always emphasizing the surface of my pictures, that I'm interested in textures. I'm not interested in texture any more than a painter is interested in the paint.

JB: What about the issue of abstraction and evocation? Does abstraction depend upon evocation to convey its meaning?

AS: A lot of its power and attraction comes from that I think. All art evokes, but when you have a picture that doesn't have ostensible subject matter to depend on, it has got to stir you up in some way. The Abstract Expressionists banged away at the whole problem of what a picture means. Is the meaning of every Madonna and Child the same or different? Is a Madonna and Child painted in seventeenth-century Belgium the same as a Madonna and Child painted the same day in Rome? Obviously, they are all different. This difference has to do with how the thing is done, and, to some extent, the subject matter. Two paintings made in the same country with similar sorts of women can be worlds apart. One can take you to heaven, the other drops you to hell. Why? That's the thing that I'm concerned about, that's where the meaning is. It has to do with how the painting is made and many, many subtle things. This is what differentiates art from every day life. As a matter of fact it helps us understand life a little bit better and also makes us be able to bear it, which is a very important thing.

JB: That is usually a function assigned to religion isn't it?

AS: Well sure, religion does it, but art does it in a different way. Whenever you have a very deep relation with a work of art, whether it's music or painting, it creates in you a feeling of wholeness. It can give you ecstasy, courage, it can do all kinds of things to you that are difficult to get out of life. The main thing that a work of art has to give you is *order*. It takes all this mess of ours, which is so wonderful and so disturbing, and puts it together for us so that we can contemplate it. It removes you from life so that you can live your life. These are some of the basic things I think about art, but it can do many other things. It can be used, and that's where we have to be careful.

JB: As in propaganda?

AS: Not only propaganda, but to use it for power. That's what a lot of the Marxists complain about, that art is really being used to impose the ethics and ideas of the establishment. Art is used all the time to get you to buy products.

JB: As you have put it, one comes to a work of art, to its order, out of an act of freedom.

AS: I think that is the ideal condition—that you come upon it either by accident or because you seek it out because of some other experience that you have had. It gives you a sense of wholeness. I get it all the time, primarily through music. Music has taken me out of the dumps to let me work, let me live. It fosters a variety of meanings and experiences—particularly the recall of pleasure, a function that we tend to look down upon. We talk about the seriousness of art and mix that up with the uses of art. I mean what do we really want out of life? We want that feeling of harmony, of tensions resolved. What are we striving for? We are trying to resolve things, trying to have pleasurable sensations, trying to be able to fly in our mind, to move. We are not struggling for the struggle itself, we are struggling for some kind of resolution. And, in art we have resolutions.

JB: You have, in other interviews, spoken extensively about ambiguity. Ambiguity seems to me the opposite of resolution.

AS: If you simplify what I'm saying about harmony, then you get into just mush, you know. We require, as thinking people, abrasiveness, which moves us toward some gratification, satisfaction, or resolution. What I am trying to say about ambiguity is that if I am going to make the resolutions in my picture meaningful, I've gotta have something to resolve. That's where the ambiguity is. If all I make are pictures which are just plain representations, that to me is mush. It may be lovely as a representation, but if in that picture you can get other things that are interplaying with that representation—some ambiguity, the feeling that there is something else there, other meanings—you have to resolve them without destroying the subject matter. Once I came up with a thought for Thomas Hess in *Art News*. Something to the effect that: though you may have the resolution in the picture, the tensions must continue.

Another kind of resolution is how the different elements of the picture are resolved. This has to do with other things that the camera does not do for you, which you have to determine— such as the tonalities, how you are going to weight them, what you leave in the picture and what you leave out, context, the depth in the picture, the lightness. These determinations are made in relation to the kind of resolution that you want. I'm not sure about the relationship between this kind of psychological resolution in the picture and the more mechanical aspects of the camera.

JB: Don't you think that every mechanical thing that a photographer does in the process of making an image has ramifications for the psychological aspects?

AS: Of course. I used to tell students, when they were having difficulties making pictures, to stop looking at the subject. Just keep looking at the ground glass! (laughter) The camera will do everything for you!

JB: Where does the idea arise in the picture-making process? The subject is out in front of the camera, yet one studies the ground glass. What is the relationship between the idea and the process?

AS: This is a very crucial and important question. Where does the idea come from? The idea will come out of a picture because of a number of factors: what you leave out and what you leave in the picture; the tonal ways in which you handle the picture; all the lens-oriented devices such as sharpness or lack of focus. It has to do with making selections that obviously refer (this is crucial) to other pictures. To me the meaning that is in a picture is very much dependent on other pictures. That's where it comes from. Where do you think I get the ideas for my pictures? My experience of pictures as well as my experience of life. But the main thing is that the experience of pictures guides you. Once you listen to that, without rejecting it because it sounds so awfully tight and elitist, it's the truth. Art, picture-making, is a cultural phenomenon. It is based upon the whole history of what you are doing—it comes out of it and what you are doing is part of it to a certain extent. Art is both social and personal. You are saying something and the whole world of picture-making is saying something. The excitement and tension come out of combining those things.

JB: Don't you think that receptivity to the kind of ideas that you are talking about is dependent upon optimism about and faith in the sublime aspects of art?

AS: The kinds of ideas you find in art depend upon what you think art can say. Ad Reinhardt used to go around saying that art doesn't mean anything. What he was driving at was that it doesn't mean all the things you say it does. We really don't know what it ultimately means. We don't! What the hell is a piece of music that moves you or shakes you when you listen to it? What does it mean? Reinhardt once did a cartoon in which two people were standing in front of a picture. One asks the other, "What does it mean?" Then an arm shoots out of the picture with a sign

which says "What do you mean?" (laughter) What is the nature of the meaning of art. We make it mean a lot of things, because we use it for many things. But what it actually means, well—we know it affects us.

JB: Are you saying that the meaning is in the realm of experience?

AS: I'm not telling you I have the answer. I do know that if I were out making pictures and was saying to myself that I am going to express something in the picture, I would never make a picture. That is not the nature of my experience, because the making of a picture, a work of art, is too fast—like the difference between the way the mind works and a fire works. If someone asked Harry Callahan what his pictures mean, he'd look at him as if he were crazy. Look at his pictures, they are unbelievable. He never put a wall in front of him saying, "I'm going to express meaning." He got involved in picture-making, saw certain pictures by Ansel Adams or Eugene Atget, for example, and knew that he had to make pictures. Then he went out, photographed, and looked at what he did.

The biggest influence on a photographer is his own pictures. Maybe the most important picture taken is the first one. Carl Chiarenza pointed that out in my work. There were certain ways in which I organized a picture, saw the world and translated it into a picture, that was there almost from the first picture I took.

JB: Hilton Kramer included your work with Callahan's under the heading of "formalists" in a 1977 review. Do you feel comfortable with that kind of approach to your work? Does it apply more to Callahan's work than yours?

AS: We are both very much formalists and Kramer is very perceptive. We are always simplifying the world into the picture and we are also concerned with where things are placed in the picture. But that's not solely what the work is about. My work is looser than Harry's. With him everything is always in the right place. Harry is such a strict formalist that he would not sandwich negatives. There might be a hundred exposures, but it had to be on

one piece of film. That has to do with the form and a belief in the entity of the thing itself. If he wants to make a collage, he'll make a collage and then photograph it. He uses many formal devices to translate nature.

My problems have been a little different. I don't use the range of techniques that Harry uses. I have to work with aspects of ambiguity—how expressionistic do I allow the picture to get. I might photograph a torn poster in which the subject matter is almost wild, other times I will work with simple lines. Those are all formal considerations, but they have to do with the subject matter. This may seem curious to say because Harry is always dealing with recognizable subject matter. With me subject matter always tries to take over, and I'm always fighting against that. So there is a struggle between the expressionist, the formal, and the abstract. No matter how much I try to get away from that expressionistic stuff—which disturbs me and I don't care for it— I still keep going back to it.

JB: Ambiguity of scale seems to be an important part of your work. The pictures of the rocks in Martha's Vineyard seem like immense boulders when in fact they are from a low stone wall.

AS: That has to do with translation. Hilton Kramer calling us formalists, at bottom, was right. But, at bottom, he was just using a cliché. Every picture is a formal resolution of life in the broad sense. Obviously, when I was photographing those stone walls I wasn't trying to make a document of those stone walls. On the other hand, when I was photographing the guy with the pie in his hand, I was trying to make a document, even if it had formal aspects. But that's the kind of mind I have anyway.

JB: That goes back to the issue of order that you raised earlier.

AS: That's right. With Callahan, he's so good at it that he doesn't have to think about it. I have to think about it. One of the main reasons why Harry and I are so congenial toward one another is not because we make the same kind of pictures, but because what we want to do is make a *picture,* something to think about. It

sounds stupid to say that, but that's all we are concerned about before anything else. How does the world enter the picture and rest there for a little bit. We have both been reduced in our lives to have no success at anything else. So our total gratification has come to rest in photography. More so for Harry than for me, because Harry has had a very simple life, very hermetic. My life has been all over the place. The only place I can find peace and quiet is in making a picture. I've had miserable marriages among other things. Even though our work has been exhibited a lot together over the years, our pictures have sometimes been very far apart in their meaning.

I always got involved in the discussion of my pictures because people were always challenging me about them. I also met up with the Abstract Expressionists who also talked extensively about the meaning of pictures. My way of working was close to theirs. To tell you the truth, when I found my way of working, it really excited me. I was able to make objects that I thought were marvelous, but I didn't know what they meant really. Where do they come from? They don't come from me . . . I don't know, you see. This is not only a way of working, it's also a way of living. I really don't have a sense that I made this [picture of the rocks].

JB: You seem to be saying that biography is irrelevant.

AS: The only part of the biography that is important is the something that happened to me that permitted me to contemplate photography, to go at it. I couldn't do anything until they gave me a camera. I tried music, tried poetry for a long time, but it was the camera that did it. I'm sure that my experience of art was important for that. I don't want to say that it was more than me. I don't want to get into mystery—but the way in which my photography happened is something more than my personality. I'm sure all the elements in my life could have made a criminal out of me instead. What you get from me is an attempt to recapture the quintessential art experience that has been happening since the Renaissance. I am always conscious of it, always struggling with all the other forces that are in contemporary art.

Aaron Siskind, Los Angeles 3, 1949, gelatin silver print. Courtesy Museum of Modern Art, New York. Copyright © 1993 by the Aaron Siskind Foundation.

JB: Do you find a close relationship between photography and literature or music?

AS: The thing that brought me to working with ambiguity was that I didn't like pictures that were too simple. The whole thing about ambiguity is like poetry. In poetry one writes economically, where phrases or words need to have multiple meanings or ideas. I found that even in the early years, that I used to compose my pictures in terms of rhythms. Visual forms had musical equivalents. So music gave me a kind of structural basis and a feeling for a picture. If it weren't for those experiences, I'm sure my pictures wouldn't be the same.

JB: What about the literal content in the images?

AS: I never can think of any titles for my pictures, maybe in a few cases. But my pictures are not verbal at all.

JB: Some of Frederick Sommer's work provides an example of the importance of literal content. Do you feel that your work is close to his? I'm thinking particularly of some of your torn poster images.

AS: Once in a while, as with the divers [*Pleasures and Terrors of Levitation*], the titles help extend the feeling of the pictures. When I did the small series *Remembering Joseph Cornell in Merida* (1975), it was his pictures and boxes that I found a kind of expression of in cemeteries. I saw them only because I experienced Joseph Cornell. The *Homage to Franz Kline* series arose out of our aesthetic relationship.

JB: Your work and Abstract Expressionism began concurrently with World War II. Your change from working in a social documentary mode to a more abstract and picture-plane oriented mode paralleled a similar shift in Jackson Pollock's work. Were you responding to the change in world order and alignment that came as a consequence of the war?

AS: There were a lot of forces operating. I don't know exactly what went on with Pollock, but there were a lot of painters that had the same reaction that I had. We were all working in a realist way. Remember when I was photographing in the 1930s I was a beginner. Most of the painters had been working longer than me. In the thirties, there was great stress on realism, and the dominant social force that was affecting us was Communism— the party and activities of the party in New York. Many of the artists belonged to the artist's unions; I belonged to the Photo League. Inevitably, we had a great revulsion. One after another they got sore at the artists, because they were politically motivated and the whole motivation with the change in the political situation made demands on them. They didn't like art that didn't support the ideology. There was a tendency, on the part of the artists, to reject the politics and turn inward on themselves. I remember Mark Rothko saying, in the late thirties, that what motivated him was his having come to the conclusion that social agencies did not help people, they had to help themselves. Instead of defining or finding order through politics, we had to rely on ourselves. Both Rothko and Adolph Gottlieb wanted to go back to very fundamental themes and forget all about the realism. That was one force. That's what happened with me, I imagine. There other things too. I had some personal experiences in terms of picture-making which convinced me to go one way rather than the other.

Another force operating with painters was that just before and during the war many European artists came to the United States. That was a great influence. There already was a strong neoplastic movement. But these guys were a little different because they were expressionistic as well as abstract. It was a wonderful world in that no one was making any money, but every one was painting and they were near each other. There was a lot of cross influence and infusion of energy. We formed a club in which I was the only photographer for a long time. They accepted me as a member partly because, even though I was teaching elementary school, an old friend of mine was Barnett Newman. We were in the same literary society in college. (laughter) He was close friends with

Gottlieb who saw some of my early photographs done in Gloucester [Massachusetts] in 1944. He suggested that I see Charles Egan who had a gallery which was about the size of a living room. Egan saw four or five of my little 8″ × 10″ prints and decided to have a show of them in 1947. That's two or three years before de Kooning or Kline and the show was one of the reasons that I got to meet them. I had four shows back in those days, and you know, I can't remember ever receiving a nickel for any picture that was sold.

JB: Does that mean that the pictures didn't sell or the dealers weren't honest?

AS: Well, they didn't sell very many and they didn't sell for very much, but he kept the money and drank it up. (laughter) But that's history now. I got to know the Abstract Expressionist painters and they got to know me. We traded work. Photographers, especially professional photographers, wouldn't look at my pictures because they didn't amount to anything. They were very unpretentious, the prints weren't that good (I had taught myself mostly). It was really the image that the painters responded to. Many of the young painters were very strongly affected by them—they told me. They were working out of a richer tradition—after all what was I working out of? We actually knew very little about what had gone on; we had seen some Atget pictures, maybe later on a Cartier-Bresson. In those days when I moved among them, before the 1950s when they were promoted by galleries and started to make a lot of money, they would come up to my place with *innocence*. All we were interested in was what we were doing and making art. It was a wonderful time even though the world was in terrible shape.

JB: It's interesting that you mention the effect that sales and money had upon the art community then, because there seems to be a similar situation presently. Artists have become very proprietary or territorial about their work because of marketing approaches.

AS: There are a lot of good artists in New York and they form groups. Some have to live a fairly hermetic life because they don't like what is going on. Others revel in the commercialism. There are certainly more opportunities now, but there are a hundred times more painters and photographers.

JB: What have you been doing recently?

AS: Let me show you a box of pictures that I made recently of tar poured in the cracks of light-colored concrete roads. The only problem with photographing out on the road was not getting killed. I just parked the car at the side of the road and worked in front of it. I have another batch here of spackle. Did you ever see any of my pictures of spackle? (laughter) It all comes to the same . . . all boogie men coming around. I had a rough time for years, but I'm over that. The last few years have been very good to me, so I've been able to help others, which I enjoy.

Vilem Kriz's photographs have an Old World charm which establishes them as objects of curiosity and contemplation. His black-and-white images are printed on a pebbly-textured paper and are toned a variety of colors ranging from warm or cold brown to a green tint. His secret toning method (he claims it will go with him to the grave) also stains the paper base, most noticeably in the highlight areas, and gives the prints a vintage appearance. The prints seem far removed from the contemporary technology of photographic print-making. They serve as vehicles for, or rather, by-products of Kriz's involvement in and enthusiasm for the relationship between man's immaterial aspects such as mind, psyche, or spirit and his ability to express these aspects in concrete form. Kriz's aesthetic heritage is Surrealism, a philosophical vision he has carried throughout the last forty-five years. His photographs convey the authority of that impulse and establish him as a significant historical figure.

David Featherstone, in his introduction to the Vilem Kriz monograph published by the Friends of Photography in 1979, traces Kriz's personal history and establishes the photographer's participation in the Surrealist movement. He was born in Prague, Czechoslovakia, in 1921, where he grew up surrounded by photographers and writers such as Josef Sudek and Franz Kafka. In 1946 he moved to Paris where he later became close friends with Jean Cocteau, the Surrealist filmmaker and poet. He moved from Paris to the United States in 1952 and settled first in

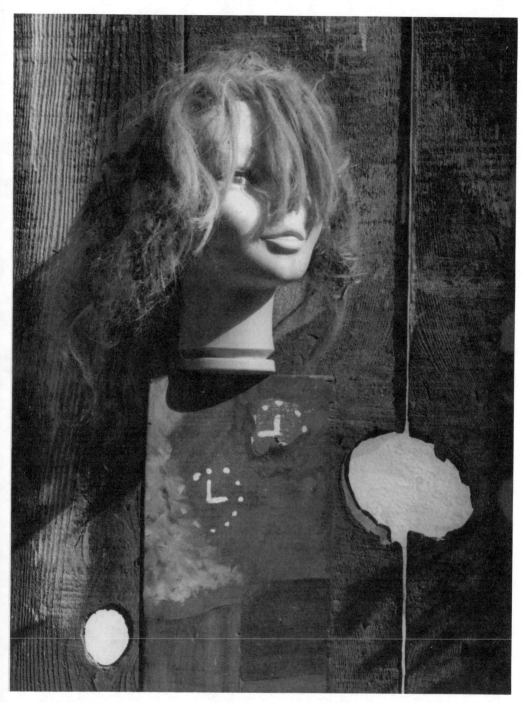

Vilem Kriz, *Berkeley,* 1977, gelatin silver print. Courtesy Vision Gallery, San Francisco.

Berkeley. He then moved to Montreal, Canada, then back to Berkeley where he has resided since.

Like most photographers, Kriz was constantly searching for subject matter appropriate to his aesthetic. He recognized that the camera with its own peculiar vision could transform that subject matter into a symbolic language; that somehow photography was an inherently Surrealist medium. He was able to use his camera as a spontaneous receptor of visual imagery analogous to the way images arise in the human imagination. That imagery arises sometimes with singular clarity and other times in kaleidoscopic density. Kriz has been flexible enough in his photographing with normal or multiple exposures to address both these forms of perception.

André Breton wrote in his seminal article "What is Surrealism?" (this quotation is from the 1936 translation):

> A certain ambiguity contained in the word surrealism, is, in fact, capable of leading one to suppose that it designates I know not what transcendental attitude, while on the contrary it expresses—and always has expressed for us—a desire to deepen the foundations of the real, to bring about an ever clearer and at the same time ever more passionate consciousness of the world perceived by the senses. . . . At the limits . . . we have attempted to present interior reality and exterior reality as two elements in process of unification, of finally becoming one. This final unification is the supreme aim of surrealism: interior reality and exterior reality being, in the present form of society, in contradiction.

The artists who espoused Surrealism attempted to articulate the imaginary language of interior reality, of dreams and the unconscious. For the most part, because the movement was primarily a literary one, the images maintained a representational character. The new language was founded upon recontextualization, the dearrangement of the space and sequence of external reality. Surrealist imagery brought a new ordering of subject matter. Kriz, though certainly not the only photographer working in this manner, uses both multiple exposure and multiple printing to achieve this end. Yet many of his strongest pictures

are straight exposures of still-lives or tableaux which he has constructed out of objects and surfaces chosen for symbolic content.

Dolls, mannequins, and a transparent plastic figure are recurring subjects in Kriz's pictures. He photographs them in postures or arrangements which convey through gesture a feeling of animation. This ability to imply animation, to transfer human qualities to them, is key to the Surrealist content of Kriz's images. The transparent plastic female, a product of the push for scientific educational toys in the 1950s, serves the same purpose as the mannequins in the earlier pictures. As subject matter, the plastic figure and the mannequins are equivocal. On one hand they are symbolic and stylized representations of the human figure; on the other hand they have character or moods of their own. They work on abstract and emotional levels, and thus embody Breton's "process of unification." (Mannequins became a ubiquitous Surrealist symbol, an identifying mark, much as did the crystal sphere for the Photo-Secessionists in the nineteenth century).

Kriz's repeated use of that figurine is an example of his poetic method for building a meaningful language. The Surrealists drew upon the methods evolved by the physical sciences based upon the repeatability of experiment as a measure of meaningful results. At the same time, they incorporated the new models of perception formulated by Freud and Jung. These new models, based upon assigned probable meanings, were used to interpret the abstract symbolic realm of the invisible, the unconscious. Thus Kriz and the other Surrealists were able to bridge pre-Renaissance art which was based on a language of symbols and post-Renaissance art based on representation which is the science of appearance.

The Surrealists made use of the unconscious through spontaneous acts such as automatic writing and by trusting intuition as a guide. Max Ernst wrote in a piece titled "Inspiration to Order" (1948): "Since the becoming of no work which can be called absolutely Surrealist is to be directed consciously by the mind (whether through reason, taste, or the will), the active share of him described as the work's 'author' is suddenly abolished almost completely. The 'author' is disclosed as being a mere

spectator of the birth of the work . . . so the painter has to limit and give objective form to what is visible inside him." The majority of Kriz's work seems to be motivated by this impulse. The spontaneous approach to evolving the images needs to be separate from the evaluation of it. Not every act, though it be consistent with Surrealist criteria, is equally significant. Kriz's work would appear stronger with more careful editing. Some of the images seem dated, some trite, but the overriding feeling that emerges is a great sense of wit and a love of vision.

The Surrealists took an important risk by bringing an intensely personal language into a public forum; they made an artistic issue of what Jung called the collective unconscious. They did so for the purpose of changing their audience's perception of reality. Kriz succeeds. The risk, however, was having that language become totally inaccessible or cliché-ridden. The images of second- and third-generation Surrealists such as Jerry Uelsmann suffer these problems. But Surrealism is still the root concept behind the fictive impulses in contemporary photography. It is refreshing to see Kriz's photographs as a source for these continuations of the Surrealist aesthetic.

The Surrealist concept of reality, based on a belief that the unconscious is equally as valid as the externally perceived world, is cunningly infectious. It holds within it a liberation from the mundane, and a disclaimer of responsibility for anything but its self-defined principles. The Surrealists' irreverence toward accepted forms, and their passionate obfuscation of rational discourse provided a much needed tonic in the arts in the 1920s. They redefined the process and content of imagination which in the teens was still guided by classical notions of beauty. By the 1940s painters had moved on to Abstract Expressionism, a rejection of subject matter, an emptying of literal content, in favor of a more gestural approach to conveying feeling and idea. Photographers, on the other hand, have been accused of keeping Surrealism alive, because they have always contended with the peculiar relationship between camera and subject matter.

Photography, the medium that comes closest to the Renaissance ideal of illusionistic representation, served the Surrealists as an illustrative form for perceptions and constructions of a supranormal reality, as an embodiment of their world view. Photographers, with the exception of those who have consciously embraced the Surrealist style (such as Duane Michals and Arthur Tress), have struggled ever since to shake the Surrealist infection, to use the factuality of the photographic image to address issues beyond the Surrealist argument, which share the visual forms of Surrealism. Our culture is fascinated with abnormality, sexuality, and fantasy. While the Surrealists brought these

JOEL-PETER WITKIN and L'AMOUR FOU

at San Francisco Museum of Modern Art, December 1985/ January 1986

123

aspects of psyche and culture into the vocabulary of art through symbolic language, contemporary photographers deal with them as more palpable social realities.

The concurrence of two exhibitions at San Francisco Museum of Modern Art, *L'Amour Fou: Photography and Surrealism* and *Joel-Peter Witkin: Forty Photographs* offers viewers a first-hand look at Surrealist photography in an historical context in the former, and a look at a *seemingly* related vision of a contemporary photographer, Joel-Peter Witkin, who has recently received much critical attention. The Witkin exhibition was curated by Van Deren Coke at San Francisco Museum of Modern Art and will travel after its tenure here. *L'Amour Fou* was organized and circulated by the Corcoran Gallery of Art, Washington, D.C.

Curated by Rosalind Krauss and Jane Livingston, *L'Amour Fou* presents the work of well- and lesser-known Surrealist photographers, and, with careful scholarship, corrects the mistaken notion that anything vaguely resembling fantasy fits within the confines of Surrealism. The essays in the catalogue demonstrate that photography was at the core of Surrealist practice, and was in fact the ideal visual medium to convey what was initiated as a literary impulse by poet and writer André Breton. Dawn Ades cites their philosophical purpose in the opening lines of her essay "Photography and the Surrealist Text": "It worked for a revolution in our modes of thought and in our consciousness of ourselves and the things around us." The continuing influence of the Surrealist vision, particularly in the advertising industry's use of incongruent juxtaposition as an attention grabbing device, supports Ms. Ades' assertion. Historically, photography has always been connected to "the things around us," yet the Surrealists were able to imbue familiar subject matter, such as the human figure (for example, Man Ray's *Anatomies*, 1930) and popular objects such as public sculptures, with a sense of the surreal through choices of lighting, atmosphere, camera angle, and distance from the subject.

How Surrealist photography helped change our modes of thought is less clear, because the contribution came not in pictorial terms, such as a concern with beauty, but rather in the realm of language structure and how information is conveyed,

Man Ray, *Larmes*, 1933, gelatin silver print. Private collection.

received, and interpreted. This linguistic model was first formulated by Roland Barthes in his seminal essay "The Rhetoric of the Image," in which he interpreted photographic content and structure as symbolic language. Since Surrealism is not defined by a particular visual style, Surrealist artists concerned themselves with a symbolic approach to content (though there were bitter arguments over methods within the movement). This philosophical posture explains why the Surrealists could designate and co-opt such a broad range of artifacts as falling within their parameters. At the time of Surrealism's emergence, Western culture had already been shaken by re-vision. Cubism, Einstein's theory of relativity, and Freud's newly formed theories of the

unconscious were a few of the innovations which preceded the movement. These theoretical worlds demanded a language whose metaphors could make the theoretical convincing. Rosalind Krauss addresses the linguistic model for photography in her first essay "Photography in the Service of Surrealism." She writes:

> If we are to generalize the aesthetic of surrealism, the concept of convulsive beauty is at the core of its aesthetic, a concept that reduces to an experience of reality transformed into representation. Surreality *is,* we could say, nature convulsed into a kind of writing. The special access that photography, as a medium, has to this experience is photography's privileged connection to the real. The manipulations then available to photography . . . appear to document these convulsions. The photographs are not *interpretations* of reality, decoding it as in the photomontage practice of Heartfield or Hausmann. Instead, they are presentations of that very reality as configured or coded or written.

The manipulations to which she refers include multiple exposure, sandwiched negatives, negative prints, solarization, and perhaps most important, photomontage in a freely associative form.

The linguistic model is based upon a presumed relationship between words and images. Simply put, the word for an object has a similar signifying relationship to that object as does an image of it. As images overlap or "double" (to use Krauss's term), statement is developed out of the internal relationships within the images. Further, the rules governing the Surrealist use of language are internally rather than externally constructed. The various techniques used by the Surrealists made concrete a visual complex which cannot be experienced in any other way. It is interesting to note that these were the same techniques that the "new vision" photographers in Germany were using toward a more formal end. However, striving for a new linguistic model stressed the technique, the transparency of which (for example in the distorted figures by André Kertész) is anathema to the success of the Surrealist image. When one can analyze the me-

chanics of the picture easily, can recognize the deceit, one experiences only the style of Surrealism as visual delectation rather than its philosophy as thought reforming. Much of the Surrealist photography included in the *L'Amour Fou* is about style, or is made out of a naive understanding of the relationship between technique and idea in photography.

The strongest Surrealist work is fascinating and profoundly disturbing. Max Ernst's photomontages are filled with remote and highly personal iconography, yet convey an authority that is politically and psychologically charged. They epitomize the Surrealist use of the "open secret," on one hand informing, on the other denying. Georges Hugnet's photomontages are much more like French farces which in their humorous coherence reveal flaws of human nature. Hugnet's *Initiation preliminaire aux arcanes de la forêt (Preliminary Initiation to the Secrets of the Forest,* 1936) depicts some strange sexual ritual with the symbolic overlay of a yellow rose, the symbol of romantic love. The graphic location and irony of the rose's imposition give it the appearance of a metaphysical stamp of approval.

Hans Bellmer's extended series of images, for which he sculpted an extraordinarily strange multimodular doll *La Poupée,* addresses a perverse obsession with morality and sexuality. What he was not able to achieve by creating tableaux-vivante with his doll, he accomplished by the literal and sexually explicit use of a female model. What remains disturbing about Bellmer's work is an insidious undercurrent which implicates the viewer in another person's private fantasy. Krauss approaches this aspect of the work from another point of view when she writes:

> In Bellmer's manipulation of this cycle, everything is concerted to produce the experience of the imaginary space of dreams, of fantasy, of projection. Not only does the obsessional reinvention of an always-same creature . . . give one the narrative experience of fantasy, with its endless elaboration of the same, but the quality of the image, with its hand-tinted, weirdly technicolor glow, and the sense that, though it is in focus, one can never quite see it clearly, combine to create the aura and the frustration that are part of the visuality of the imaginary.

André Kertész, *Distortion #79,* 1933, gelatin silver print. Courtesy André Kertész Estate.

Krauss has precisely explicated the mechanics of Bellmer's work, yet the images seem more in tune with contemporary sensibility than the work of other Surrealist photographers. One of the primary reasons behind this thought is that Bellmer's vision is post-innocent, it presents carnal knowledge not as poetic sexuality, as in Hugnet's work or in mystical literature, but as a translation of some direct and terrifying experience. It is on this level of transmission of ideas and knowledge that Joel-Peter Witkin's work is akin to Hans Bellmer's Surrealist fantasy.

Witkin's imagery, which uses a Surrealist principle of simultaneous fascination and repulsion, represents a more conscious and structured use of fantasy—fantasy which accepts The Fall rather than Paradise as its *prima facie*. In Jungian terms, Witkin is the trickster whose tricks are always transparent, yet always

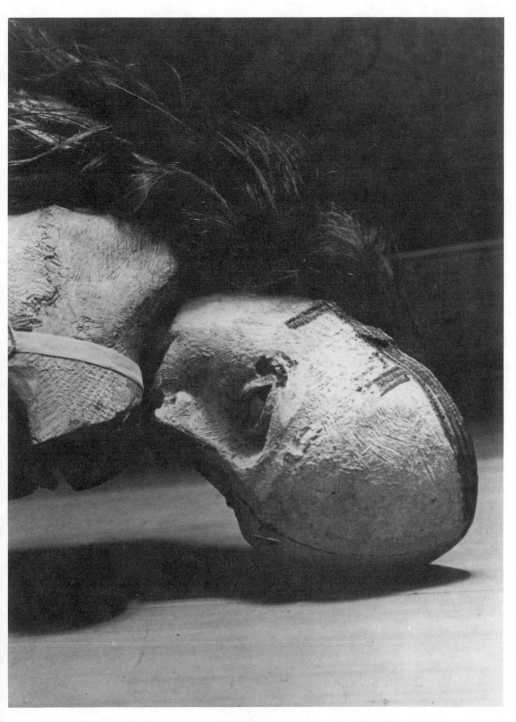

Hans Bellmer, *La Poupée,* 1934, gelatin silver print. Courtesy Jill Quasha, the Quillen Company.

successful. His images are fascinating because they draw one into the process (or the "trick") of believing his fictional world. His technical veneer, which includes scratching the negatives, overlaying tissue on the photographic paper during printing, and split-toning the prints, functions as a lead in the longer process. The tissue paper is a literally transparent technique. Once in his pictured world, one confronts a cast of characters and use of properties made credible by the camera's precise description. What contributes to the convincing quality of the pictures is that Witkin has been able to locate his players and props from among us, though he looks in darker corners than most of us would wish to acknowledge.

Van Deren Coke's introduction to the Witkin catalogue establishes a broader historical and cultural context by citing such precedents as Fellini's *Satyricon* and the blood rituals performed by Hermann Nitsch's Orgien Mysterien Theater in the late 1960s. Drawing upon extensive interviews with the artist, Coke illuminates the thought and fabrication process for many of the works to such an extent that one can almost feel comfortable with the work, though I doubt that was the point of the essay.

In the pieces which have overt art historical references, one is released from the trick. Images such as *Canova's Venus,* the restatement of Canova's sculpture (which in turn was a restatement of a Roman sculpture) close the circuit of artistic structure. When art so engages in referring to itself, the emphasis is placed on an extended elaboration of the previous works. The most powerful and truly haunting images are those that allude directly to cultural rites and practices, *Penitente,* 1982 and *Sanitarium,* 1983, for example. *Penitente* points out the important distinction between the actual act of crucifixion, which was meant as cruel punishment, and what it represents as a religious and spiritual event in the history of religion. Though this image is incendiary from the point of view of conventional Christian religion, it directly addresses the politics of religion. The struggle over which religious group has the most persuasive meaning for the act of crucifixion, reflects the history of the use of claimed spiritual power for political purposes in Western culture. This is as true for the dissident Franciscan (Spiritualist) order in their denial of the power

Joel-Peter Witkin, *Canova's Venus* (New York), 1982, gelatin silver print with toner. Courtesy Fraenkel Gallery, San Francisco, and the artist.

of the papacy in the Middle Ages as it is for the claims of the present Moral Majority. Witkin used the appearance of the cultural rite of the *Penitente* to make us aware of the significance of the original act which it imitates.

What most clearly distinguishes Witkin's work from that of the Surrealists is his relationship to death, cruelty, and bestiality. In his forthright acceptance and expression of these processes his

work conveys a medieval sensibility. His metaphor is the same used by medievalists such as Hieronymus Bosch; that which appears as fantastic to contemporary eyes was assumed real at the time. The distorted and grotesque figures that inhabit Bosch's paintings or adorn Gothic cathedrals carried with them a presumption of truthful vision, and consequently were used to exert power in the moral realm over individuals. Witkin actually constructs his tableaux for the camera. And, his images are endowed with truthfulness because of the camera's "privileged connection to the real," though his content is filtered through a stylized transparent technique. Thus, his images exercise the same moral power as much medieval art. However, the authority to distinguish between good and evil no longer resides in political or religious structures, but rather within the individual. Witkin's work, if one accepts it as moral rather than as a celebration of the perverse, forces the viewer to assume that moral responsibility, to confront oneself in the face of the trickster.

Note

The exhibition catalogues are: Rosalind Krauss and Jane Livingston (with an essay by Dawn Ades), *L'Amour Fou: Photography and Surrealism* (New York: Abbeville Press, 1985) and Van Deren Coke, *Joel-Peter Witkin: Forty Photographs* (San Francisco: San Francisco Museum of Modern Art, 1985).

As a medium of record, photography can be deceptively simple. The translation of subject matter into image establishes what appears to be a literal correspondence. However, photographs in their most basic form represent a particular individual's view (but not necessarily perception) of what stands before him and the camera. Selection—that is to say, at what, where to point the camera, how to frame the image, as well as more technical choices—is key to the photographer's decision-making process and consequently to the photograph's exegesis. John Szarkowski elaborated upon this notion of selection in his attempt to establish a syntax for camera language in his popular book pointedly titled *The Photographer's Eye* first published in 1966. He identified five categories to embody his theory of photographic vision: The Thing Itself; The Detail; The Frame; Time; and Vantage Point. Of these, The Thing Itself is the most problematic and at the same time most relevant to his argument that the photographic record also constitutes a document of fact. His brief introduction to this section reads:

> More convincingly than any other kind of picture, a photograph evokes the tangible presence of reality. Its most fundamental use and its broadest acceptance has been as a substitute for the subject itself—a simpler, more permanent, more clearly visible version of the plain fact. Our faith in the truth of a photograph rests on our belief that the lens is impartial, and will draw the subject as it is, neither nobler nor meaner. This faith may be naive and illusory (for though the lens draws the

LEE
FRIEDLANDER:
SHILOH

at
Fraenkel
Gallery,
February 1986

133

subject the photographer defines it), but it persists. The photographer's vision convinces us to the degree that the photographer hides his hand.

If Postmodernist theory (from the viewpoint of a generation later) has convinced us of anything, it is of the fictive basis of the camera image, undoing Szarkowski's Modernist rhetoric.

The year following publication of *The Photographer's Eye*, Szarkowski curated an important and influential exhibition entitled *New Documents*, which included the work of three photographers: Diane Arbus, Lee Friedlander, and Garry Winogrand, all of whom through slightly differing approaches affirmed his photographic theory. Of the three, Friedlander's work was the most conceptual because of his synchronic structuring of content into multivalent spatial layers and planar subdivisions. His photographs were as much about the structure of camera vision as they were about the inference and appearance of the cultural stuff he photographed.

Ten years later, in December 1977, Friedlander spent a day photographing at Shiloh National Military Park in Tennessee. From this outing, Friedlander culled the thirty-two black-and-white images which constitute the portfolio *Shiloh*, published with an introduction by Robert Sobieszek in 1981. The portfolio as it is installed for wall exhibition is carefully sequenced (as per Friedlander's instructions) with interspersed singular and paired images and is intended as a collective unit in which each image or pair of images contributes to the overall mood and statement.

Though the Civil War monument at Shiloh constitutes a restricted field of operation and all the images center on the concept of place, which both governs and develops throughout the portfolio, the sequence itself reflects Friedlander's concern with multifaceted structure as evidenced in his earlier images. Two axioms of the sequential mode in photography are that no image supersedes the meaning of the whole and that as a structure it is subject to the rules of serial development which have chronological as well as poetic aspects. Since there are no procedural indications or topographic plottings given to explain the logic of sequential order in *Shiloh*, Friedlander's intuition must be assumed as the guiding principle. And, it is the poetics of his

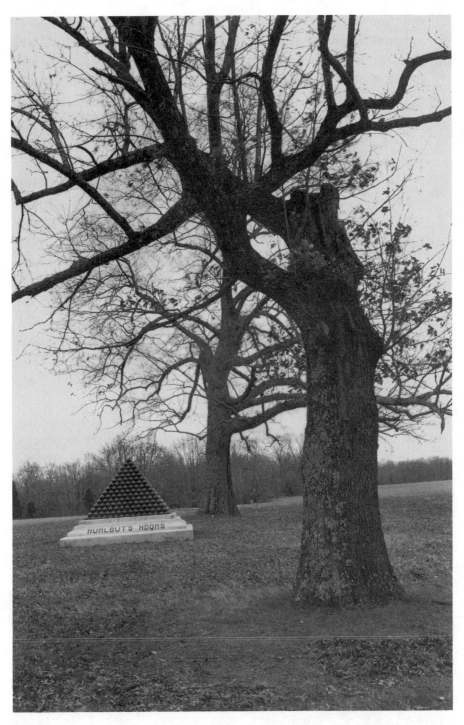

Lee Friedlander, *Shiloh,* 1977, gelatin silver print. Courtesy Fraenkel
Gallery, San Francisco.

intuition which reveal his intelligence and sensitivity despite the apparent simplicity and near mesmerismic redundancy of the pictures. Building the relationships between pictures upon subtle details such as the figural suggestion of a tree form, a slight off-axis shift of the horizon line, the radical change from the deep space of the open field to the condensed space of the surrounding woods, Friedlander never loses sight of the overall mood toward which he works.

The mood of *Shiloh* is of one of absence. The coldness of the overcast December light, illuminating defoliated trees, steeled cast figures, ubiquitous pyramidic stacks of cannon shot, and rows of aimless cannon, is complemented by the impression of unabated wind seen in the movement of grass and limbs. There is no human presence, with the exception of Friedlander's "hidden hand." The rhythm of single or double images in the sequence systematically avoids focus on any particular image or grouping, and the prevailing print tone is mid-scale gray thus avoiding the form distinction and drama of bolder contrast. The risk of evoking this sense of absence is that the viewer will receive it in its literal sense with a response of ennui.

It takes a photographer of Friedlander's stature to take such a risk with his audience; and it takes a willing audience to engage such a mood. What fascinates me about this series of work is the line it treads between Szarkowski's dicta, for certainly they are all functioning in these images, and its poetic mood which is based on fact but far from factual. The former are demonstrable, the latter is experiential. The line is snapped, however, by the last images of the sequence in which Friedlander has photographed the explanatory plaques at the entrance to the park. As a Brechtian shift in metaphor, these last images serve to distinguish between the record of fact and the record of perception and, finally, remind one that *Shiloh* is a twentieth-century production. The portfolio and sequence as a whole became stronger for me after leaving the gallery. Memory, a signifier of absence, is also a great unifier.

Notations

as

Fact

In working toward a Ph.D. in art history, which she received from the City University of New York in 1985, Sandra Phillips did research focusing on early photojournalism—the very seed bed (so to speak) from which *Life* magazine emerged in 1936 with the influx of European artist/photographers. In the interview, she discusses the origins of the European picture magazines and the development of the then new field of visual journalism. The broader context for the discussion is the concomitantly developing aesthetic of the European avant-garde, in which the journalists shared.

Phillips's concern with the emerging field of photojournalism has guided the curating of several exhibitions, the most notable of which is *André Kertész: Of London and Paris*, but she has taught history courses in contemporary photography and American painting, 1945–60, as well. Since her appointment as curator of photography at the San Francisco Museum of Modern Art, her task has been to fill the position left by Van Deren Coke, former director of the department, pioneering photographic historian, and controversial curator, who resigned to become curator emeritus in 1987. Dr. Phillips is keenly aware of Coke's achievements, yet has her own vision which she will bring to the department. This vision is partially elucidated in the interview, as much as can be brought forth in one conversation; what is also clear is that she is approaching her job with candor, a desire to explore the photographic work done in the Bay Area, and a willingness to broaden the San Fran-

cisco Museum of Modern Art Photography Department's cu-
ratorial ken.

JB: What attracted you to San Francisco and the museum?

SP: The collection. It's a collection that, though it covers a com-
paratively short time period, is very intense, a very strong per-
sonal statement and in-depth, regardless of whether one likes the
early Modernist period or not. I happen to like that period and
want to mine it for a while. It's a rich period that deserves
examination, just as those figures in the early Modernist period
of art have been.

JB: Is it that you feel there's been enough time elapsed since that
period that we can have an objective look?

SP: Right, and we are also discovering people. We are still writ-
ing our history, which is what is interesting about being a his-
torian of photography.

JB: One implication of that historical distance is that through
curating and historianship one could identify ideas from that time
that might be of significance or an instigation for contemporary
activity in photography. Do you see that, for example, as the
Dadaists were very important to what was going on in the sixties.
So now that we are almost in the nineties will we need to look
at the forties?

SP: There are always pockets of things to be discovered. I'm
very interested in the twenties and thirties, but I'm presently
looking at the fifties, which is an unmined period.

JB: Until 1959, the fifties seemed in photography like a quiescent
holding period. What have you found to indicate that it wasn't?

SP: For instance, Helen Levitt is a very important figure. Her
contribution has been obscured by the fact that she's lost a lot
of work, and she's had fires in her studio. Her work has been

seen in fragments—she's done work in color transparencies, for example.

JB: Are there other key figures from the fifties?

SP: There's Robert Frank. I think some of the Photo League work is significant. Sid Grossman is a very interesting photographer. [Ralph Eugene] Meatyard is important. We're interested in having an [Art] Sinsabaugh show that's now being organized. Those are some of the things that I see as important discoveries that I want to make alive.

JB: You mentioned two focuses of activity, New York City and Chicago in the fifties. Do you think there are other geographical areas where there was a great deal of activity?

SP: Like San Francisco?

JB: Well, I don't know.

SP: I don't know either; that's what we'll find out. I know John Gutmann's work, but I don't know very much else of what happened here at that time. I certainly know the classic figures in California photography, the Westons and Adams. Weston in the 1940s deserves a real examination, and, as far as I'm concerned, that is the strongest part of his work.

JB: Do you see a change in his work in that particular period?

SP: I think it's more complicated, it's about things such as transcendence and death.

JB: It's interesting to hear you say that. I have stated in lectures that he had already met his death to a certain extent through his camera in one particular image taken at Point Lobos in 1946. There's a tree form suggestive of the shape of a crucifix, rising distant on the side of the hill. One doesn't see that in any of the pictures before that.

SP: And there's the very famous one with the Cala lily stuck on top. You don't put a Cala lily in a picture without having associations of death. I'm sure that, if not deliberate, it was in some way calling upon something in the deeper reaches of his consciousness.

JB: You have done a great deal of research into photojournalism in the twenties and thirties. Do you think that the photographers, particularly in Europe at that time, were working with a consciousness of making art or were they just really out there trying to deal with the content and the camera? I wonder how much of the art in those pictures was a consequence of the picture editors, as much as of the photographers?

SP: That's a very complicated issue, and I would start out by saying that the medium of photojournalism was very young and the photographers and editors were just really inventing it. There was a lot of room for learning, experimenting, and having fun. There were magazines like the *Berliner Illustrierte Zeitung* and *Münchner Illustrierte Presse* and ones in France like *Vu* and *Voilá*. They were very small operations with minimal staffs. The German papers were usually smaller corners of a larger firm. For example, the Berlin paper was the illustrated magazine section of a very large publishing firm that also had a radio station among other concerns. The only older examples they had were cartoons and line drawings from photographs in the illustrated papers. There were weekly papers in the nineteenth century like *Simplicissimus* that were illustrated. Those were really the historical antecedents and they were fun—that's the point, they were meant to amuse.

JB: So there is definitely an entertainment factor.

SP: Yes, definitely. They were not meant primarily to inform, because they were issued once a week. The newspapers provided you with basic factual information, but they were not illustrated. So the genre, if we can apply an art historical word, was investigating ways of using the camera to illustrate something that

was often very common, that hadn't been recorded. Only later did news photography as we know it today become an issue because of the political situation.

JB: So, you're drawing a distinction between the early sort of journalistic photography and what later became a separate practice as news photography.

SP: That's right. [Robert] Capa's work is very important. He really came out of the political trauma of the period. He was Hungarian, but left Hungary for political reasons. He then went to Germany, but left there for political reasons as well. Even in France, he was always kind of an outsider. His work was politically committed, but he only became an important figure to contend with in the Spanish Civil War. That event in 1936 really changed the course of the history of photojournalism. That's what gave rise to the whole idea of the photojournalist as hero, as one going out to participate in the cause and turn viewers' minds about what was going on on the battlefield, and how these brave soldiers were being overrun by Franco's forces. That is the change, and you didn't get that before.

JB: That's concurrent with a much broader change in the arts as well. Are you saying that all of a sudden photojournalism became an important force because there was a matching of an aesthetic with the politics?

SP: Definitely. In the mid- and late thirties you could not be an artist without some kind of political ideal.

JB: So the editors were important because they were certainly supervising. Would one get jobs or be sent on assignment if the politics were wrong?

SP: That's a funny issue, because we're talking about France and Germany, and Germany is different than France. The first thing the Nazis did in 1933 was take over the newspapers and the illustrated magazines. They used them deliberately as propa-

ganda. So there was a change in Germany from that point on. It's been a sore point that the Jewish owners of many of these magazines and newspapers did not make a stand. The Ullstein press of which the Berliner paper was a part was owned by second-generation, pretty much antireligious Jews. They were afraid of taking any kind of political role because they didn't want the paper circulation to go down. They were probably right.

JB: It was eventually closed anyway.

SP: It was closed after the war. But in France, by that time in the thirties, the political situation had gotten so confusing that you had papers taken over by different factions. The liberal paper *Vu* was a very active force politically. It was not so much the editors—the editors, of course, did play a role, but rather the owner of the paper, this wonderful Alsatian named Lucien Vogel. It was a comparatively small paper [circulation of about 200,000] and it was a very beautiful paper. Vogel sort of took a personal interest. It was really his paper and he was a liberal. With one of the Spanish Civil War issues in which Capa and other photographers played a considerable role, his backers withdrew their support. He sold his paper to a right wing consortium, and it became very boring.

JB: What kind of educational process did the photographers go through. I look back at Munkacsi, for example, who began as a writer, then started taking pictures. He was soon recognized as a good sports photographer and later, after emigrating to the United States, became a leading fashion photographer. For anybody interested in photography, who is involved now or thinking about it, that's a very peculiar structure to look at.

SP: People like Munkacsi, Brassai, and Kertész came from Eastern Europe. They had been displaced by the First World War or its aftermath. They were in many cases very well educated. [Erich] Salomon just lost his money through historical circumstance: the effect of not only the war but also the economic crash. Some

of these individuals actually had gone to the Bauhaus to study art, and now they had to learn how to make a living. One way you could do it, and not have to worry about communicating verbally or learning a new language, was photography. And that's how a lot of these people really earned their living.

JB: So technically speaking, their training was marginal. But then where did the vision come from?

SP: The time between the World Wars was certainly chaotic, stressful, but also very exhilarating. It was a wonderful, tense, time to be living. There was a lot going on in art and politics. The photographers we're talking about, Munkacsi, Kertész, Brassai, or Bill Brandt (whose work we'll be exhibiting) thought of themselves essentially as journalists—as journalists with an aesthetic edge, an aesthetic awareness, but not as art photographers with a capital "A". In some cases they were hostile to that idea.

JB: So is it a betrayal of the original intention, then, to put up exhibitions in art museums of those photographs which were not conceived as art photographs?

SP: The art of the Russian Constructivists was meant to uphold and stimulate the masses toward an ideal new society. It was not meant to be hung on walls of museums such as we understand that today.

JB: It was that kind of a real social impulse, then—

SP: For many of them, but not for everyone. The interesting thing about photography is that you cannot judge quality only by the intent of the photographer, or how it was used. You have only your eyes to rely on, to figure out what is artistic, aesthetic, fascinating, or important—I mean it's like Picasso finding Douanier Rousseau. He wasn't in museums! Yet Picasso saw him as an original, stimulating, fascinating artist. [Laszlo] Moholy-Nagy was the first to take anonymous newspaper illustrations and put

them on the walls. It was his idealist intent to make photography a medium that would communicate to everyone, on every level.

JB: There are two threads in what you're saying. First, there's the social impulse, and then there's the impulse that serves the purpose of communication.

SP: We see Moholy's work now as totally aesthetic, and that's wrong, historically wrong. To say that is really to misread Moholy.

JB: It would be a misreading of the whole formalist movement. It has always intrigued me that the journalists could fit right in there with the constructivist painting and other nonobjective work; one seemed totally formal, while photography was content oriented. The visible distinctions seem to be irrelevant.

SP: You have to be a little careful. First of all, in the case of someone like Kertész, there is journalistic work from which he himself drew out aesthetic work. For instance, for an assignment he was told to do a report on fortune tellers in Paris. He went to a couple of people, a man, a couple of women. From that came a two- or three-part article that appeared in *Vu* magazine and was reprinted in the *Berliner Illustrierte Zeitung,* and a couple of other places in Spain and Italy. He pulled out certain images from that essay to exhibit as art. One of the images from the fortune teller series is in the collection here. There's not really such an important distinction between the journalistic and artistic because the beginning stage was a kind of primal photojournalism.

JB: Primal photojournalism. That's an interesting thought. Is it a term you have coined? Do you think it was just that some pictures were more interesting than others, or were there other ideas occurring in them?

SP: Though photojournalism was an emerging form at this time, there was this idea, mainly coming from Germany, that photography could also be art. And you did have, in 1927, the first photography-as-art exhibit in Paris.

JB: Do you think Surrealism continues to be an important element in photography?

SP: It's an important element, but I don't think it's the only one. Photography as documentation is just as much alive. Photography as informed journalism is also an alive and an important aspect of photography. The thing about photography is that, unlike what we call art or painting or sculpture, it has this ability to communicate in different ways on different levels. That's what's fascinating about it.

JB: Do you feel that there's a different sensibility about photography on the West Coast than you encountered in the East, particularly in terms of contemporary things that are happening?

SP: A different sensibility? I don't know. I'm not sure I would say that. As a person who has been living in the East, I'm not aware of a regional sensibility, but there's a lot of stuff I'd like to see. That's part of being a curator.

JB: What is happening in photography in the eastern part of the country? What kinds of discussions are going on about its purposes?

SP: It's very easy to answer that in perhaps a superficial way. I guess the "cutting edge" of what is going on is what was recently exhibited in Los Angeles in Andy Grundberg's show [Art and Photography]. I think some of that's very interesting stuff.

JB: Not all the work in the exhibition was eastern in origin.

SP: No, that's right, some of it comes from Los Angeles. I don't even know that these regional distinctions make sense any more. Everyone can get *Artforum* and all the photography magazines, wherever they live. Everyone can read the reviews and know what's going on.

JB: In terms of the collection here, have you had some time to rummage through it?

SP: I really haven't. This trip here was so that I could do just that, to try to pull together a schedule, and figure out how many square feet the new museum needs for photography. What we're doing right now, is putting together a kind of ideal museum. We have to figure out exactly what this museum should be like in the future, physically, so I've spent a lot of time just trying to figure that out. How many secretaries or interns or square feet. . . .

JB: Square footage sounds more exciting to me. I'm one of many people in this city who regret looking at an awful lot of pictures in hallways. A good bit of the collection has been exhibited over the period of time while Van was here. If you were a regular attendee of the museum, you had a pretty good sense of what was in the collection. It seems somewhat divided: very solid in that period of time that you've addressed already in the European avant-garde; but then there's quite a collection of contemporary work done in the last ten years. Is that an area you feel that you can support or add to along the lines that this collection has taken?

SP: I think that there's a lot of filling out to be done with this collection, in many directions. I think it's wonderful to have such a strong collection of the twenties and thirties. I'd like to see earlier photography, too.

JB: Nineteenth century?

SP: Well, at least before 1920. It's important if you're having late Stieglitz to have early Stieglitz. And if you're having early Stieglitz, to have the Photo-Secessionists. If you have early Strand, to know what was going on with Lewis Hine, and things like that. So, I think if we're going to be historically responsible we've got to look at collecting that way. I have to figure out exactly what to do about the nineteenth century, because it's a very wonderful period, and it may be something that we will want to consider in terms of buying.

JB: It seems that there was a very conscious decision on the part of the museum to deal only with the twentieth century.

SP: I know that. On the other hand, there are earlier paintings in the collection. There is going to be an assistant curator of the historical Modernist period coming here, and it may be what I would call responsible to consider how to approach that period in photography.

JB: So you feel that the collection is a teaching tool?

SP: Oh, absolutely. This collection, mainly because of its space limitations, the design of the viewing rooms and things like that, has been underused. That's why I'm so concerned about our new space. We've got to have a viewing room, we have to have quality interns helping us, and learning from our collection. I think that's a very important service we should offer to our community.

JB: You have lectured in the history of photography. Have you ever taught picture-making, or do you make pictures at all?

SP: No.

JB: Never touch the stuff?

SP: I was a painting student. My former husband is an artist, so I leave that stuff to those that can do it. I can make a photograph, but a photograph that's interesting, that I've chosen not to do.

JB: What are some of your current preoccupations?

SP: I'm obviously thinking of exhibitions. I'm interested in putting together a schedule so that San Francisco can have a continuous range of things to look at. I'm interested in broadening and filling out this already very substantial and important collection. San Francisco should be very proud to have such an international collection. The historical part of it is very intense.

JB: What did you mean in your press release statement when you said: "new ways of conceiving photography." What stood behind that thought?

SP: Well, as we've mentioned here, it's important to consider photojournalism as a living art photography form. And, as you know, there's an important body of conceptual photography here at SFMOMA. There are other things like documentary photography that need to be examined here, while still remaining aesthetically conscious.

JB: What did you mean, then, by new?

SP: Well, new to San Francisco. And, I don't think that the Museum of Modern Art in New York would put on a show of a contemporary photojournalist, but I would. I am also interested in exploring different geographical areas that haven't been really looked at, such as South America, Japan, and some parts of Europe, maybe Spain. So, I see myself doing a lot of traveling and getting to know people my first year. I'm going to be tired. I certainly appreciate all the energy Van put into this place, and I think it was commendable to put out so many publications. My instinct is to do the same number of shows but to put out fewer but bigger publications. That's where my energy would go.

JB: Do you sense that there's been a change in—I don't want to call it policy, but in mood—in the overall direction of the photography program, relative to the rest of the other programs in the museum?

SP: I think everyone's very supportive, everyone's very conscious of the role of photography in the museum, and they're very interested in keeping it at a very high level and a very public level. Now it's just a question of so many hours in a day—and trying to finish my job in one part of the country while beginning the job here.

It is no accident that photojournalism hit its first peak in the 1930s. In the United States, the depression had stratified society, and created economic havoc. In Europe, Fascism was taking hold in a climate of fear, suppression, and deprivation. Starvation in Russia reached epic proportions despite the second five-year plan. And the four most popular songs of the day (1933)—*Smoke Gets in Your Eyes, Stormy Weather, Who's Afraid of the Big, Bad Wolf?*, and *Boulevard of Broken Dreams* could not, in retrospect, seem more prophetic.

The correlation between photography's rise and the downward turn of human affairs leads to an obvious conclusion—misery makes good pictures. And culture has a double-edged fascination with misery, suffering, and destruction. Misery portrayed in a magazine has great commercial value as a social cathartic. Conversely, the immediacy of the photograph presented in a timely manner has the capacity to produce direct remedial action. Both aspects have contributed to the rise of the fourth estate.

However, some historic forces at work in that early Modernist period put photography in a different light. The ascendancy of photojournalism and the instability of the socioeconomic fabric are by-products of the political polarities that emerged in the 1930s and were cast in iron (so to speak) following World War II—polarities between East and West territorially, between political systems and ideologies, between races, between halves of the brain.

It also seems true that in the presence of extreme polarity and its consequent disin-

AN INTERVIEW WITH SEBASTIÃO SALGADO

October 5, 1990, San Francisco

151

Sabastião Salgado, Untitled, Mexico, 1980, gelatin silver print. Courtesy
the artist/Magnum Photos, Inc.

tegration, healing forces emerge in an attempt at reconciliation.
The Family of Man exhibition held in 1955 represented one at-
tempt, albeit sentimental and politically slanted, at reconsidering
holistic humanistic impulses. While that exhibition appealed to
an audience of millions, Robert Frank was reminding his limited,
literate audience for *The Americans* (1955–56) of the wounds of
isolation and alienation. It was not a popular message at the time;
it was unpublishable until 1959 in the United States.

The popular appeal of W. Eugene Smith's profoundly hu-
manistic essays in *Life* magazine in the late 1940s and early 1950s
created a momentum for photography as a healing force. Smith
commenced in 1955 upon a documentary project so encom-
passing that it never came to completion. His portrayal of Pitts-
burgh was to be a study of the human condition in the context
of industrialization. However, the lessons of Pittsburgh served
Smith well in the 1970s during which his work on *Minamata*

accomplished all that he had hoped for in the earlier project with the added immediacy of direct, confrontational political action. Morality became the driving force behind his work. Throughout his career, Smith produced images whose impact was therapeutic in the evolution of culture.

The evolutionary presence of polarity, healing, and morality, so much a part of today's seeming reversal of the impulses begun in the 1930s, are particularly evident in Sebastião Salgado's photographic work. Salgado, able to articulate in visual terms the crises and ironies of Modern culture, also links his audience with the archetypal realm of the human condition. In a sense he portrays a morality play with no end in which those suffering attain heroic dimension. It is a script with urgency for our time—a script in which reality and humanity are inseparable from their doubles. [This interview coincided with the opening of the exhibition and publication of the accompanying catalogue of the same name *An Uncertain Grace: The Photographs of Sebastião Salgado* (New York: Aperture, 1990).]

JB: Photojournalism seems to gain popularity, audience, and attention, at the same time that the economic and political realms are falling apart. Historically, that's been borne out in the depression, for example. The logical extension of this concept is that misery makes good pictures. That is one way of looking at the strange relationship between photography and culture. Is this something you would agree with?

SS: I feel that's a very good question in the sense that I don't believe that we actually create things. Our work as photojournalists is just a reflection of the evolution of the society where we live. When we see the problems that you had in this country in the 1920s and 1930s, we had all the FSA photographers working on them. Of course, they were brought to them by the government. But, they existed in that time. Those photographers who were where the conditions appeared produced some very important work. They were not creating something. They were just expressing, by their photography, the reality of something that was happening in their time. And I don't believe that they

went to photograph all this to be good photographers, to present themselves like creative photographers, like artists. They went because the social problems were in front of them, and it was necessary for them to deal with them through photographs. They also represented what was important inside themselves, because they were very concerned about this reality.

Today, in photography, it's about the same because we have huge social problems. We have a huge global population. In the Third World countries, the cake is smaller for each person because the transference of revenue from the poor countries to the rich countries is bigger each time. And there is a huge increase in population in Third World countries. At this moment, I think that some kind of reaction is beginning to exist in the society where you live, and where documentary photography, film-making, and journalism begin to appear, to be powerful and show these problems. There is a kind of movement of moral reserve that acts to *preserve* something inside society, inside humanity. We begin to look, we begin to speak, and something begins to happen. I think that's the only way humanity has preserved itself. We speak about the problem, we socialize the problem, and the solution that follows must be great.

JB: Is your series of photographs *The Archeology of Industrialism* a form of preservation? And, what is it preserved for?

SS: If the pictures represent the essence of the problem and the reality that you are working with, if you are really close enough to the problem, if you arrive to transmit the historic moment that is revealed, these pictures can stay! That can show in pictures like *The Archeology of Industrialism*. If they are not really representative of what is happening, if you have not really integrated yourself with the thing you are photographing, they probably will not last. The form of these pictures must represent the problem, the reality, the basis of what is happening. What I really want to do with these pictures is to produce a kind of homage to the working class and the old ways of producing that are disappearing. My pictures are about the end of an era, are an

homage to the producers of my time. These workers have motivated me very much in my ideology, in my way of thinking.

If you went inside a factory in the United States, to see how a car was produced ten or fifteen years ago, all these men, together, screw by screw, made a car. The car came out of the social work of this group. Now, this car is made by robots—with a technician that's no longer a working-class man, he's more an engineer. These men that I photograph represent another era, represent another thing. I want to portray them as a group. I've tried to work with those branches of industry, like the mines, which use large groups of workers. When I put them all together I want to have a family of workers.

JB: Did you see the exhibition *The Family of Man?* Was that an influence for you?

SS: Yes, I saw the exhibition, but I didn't think about that as I realized this work. I think it affected me more inside me when I saw this exhibition. It was a kind of exorcism of the economist inside myself. *The Family of Man* was a wide open work. We have all things inside this family. My work is more specific. The working class is one group of people that I can get inside of.

The other side of the first question you put to me is that the stories are happening now. If it were not me capturing these things, the end of the era, it would be another photographer. I believe that the human species is like a whole. It cares a lot about itself, and this chapter would be written in any case. If, for example, you look at the Soviet Union today, and you say, "Oh, if Gorbachev were killed or would die, it would be a disaster, because we would go back to the darkness of the kind of socialism that we knew from before." That's not true. Gorbachev, for me, is a fruit of evolution. And if Gorbachev disappears, we'll have one thousand Gorbachevs after him that will continue this evolution. I trust in evolution.

JB: What, then, becomes of the relationship between politics and art or aesthetics? What you are saying is that political reality

is a sum of what's growing out of a culture, out of a society. Gorbachev is simply a representative of that. . . .

SS: No, he's not simply a representative. He's a very dynamic representative whose program is the reason those changes have happened.

JB: I'm trying to look at the role the photographer plays in this historical-political evolution. Traditionally politics and aesthetics have remained somewhat separate. On one hand you have a kind of an agenda, your ideology, as you call it, your motivations. And you're taking pictures which have a certain aesthetic quality to them. There are political realities involved in the images as well. Are we working with a model of aesthetics which is inherently political?

SS: See if I understand the question. You are speaking about the plastic quality of the pictures linked with the political side and the human side of them.

JB: That's right.

SS: You know, I'm a photographer. That's the first thing that I am. I'm a photographer. The only thing that I know is to do pictures. And each photographer expresses himself in a different way. And, of course, the way one expresses is what you call the ideology. But when I say ideology, it's not a political ideology.
It's the complex of ideas that you have inside your head. The pictures I made of my mother, my father, with my friends, when I was a kid . . . I came from a small town in Brazil so when I looked at the sea for the first time, I was so impressed. Who knows if that has influence inside me. Out of this I have formulated my way to interpret reality, to look at reality. I go to reality motivated by human reason, by political reason, to photograph. And, of course, because I have all these aspects inside myself, I accept that my pictures are like . . .

JB: Dramatic, or theatrical?

SS: Theatrical. But it is drama. I don't bring myself inside my pictures. I cannot explain to you how these dramas appear inside my pictures. You know, I don't control or set up lights because it will bring a kind of drama. I don't interfere with anything in reality, with the people that I photograph. But this kind of drama is one thing that's intrinsic to myself. For example, when the Latin American writer Gabriel Garcia Marquez writes about the assassination of hundreds of workers in the banana industry in Colombia, he speaks about this with so much irreality [sic]. He's speaking from the clues of reality with such completely irreal ways of thinking that he flies with you. He has his way to tell you things, his particular way. But what's going inside of this is Garcia Marquez and his mind, with all his ideologies. You can speak about my photography if you want, but me, I cannot. Because I think that I have no explanation for it. How I compose a picture is completely different from how another photographer does it. This is a very, very instinctive way of working.

JB: Do you think the theatrical quality is a consequence of understanding how a camera sees, the kind of optical space that is there, and that this is a kind of theater that happens within the confines of a lens, or the lens space?

SS: No, I don't think so. I don't believe many of the things that have been said about photography. I have my own experience, and I prefer to trust in my experience of what I am seeing. I am a very good friend of Cartier-Bresson. We worked together. We see each other often. Now we get holidays together for many days in August. But one thing he speaks of I disagree with. I don't trust in the decisive moment as a real aspect of photography.

I believe more in the photographic phenomenon than other things in the kind of documentary photography that I do. When I go to photograph a person or a family, or an event, or workers in a factory, I create certain conditions which I experience as a phenomenon. You live a certain time, a short time or long time of your life, inside of this phenomenon. If you want to see it in a mathematical way, you go inside this parabola which describes

this phenomenon as you photograph. In the beginning, the relationships are hard. After they begin to be easier you go on evolving through a series of moments. Within the parabola many things happen. For me, the decisive moment is like a tangent. The highest point of the parabola where the tangent meets it, is the decisive moment. If you want to define that moment in the strictest way it is that you, photographer, get all the information, you, photographer, have your future, you, photographer, are smart enough to see the phenomenon happen at its strongest. You catch the picture, bang, and then you disappear. That is the decisive moment. I don't believe in this.

I believe that the phenomenon begins at the beginning of the parabola and finishes at its end. You are integrated with it and have a lot of small tangents. You photograph here, you photograph there, you speak with people, you understand people, people understand you. Then, probably, you arrive at the same point as Cartier-Bresson, but from inside of the parabola. And that is for me the integration of the photographer with the subject of his photographs. I don't really believe that the photograph is the only response that the photographer captures with his camera. A big part of this photography is a gift you receive from the person that you photograph. An image is your integration with the person that you photographed at the moment that you work so incredibly together, that your picture is not more, your camera is not more than the relation that you have with your subject. Your camera is just a movement inside all these movements that happen, that keep going. I trust in this. I'm probably wrong, but that's my own view. . . .

JB: It works!

SS: I don't know if it works or not, but. . . .

JB: One of the very clear themes that emerges from your work is a real interest in rites and ritual. There are a lot of group dynamics, and even some of the portrayals of the workers have a kind of ritual aspect—all these people climbing up the hillside

together. Are you attracted to those situations because of the nature of the photographic phenomenon?

SS: Probably. But that's not clear for me. It's the first time that I have thought about this because you have asked me this question. One thing that I tell to you, the only thing that's really interesting in photography, is human photography. Many times I ask myself the question, "What interests me more really, photography or the relations that I have with the people that I photograph—what I discover when I am with them, receive something from them, and give something to them?" It's very interesting, it's probably my disease, you know? A kind of sickness! But it's one thing that I like very much. I have no interest in doing landscapes or sports.

JB: What do you see when you photograph?

SS: Sometimes you feel so many different situations when you have a camera in front of your eyes. There is one picture, for instance, in this exhibition. You have a man that has no head. His hands are in a lot of pipes. He's inside a steel plant, and he's repairing electric cables. When I looked inside my camera, this man was playing the harp; he is a musician playing inside the center of this huge machine. There is a person in another picture who has cut sugar cane. The figure is completely covered and holding an enormous machete. You don't see a face. When I looked inside my camera, it was a representation of death for me. I have so many pictures that have death and dying in them. But that's not a representation of death for me. This woman was a representation of death. It is the most violent picture. When I look inside my camera, there are so many things happening! So many representations, so many ways to link with the people.

JB: At what point did you decide, no more economics, I'm going to make pictures? What happened at that moment?

SS: It was an accumulation of the moments that pushed me to

what you call in America, a point of no return. And photography was like this. I discovered photography very late. I was in Paris doing a Ph.D. in economics when my wife, who is an architect, bought a camera, to do photography of architecture. And I looked inside this thing. What I saw was so fantastic! It was a completely different way to put yourself in relation to the person that was in front of you. After my masters, I worked six months in Brazil. The way I presented myself to people as an economist dealing with the social problems was completely different than with the camera. I saw that I could probably have with the camera another contact with the work that I didn't have until then in my life. I began to job a little bit with this camera in 1970. I went to work in London to finish my Ph.D. in 1971. I worked alone as an economist in an international organization. I had a camera that would travel with me to Africa to see the economic projects we were working with there. I took some pictures there, and the relation that I got with the people I photographed was completely other than is one that I had as an economist.

When I came back to London after each trip—I was living alone at this time—my pictures gave me ten times more pleasure to look at than the economic reports it was necessary to write. After two years I made a resolution and I resigned. I think I had a maturation at that point. I went straight back to Paris and said, "From today, I'll be a photographer." The first story I did was in Sahel in 1973. It was about starvation. I tell you from the first it all worked.

JB: So you knew, somehow or other, that it was the right decision, the messages were there.

SS: You know, it was an important decision, this chance for me to discover this camera, because it's possible that if I had not discovered this camera in this month, I would have spent my whole life like an economist! And then, what chance of doing it again?

JB: I asked you what you actually see when you photograph. Do you see that again when you see the photograph?

SS: Of course.

JB: Do they all have a kind of a story for you?

SS: Absolutely. Sometimes people ask me to show them what picture in a room I like most. I say, "I can't." Because it's not that I do or do not like this picture. What I like is the whole thing that you don't see in the picture, that is in back of the picture. A picture, for me, is like the point of an iceberg. What you see in each picture is one point of contact, one relation, one preparation. That is what you see inside your camera. It's the editing, the people that help you to arrive there, the person who labors over your prints. All these, in the end, are part of and come out of the pictures.

When people come to see them, they see just a picture in a paper that can represent a lot more different things for them than they might represent for me. For me, each picture represents so many things, that I cannot tell to you which one I like more. What I like is all that's behind the pictures.

JB: Do you think that the care that you speak of, that concern for really what stands behind the picture lends a moral force to the pictures? They are very powerful pictures. Do you think some of that response is to what stands behind a picture, or is it just for the picture itself?

SS: I could say, maybe, but inside, who knows? Victor Hugo wrote that if a reason is strong enough, if you are integrated enough, if you put yourself inside enough, if you try the most to understand what people give to you, something is there! You can look, but I cannot tell to you this. Sometimes when a person looks at a picture they see their life inside it.

I look at many pictures that I like. Sometimes I have the impression that it was me who made those pictures. One day, I was looking at a magazine with my wife, and I said, "Oh, they published my pictures there." She had to remind me that they were made by someone else. It's true, it speaks of the power of pictures. For me, photography is *very* special. Photography's

photography. Photography is the one medium in which you have all your emotions during a short lapse of time integrated with the person that's in front of you. In a few moments you can get something that represents all these together. Only photography can get this.

JB: Do you think any of the electronic media can or will do that?

SS: Probably you are right in the future, but for now it's only photography that can do this. Like photography is not paint. Electronics is not photography. It's another communication. It's another way. Evolution keeps going, humanity keeps going, and we will have to find another way to solve the problem of representing it. In the end, I believe that we are a small chapter in the representation of the evolution. Photography is a way of life, and it represents the historic moment in which you live—just as paint did a century or more ago.

JB: Do you think your work is religious?

SS: No.

JB: Not at all?

SS: No, I don't believe it. I'm not religious. I doubt my work is religious. What's interesting, really, is the people that are inside my pictures. What interests me more is the spiritual side of man. But that is not religion. The spiritual side is one thing that's particular to the man. We are more a spirit than we are elements, more than we are material. What I try to get in my pictures is the most spiritual side of the man, the spirit is a kind of thing. These blues you have in the United States, you think that's religious music. That's not religious music, that's music from the spirit. It's so deeply inside of this. And photography. I try to go inside and to get this side. A person has the impression that they are looking at religious themes, because for them,

sometimes, religious things are things of the spirit. But I'm not religious.

JB: Is there something spiritual in the concept of the photographic phenomenon? This curve of time that happens, that you're participating in, what guides you through that? You spoke about the worker repairing the pipes that looked as if he were playing the harp. Was that something very spiritual being presented?

SS: Absolutely. It's because music is so spiritual. He is completely touching a material thing, but, for me, I look at him in another way. Some people probably will not look at it like this. But if I don't have this kind of motivation, for me, it would be very hard to photograph, it would be very dry. It would be not a proper kind of picture to do, not a human picture.

JB: At Magnum do you ever argue about aesthetics and the purposes of photography and why you're all making pictures?

SS: Oh yes, this is discussed a lot. That's the main preoccupation within the group of forty photographers.

JB: And there's not much agreement as to why?

SS: No.

JB: Do you think Cartier-Bresson's aesthetic is still pretty much alive in the Magnum group?

SS: Cartier-Bresson is very much alive inside mine. He is eighty-three years old and for me, he is one of the youngest photographers in Magnum. He is very dynamic, very open. I believe that the members respect him a lot. A lot, a lot, a lot. His work is really great. It's such very strong spiritual work. It's really fantastic. You know what happens? For me, there are not many photographers, but there are many people who use cameras. There are many people that write, but very few writers. It de-

pends upon the integration that you have with thing that you do—the patience that you have inside, or the romanticism that you have inside. Cartier-Bresson is one that works that way. Others? Gene Smith, Walker Evans, Bill Brandt, Alvarez Bravo, Werner Bischof. . . . There are so many great photographers.

JB: What is it that ties their work together?

SS: A lot of it is the things that they did. It's in some ways the dedication for the things that they photographed, the patience to put all their life into what they trusted, what they believed. And their contact with the people. Take Walker Evans, for example. Look at the pictures Walker made in Cuba. Very simple pictures, but they are Cuba pictures. This man spent much time in Cuba. He loved this place! I never met him, of course. I'd never read many, many things about him. But I don't need to. I can read all these things in his pictures. You can too. When there is a picture as real as his picture, it is a concentration of power.

JB: So, in some senses, do you feel like you are participating in that kind of tradition.

SS: No, I don't feel anything like that. I'm preoccupied with photographing. I'm going to Poland next week to work in a shipyard. I'm very comfortable with the shipyard. I will then go to Brazil to photograph there. I'm not preoccupied to be close to these spirits because it's not my problem. I respect them very much, but my problem is to use my time to photograph, to integrate them inside myself, to keep going, and get pleasure from the things that I'm doing.

JB: What's waiting for you in Poland?

SS: Gdansk, because I am working on a chapter about shipyards. I did a story in France in a small shipyard that has disappeared now. But some men were suffering and disappeared from the shipyard. I did the story on military shipyards where they con-

struct aircraft carriers. In Bangladesh, I did a story on the people that break up all the ships that the others construct. They deconstruct old boats there because they need the metal. They don't have steel; they don't have iron and coal to produce the steel. They just form old metal into the instruments they need to work. But some old ones are not too old, because lines have a lot of ships in the world that they cannot sail any more.

They come to the beaches in Bangladesh. One day, when the water is very high, they push them very fast on the beach. And when the water goes back, they destroy the boat completely. That's terrible to see, when you see how hard it is to construct a ship. And how hard it is to destroy each ship. And how, in this world, all things are just a transformation, huh? The metal that comes from a mine, is transformed into a ship. This ship goes to Bangladesh and becomes primary metal, which is transformed into a knife, and this knife, one day, will disappear in the earth and will become an iron mineral to grow things. It's incredible! To close this chapter about ships, Gdansk is very important. Solidarity began there and I'm sure there's a lot of power in that place.

"YA BASTA!" states the banner in Eli Reed's photograph entitled *Political Rally, El Salvador.* This black-and-white image is dense with information from the slightly out-of-focus "Libertad" monument in the high background to the emotionally charged anti-Communist, anti-Nazi political banner to the smiling mother and child posing for the camera in the lower foreground. An orator, arm raised, speaks from the podium above the sign. The image is full of irony, seeming contradictions and ambiguities. The social strife and political chess presently occurring in Central America provide a context for this ambiguity; the news media have thrived upon it. In Eli Reed's images it becomes an element in the human drama portrayed with pathos, thought, and a highly trained eye.

Reed is a staff photographer for the *San Francisco Examiner* and is also a member of the renowned Magnum Photo agency. The latter was founded in 1947 by Robert Capa and Henri Cartier-Bresson as a way to support and disseminate the work of its member photographers. Reed's style draws upon the tradition of concerned photojournalism exemplified by Magnum's founders and other noted members such as Bruce Davidson. Reed has also been influenced by the humanistic, psychological, and political impulses which have made W. Eugene Smith's images so powerful. Reed has in fact studied with both Davidson and Smith.

The strength of his style arises from his ability to compose images that make even the most mundane content interesting. Yet he is sensitive enough to compelling subject matter to avoid the interference of style. His

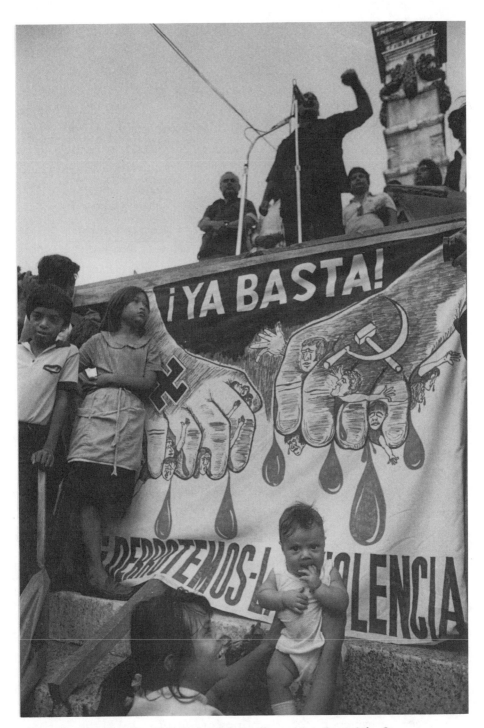

Eli Reed, *Political Rally, El Salvador*, gelatin silver print. Copyright © 1992 by the *San Francisco Examiner*, reprinted by permission.

picture-making vocabulary includes techniques such as placing figures in unexpected locations within the picture (a technique which Davidson used in his photographs of the circus), using a wide-angle lens to exaggerate spatial relationships or to emphasize for editorial purposes, and printing for a dramatic tonal range by darkening the less important information in the picture (Gene Smith was a master of this manner of interpretive printing). Reed is keenly aware of everything that falls within the camera's field of view. In his photograph of two uniformed soldiers entitled *Guatemala,* the shape of the portico and shadow repeats the angles of the front soldier's arms. The edge of that same portico points directly at the head of the second soldier in middle ground. Background echoes foreground. This compositional technique, whether achieved consciously or intuitively, gives the picture a formal coherence and intensifies its psychological impact. Reed's images depend upon flexibility of composition and consistency of style to communicate his editorial stance.

W. Eugene Smith, who was an important influence for Reed, studied paintings by the great masters such as Rembrandt and Rubens. Though Smith's images rarely imitated these works, classical techniques of image organization were an important part of his vision. Smith recognized that a strong pictorial structure was necessary if the photograph was to have significance beyond its reportorial context or newsworthiness. He wrote in the magazine *Photo Notes,* June, 1948: "To have his photographs live on in history, past their short but important lifespan in a publication, is the final desire of nearly every photographer-artist who works in journalism. He can reach this plane only by combining a profound penetration into the character of the subject with a perfection of composition and technique—a consolidation necessary for any photographic masterpiece." In this statement Smith, recognizing that the photographer is mediator between subject and image, makes an important connection between picture structure and editorial stance.

In his photographs of Central America, Reed demonstrates a keen awareness of the conditions of life. Amidst all the destructive military activity and political tumult, the people he depicts live with dignity. Most of the images are concerned with this

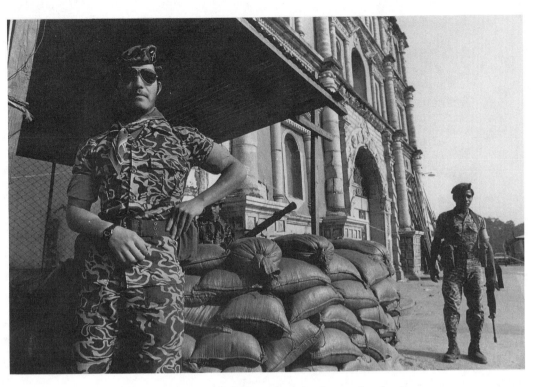

Eli Reed, *Guatemala*, gelatin silver print. Copyright © 1992 by the *San Francisco Examiner*, reprinted by permission.

optimistic vision of reality, or perhaps better stated, the photographer is able to extract this appearance from his subjects whether they be prostitutes, a family washing clothes in the river, or orphans in a home. Though he has in no way ignored the violence, his approach to it, as presented in this selection of images, is indirect and by implication. One image shows a group of skulls in a barren field. In another, we see a woman and child in a cemetery. In only one picture is there a direct portrayal of dead bodies; they are photographed from the back, faces hidden. Their presence in the picture is overpowered by the facial expressions of the people who are standing over them. (One is reminded of Gustave Courbet's painting entitled *A Burial at Ornans* in which those attending the ceremony are given far more attention than the anonymous person being buried.) The facial expressions are emphasized by being placed at the upper edge

and by the lenticular distortion of a wide-angle lens. Reed is more concerned with the human response to the situation than with the fact of the death of the three men.

In his portrayal of life conditions in Central America, Reed conveys an awareness of the history of photojournalistic techniques and imagery. This history which began with the invention of photography has been marked by three major events since the late nineteenth century: the ability to produce halftone images on high-speed presses in 1897; the invention of the Leica in 1924; the publication of *Life* magazine in November 1936. While this may seem a convenient oversimplification, this combination of developments represented a technological advance in cultural communication of news events and human drama and made photography a medium of public accessibility. The mass publication of photographs also meant that the photographer no longer held sole domain over his images. The decision to print depended upon the editor and the publisher. And, no less significant, the summary interpretation of the image was left in the hands of the layout staff and caption writer.

Reed's photograph entitled *Political Rally, El Salvador* is a case in point. When the *San Francisco Examiner* ran this image on the back page of a special supplement "Central America: The Tortured Land," the caption read: "Scene from El Salvador: while a politician makes a point at a political rally in March, a mother and child find other diversions." The other diversion seems to be the presence of the media. When one is aware of the strained political situation in El Salvador, that political opposition to the government is suppressed, then the image becomes a portrayal of indifference and irony. The caption emphasizes the least significant aspect of the picture. The young girl in the left center is actually posing for a photographer barely visible on the right edge, a commentary on the presence and role of the media at the event.

In the exhibition at Focus Gallery there are no interpretive captions. Reed has given only general titles such as the location or a simple description. Whatever knowledge of the circumstances in Central America the viewer brings to the images will enrich the experience of them. But the result of the pictures is

not to politicize or change attitudes, but rather to report upon present human conditions from the viewpoint of a lover of humanity. Donald McCullin, a noted British photojournalist and war photographer wrote: "The photographer must be a patient and humble creature, ready to move forward or disappear into thin air. If I am alone and witness to happiness or shame, or even death, and no one is near, I may have had choices, one to be the photographer, the other the man; but what I try to be is human." This aptly describes Reed's ethical stance in photojournalism.

THE TURBULENT SIXTIES IN THE BAY AREA: PHOTOGRAPHY OF DISSENT

at the Focus Gallery,
San Francisco,
June 5–July 14, 1984

RICHARD GORDON: AMERICAN POLITICS, 1980–1984

at San Francisco
Camerawork,
June 19–July 28, 1984

LIONEL DELEVINGNE: GLORY, GLORY

at San Francisco
Camerawork,
June 19–July 28, 1984

The emotional energies and vested interests surrounding campaigns and political movements make objective discussion and reportage virtually impossible. In a highly charged political season, image and imagery projected through the media in every purchasable time slot propagandize, proselytize, and manipulate. However, the imagery itself outlives its historical context, even if it is never entirely free of it.

The Democratic Convention in San Francisco last summer set the tone for two San Francisco photography venues—San Francisco Camerawork and the Focus Gallery—to mount exhibitions that had political themes. Helen Johnston, director at Focus, organized "The Turbulent Sixties in the San Francisco Bay Area: Photography of Dissent." Johnston contacted twenty photographers who she knew had been active in different facets of the 1960s protest movement and solicited work prints, from which she selected the final prints for the show. In some cases the participants are no longer active photographers, others have moved into broadcast media. The exhibition brought together a disparate group of people who shared an intense commitment to social change through political action. The photographers are: Robert Altman, Ruth-Marion Baruch, Jeffrey Blankfort, Elihu Blotnick, Nacio Jan Brown, Michael Bry, Alan Copeland, Paul Fusco, Bob Hirschfeld, Helen Johnston, Pirkle Jones, John A. Kouns, Phiz Mezey, Colin C. McRae, Helen Nestor, Bill Paul, Terry Schmitt, Steven Shames, Lou de la Torre, and McLeod Volz.

San Francisco Camerawork showed two

individual exhibitions: *American Politics, 1980–1984,* by Richard Gordon; *Glory, Glory,* by Lionel Delevingne. Gordon photographed several recent significant political campaigns and events such as the Reagan victory party in 1980; the bitter, racially charged 1983 Chicago mayoral race between Harold Washington and Bernard Epton; and most recently, the Democratic presidential primary contestants. Delevingne has also photographed more homespun political and social events such as V.F.W. parades, small-scale nuclear energy protests, and other peculiarly American rituals in which the flag is significantly evident.

The three groups of images in these exhibitions represent a spectrum of approaches to photographing political events and people. Subject matter, context, and the style of composition and printing make the photographs as much indicators of the image makers' sociopolitical attitudes as records of human activity. It is this relationship between attitude and subject that shapes the impact of political "content." Of no less significance is the fact that twenty years (a historical generation) separate the work exhibited at Focus from the relatively recent images at Camerawork.

The broad consensus of the protest movement brought together radically disparate causes and groups of people. The long-term aim of the movement was an all-encompassing reformation of society. Contemporary political alignment tends to be around more narrowly defined principles—single issues such as nuclear freeze or right to life. The "Bob Dylan" of the 1960s who was concerned equally with the liberation of the psyche and social renewal, is in the 1980s a born-again Christian concerned with the salvation of the individual.

What distinguishes "The Turbulent Sixties" images from Gordon's and Delevingne's is that the sixties photographers were participants in the protest movement. They used the imagery as an alternate voice for speaking their outrage. Because many of the pictures were circulated nationally through the underground press, the photographers served as active supporters of the causes for which they worked. They recognized the dual role of photographs: to incite by giving broad and unchanging exposure to incidents that, in actuality, were more often than not small (but

not insignificant) and localized; and to become the documents through which historians would visualize or reconstruct that historical period. In an introductory note to the limited edition catalogue, Elihu Blotnick wrote: "Protest, however, is of the moment. Photography isolates the moment. Often a photograph is a stronger statement than the act recorded. In many instances, the photographs were more forceful than the protests. Photography in fact became part of the act. The photographs helped create and recreate the protest indefinitely, allowing continual renewal."

Though each of the photographers in this exhibition had different personal biases and photographed different events in the Bay Area, style itself (with few exceptions) was not a major consideration. Typical of news photography in being practical rather than aesthetic, the style is based on the assertion of content within the camera frame. The images are about the newsworthiness of content, the confrontations, ironic juxtapositions, and the iconography of protest. Whether photographed in color (and there are a surprising number of color photographs) or in black and white, the uniforms of the police and the military—as repetitive visual elements—symbolize both authority and power. The images celebrate the nobility of the protesters who suffered violence at the hands of the authorities. The photographers' direct feelings for and connection with this struggle resulted in a concentration upon "content." Moral stances can be clearly interpreted without having to strip away a veneer of style.

The protesters were beginning to understand the importance of the media as a political vehicle, but not yet as a tool for cynical manipulation. Consequently, the photographs verify real struggles and confrontations and have the power to evoke (or re-evoke for those who were involved at the time) strong emotions. This collection of images, though it could have used some editing to remove the sentimental pictures, is an important addition to the immense body of imagery from the sixties. Ironically, the media imagery of the sixties, of which the most notable example is the footage of police brutality during the 1968 Chicago Democratic Convention, contributed significantly to the media-consciousness prevalent in contemporary politics.

Max Wartofsky, in "Representation, Photography, and Human Vision," comments on the cyclical effect of imagery on perception:

> The trained photographer, however, with hand-held camera and a fast draw or trigger finger, is trained precisely in the ability to see, in "normal" time, just those features which it would be interesting to peruse in the "still." And the culturally trained viewing public also comes to notice in the normal flux of visual experience, those moments, instantaneous cross-sections, flitting shadows and cues of emotion or significance which a particular photographic culture or style has captured and made commonplace in the image.[1]

While this concept is not new to the photographic community, it is significant in that it is now part of the basic thinking of the image makers (from make-up artists to media consultants) who stand behind the candidates and campaigns. They have attempted to reverse the cycle, to control media by projecting images.

Richard Gordon's photographs demonstrate that the cycle has proceeded so far that objectivity (once the main purview of the press) and authenticity are irrelevant. By photographing politics in the eighties, he has chosen an extremely image-conscious, media-conscious world. What removes Gordon's pictures from the image-generative cycle is his use of a Winogrand-like style, which is both offhand, yet sensitive to significant details. Images are occasionally off axis, with the horizon line tilted, or the upper half of the picture is vacant. This is not the style of a participant, but of an observer who detaches himself from "reality" by exaggerating the mechanical nature of camera recording. His use of electronic flash, particularly in combination with the blur incurred with ambient light, greatly extends this detachment.

Gordon shows us that politicians are constantly on stage, whether it is Harold Washington casting his ballot, Adlai Stevenson, Jr., pensively watching election results, or Jesse Jackson admonishing reporters at a press conference. The performance is the constant projection of image for the ever-present media. Their presence, like the visible edge of the trompe l'oeil backdrop in most studio tintypes, is a reminder of the artifice that has become an essential part of political campaigns.

If Gordon's images are perhaps too coyly detached, Delevingne's reiterate the photo-documentary style developed in the late fifties and early sixties by Robert Frank, Dave Heath, Bruce Davidson, and Danny Lyon. He has used political settings, such as a 4th-of-July parade, for social commentary. But the image, a boy firing a toy cork gun at the parade, is hackneyed. Although he displays an ability to empathize with his subject, the empathy rarely transcends the sentimental, a mood reinforced by the warm brown tone of his prints. Delevingne seems a victim of the image-perception cycle; he has photographed what one expects to see in a photograph.

The political world has progressed toward a more conscious relation to the media, particularly in the last twenty years. This growing partnership produces images that influence thought through vision. In a media-conscious environment, authenticity and moral clarity are difficult to attain. In the realm of socio-political document, as sources or subject matter have been altered (even by an awareness of the media) for the image, the power of the image to move us, to speak on the deepest moral level has dissipated. The sphere of "imaginary" politics has stimulated a desire within us to break the image-perception cycle, to seek authentic, unmediated experience as a curative measure.

Note

1. Max Wartofsky, "Cameras Can't See: Representation, Photography, and Human Vision," *Afterimage* 7, no. 9 (April 1980): 8.

Experience of the classroom has left us all with associations, memories, and residual neuroses. These are touched and released by Catherine Wagner's photographs of *The American Classroom*. The twenty images selected for this exhibit at the Oakes Gallery of the Oakland Museum range from elementary school and university classrooms to more specialized educational environments such as a dog grooming school and a beauty academy. Evident through the pictures is that the conventional concept of classrooms has been redefined; a classroom is simply a location in which something, regardless of how bizarre or obscure, is taught. The classrooms are filled with familiar objects of learning—globe, desk chair, biological specimens, and the ever-present palimpsest, the blackboard—and newer devices such as the computer terminal. This educational iconography is what sparks associations, what makes the images work on the level of feeling. In Wagner's photographs these icons dress the environments and are part of a deeper study of spatial structure as rendered by the camera.

Education has been a hot topic in journalistic and political realms. Most of the discussion has focused on teachers and curricula. Less attention has been paid to the nature of the educational environment, its physiological and psychological effects upon students, although there is adequate research available. Wagner's pictures are timely in addressing these aspects of the classroom. She has tried to be nonjudgmental by including rooms texturally varied, such as *Moss Landing Elementary School, Seventh and Eighth Grade*

CATHERINE WAGNER; THE AMERICAN CLASSROOM

at the Oakland Museum, April 1985

177

Catherine Wagner, *Moss Landing Elementary School, 7th and 8th Grade Science Classroom, Moss Landing, Ca.*, 1984, gelatin silver print. Courtesy the artist and the Target Collection of American Photography, Museum of Fine Arts, Houston.

Science Classroom and rooms more institutional in their formality, such as *Defense Foreign Language Institute, Language Lab*. Whether one has a predilection for one kind of space or another, one can respect each on its functional level.

Environments are given meaning by the activities which they support, but Wagner has made a point in isolating the aspect of place from the rest of its educational constituents. She shows us the classroom as a spatial structure, as a visual entity with abstract qualities for the viewer to consider as an integral part of the educational process. People would present an aesthetic problem

that would detract from the purpose of the pictures. The props, icons, and artifacts condition those abstract qualities and, in turn, condition response to the images. She is keenly aware of the importance of these details as they are thoughtfully chosen and carefully composed.

Wagner has chosen to be the sole witness in these spaces. Consequently, the viewer is given the same privileged perspective. Figures are included in only one image, but their backs are turned; they seem unaware of the photographer. In *Hill's Professional Dog Grooming School,* the dogs, blurred by long exposure, remain without their groomers on their stands. Given full rein over the environment, she has imposed a lenticular and grid-like structure upon the space. When the grid is used parallel to the picture plane, walls and the accompanying shapes such as the blackboard or cabinets reiterate or subdivide the rectangle of the picture. More frequently, however, she uses the grid in perspective with the vanishing point above table level and centered in the frame. With this structure she establishes a kind of symmetry of space which simplifies the issue of composition and posits a formalized conceptual rather than intuitive basis for ordering the subject matter in the frame.

In *The Shape of Time: Remarks on the History of Things,* George Kubler wrote: "The devices and artifices of planned illusion are the working gear of the artist who is engaged in substituting his own codes of time and space for our older and less interesting ones." Eugene Atget, the seminal documentary photographer of Paris in the early twentieth century, chose a specific wide-angle lens and a consistent camera height for a majority of his images. Aside from the pragmatic aspect of including more information at closer range, his pictures engender a feeling for the space as well as the content. Wagner's is a more detached vision. She has used camera perspective, defined in her case also by a wide-angle lens, as a topographic device to reduce composition to a mathematical logic. That the images are printed in black and white adds to this reductive quality. This strategy becomes increasingly evident as one moves from image to image, and it thus elaborates the conceptual basis of the entire *American Classroom* series. She has engaged in an open-ended intellectual dialogue between ar-

chitecture (transformed as picture structure) and the stuff of class-
rooms (transformed as icons).

The blackboards that recur throughout the show provide a
humorous and sometimes ironic relief from this dialogue. The
linguistic fragments represent coded and structured information
detached from its specific communicative function. When de-
cipherable, they invite hypothetical reconstruction of the original
context, an experience comparable to reading ancient picto-
graphs. Perhaps the most portentious configuration is on the
blackboard of *San Francisco Police Academy, Lecture Room.* There
are two definitions written: confession—admission of guilt; ad-
mission—establishment of a particular fact. These are accom-
panied by a drawing of an arm holding a billy club. Inclusion
of this board is as close to editorializing as Wagner comes in her
images.

In her images the classrooms are isolated from the world and
specialized in function. They are designed to produce somewhat
predestined modes of thinking. Nature is studied abstractly through
diagrams, stuffed specimens, wings separated from the bird, mo-
lecular models made of sticks and balls. This kind of abstract
presentation separates observation and thought from direct feel-
ing by removing things from their original context. Camera
photography works this way as well; selection and isolation are
its essential mechanism. Thus the medium seems well suited to
a culture which has been educated through this abstract mode.
In *The American Classroom,* the photographs as objects convey
this same educational message, the presentation of fragments as
substitutes for the whole.

Photographers have served history well. As faithful recorders of important events and personages, they have bestowed both with historical authenticity and longevity. However, photographic documents have an aesthetic and contextual life in the present which often clouds the understanding of the historical circumstances in which the images were made. Images which are technically stronger (richer tone scale or sharper focus, for example) tend to have more presence or command more authority than those which have faded or which lack technical coherence, though the latter may be of more historic import. Thus the criterion for evaluating historical images is twofold; aesthetic concerns must be weighed along with documentary value. The exhibition *The World of Agustín Victor Casasola, Mexico: 1900–1938* consists of photographs which fall across this aesthetic/historical spectrum. Some images, paralleling the documentary work of Lewis Hine or August Sander, are technically accomplished and strongly emotional. The image entitled *Child Soldier,* for example, is loaded with social irony. Many of the other 150 black-and-white photographs included are closer to the detached form of news photography whose aesthetic is content-based and whose purpose is preconditioned by its market.

A look at the professional life of this "unknown photographer" (as he is called in the exhibition catalogue) sheds some light on the politico-aesthetic biases of the photographs displayed. Born in Mexico in 1874, Casasola began his career as a writer for newspapers and in about 1900 switched to

181

photojournalism as his primary venue. He did, however, continue to write captions, which are included for each of the photographs in this exhibition. In the early 1900s, he worked for the two major newspapers published in Mexico City, *El Tiempo* and *El Imparcial,* where his job was to photograph the official activities of General Porfirio Diaz, the reigning dictator. The editorial style of these images was determined by the celebratory needs of the people in power and by the political consequences (such as imprisonment) one would suffer if one dared publish a photograph of the truly squalid conditions under which many of the citizens lived. Diaz fled Mexico because of the Mexican Revolution in 1910, and subsequently Casasola founded a Society of Press Photographers whose purpose was to document the activities of the new government. Though the Society's photographers depended upon those in power for their living, they did not produce what I would call conscious propaganda. Their purpose was the presentation of newsworthy events which would put the current political leader in a favorable light. If I read the exhibition correctly, Casasola and his colleagues never assumed the role of political advocacy. Their images were, rather, incidental or passive propaganda made out of tacit acceptance of the ascendant political values of the moment. The benefit of this stance was privileged access to often highly guarded political figures. (The photographs of the pioneering German news photographer Erich Salomon, who worked primarily between 1928 and 1933, make an interesting comparison with Casasola's, in terms of their respective approaches to this privileged access.)

Because of increasing turmoil between warring factions of the revolution, all of whom vied for control of information, both of the major newspapers were closed down by 1914. Amidst all the confusion, Casasola and a few associates set up Mexico's first Photographic Information Agency as an entrepreneurial effort. While Casasola himself remained close to the government as its photographer, the agency had a staff of photographers assigned to cover the extraordinary and rapidly changing circumstances in Mexico City and in the outlying provinces where the majority of revolutionary fighting took place. What they could not photograph themselves, they either collected or commissioned from

Victor Casasola, *Factory plant; engine room,* Mexico, ca. 1915, gelatin silver print. Courtesy Fondo del Sol, Washington, D.C.

other photographers. It is interesting to note that this agency had a virtual monopoly on photographic images circulated not only to the Mexican press but also to the foreign press which sought information about the events of the revolution. At the end of the revolution, Casasola was hired by the succeeding governments of Obregon and Calles as chief photographer of several offices, including the Court of Belen Archive's Registry of Arrests and Prisoners. In 1921, in an effort to summarize the events of the preceding ten years, Casasola published the *Graphic History Album.* This was followed shortly by the ten-volume *Graphic History of the Revolution* published by his son, Gustavo Casasola. The photographs for these books were drawn from

the Casasola family's negatives, many of which had been made by since-forgotten or uncredited photographers. (Thus the comparison with Mathew Brady's American Civil War archive mentioned in the exhibition's introduction.) This vast collection of images now constitutes the Archivo Casasola in connection with the National Institute of Anthropology and History in Mexico, the source from which this present exhibition is drawn.

Organized around the broad principle of subject matter rather than authorship, none of the images is ascribed to a particular photographer. Thus, photographic style is a marginal concern. Instead, historical coverage is approached by categorizing the subject matter according to headings such as "Industry and Labor," "Intellectuals and Artists," and "Railways in Mexico." But the groupings make a rather indirect statement about the social changes of the revolution. For example, the newly established sociopolitical role for important mural artists such as Diego Rivera is only hinted at by one picture which shows him leading a funeral march (*Diego Rivera and other members of the Mexican Communist Party at the funeral of Julio Antonio Mella, 1929*). Interestingly this image is in the "Industry and Labor" group. The flourish of government-supported artistic activities which contributed to the Mexican Renaissance—that exciting postrevolutionary period which attracted American artists such as Edward Weston and Paul Strand—is represented in the "Intellectuals and Artists" section by images of Modernist poets, a humanist, arid a Dadaist poet as diplomat all stiffly posed and in formal or ceremonial attire. This group also contains one of the more bizarre images of the exhibition, *Manuel M. Ponce, romantic composer and forerunner of nationalism in music in Mexico, with Mrs. Grossman, noted harpist of the day, 1918.* The image shows a third unidentified person, a woman with a stern expression and pince-nez askew, the only member of the party looking directly at the camera. The composer, in the left of the frame, seems totally unprepared for the picture moment, and the harpist, dressed to match the floral decorations on her harp, stares vacantly off-camera.

Two radically different images of Emiliano Zapata, the martyred head of the revolution in the south, and perhaps one of the most romanticized figures of the revolution, demonstrate the

Victor Casasola, *Emiliano Zapata and his comrades parading before Francisco I. Madero,* Cuernavaca, Morelos, June 1911, gelatin silver print. Courtesy Fondo del Sol, Washington, D.C.

variation of picture syntax and psychological impact which characterize the exhibition. In the first, we see Zapata in full *caudillo* dress, one hand on his rifle, the other on his sword. One foot forward, hips turned, he looks directly at the camera. He is posing to project an image, for the look of authority. The camera's wide-angle lens thrusts him forward and elongates his body. In the second image, we see just head and shoulders. Here Zapata has opened himself. He bears his psychological intensity within his expression as if it were his last and final weapon— which indeed it was. Unlike many of the other images in this show, in which history is sanitized by the temporal distance and apparent objectivity of the reportorial camera, this image of

Zapata seems curiously contemporary. The anticontextual white background, unguarded intensity of gaze, and transactional (as opposed to a facade) relationship with the photographer are betrayed in time only by Zapata's style of clothing.

The images in the show, particularly the ones in which there is large group activity, tend toward a neutrality, which is countered primarily by the accompanying text. But this is in keeping with the role of captioning in modern newspaper practice. As in modern newspapers, the picture editor's job is to identify and crop the images which most succinctly convey information within the newspaper's editorial position. Casasola was able to perform this editorial role not only as a photographer, but also as the director of the archive until his death in 1938. Though he sold his (or the agency's) photographs to the media for a living, he also made his archive available as source material for artists such as Rivera, Siqueiros, and Orozco who incorporated them into many of the great mural projects of the time. As Casasola's images continue to surface transformed in contemporary Mexican art, it is artists rather than news professionals who have been able to bring out of them the revolutionary spirit. Casasola was aware of this spirit, but was forced to remain detached from it because of his self-assigned role as court photographer.

Photographic images are momentous, representing a select aspect of experience for which a context and history are acts of reconstructive imagination. Photographs allow us to be time travelers, and, perhaps more important, consciousness travelers if it is our will—enough context and we may conjure the actual experience in its time. Enough context and the approximation of the actual may seem trivial and secondary to the image's fictive potential in the present. As the English linguistic historian Owen Barfield has stated: "in the language of imagination at its most powerful we are made to feel a kind of *union* between the observer and what he is observing."[2]

To actually participate in a spectacular event as a witness gives one the direct experience of another consciousness, a group consciousness formulated from the simultaneity of myriad individual inner experiences and the bonding power of a common outer experience. When evident in the photograph at all, that group consciousness is opaque, suggested only by figural gestures and ambiguous facial expressions. The photographer defines what will remain as the right moment not from within the experience, but from the most practical or sensational graphic depiction of its appearance. In making a comment which can be applied to the role of the photographer, William Gass wrote: "Popular culture occurs in public; it is as much an event as an experience; and it is reported on in the same spirit. There are therefore both participants and spectators, and in much of popular culture a steady drift toward voyeurism and passivity."[3] The con-

DAREDEVILS AND FALLING HORSES: NOTES ON SPECTACULAR PHOTOGRAPHS: UNFORGETTABLE FACES, FACTS, AND FEATS

January 1988

In a camera obscura, the butcher's cart, and the figure of one of our own family amuse us. So a portrait of a well-known face gratifies us. . . . In these cases, by mechanical means, is suggested the difference between the observer and the spectacle,—between man and nature. Hence arises a pleasure mixed with awe; I may say a low degree of the sublime is felt from the fact, probably, that man is hereby apprized, that, whilst the world is a spectacle, something in himself is stable.
RALPH WALDO EMERSON, 1836[1]

sciousness of the photographer is that of one who capitalizes (either aesthetically or financially) upon appearances. Thus the photographic record of a spectacular event is a veiled perception, a richly detailed description which is both prejudicial historical evidence and fascinating story.

The circus, as one of the nineteenth century's most popular forms of public entertainment, began in the United States out of a *showman's* impulse to emulate the context of a museum. P. T. Barnum's American Museum, which opened in New York City in 1841, was a showcase for "curiosities and oddities," including such noted figures as General Tom Thumb.[4] In essence, he collected in much the same sense as the natural history museum. This museum was an *exhibition* hall, which housed objects as well as performances, through which the audience moved at its own pace (if there is such a thing as collective pace). The photograph *Alexandre Patty Descending Staircase,* of a man whose talent it was to be able to walk down stairs on his head, exemplifies the kind of performance for which the camera is surrogate witness and audience. The closed nature of the relationship exaggerates the surrealistic aspect of the view (even his suit is antigravitational) and the freakishness of the performer despite his feigned normalcy of dress. Such exhibitions held a fascination for the public, witness the droves who attended Barnum's and competitor's museums and the continued draw of the side show, but the power of that fascination was not fully exploited until the audience could be seated, fixed in place, "passive" in Gass's word. When the audience ceased to move, exhibition became spectacle, "The Greatest Show on Earth" as Barnum was wont to call it. The three-ring circus (since incorporated into our language as a fascinating metaphoric idiom) was so engaging, so overwhelming in visual display, that all notions of self in the audience were surrendered. That is the spectacle's power and control of viewer—a step beyond willing suspension of disbelief to the *unbelievable* (in the exclamatory sense). Audiences, as they witnessed feats performed at the limits of or seemingly beyond human capabilities, experience a voyeuristic empathy with the performer passing through that threshold, albeit a "safe voyeurism."[5]

C. E. Holmbor, *The Daring Ride of Mrs. Eunice Padfield, July 4, 1905, Pueblo, Colorado*, gelatin silver print. Courtesy Library of Congress.

What threshold is crossed in the *Daring Ride of Mrs. Eunice Padfield?* There in a Pueblo, Colorado, fairground on July 4, 1905, horse and rider take a leap of faith. One such rider who made her living performing a similar act was blind; ironic, but the image considered here was accessioned in the Library of Congress under the heading of "animal acts." There is virtually no history other than the visual record of this particular act or others like it—it was not a common one.[6] The image's graphic brilliance is matched by the sheer density of cultural information provided. For example, the well-dressed, mostly male crowd is punctuated by the white dresses of what appear to be the only two women

close to the event—a telling demographic. The image itself, a constellation of information and history, becomes a threshold.

A predisposition toward the death risk is a subtextual part of spectacular events. Self-destruction and the sheer power of audience-financed destruction, as found in the practice of locomotives hurling toward each other at full bore on the same track, are also significant facets of the death risk. In fact, audience members were seriously injured in the stands by shrapnel set aflight by these collisions. Such words as *breath-taking, death-defying,* and *daredevil* recur with frequency throughout the publicity for such staged events. *Daredevil* is a colloquial term that can be interpreted on several levels: daring the devil who symbolizes an aspect of death; or in another sense, as the devil would dare to implicate the audience or photographer as an accomplice. *Daredevil Diavlo: the First Man to Loop-the-Loop on a Bicycle* is a tragicomic illustration of the daredevil image taken (and presented) literally. The silhouetted black figure rides his bicycle around the wooden loop. Though virtually all detail of the figure is suppressed, his outline shows us two small horns protruding from his head (the devil), that he is wearing gauntlets (the knight), and, in one of those wonderful and fortuitous camera transformations of the bicycle seat, that his male organ is projecting forward (the barbed lance). The photographer has recorded him at a moment when he seems suspended from the track, supported by his own centrifugal force, during a practice run. The other men, focused on preparing the drapery for the show, are undiverted by the event occurring next to them; it is an ironic juxtaposition. The label on the back of the photograph reads: "Diavlo was killed the same season doing the same stunt."

Harry Houdini, the great escape artist, chose a much less innocent approach to costume. Houdini was a master of the spectacular event, and one of the first public performers to fathom the significance of visual reportage. Houdini also had a cynical fascination with the camera as a publicity tool. He was always careful to surround himself with collaborators shorter than himself, and, as in the image of him about to jump off the bridge, his costume was the publicly acceptable minimum that would

in the photograph be indistinguishable from his body. The more manifestly physical Houdini could be (he was known to stuff his body stockings with extramuscular materials), the more herculean his feats would appear. Houdini converged public and media spectacles.

Those who make a spectacle of themselves, or those who perform spectacular feats in an orchestrated context are certainly at the extreme of human behavior. But the spectacle can have a dark side, far from the realm of entertainment. Spectacles provide the acceptable conditions under which social or cultural beliefs can find expression in acts which may contradict individual conscience and morality.[7] This is perhaps one of the major points of Walter Van Tilburg Clark's insightful study of group psychology in the *Ox-Bow Incident*. But, in *The Crowd Gathers to Witness Henry Campbell's Public Hanging*, the impenetrability of the individuals, despite their Ensor-like faces and their collective willing collaboration with the photographer makes for an unnerving image as spectacle.[8] This black man stands on a horse-drawn cart in a procession to his hanging. There are few black people in the primarily white male crowd. Since the majority of the crowd has directed its attention to the camera, this is not a news photograph but an event turned spectacle for which the camera produced the necessary condition of fixation. The image is a consciously constructed historical record which reveals an archetype of social behavior, both blatantly racist and inhumane—an unacceptable archetype which continues to surface.

The social, political, cultural, historical, and psychological issues raised here by these images and the others included in the exhibition *Spectacular Photographs: Unforgettable Faces, Facts, and Feats* are timely and rich with implications. However, regardless of discussion, the photographs remain as artifacts and objects of contemplation. The processes of photography, like those of thinking, are death processes. As depressing as it may seem, nerve cells are sacrificed in the morphosis of thought. The photographic image is in a sense dead imagination (frozen and materialized); yet it is enlivened when it is cogent enough to work with or in memory or soul-experience. The image (the dead

imagination in material presence) is then transcended as it merges with thought. The life of the image is thus intimately connected with the life of the mind, and it is to each viewer that the image looks for renewal.

Notes

1. Ralph Waldo Emerson, *Nature, Addresses, and Lectures* (Cambridge: Belknap Press of Harvard University Press, 1979). From the essay *Nature* (1836), Chapter VI, *Idealism*, p. 31.

2. Owen Barfield, *History, Guilt, and Habit* (Middletown: Wesleyan University Press, 1979), p. 24.

3. William H. Gass, *Fiction and the Figures of Life* (Boston: David R. Godine, 1978). From the essay *Even if, by all the Oxen in the World*, p. 72.

4. For a detailed history of Barnum's life and circus ventures see: Neil Harris, *Humbug: The Art of P. T. Barnum* (Boston: Little, Brown & Co., 1973).

5. This term was first mentioned to me by Professor Keith McElroy, a photographic historian and an authority on photographs as conveyors of cultural content.

6. There was a diving horse act in residence in Atlantic City, New Jersey, until the Boardwalk area was reconstructed about forty years ago. This information came orally from Mr. Tim Rivers of Florida, who is one of the last people to still tour a diving mule show.

7. I am once again indebted to Professor McElroy for providing the basic perception of this issue and its relevance to spectacle in photographs.

8. This image bears an uncanny similarity to James Ensor's painting *The Entry of Christ into Brussels*, painted in 1889. Parallels include: graphic structure, caricaturization of the crowd which faces the artist rather than the event, and in the images' social and political overtones.

The

Poetic

Imagination

Henry Holmes Smith has been involved in photography for sixty-one years. He has done pioneering work in color photography, the history of photography, and the development of photographic criticism. As a devoted teacher he has sacrificed much of his own time to helping his students, many of them noted photographers in their own right. As such Henry Holmes Smith should be regarded as a seminal figure in the history of photography. As concerned with ancient mythology as he is with contemporary society, his cameraless images address them both in an intensely poetic form.

As we sat in Henry Holmes Smith's dining room, I noted a connection between the view of San Francisco Bay out his balcony window and the schoolroom map of ancient Greece which hangs on the wall there. The connection is a conceptual one and reveals how Smith's exterior world is related to his imaginative life. The vista exists in real time, changes with the cycles of the day or year, but the map is fixed, a topological symbol of a vanished culture. Yet in content, the geography of land and water, the view and map merge as aspects of a visionary stage set upon which man has continued to live as a cultural being. Smith speaks as easily of the heroes and gods of the ancient world as he does of contemporary society, for they are both essential to his understanding. Themes drawn from Greek classics are as relevant today as ever. Smith is a deeply perceptive student of the human condition.

Before we began the formal interview, he showed me a book that he was reading. Called *Distinctions*, it is a study of the formation of

AN INTERVIEW WITH HENRY HOLMES SMITH

December 31, 1984, San Rafael, California

taste in contemporary society. He explained that he hoped it would help him understand how and why people make their decisions. At seventy-five, Smith is still searching. At the same time, he has been a significant teacher of photography since 1937 when Laszlo Moholy-Nagy asked him to join the faculty at the New Bauhaus in Chicago. In 1947 he was invited to teach at Indiana University in Bloomington, where he continued until his retirement in 1977. He pioneered one of the first courses in the history of photography to be taught in a university and made through his writings significant contributions toward the development of a critical language for photography. Noted for his teaching as well as his writing and photography, he received the Herman Frederick Leiber Distinguished Teaching Award and an honorary Doctor of Fine Arts degree from Maryland Institute for his pioneer work in color photography. Since 1977 he has lectured and given workshops throughout the United States. His biography, *Henry Holmes Smith: Man of Light* by Howard Bossen, was published in 1983. It had been thirteen years since Smith had shown his photographs in the Bay Area, and much of the work at the Focus Gallery had been made recently.

JB: You've been involved with photography for almost sixty years, is that right?

HHS: Sixty-one.

JB: I wondered if you might mention what some of the highlights have been for you.

HHS: Well there are about five. The first one was discovering photography, the magic of the picture, of making the picture, and I discovered that very early.

JB: How old were you?

HHS: Fourteen, when I was making my own little snapshots, developing the film, and making contact prints. The second one was when I found out that I actually could devise a way, it wasn't

that I invented it but that I could do it, of making photographic cartoons with little puppet figures.

JB: You mean you were actually setting up little still-lifes and photographing them?

HHS: Yes. They were still-lifes with the equivalent of flat marionettes.

JB: Sounds almost like a shadow theater.

HHS: Well not really, because I put cloth garments on them and set them up. The most elaborate one I did was a series for a college annual in which these two characters went through from matriculation to graduation in one year. Well, anyway that was the second [highlight]. And then the third was the discovery of Bruguière and Weston, Steiner, Strand, and several others. And then the fourth one was when I actually found out that I could make these color pictures from colorless objects, which was a sheer delight to me, something that I have worked with ever since. I thought that out in 1937 and put it in practice in 1946. So from that time on I've been working with it, about some thirty-eight years. Then, the next one was when I found out that not only could the colors be derived from colorless objects, but that these almost intangible characters from the ancient world could appear for me when I used my syrup to make drawings. At that time I was able to bring together my interest in drawing, color, and photography and this ancient world. And if there is another one it would be that I found after many years away from it, that I could come back and do it again.

JB: Was it difficult to be away from your work?

HHS: Well, when I was involved with teaching, I did very little of it; sometimes there would be a lapse of almost five or ten years between when I could get back to my own work. See, I worked in 1949, 1951–52, and then there was a lapse until 1956 when I began doing color printing again with ordinary subject

matter made through the camera, the separation negatives. Then in 1960 I began making these refraction prints on matrix film; in 1959 I did that, and then there was a long lapse in time until 1970 when I really got back to it. For years these mattes would just hang on a line in my studio and I didn't touch them. It was a matter of not having time in the sense that there were a great many distractions including eye trouble in 1962, 1963, and 1964 and then I got back to it in 1970. In 1973 I had another eye difficulty that was cured, or at least alleviated so I could see again. But that kind of creates this problem. About that time I was getting very impatient with teaching and the students, so that's a different ball game. Then they gave me some time off, which I was happy to take, I'd earned it. And then I retired. Now I can work as I wish, and I'm getting at lot more done. Plus helping my daughter-in-law and son. So those are the five or six things that are important, the last being that I found that I could do it again, better!

JB: Have you accomplished all that you have wanted to accomplish?

HHS: No. I would like to have published a selection of both kinds of work, the kind that has the color in it and the kind that has what I call ancient images. Right now I can't see how it would be done unless someone else participates.

JB: Do you mean publishing it in book form or portfolio form?

HHS: I would like it to be published as a book, as a paperback.

JB: To summarize your work?

HHS: I would like it to go across the board.

JB: Your cartoon photographs were really an early precedent for the "Fabricated to be Photographed" work going on today.

HHS: It wasn't only I, it was widely done in advertising, *Life*

magazine, the humor magazines used these kind of things for covers. Advertisers used soap carvings and cut outs and Anton Breuhl was doing this for a clothing store chain in New York, all in the 1920s.

JB: You know and have worked with many of the most noted people in modern photography in this country. You have spoken of the importance of your association with Moholy-Nagy. Do you feel that you have been influenced by others or in turn have influenced them?

HHS: I've been influenced by the important ones one way or another and that would include Ansel Adams. I'm in awe of his craftsmanship, while I wouldn't in any way aspire to his kind of subject matter. I think [Oliver] Gagliani is one who just stuns me with his craftsmanship now. So I would say that that is one kind of influence, in fact, I wish that there were more of that. Bruguière was a seminal influence, as was Edward Weston, though I never could do Edward Weston's kind of pictures. I was quite taken by the monumental subject. And Moholy's fascination with light I always felt was a very important thing. I first saw Bruguière's work in publication in 1927 and I couldn't figure out what do with this intensely important influence that I had until the 1940s. I used it as a teaching devise at the New Bauhaus and when I first went to Indiana in having the students make light modulators. Again and again I'd find that students would do repetitive things, the next student group would do the same thing as the other student group and without seeing it, so I figured it wasn't a very good pedagogical device. When I got to the syrups, and I got to that out of a student doing some things, I found my niche. I'd known from the colorless subject matter turned into color pictures in 1946 what I could do with it once I got it into that stage. But I didn't do anything with it for a number of years because I either didn't want to set up and copy those things or I made them on matrix film in the first place so there was no way to copy them. Eventually there was a way to copy them, which was make a transfer and then go from the color transfer, usually blue with a red filter, to get the monochrome negative,

Henry Holmes Smith, *Angels,* 1951. Courtesy Smith Family Trust.

and then you could do whatever you wanted. Even the documentary people, people like the FSA people, Russell Lee, Dorothea Lange, and so on were very important influences, but I couldn't deal with their kind of subject. I never had the same kind of influence from the archeological work of the nineteenth century. I liked to look at it, but it didn't seem to have the kind of influence that being in the presence of a busted stone would have had, rather than a picture of a lot of busted stones.

JB: But the nineteenth-century photographers were really concerned with the way things looked or the appearance of things.

HHS: Yes, but I have a lot of respect for that, you could see in those pictures of the chimney and so on that I was doing what

was fashionable to do in the late 1920s. Look up or look down. Actually in 1923 I went up to the top of a chimney and photographed down so there was a shadow, it's a very strange-looking photograph. There was a pumping station built for a reservoir of artesian water in the town that I lived in, so here's this long straight line and a circle, they're both quite dark. It was a motif like you'd see in those days.

But long before I had seen those things in photographs. It just was there and I photographed it from the top of the chimney.

JB: Do you feel you've been an influence on other people?

HHS: Maybe in a general way. I've tried not to be in an oppressive way. Let them do what they want but be an influence in the sense that I would try to encourage them to be better or if they got themselves in kind of rut to help them find a way out of it. And I think so, but you'd have to ask them. Some people have said I was.

JB: Like who?

HHS: Well, the most important one would have been Welpott, who says it again and again, but Jerry Uelsmann says it quite openly. Betty Hahn has said so. What I will do before you leave is give you a series of papers by people who wrote in connection with the 1973 show.

JB: You mean the Fifty-Year Retrospective?

HHS: Yes, it was meant to be a book with pictures, but there was never enough money raised to print it. There are others, but I'd have think about it.

JB: You mentioned in an earlier interview Stieglitz's importance for you—it wasn't necessarily influence, but that he was very important in his striving for truth.

HHS: Well, I would accept that as something I would have said,

but he was from my point of view in my later life much more important for his pictures. Obviously he was involved with truth, that's what he was doing, but it was just the intensity of the pictures. It got to the point, if I've read his biographical material correctly, that he was a little more, maybe pompous, maybe that's not a fair word, but he was a little more arrogant than he needed to have been for a person of his power. But, you have to be the way you are. And you can't correct yourself to match somebody else's wish for what you are. I think that's terribly important, and you shouldn't even try unless its a matter of domestic harmony.

JB: Did you know Stieglitz?

HHS: I never met him, but in 1932 I went to New York from Columbus, Ohio, and this individual who was a friend of my aunt's took me around New York and we went up to An American Place. And there in a little alcove Stieglitz was looking at some things with John Marin, who was another hero of mine, a very important influence as far as what I like to do, or think about doing, or try to do with painting. I'd only seen his work reproduced and it was a very startling and freeing kind of thing to see. So I would credit him with a lot of influence. And in the Columbus Gallery of Fine Art in the early thirties there was a whole room of his stuff with Charles Demuth. I found out later how they happened to have it. A man in Columbus had been acquiring them at about one or two per year. He sent them $15 and they sent him one, something like that, a very small amount. That was in the teens when those were very startling kinds of pictures.

JB: Certainly Marin had a relationship to subject matter that you don't have. What is it about the work, just the use of color or the energy in the work?

HHS: Energy and also subject matter. I did a lot of landscapes; they would be imitative, but they nevertheless had subject matter.

JB: So it wasn't so much an influence on your photography.

HHS: Oh, no. It was an influence on a way of making notations of the world. There would have been three different things involved in that. First the way I did those paintings from landscapes, actually from the world out there. The second was the way I drew from this imaginary world which has a whole different character and you can't relate it to what John Marin did . . .

JB: Not directly, no.

HHS: Well, in any way that I can account for. Somebody else maybe can tell me. Painting from landscape and representation of imaginary things came together [in the third way] with the light drawing.

JB: In a way there is a gestural quality in the painting, and there is a similar gesture in applying the syrup.

HHS: Yes, that's right.

JB: What are some of the most important resources or sources for your ideas and inspiration?

HHS: An awareness of all the kings and princes destroyed and their palaces ruined on the one side, forts torn down by people at sword point. I like to contemplate or think about the events that led up to the tearing down of a pre-Christian temple, the scavenging of stone parts from some fortification, or just the absolute random careless destruction of things. I don't mean that I'm praising the destruction, but it gives you a sense of what might be ahead for places like New York or Chicago, Los Angeles or San Francisco skyscrapers and a sort of hint of the short-term tenancy of the human being. I like to see the old artifacts that survived. I've never been in Vatican City, but I often think of the circumstances under which the Vatican City might be despoiled, as a kind of restatement of the fate of so many temple cities like Ephesus. So I guess that that's a source that will go on to the end of my life. And then as I find out about other certain things, for instance, in an anthropological museum in

Madrid there is a reconstruction of a tomb from the post-Christian world, I mean after the Christian era. There was a family tomb, and in this tomb was a life-size seated figure of a woman, very realistic, very impressive, as though she were taking charge of all those dead people. Mother of the family. Now, I don't know who it was, maybe it was a goddess, but it looked like a woman. Well, that sort of thing will stick in your mind. That's all I know about it. I think in the years between maybe A.D. 400 and 800, there were a whole batch of these tombs because they had a diagram of where they'd found them. They were in a certain hill and they were all together, which is the way things go. And, it was absolutely fascinating to contemplate bringing a new remains, a new dead person into that situation with that seated figure there. Some sort of a guardian, I assume. It's that kind of thing, all those funny little mysteries that you run into different places. Sometimes they are so intangible that you just can't do anything, just let it soak in, then suddenly it may bubble up.

JB: So really it has been out of your experiences traveling or being different places that have . . .

HHS: That's just part of it. Reading, too. Like in *The Ghost Dance*, the book by Weston La Barre. I don't have to have traveled there, but, when I did I saw things that I hadn't read about. La Barre dedicates the book to a great uncle who was executed for heresy in France. I like that little touch. There's no self-pity in it; they got the guy, but it's memorializing him.

JB: It says something about the intention of the book too.

HHS: Oh, definitely. It is a very severe critique of the world we now dominate.

JB: Why have you chosen to work primarily in cameraless imagery? How have you resolved the question of content?

HHS: I would have thought from what I've said that it would

be pretty self-evident that what I'm dealing with isn't accessible to the camera. Stop to think about it at least not in the way we usually use the camera . . . point out there and expect to see whatever it is you are going to photograph. You can photograph that way with the camera to get these things by implication and shadows, reflections, and wiggly this and scrawls and splotches and so on, but I don't like to do that.

JB: Are you talking about people like Aaron Siskind and Minor White?

HHS: Yeah, but I don't think its necessary to vindicate your picture by having found it out there in the world. I think that if you can let light work, you let light work. If you can participate and know enough to collaborate with it. For me it's like when I did crowd pictures some fifty years ago, go out and photograph street people. I would not know exactly everything that was going to be in that picture, I wouldn't have seen it all beforehand. I think very few people do, especially if you take a run of thirty-six extremely rapidly you may be aware of this or that person is going to be in the picture and then not in the picture. So that's why, accessibility of subject matter which would otherwise be somewhere else. You couldn't properly focus the camera lens for an idea in your head, then snap the shutter and get anything but probably the skin on your forehead. So you reject the one, or at least don't use it because it's not very useful. It would be like painting with the stick end of your brush. It can be done and sometimes it's not bad looking, but if you want the brush, use the brush, otherwise use a stick. It's preference. The gestural quality of the drawing is possible to find with the camera, but it's difficult to go hunting for it and not spoil the whole thing by hunting for it with a preconception. This is drawing without a preconception. These are given, these are not made.

JB: Does it take you a lot of them to produce one that you keep?

HHS: No, if we had the time I'd show you the whole batch, they are all good ones. They are not all the same level of good,

but they are all acceptable. Working the way I do I get some pretty nice things without having to do a lot of them. I have found that I can set the glass down and let the syrup harden, then I've got a negative equivalent which then can change by dipping it in a tray of water.

JB: Does that soften the syrup?

HHS: Yes, it's the edges and the flow of the liquid that gives you some of these light plays.

JB: From everything that I have read you seem deeply concerned about the quality of education and life generally in contemporary society.

HHS: I am.

JB: Running parallel with that is a concern with heroes, myths, and even spiritual beings. I see them as two parts of a whole vision.

HHS: They are. But I think they are united just like good and bad or fortune and misfortune. I don't see anything spectacularly contradictory about them. The awareness of something and the admiration for something, you could be aware of being in a pest hole and yearn for being out of a pest hole. You can see how the villains dominate, yet yearn for the heroes that used to take care of some of those things.

JB: I guess I never suspected a contradiction, I just didn't understand how you saw the connection. Do you feel that some of these heroes and spiritual beings are still working, still struggling?

HHS: I don't know. I wish they were long-lived, but I don't know. And I don't think they are needed that way. They just are something I know about. I think we need them today, and I think it would be great to find out how to locate them and support them. And I'm sure they are around. I'm going to say very flatly

I think Martin Luther King, Jr., was a hero, the way I look at heroes. He doesn't come into my iconography, but that doesn't mean I don't admire him. And when I see the enormous effort being spent to destroy certain people who had heroic attitudes or inclinations, I am very much disturbed.

JB: Whom do you mean?

HHS: Martin King, for example. And the opposite in the case of J. Edgar Hoover, there was nothing redemptive about that man, that was an honest-to-God villain. Yet they spend more time making Lyndon Johnson villainous than they did J. Edgar Hoover because there was something to gain, which is a public view of encouraging the contempt for a man who, for whatever reason, began to make it possible for some people to receive medical attention. I think it is transparent that the evil that has been done recently will live after us. The heroes of ancient times used to get right in there and mess around, but even Hercules got into trouble at the end. He made a mess, but it may be that is a hero's fate. I used to not want that to be, but you remember how Loci, that little mischievous god got in there and spoiled Thor's hammer handle. (laughter) It seems like they always get away with it, the bastards. I mean what did he gain, just a kind of little temporary mischievous, willful, spiteful thing. This is the kind of thing that goes on in my thinking which makes me realize that it's not new and that I'm not big enough, or smart enough, or courageous enough, or muscular enough to take some of them on. But I admire the ones who do.

JB: You have been a pioneer in experimenting with color in photography. The use of color is certainly more prevalent today than in the past. Have photographers come to grips with the expressive aspects of color beyond representation?

HHS: Well they haven't gone very far with it because they've limited themselves. It's just a rule of their practice that you either alter the colors by using negative to positive or using the prevailing light as it changes in color or you alter it with filters.

That seems about their limitations: filters in the camera, filters on the enlarger, or colored lights as they combine in the different balances. Oliver Gagliani was doing that sometime in the late 1950s in the enlarger. I think they haven't begun to explore it because they can't disentangle themselves from the color subjects. When you get separation negatives, very old fashioned and very limiting, you had an automatic monochrome statement of a color sensation. You could do anything you wanted with it. Then I went one step farther, and I don't think many have gone that step, to originate a monochrome statement unrelated to color, which is then introduced into color through a color printing process. I think you've got a lot more options. I think it's obvious in what I do. The fact that nobody seems to see any consequence in that has always puzzled me, but then I'm relaxed about that because I know many times that when you move to one side or away from a certain convention and set another convention then it takes maybe two generations to come around to it. There's nothing more that I can do except do it. And if they don't like it, well . . . Szarkowski is a good example; he can't stand it, that's it. I don't think it's my fault. I mean I have never gone to him with an argument, and I don't propose to but . . . I do feel this way, that a custodian of a cultural form, as he is at his museum, ought to be a little more limber. I think rigidity is not called for. I don't know whether I answered the question, but I made a statement about what I think.

JB: One would think with so much more color photography going on that there would be that much more experimentation and it doesn't seem . . .

HHS: No, they're just drowned in the adjacent possibilities from nature, many of which they don't exploit well and many of which are redundant anyway. Like the sunset and sunrise, and I'm hard put to know whether they then should do what Eggleston did and go to colored objects, but that's almost as dried out as the other stuff. I just have trouble, but I'm not going to worry my head about it.

JB: I wanted to ask another question based upon your background in cartooning. There's a wonderful essay called "The Harp and the Camera" by Owen Barfield in which he talks about the nineteenth-century Romantics. The wind harp was the metaphor of that time, and the camera is the metaphor for contemporary times. He speaks of the harp as open to inspiration because the air could move through it; the camera is a closed mechanism. He argues that the camera image is a caricature of our imagination. We assume that we see as a camera sees, but it doesn't directly relate to our imagination.

HHS: I agree with all that. If you stop to think about the wind harp, I don't know what the corresponding instrument would be but we have the light harp. We never knew how to do it, but for years they tried to have things like light organs. The difficulty was that it would be as though you decided you were going to use as a wind instrument a tin whistle, because they restricted what light could do when instead of opening it up they got the same thing over and over. All they needed to have done, and I still think somebody will do it sometime, if they are smart, they would have this kind of liquid form interplay with the light, and then you get away from these simple geometries which are so boring after about five minutes. What the man missed was that the limitations of the camera are honest-to-God nineteenth-century limitations. They are not limitations to photography as this stuff shows, but they are limitations to a kind of photography. Even when Weegee tried to distort his lenses by whatever he did to them, he still stayed too close to the camera-object relationship. And that was where the trouble was. Light, my God, it's all through this room, it's all through that room and you don't even pay any attention to it until it hits something, dust or smoke or ice or whatever, and boy when it does there's excitement. But that excitement is reduced when it's taken from that sensation and put into the camera. If you've ever photographed icicles you know how different the experience of the icicle is from the photograph of the icicle. That's what he is complaining about, it's in the nature of the camera. It's not in the nature of photography

or light. Now I know this is true, this is something I can speak about as a prophet or at least a person who's been fiddling with it for a long, long time. Since I was a kid, since maybe I was two when I saw my first candle lit on a Christmas tree.

Too many of the people who write about it misunderstand the range of photography. As you run over what you can do with it, like X-raying, you're presenting the world with aspects of itself, through light, which you couldn't see any other way. There's plenty to do with light, especially if you are an artist and not a doctor. You artificially limit a medium and then you say it's all the fault of the medium. You can't do that with it, to take the restriction of your knowledge and apply it to something which is much broader in range than your knowledge, then take the restriction as the governing mode or limit. You see that in lots of people who talk about photography. Susan Sontag is like that. I love the idea of what she did; I didn't like the idea that people were so uncritical of what she did. I'm talking about the people who published it. They would never have done that with other areas, what they let her get away with there. I find it kind of saddening that I didn't have enough guts or enough knowledge to take her on, but every sentence I'd stop and find a flaw in what she was talking about. I could never finish one of her damn essays because I was checking it out all the way along and it took me too long. I could have made a career out of it! Not criticizing her, but analyzing what she was saying and then testing it. She does not lay the proper ground work for one assertion on which she builds another one. I hope I don't sound like I'm pontificating, I'm kind of sore about some things, and I think in a way the new generation of people who are looking at photographs are doing it on the wrong assumptions. That's why I thought this book [Distinctions] would help me find the source of some of the assumptions. I think one of them is the half-baked teaching they get, but the other is where the dominant taste is. When Life was formed the editors took on enormous responsibility and flubbed it. They cut off a whole lot of avenues of expression simply because they felt it would not suit their readership or their advertisers or their personal preference. I followed that magazine from its very first issue, actually a little before that. I was

an ardent believer for a while until I saw it fail its duties. It was doing the same thing that the British did with photographic propaganda in the First World War. They had a Canadian crucified on a barn door, photographically illustrated, not drawn, a Canadian soldier nailed to the door. Turns out it was all baloney. One of the most beautiful ones was where they had John Foster Dulles and Richard Nixon and someone else, whose name I cannot recall, looking in adoration. The caption tells you that they are looking at Eisenhower. You'd have thought they were looking at the second coming. When you see enough of that, it's enough. Those are some of the taste-forming environments.

JB: With the burgeoning of photography in the 1970s, both in galleries and universities, do you think that the audience has expanded, become more open and educated about the medium?

HHS: I said that I felt that it narrowed and restricted almost to the point where they didn't welcome adventurous things unless they trashed the medium. I've not been to these shows, but I got the *Camerawork Quarterly* that had an overview of all the shows they've had in ten years, and it was full of this kind of stuff where you'd either trivialize something or make the human adventure seem less than perfect in a way that doesn't help toward perfection. I think this is one of the things that happened from the sixties on. And I think I have to say this even though I was involved with the S.P.E. [Society for Photographic Education]; after around 1970 it took a sharp turn away from the goal which could have been stabilizing technique and standardizing basic fundamental activity. I'm not against any of the other kind of stuff, but I think there's got to be, for some people anyway, the basic practice.

JB: You mean by setting standards of quality?

HHS: Yes, absolutely. I used to tell my young students, if this is all you want to do, go do it! You don't need to do it for credit; you don't even need to do it in my classes. I'm no help to you. Just go puddle around in it. But if you want to do this other

kind of thing, then you need to establish a system, you need to understand it. The discipline that's lacking here is the difference between honking your horn and learning the subtleties of playing it. Or smashing a guitar and playing it.

JB: One seems to get more attention these days from smashing it.

HHS: Then what have you got? You've got a broken guitar and very short attention from people with very short attention spans.

The recent fascination with the image of Jesus Christ in the visual arts is part of a complex pattern factored from historical resonance, adopted images prevested with authority, materialistic and politicized attitudes toward spiritual problems, and a genuine search for renewal. This hypothesis has been percolating in my mind now for some time. And, if all these factors seem presumptuous, vague, and contradictory, it is because they reflect the energies of that moment when coincidences and hunches collected over time merge into coherence.

Keynoted by works such as Georg Baselitz's *Good Shepherd*, Julian Schnabel's crucifixion paintings, Arnulf Rainer's *Christus* series, and more recently by the Starn Twins' *Christ Series* (to name but a few), a questionable pattern was given some urgency by the August 15, 1988 issue of *Time* whose cover bore the interrogative "Who was Jesus?" The construction of Jesus's face from art historical fragments, displaying a range of interpretive license, sets the tone for that magazine's coverage of the controversy over Martin Scorsese's film *The Last Temptation of Christ*. Why the renewed currency of the Christ image? The timing is fascinating in itself as we approach the end of a millennium—historically a moment of conclusion, consolidation, and insecurity about the next beginning. Insecurity, if one is to overcome it, breeds at least a temporary faith and a need for moral (rather than political) authority. In Western culture at least, the Christ image remains vested with that kind of authority, although it has been highly politicized by organized religion's concern with

December 15, 1987, San Francisco

power. Thus we come to an essential issue, the divorce of matters spiritual from matters religious. The image of Christ holds both religious and spiritual significance, though in the present cultural climate, it is difficult to bypass its politico-religious connotation.

An examination of the last millennial change (the end of the nineteenth century) provides an interesting and remarkable precedent. The Post-Impressionists, notably Vincent Van Gogh and Paul Gauguin, demonstrated a deep interest in religious and spiritual themes. Gauguin's *Yellow Christ,* painted in 1889, is a direct result of this kind of concern, as was F. Holland Day's staged crucifixion of himself as Christ made nine years later. By the end of the century such traditional iconography was cast aside in the search for a more purely spiritual visual language—abstraction. The increased interest in matters occult and spiritual toward the end of the nineteenth century and into the twentieth has been well documented in the catalogue to the important 1986–87 exhibition *The Spiritual in Art: Abstract Painting from 1890 to 1985,* published by the Los Angeles County Museum of Art and Abbeville Press. The essays in the catalogue constitute a revision of Modernism from a formalist basis to a spiritual one and provide a critical background for discussions such as the present one. If one applies the logic of artistic development provided by the last centennial turn, the current interest in the image of Christ presages a deeper spiritual movement in the arts.

When we planned this issue [of Photo Metro] some five months ago, we had no idea that Scorsese's film was imminent, or that *Time* would devote a cover story to the controversy the film has raised. It was coincidence. In Meridel Rubenstein's interview, we explore her concerns with myth, religion, and spirituality which she addresses both in documentary work and in staged symbolic-metaphoric images.

The journey is a significant leitmotif throughout Meridel Rubenstein's photographic work. Whether working with documentary content as in *Low Riders,* a multivalent study of low-rider culture in New Mexico, or with a more poetic and assembled vision as found in her portraits *La Gente de la Luz,* the journey is manifested both as outwardly physical and inwardly psychological. Her more recent work with mythological themes such

as the Minotaur and the Labyrinth bring the physical and psychological together in the service of exploring a higher form of journey—a spiritual one, both collective and personal. Following such a direction with a medium which is so dependent upon representation is difficult, perhaps even bound to fail, but, as one senses from this interview, Rubenstein has the will and faith for such a struggle.

Born in Detroit, Michigan, in 1948, and concluding her B.A. degree from Sarah Lawrence College in 1970, Rubenstein became a special graduate student in photography under the tutelage of Minor White at Massachusetts Institute of Technology in 1972–73. She then went on to complete graduate studies and to receive an M.F.A. from the University of New Mexico in 1977. She has been granted a John Simon Guggenheim Fellowship (1981–82) as well as several awards from the National Endowment for the Arts. She is presently associate professor and head of the photography department at San Francisco State University.

JB: For you, what is the relationship between life process (or autobiography) and the photograph?

MR: When I look back over a long period of time and many works, I often say, "This work is about home." I've been calling myself a portraitist, but the portraits are a way of me locating people in relationship to where they live. Where you live can be cultural, environmental, it can be religious. Where you live can be inside yourself, inside your mind. I mention this because it's a roundabout way of talking about life process. I tend to think about things on different levels. I locate who's there and why they're there, and use that idea as a vehicle to find out where I am in my own life. So, I will fess up to an extremely biographical or personal connection to what I'm doing. Fortunately I get to escape that by sometimes having interesting subjects that will get me outside of myself—like the Low Riders or the New Mexico portraits. But (Nathan Lyons has said this forever too), underneath what everyone does is some autobiographical connection. On a very superficial level, one could say what I do is portraiture, but there's a whole other level that's extremely personal, looking

Meridel Rubenstein, *Native Son, New Mexico*, 1982, palladium print.
Courtesy the artist.

at how people fit in and are connected, the relationships that they have and what they're searching for.

JB: What is the relationship between the documentary and more idea-oriented aspects of your work? Do you see them in opposition or are they really just different aspects of the same?

MR: I've experienced them in conflict for quite a long time, but not so much anymore. During the first ten years of my work I felt schizophrenic. I would involve myself with a real internal process and then due to several grants be called upon by the world to be concerned with external processes. With the documentary form, I feel this responsibility to include more fact, or to actually research more, involve people more, to be responsible to them. This is true for all three documentary projects, *La Gente de la Luz, The Low Riders,* and the NEA Survey: *The Essential Landscape.* I was nervous at first with the Low Riders because I felt it pulled me away from an intuitive way of working. What I learned from that documentary project was that I brought my most internal concerns to it and layered those onto it.

JB: Well, on the level of how people respond, the Low Riders are a cultural symbol. How different is that than the Bull's Head from the recent Labyrinth series?

MR: The Low Riders were different initially. The symbol of the car at first was just a car to me, but it became a coffin, a boudoir, a phallus. The cars do this sexy hydraulic hopping. They have these plush velvet interiors and wonderful imagery on the outside. I put the color photographs into a red velvet portfolio box lined with silver metallic paper and tied it with satin dice. It was important to me to contain them, especially in a sensual manner, because the cars themselves are containers of so many religious and sexual images. This was the first time I used materials to convey certain ideas. That Bull's Head, or the spiral labyrinth symbol, goes back through all of time. But the cars also represent old ideas: the chariot, the procession, and the reliquary. I'm glad you asked that question the documentary versus the idea-oriented,

internally felt picture, because the new work is all about that split. I'm really determined to act all that out in my work.

JB: As you were talking about the Low Riders cars as metal casings with this sort of velvet soft stuff inside of it, I'm thinking about your current pictures with this metal housing, a steel frame, and velvet soft Palladium pictures inside. Does that kind of opposition carry a tension that you think is important?

MR: I never thought about alchemy before I did these last pictures, but I began to work with the Palladium prints and I felt they had to have the steel frames. It's taken awhile to articulate it, but it seems to me that the materials in this latest series are crucial to the statement. Steel is the coarsest, grittiest, oiliest, crudest, heaviest, roughest of materials while Palladium is the most elegant, refined, soft, gentle. And then, I'm investigating the idea of myth. I don't mean heavy or weighted, but something that has, even in the most mundane things that we do, some kind of heroic aspect.

JB: Do you find some irony or tension between the notion of the myth and the labyrinth and their presentation in this medium which is so descriptive and literal?

MR: I'm not sure I'm going to answer this question exactly, but I think one of the things that is expressed in this work has to do with a mind-body split. The things that happen to us that often mean the most have nothing to do with anything that we understand literally. They come in other ways, and yet we're constantly being forced to understand things literally. In answer to what you're asking about something being literal or not, these pictures rest on a clash of materials and a few words that get in the way of your brain while you're trying to look at, and feel something, through the imagery.

The pictures themselves try to recreate a conflict. When you're looking at them, you have to think and feel at the same time. I'm trying to make the viewers more active in the whole experience.

JB: That requires that the work have a kind of conceptual basis. Is the intellectual aspect of that consistent with what you're trying to get at in the work?

MR: You could have a conceptual basis that was both intellectual and intuitive and you could be demanding a complete sensory, emotional kind of response.

JB: So the concept is really in the reception?

MR: I think I learned that from the Low Riders, because what you really get from the Low Riders is touch and emotion. Then you can make all these other kinds of associations, but you have to touch all this stuff first.

JB: In that sense then, the experience is really within the physical quality of the materials. But, photography's not very physical?

MR: Not usually, it's very cerebral, unless you choose to make it physical.

JB: This goes back to the problem of how you have literal, very cerebral information that's rendered by the lens, which is intended to call forth an experience which is far more dimensional than the physical or material.

MR: The idea of charged symbols or icons is very basic in my new work. You've got the naked body, the bed, the fire, and the spiral, and those are very charged symbols. I should ask you as the viewer, do you react on an emotional level when you see these symbols or does your mind start working to make certain meanings?

JB: There are two parts to that. One is on a symbolic level. I tend to respond with the intellectual, reading the symbols and trying to make those associations. On the other hand, if one is struck on the iconic level, the pictures really function well as gateways. The moving apart on several of your pictures there,

Meridel Rubenstein, *Home,* 1987, four palladium prints on steel.
Courtesy the artist.

they're torn, for example, and the separation is really the sense of the gateway or the passage through.

MR: I never intended the narratives to be read literally. But I did realize, thinking about this work, that I was trying to get people to experience a series of images as if moving along a pathway or a bridge.

JB: Do you find that portraiture stands somewhere in that middle ground between the documentary and the idea, or the more kind of metaphysical aspects? Is that one reason why you've been attracted to portraiture?

MR: Portraiture came first before I ever thought about the document—it's always been there at the heart of what I'm doing. I never thought of speaking about it in this way, but people are containers, they represent all our beliefs, they have stories, and they have longings that fit into both realms.

JB: To me the ultimate question for a portraitist is how, when you're working with such an extraordinarily powerful descriptive tool as a camera, how much of an inner experience does that render and how accessible is that in the image?

MR: For a long time I tended to think I was completely invisible in my images. I was always amazed when the pictures seemed to be as much, if not more, about me than about the subjects. It's only with this newest work that I chose the subjects because their stories were something that I needed. I wasn't totally denying their existence, I was interested in them for my own purposes.

JB: In working with your figures, there's more of a sense of anticipation.

MR: Anticipation or recognition of a warp change, if warp is the right word to describe where one reality is about to merge into another, that moment of change. In a metaphysical realm,

one would talk about transformation. A lot of these pictures seem to me poised at that moment where there's a possibility of transition—like the bed just erupts into fire or the person just splits.

JB: And when you're working with these people in a directorial mode, are you trying to create a meaning through a visual equivalent or are you actually working with them as in a performance?

MR: It wasn't very much of a performance except for the fire. They're very frozen and I use them as icons—I don't like the way this sounds much, but they actually were arranged.

JB: Is the inner experience of the people that you're working with somewhat irrelevant?

MR: Yes. In fact, I was very nervous about what these would mean to them, so I had to have private viewings for everybody. They weren't used to this, they were used to being themselves in my photographs.

JB: Is psychology some kind of language to come to grips with the intangible?

MR: Art does that all the time. One of the biggest problems about photography is that it's always been completely tied to the literal, the idea that whatever you point the lens at is true or that something was real and alive at that point in time and it's not intangible. But, I've raged against that idea, because it just depends on how you use the medium.

What I'm doing in this work is actually taking a 5 × 7 negative and enlarging it to a 20 × 24 negative—I'm playing on the optics to a fairly heightened photographic degree where things are sharper than one can imagine. There are things about these images that are extremely photographic in terms of light, line, sharpness, tonalities, all this stuff that suggests the real. But you can create a form of description that's so heightened that it's "supra" real. That gets you to some other kind of level. I don't know if you could say it was intangible, but it's very heightened.

JB: You did some special studies with Minor White. Was he an important influence at that particular time?

MR: Wendy McNeil was my first influence, as a friend. Minor was my first serious teacher. At MIT, I took one of his creative audience classes, designed to teach people how to experience photographs. There would be a Weston "pepper" photograph and he would have these scientists doing physical things, like touching hands and dancing to the image. I respect the idea, but I still didn't understand why you couldn't get that charge directly from the image, why you had to loosen up, go through these mind altering states. There's some of that in these pictures. I'm sure that comes from him, the idea that the photograph could convey an altered state or an extremely intense spiritual experience.

JB: Is there a quality of religion in your work?

MR: No. There's only a desire. I said such an emphatic no, because I don't myself know what religion is in terms of my own experience. But there's a longing and desire expressed in these images to enter a sacred space, to be able to have the time and attention and understanding to do that. There's an internal space which is sacred, but then there's that sacred space which puts you in touch with all the goings on in the universe. These images express that longing, that desire.

In light of the question about religion, I realized that what I'm trying to do next is find sites that aren't interior, that are mythic, but are real and involve communities, and that raise some of the same issues that the Labyrinth pictures do. For example, I photographed a ranch foreclosure this summer in Montana that involved a large family. I am trying to weave a piece about home, the loss of home, the breaking apart of a family in the present but with references to more dreamlike, ancient ideas. I'm also going to be working at Los Alamos to try to make a piece about the implications of that community. The Labyrinth pictures were about that solitary person trying to figure things out, and now I'm going to involve larger groups of people.

JB: Do you think that's been encouraged by your having moved to a city?

MR: Partially that and partially a notion of wanting to incorporate the real world. San Francisco is certainly more the real world than a place like New Mexico. There's a whole element of place out-of-time there, where here you're really in the moment.

JB: In terms of writing the text stamped in the steel, does it come before or after the imagery?

MR: The text has all been after the imagery. Again, it's trying to add one more layer that will give you some sense of different dimensions. In some of these pieces, particularly in the bed with the maze, I've actually tried through language to take the viewer from an everyday space into a more mythical kind of space. Or just the use of a word creates some kind of pathway where you get to go inside. There is one piece that is just a listing of names. It's a counterpoint piece where you see these mythic figures, but there's stamped in the steel all these names of cultural heroes— like Galileo, Freud, Marx, and Jesus. I wanted to create a litany of names that we constantly measure ourselves against. All these heroes we have that we want to be like and do as well as. But in another way, they get in the way of our ever accepting ourselves.

JB: Is the text written in response to the imagery? Is it inspirationally formed?

MR: Some were like the one that says "Don't kill the Minotaur dance with the bull."

JB: It just showed up in your head?

MR: It just showed up as in neon that it should be dancing around on top of that image. In the picture of a bed with a maze in it, I used the language to charge the bed a little. I don't know if you've had this experience of people complaining, but in my life, people always complain. So, in this image, the voice says

"the pillows are too hard, there's not enough light to read, I can't see the clock," and it moves from this mundane language to more mythic statements: "The table's set with knives and forks. There's a fire. Now."

JB: Generally speaking, we explain the irrational by what we know as rational. In your combination of text and image, things seem very rational but the entire basis is irrational. It's a very subversive technique. Could you talk more about symbolism?

MR: Let me just refer to this one picture called *Cochlea*. It's a big, eleven-part picture. The overall image of the rope labyrinth is broken into four main parts with other pictures showing through the cracks. (There's a big ear in the center, water, a doorway, columns, and ruins.) The whole image is resting on moving through these symbols in a visceral manner.

JB: Do you feel a connection to the Postmodern era in either agreement or reaction against that?

MR: This new work is my response.

JB: Is it a reaction against what has been politicized as Post-modern, or . . .

MR: No, it's a reaction to that idea of the death of the self. This is where I, Meridel, am interested in a lot of the same questions about identity and culture and media and the things that get in the way of anyone knowing what they think, who they are, and what they have to say. This work is really trying to make a plea for a direct experience, however impossible that may be.

JB: Using photography makes it a mediated experience right away.

MR: Some of my images talk about the way culture prevents us from having our own experiences. We certainly need to read, to embrace certain things we've been given. But then we need to

move through them to get at our own experiences, as best we can. I still can be seen as a Postmodernist, and still see myself as a victim of Postmodernism. I can't avoid that theory, it's theory that I read, I think about, I ponder. It definitely is affecting what I do, but I see myself completely on the other side. There's this poor self that wanders and tries to locate its place amidst all of this activity and imagery and second-generation experience.

JB: It's almost impossible now to have an aesthetics which isn't politicized as well.

MR: The political aspect of Postmodernism has shaken up a lot of things that needed to be shaken up. We need to rediscover the basic things about art and life. Then you get caught again in that you're going back and there's nostalgia. Hardly anyone's been able to move beyond Postmodernism to see it—it's sort of presented as a wall. You're saying that political connotations have gotten in the way of certain ideas, and I think that too. The theory has dead-ended everyone.

One of the things about being on the West Coast is that we still have some modicum of nature left. I think that's going to be a saving grace for trying to get beyond this Postmodern theory, which is overwhelmingly one-dimensional.

JB: Postmodernist theory may be more about the audience than it is about the art.

MR: Theory is one of the most ultimate forms of sublimation I've ever experienced. The things that Postmodern women have done in terms of their use of language and in attacking the whole woman/object idea can only help open up a different way of using imagery. But overcoming the Postmodern wall is going to have to do with seeing nature, the universe, and sensual concerns in a completely different way.

The task of the critic is to transcend the idiosyncrasies of his own vision. This can be done by using these idiosyncracies as a point of departure, thus making them a strength and an inherent part of subsequent commentary. The second method is to ignore them, to strive for a more objective view based on the traditions of the medium being considered. The first technique mentioned is certainly the more popular, more akin to informal conversation; the second is more academic. These aims parallel those of the photographers exhibiting in *Primitive Images*. The photographers included have engaged the vision peculiar to plastic and pinhole cameras to make images which celebrate the idiosyncratic for its own sake and to use these cameras' transformative powers to give us a refreshing if not novel view of the world.

Primitive Images is an international exhibition. Its intention is to be a survey of the photographic work being done with plastic (the famed dime-store Diana, for example) and pinhole cameras. While most surveys are done out of curatorial initiative and invitation, this exhibition is an exception in that a general call for entries with a fee was placed in a number of photography and art publications. Thus, the work represents a broad spectrum of picture ideas and techniques. The show is evenly divided between images made with the two kinds of cameras, while the prints range from straight black-and-white to toned black-and-white to Cibachrome and Type C color prints. For the most part the images are fairly small in scale due presumably to the technical limitations

PRIMITIVE IMAGES

at Eye Gallery,
November 1983

of the negatives produced by the primitive cameras. Yet the quality of the prints is so refined as to betray this lack of sophistication in the cameras' optics.

The pinhole camera has a longer history than photography. It is a portable version of the camera obscura first practically described and made accessible to the Western world by Giovanni Baptista della Porta in 1553. (The camera was known and used for astronomical observation as early as the eleventh century in the Arab world.) Della Porta's work was termed heretical by the Church in the sixteenth century because of the magical quality of the image. The camera uses the principle of selection of coherent light waves reflecting from objects to recreate the image on a projection surface. It was used by artists and draughtsmen as an aid to rendering nature long before the technology was available to record that pale image on a light-sensitive plate. Perhaps one of the most significant aspects of the pinhole camera was that it could be made by the artist-photographer to suit his or her specific needs. The format of the image simply depended on the relationship between the size of the hole and its distance from the projection surface. A shorter camera is more wide-angle than a longer one. While the variables are easily controlled the acutance of the image is governed by the precision of the hole itself. It is theoretically possible to make an image which approaches the sharpness of the lens-made image, but the pinhole does not correct for differences of color wavelengths.

The pinhole work in this exhibition is sharper than the work done with the plastic cameras. The latter tend to be less optically logical. Wiley Sanderson has made black-and-white paper negative images of a nude in which the limbs show extreme foreshortening. Sanderson's images are circular, a format which best uses the image projected by the pinhole. Willie Anne Wright has made direct color images onto Cibachrome materials. She uses still-life set-ups to make the viewer aware of the imposition and distortion of her camera process. The blurring which occurs in the foreground of the pictures is notable for its similarity to some of the earliest still-life pictures made in the late 1820s by Hippolyte Bayard whose images were also made with a reversal process. Given the nature of the pinhole technique and its ex-

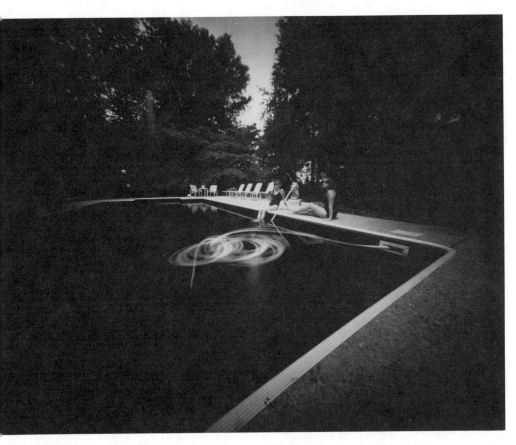

Willie Ann Wright, *Jack B's Pool and Hose—Janet and Susan,* 1983, gelatin silver print. Courtesy the artist.

tensive history, images produced with it are bound to have historical precedence. What is more pertinent to this exhibition is that to choose to work with a pinhole (and this is true of plastic cameras as well) when more sophisticated optical instruments are readily available becomes in itself a statement by the artist. In the rejection of modern technology is an instinct to rejoin the folk tradition in which the individual, rather than depending upon equipment commercially available, assumes full responsibility for the design and production of his tool. The resultant images are to a certain extent structured by that design.

The choice of using a plastic camera represents a different, but related artistic statement. The plastic camera is widely distrib-

uted, inexpensive (between $1 and $5), readily available, and technically crude. To use such a camera for aesthetic purposes is to contradict and challenge the norm. The folk tradition engaged by this act is to use the most commonly available tool for highly individualistic purposes. To move past the seeming limitations of the camera through such manipulations as taping the back to block light leaks or attaching color filters to alter contrast leaves the photographers free to capitalize upon the idiosyncrasies of technically imperfect lenses. There is consistency of visual structure regardless of subject matter in the plastic camera pictures because of the square format, color distortion and edge aberration.

In an article entitled "Photography as Folk Art," Jerald Maddox wrote:

> Like other folk artists, the folk photographer offers a different vision, which is in its own way as important as anything other approaches offer. It obviously is not a question of aesthetics, nor of specifically significant subject matter. It is rather the offering of a way of seeing, personal and intensely concentrated; and when one thinks upon it, this is what photography has been concerned with from the very beginning.

Primitive Images is a clearly defined body of photographic production, a collection filled with technical and aesthetic idiosyncrasies. The folk impulse to transform the visual world is as living in photography as in any other medium. Yet, the viewer becomes aware of the collective aspect of the search for style because of the overriding consistency of appearance governed by the choice of camera. This perspective is one of the show's greatest strengths.

Minor White was a master of camera craft. His vision was transformative, antiliteral, antidocumentary. He treated the visible world as a point of departure for the camera and as a vehicle for his vision and philosophy. In White's work one experiences the image as removed from the appearance of the world he photographed, though he carefully titled and dated each one. In search of a form to extend this vision, he evolved a poetics of image based upon the sequential order of photographs.

This retrospective exhibition comprised a number of photographic sequences formed throughout his career as photographer, teacher, writer, editor, and curator. With slight variation, all the sequences in the exhibition were published in *Mirrors, Messages and Manifestations,* which White authored in 1969. This tome, recently republished with warm welcome, includes selections from White's writings as well as several other sequences and many portraits. The book has become a classic of photographic literature as it set the standard, rarely attained by others, for a spate of self-designed and self-published photographic books in the 1970s. The book is a testament (to borrow a term White used) to his power as a photographer and philosopher; it provides a much fuller view of his work than the present exhibition. The selected sequences, however, are exemplary, and the prints, including small card-mounted images of early work from the California Historical Society collection, are a celebration of technique.

White was directly influenced by two major figures in the history of photography: Alfred

231

Minor White, *Tom Murphy,* from the sequence "The Temptation of St. Anthony Is Mirrors," 1948, gelatin silver print. Courtesy Minor White Archive, Princeton University, copyright © 1989 by the Trustees of Princeton University. All rights reserved.

Stieglitz and Ansel Adams, who in turn was influenced by Stieglitz. An entry in one of White's journals quoted by James Baker Hall in *Minor White: Rites and Passages* reads: "Stieglitz asked him, 'Have you been in love?' And when White answered that, yes, he had, Stieglitz said, 'Then you can photograph.'" Baker maintains in his essay that this concept of love was a central part of White's work. His portraits, some of the strongest in modern photography, are the clearest and most direct expressions of this love. They evidence deep personal connections and rich under-

standing of human psychology. Unfortunately, they are under-represented in this exhibition.

If White was affected on a personal level by Stieglitz, he also absorbed two ideas from Stieglitz's own photography: Equivalence and a technique of sequencing images analogous to the construction of music. Stieglitz set an important precedent in the ordering of pictures, and should be credited with positing the formal idea of sequence as an expressive and poetic form for photography.

Minor White harnessed the form. He evolved many sequences of his own images, which he sometimes titled simply with numbers. Other titles, such as *Sound of One Hand Clapping,* arose from White's involvement in mysticism and occult philosophy. This mystical outlook became White's credo and provided the language within which he shrouded and explained his photography. In *Rites and Passages,* he wrote: "While rocks were photographed, the subject of the sequence is not rocks; while symbols seem to appear, they are pointers to the significance. The meaning appears in the space between the images, in the mood they raise in the beholder. The flow of the sequence eddies in the river of his associations as he passes from picture to picture. The rocks and the photographs are only objects upon which significance is spread like sheets on the ground to dry." Like Stieglitz, White became his own best spokesman.

Of Ansel Adams's influence upon him, White wrote: "Ansel met me at the train yesterday. This morning in his class at the old California School of Fine Arts the whole muddled business of exposure and development fell into place. This afternoon I started to teach his Zone System. Ansel did not know it, but his gift of photographic craftsmanship was the celebration of a birthday." The Zone System is a photographic technique which treats literal rendering of the tone scale as a reference point and springboard for pictorial interpretation. The key to using the method is previsualization: the disciplined photographer is able to visualize the appearance of the final print before calculating an exposure and development.

White coupled the use of this sophisticated technique with his personalized understanding of the concept of Equivalence in-

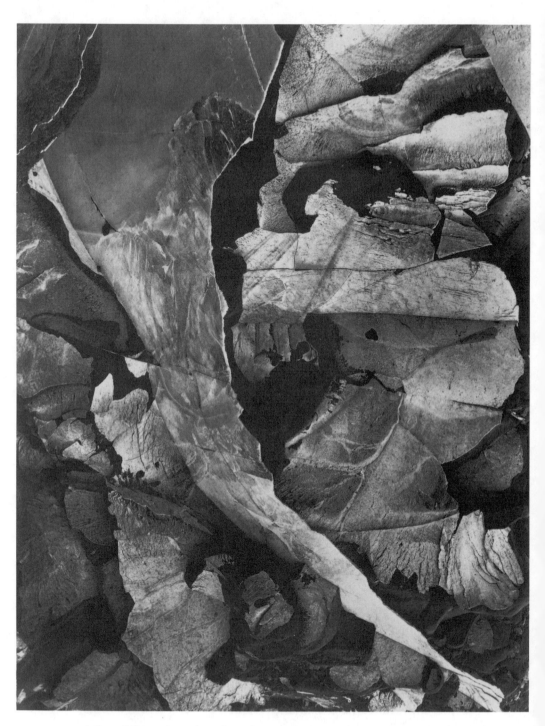

Minor White, *Capitol Reef, Utah,* 1962, gelatin silver print. Courtesy Minor White Archive, Princeton University, copyright © 1982 by the Trustees of Princeton University. All rights reserved.

herited from Stieglitz. By using the Zone System of exposure and development he was able to transform a fairly simple rock formation into a night landscape whose scale and spatial structure were ambiguous enough to refer to a larger cosmos. The final image is removed from the subject matter through an interpretive process resonant with personal vision, a vision which strived for higher knowledge through intuition. White raised previsualization beyond the practical to an intuitive level. One wonders at the eyes and mind that could see the world in such a way. His strongest nature images inspire awe. With patience the viewer can live into the transformative process, in a sense read the picture backward to its origin without sacrificing the integrity of the initial response.

The sequences seem far more tenuous than the individual images. White built his sequences using a variety of connecting links. The most basic one is graphic, the repetition of similar shapes, lines, and forms. Another is the juxtaposition of images of different spatial orientation; a picture which shows deep space is placed next to an image which is planimetric or has ambiguous spatial orientation. He thus creates visual tension and an engaging rhythm. The most complex technique is associative: he approaches the images as Equivalents, as reflections of inner experience. The image takes on symbolic properties, sometimes highly idiosyncratic. Pictures related in this way, while meaningful for the initiator, are often inaccessible to the viewer. White used care and restraint when working on this level. None of the sequential relationships seem arbitrary, yet they remain open-ended, fluid, an invitation to the viewer to discover and direct his or her own perceptions. This can be a revealing exercise, but unguided it can be as misleading as it is useful.

Minor White's work sits firmly in the territory of modern photography. He produced a body of work which has an unmistakable style and a personal vision and world view. His belief in Equivalence allowed him a self-expression in which there is a resonance between inner and outer experience. Many of the images and some sequences work forcefully on this level; they ask to be seen in this way (aside from the fact that they are beautiful pictures). But the poetics he developed through sequencing de-

pends upon a faith in language not freely given in Postmodern time. The sequences depend upon an initiated audience to be deeply understood. White expended much energy in educating his audience through his teaching and lecturing. Without the presence of the photographer or his words, the sequences as a whole lack cogency.

Helen Levitt's photographs of street life in New York City are flawed in one major respect. They are objects, still images, coded representations twice removed from direct experience, counter-flux to a living reality. Yet, as this thorough and thoughtful retrospective of her work and ideas makes clear, Levitt was so attuned to the metabolism of her working environs that some of that living reality pulses through the stillness. Her earlier images in black and white reflect a kind of grace that no longer permeates culture and cultural artifacts. The later color images, filled with older people who lack the strength to stand or courage to engage the camera, track the fading grace. The exhibition makes poignant the problematic linkage between art and life, and the obstacles photography presents in constructing that link. Camera photography has by convention been considered the art medium most tied to the concept of facsimile. But Levitt's work is so much about participatory perception that representation or likeness seem of secondary concern.

In sum, Levitt seems far more interested in the morphologies of life than in the pursuit of artistic expression. There is such a consistency of style and approach that the mediation process (no matter how spontaneous or conscious the hand camera makes it) is transparent. The picture window is probably the most conventional metaphor to describe this function for the image. But no window exists without substance, whether psychological or biochemical. And neither is there a perfect window. The physiological limitations of vision are but a small piece in

237

Helen Levitt, *New York*, 1939, gelatin silver print. Copyright © 1993 by
Helen Levitt. Laurance Miller Gallery, New York.

Helen Levitt, *New York,* ca. 1945, gelatin silver print. Copyright © 1993 by
Helen Levitt. Laurance Miller Gallery, New York.

the complexities of perception. In her still images, one feels close
to the artist's intelligence and sensibility and responds to the
absence of egocentricity, but her predilection for the forces of
life over the formality of medium is most clearly demonstrated
in her films, especially the one included in the current installation,
In the Street.

Helen Levitt is before all else a cultural ethnographer whose
chosen milieu flourished with openness, diversity, and pre-cam-
era-consciousness. She portrays the world as childlike innocence
thriving despite and possibly because of the often rubbled, con-
gested neighborhoods. Play is certainly the centerpiece of that
innocence. To engage it as a cultural phenomenon, one has to
look through the picture window. Notwithstanding her some-
times leaden prints, Levitt was adept at presenting the world as

beckoning and accessible, if not totally decipherable. Perhaps this presentational mode links her with the Surrealist stream— an inventory of all the information in a picture in no way explains its reality.

New York, 1940, an image which appears in two versions in the exhibition and three times in the catalogue (once as frontispiece), is in many respects Levitt's still summa. It depicts: an event (the shattered mirror), an omen-laden moment (mirror as symbol of unconscious with gate keepers and potential rite of passage), a constellation of characters (a naturalist's stage setting), a potent case for gender typing and class distinction (three, possibly four, generations of women gathered by the laundry, men gathered in front of the general store), and an iconographer's quarry (signs and artifacts abound). And, all of this is centered around child's play.

Both curator/authors of the catalogue, Sandra Phillips and Maria Hambourg, make much of the issue of play in their respective essays. Phillips looks at it in a more theoretical mode by pointing out its archetypal and ritual significance. Hambourg describes it in the images as something on the order of choreography. Neither of them quite reach the heart of the issue, however. Free play, the kind of streetwise spontaneous play that was available and attractive to Levitt, is in many ways the purest expression of an unfolding order that brings individuals, cultural values, social mores, and raw energy into harmony. The guiding principle of that order is imagination. As one travels from picture to picture, from the well-known pictures to those never exhibited before, one marvels at what was accomplished with limited means in a city environment that would soon implode under the stresses of race, class, and inequity of opportunity.

What one meets within Levitt's pictures is a quality of imagination unspoiled by fear and not yet preempted by television consciousness. Violence, gang warfare, and ethnic animosity have been a part of daily life throughout the time that Levitt has photographed. But it is not evident in her pictures. Neither has she chosen to photograph teenagers and younger adults who bear the roles of warrior and providers. These are the age groups that face economic and territorial demands and responsibilities;

they also have little time or use for the pleasures of imagination. Her other predominant subjects are senior citizens whose complex of dreams, experiences, and exhaustion render them inert—living in waiting, soulful, and empty.

The link between art and life parallels that between image and imagination. As paired concepts, they represent philosophical problems that have vexed artists, particularly in the twentieth century. Levitt's sentience, her capacity to translate feeling consciousness into picture order, is quite extraordinary and key to her overcoming the limitations of medium. Whether one ascribes this capacity to a feminist-based aesthetic, or simply to her own natural gift, her deep appreciation for the expression of imagination (with the joy still fresh), put her in a good position to record those expressions with directness and reductive artifice.

She had good company to work with: Henri Cartier-Bresson for inspiration (thus the Leica); Walker Evans as an aesthetic and cultural foil; James Agee as a motivator; and, Janice Loeb for companionship. Both catalogue essays explore the significance of their personal relationships in great depth. Phillips examines the formal, historical, and contextual views via graphic influences and parallels. For example, her revelation that Evans made the subway pictures later published as *Many Are Called . . .* with Levitt at his side as coach and inspiration is an important recasting of that body of work and of Evans's working methods. Levitt's Judeo-humanism provided a balance to Evans's waspish detachment. Hambourg traces Levitt's bio-artistic development, particularly her predilection for the Leica in homage to what she viewed as Cartier-Bresson's pioneering accomplishment—an integration of Surrealism (the prevalent mode in the late thirties and early forties), reportage, and formal elegance. Cartier-Bresson was a spiritual guide for her intuitive grasp of the world around her.

Her films were made in collaboration with Agee, who shared his capacities for production with both Evans and Levitt. *Let Us Now Praise Famous Men* thrives from his compassionate narration. And it was Agee who developed the jazz soundtrack for *In The Street*. The moods and structure of the music seem as connected to street life as the home-movie-like footage. An innocence and

simplicity prevails throughout. As much as the realm of feeling is critical to all of Levitt's work, the filmic movement is its closest equivalent.

The triad of Evans, Levitt, and Agee is an interesting one from the standpoint of collaboration and coinspiration. They personified in the same order, thinking, feeling, and willing to use the literary terms of philosopher and critic I. A. Richards. This threefold view of consciousness holds that each is equally important though each has a different character and is associated with a different aspect of the body—head, heart/metabolic, and limbs. This physiological picture translates readily into interpersonal dynamics as compensatory needs. From this perspective, their camaraderie takes on an interesting dimension, a cast of necessity and destiny—of place and time, New York City at its zenith. Levitt was not a seeker of public recognition. But her artistic sensibility was integral to both Evans and Agee whose names and reputations have overshadowed hers. It is to Phillips's and Hambourg's credit to have set the historical record right, to have given Levitt the exposure her work deserves. And it should be added that her work seems to benefit more from the intimacy of the publication than from the current installation. Perhaps most important, the curators have given the viewer the opportunity to reconsider the value of soul-consciousness as a mode of understanding and expression at a time when the Postmodern is hovering on the edge of cleverness.

Aspects

of

the

Psyche

Anne Noggle has worked with portraiture throughout her photographic career and has brought to photography a woman's perspective of the relationship between camera and psyche. Her images are celebrations of individuality yet collectively address the process of aging. In searching for a photographic form which could adequately reveal an individual or group, she has drawn inspiration from two masters of the portrait, Julia Margaret Cameron and August Sander, and, in Rosenberg's terms, has moved toward a reduced means for conveying her perception. Her most recent portraits are done in the isolation of her studio against the neutral background of a cement wall. Her self-portraits achieve an intensity of introspection rarely found in the history of photography, an introspection which is the driving force behind her ability to understand and portray others.

Born in Evanston, Illinois, in 1922, Anne Noggle's childhood dream was to fly airplanes. By the age of eighteen she had received her student pilot license and at twenty-one became a Womens' Air Force Service pilot. During World War II, she served as a flight instructor. After the war she taught flying and then, in 1947, joined an aerial circus to do stunt flying. The following year she spent crop-dusting in the southwestern United States. In 1953, she returned to active duty in the Air Force, assigned as intercept-controller. In 1958, she was transferred to Paris as a protocol officer and there became interested in art through off-duty visits to the Louvre and other European museums. Owing to development of emphysema, she

AN INTERVIEW WITH ANNE NOGGLE

November 1985, San Francisco

The moral principle of portraiture is respect for the identity of the subject. Such a respect does not come naturally in a medium that can without effort produce countless unrelated likenesses of the same object. Light, of which photographs are made, can endow people and scenes with emotional associations that are completely irrelevant to them—a half-lighted face transforms every girl reading into a pensive madonna. To achieve truth, the photographer must curtail his resources, which means he must make photography more difficult. HAROLD ROSENBERG, "A Meditation on Likeness," from Portraits [Richard Avedon], 1976.

took a forced disability retirement in 1959 and moved to New Mexico to recuperate.

In the fall of 1959, Noggle entered the University of New Mexico as a freshman majoring in art history. She took her first photography course in 1965, and from this experience decided on photography as a new career. She enrolled in the graduate photography program at the University of New Mexico (Master of Arts, 1970), then under the direction of Van Deren Coke. The photographs of Diane Arbus and Julia Margaret Cameron were important influences on the development of her work in the late 1960s when she made portraits with a 35mm 140° Panon camera of middle-aged or elderly people in their environments. After 1970 she began to photograph at much closer range with a wide-angle lens with her primary subjects being her mother and mother's friends. From 1970 to 1976 she was the acting photography curator at the Museum of Fine Arts in Santa Fe.

In 1975 she received a National Endowment for the Arts fellowship (another in 1978) to travel across the United States to photograph older women. That year she produced the *Face Lift* series, a psychologically intensive self-examination from before and during the recuperative period following her face lift. This series marked a concern with self-portraiture which continues to the present. From 1976 to 1980 she returned to photographing friends and family while experimenting with combinations of long exposure, ambient light and electronic flash. The *Silver Lining* images from 1978 are portraits of middle-aged and elderly couples. In 1982, Noggle received a Guggenheim Fellowship to photograph people in Seattle and Texas, out of which she evolved the series, *Seattle Faces*. A monograph *Silver Lining* was published by the University of New Mexico Press, 1983. She currently lives in Albuquerque and is adjunct professor of art at the University of New Mexico, where she has taught since 1970.[1]

JB: You have commented that your life and your work are completely integrated. Could you speak about that?

AN: I don't have just a private life and a public life or a life that is photography and another life. They are one and the same. I've

given myself over to my work almost completely. Sometimes I feel it's frightening in that I live my work. In another sense the work is so personal to me that I can't help but live it. As I get older I have less need for a private life.

JB: Why is that?

AN: I think we become more neutral, sexually, as we get older. I've also gotten deeper into my work and that has taken over my life. And I like being around other people who are doing the same kind of work that I am, share the same problems, speak the same language. I'm comfortable that way. Also, the urge is stronger to develop and complete a whole body of work; that's where the element of time comes into it, and I am more willing to devote myself to my photography. Since the main thrust of my work has to do with women and aging, I sense that a large number of images with a lot of variety in the faces of the people will make it more understandable, as a whole and as individual images.

JB: Do you see this as a way of building collective portraits of some of the individuals since we can follow them chronologically?

AN: I would like to think I could continue doing that, but the principals, my mother and Yolanda are no longer living, and there are only a few people left, including myself, that I have followed for any period of time. So maybe that is not the most important thing now; maybe it's just the gathering of a lot of photographs. I didn't know, earlier in my career as a photographer, that I would ever believe that a large body of work would be as important in its own way as the rather distilled, complete in themselves, smaller body of work was to me then. I aimed then for twelve or so images a year that would stand on their own. They are honest photographs but not especially kind. Change is evident in my work, because I don't photograph in the way that I did five years ago and the difference shows. That may be a comment on my change toward a more humanistic stance.

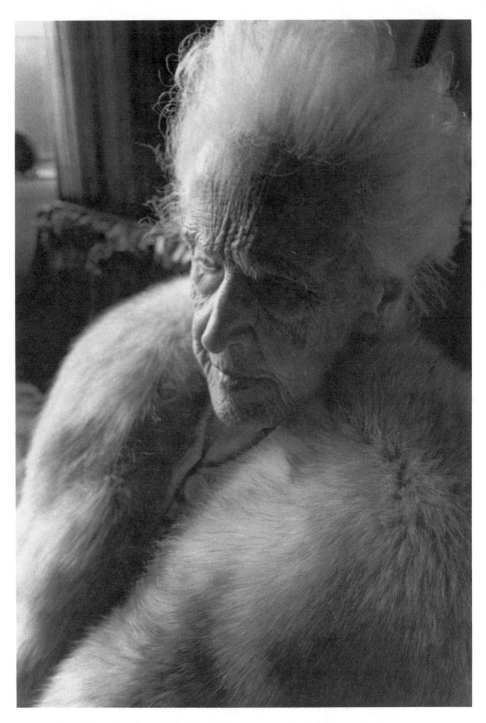

Anne Noggle, *Agnes in a Fur Collar,* 1979, gelatin silver print.
Courtesy the artist.

JB: You mentioned that you feel your pictures are becoming more compassionate.

AN: I accuse myself of that, I think it's true. That came from photographing people I didn't know well. I would feel that I was using them in a bad way, if I used them to point up some aspect of aging. When I want to do that, to show the toughness of it or some unromantic aspect, I use myself. In the past, my mother and Yolanda allowed me to picture them that way. The faces I photograph now, I see more as heroic, rather than pitiful or sad.

JB: I find your mother's statement, that she didn't want to look at the pictures any more, but instead to just give them to you, as a reflection of the relationship between portraits and people's inner lives. It's not just a question of appearance . . .

AN: Yes, and of opening yourself up and letting everyone see very clearly what she is, what she is like. I use that in the present tense because, though she has passed away, she is still there in that aspect. Photographs stop people from disappearing too. I don't think it takes anything away from them, but it leaves an aura. I feel the aura of both my mother and Yolanda very strongly in the photographs, and it makes me often refer to both of them in the present tense. They seem alive; I can't picture them as not being somewhere.

JB: In what form do you sense them being with you?

AN: It's a sense of presence. It's a mixture of appearance and in my mind the thought of them. But this is represented by their visual image which stimulated this knowledge of them. And I also hope that there are a number of photographs in which they appear to be very present, in which there is no obstruction between the viewer and the person. I always feel that there is a direct encounter in the picture of Yolanda with the silk hat. I feel her presence that way. It is also memory. I've never taken a photograph in which I can't remember what kind of a day it

was, and what that presence was like, everything about it. The moment in which you take the photograph all that becomes etched on your brain.

JB: How does the amount of time you spend with your subjects affect this experience? Do you have such clear memories from the more recent work in which you've had less time to spend with the people?

AN: A couple of hours is pretty big experience for me. Three-quarters of that time is not spent photographing, but rather in talking to the people and taking initial photographs to get beyond that feeling of tension that comes with their nervous encounter with the machine. They know they are being recorded for something and that it might just be around for a long time. At least I have a sense that they do. They are nervous about it because they want to present something that is good for or to them. They want to do it right. I've never photographed anyone that I have failed with that didn't always think that it was their fault that I didn't get a picture.

JB: Do you think that people feel that you are a vehicle for them?

AN: I suppose they do. Though, I don't know if they define it down to that. But when the sitters have definite ideas about how they want to look, you find yourself working at odds with them. Their concept is a narrow one, a one-dimensional notion of pretty, or glamour, that has nothing to do with reality. But I enjoy working with them. Cooperation is wonderful.

JB: That really is a photograph as a mirror.

AN: They never ask how the photograph turned out if I don't use it. It is as though it had never occurred. It must be hard for them. Even if you explain that it was your failure, they have a hard time accepting it. People are really nerve endings close to the surface, apprehensive. They want their picture but going through it is very difficult.

JB: Are people fascinated with the notion of being translated into an image?

AN: Yes, and they also know because of the way I explain what I'm doing that I want a lot of photographs of those of us who are older to show what it is like to be there. They want to be part of that visual history. The reason I can do this is that I am older myself. I know what it feels like, so we share this. They are willing to be open to me for that reason. I work very slowly, so they have time to respond on that level.

JB: The earlier work seemed more directorial whereas the more recent work shows more of an interchange.

AN: When I don't know the people I don't try to project some idea that I have in my head, using them as a vehicle. That's not fair. It's only with your friends and family that you can use them in some way with their agreement.

JB: About the self-portraits, because you have tracked yourself over time, do you find a parallel with what Rembrandt did with his self-portraits. Do you feel any connection with that idea, regardless of his motivations.

AN: It's a little different because much of what I do with self-portraits starts as an impulse, catalyzed by an event. In the most recent self-portrait (*A Rose Is a Rose Is a Rose*) I caught a glimpse of myself in the mirror with my hair plastered down while I had bleach on it, and I thought I looked particularly vulnerable and more starkly naked than being without clothes. Then, of course you have to go through the mechanics of setting up the photograph. After that I don't try for expression, I try for feeling, and the expression follows. I stop thinking of the camera and go back inside my head, where our life goes on when we are by ourselves. I usually take five or ten images, rethinking it each time. Or rather, re-feeling it. That is where expression comes from—our thoughts are the breeding grounds for how we look— it's the subtle things, like the play of emotions inside your head, that reflect in your face.

JB: So the images become a record of the thought process as you work toward the final image.

AN: Yes, it also has to do with the fact that if you took it the next day, your whole thought pattern would be different, and so would the picture.

JB: Do you consider your work diaristic?

AN: Some of the pictures are. But my interests are broader than that. The self-portrait I made while floating in Cochiti Lake is about what it looks like to do that. I was fascinated with the idea of it, with its visualness. So these images are not really personal; I use myself as a vehicle for a visual idea. On the other hand the image *Darkroom* is diaristic. It was a very dark time in my life and the picture reveals that. When I printed it I found it difficult to look at myself, the bitter set of my mouth, the new lines in my face. By then I thought, "Let's start being objective about this." Then I immediately liked the image, although subjectively it was not pleasant.

So for me there are at least two directions in the self-portraits. One is self-revelation, the other is more about ideas. For example, the image of me in the rain forest, aside from being a visual joke on the Wynn Bullock piece, has to do with nostalgia associated with my older body and also decay. I want to make these ideas explicit and to make light of them too. The end of one's life is just as natural as the beginning of it. Although I can't say the beginning of it comes about in a very natural way.

Almost no one that you know ever just dies, they pass away. The reasons we can use this euphemism is that we cart people off to the hospital when they get old as if they were sick. It's out of sight, out of mind. They disappear more than they die. Death is something which Americans rarely encounter unless somebody is hit by a car. We just hide death. In other cultures, such as India, it's perfectly natural just to die out there on the street.

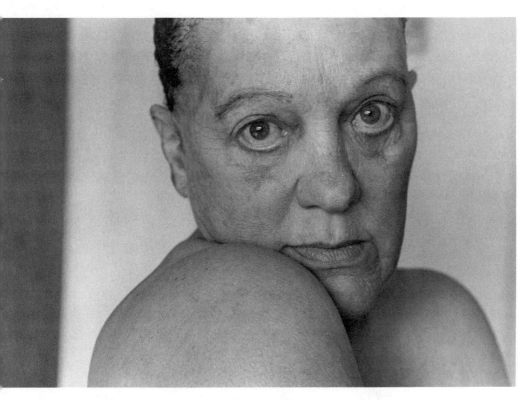

Anne Noggle, *A Rose Is a Rose Is a Rose,* 1985, gelatin silver print.
Courtesy the artist.

JB: What do you find is the difference between making individual and group portraits?

AN: To photograph one person is so easy compared to groups. You can hold one person's attention on a one-to-one basis, but two people create the problem of inattention and distraction. Most people have not learned the visual concentration necessary for putting together an image with any intensity without your guidance, and so it breaks down with more than one person in the picture. It's a struggle and takes patience on their part. I am grateful to everyone who manages it. The women seem to do better with it than men. Most of them present this bland exterior. Uninvolved. They present themselves to the camera in an empty way.

JB: Isn't that more of a culturally ingrained self-protection?

AN: Yes. That's why I have found that men who are involved with art are very easy to photograph. They are as open as women are, a lot of times. They've been given that freedom by the Modernist notion of the artist, to have feelings, to express themselves, in their dress for example, to be more relaxed. That is a freedom that most men don't feel they have.

JB: When you are working with the self-portraits, how conscious are you of the seemingly symbolic quality of the shadows? In the picture with the round shadow on your abdomen, were you aware of its implications?

AN: When I looked down at the shadow, I loved the idea of that emptiness there in that space. It was a visual loss in a sense of what was there. It was exciting to look at it. When I took the picture I didn't really care what the symbolism was as much as I liked visually seeing that place left black like that. Shadows are exciting; they can reveal as well as conceal. If it makes anyone feel anything, that feeling is a revelation of what that means to them. I don't think I can directly articulate what that means to me.

JB: I wondered more about the process of engaging that shadow than any direct interpretation.

AN: The image of me in the car is not one that just appeared there, but one that I courted. When I'm driving a car and I haven't been able to photograph in a while, I get restless and want to make a photograph. The car has been the place that I have done that, at least four or five times, especially when I was forced to make that trek back and forth to Santa Fe which used up a lot of the time I could have used to photograph. When I'm sitting in the car I often look in the rear view mirror and all around trying to find a way to use my camera. I saw the way the shadow came on my face, I kept moving around to make it fall in the right place. Again it was visual. I was looking in the mirror

which was also creating the shadow. I wanted the various parts of my face to be isolated from one another. What I really wanted to talk about was how light and shadow work. It's about that rather than being a portrait. I thought by using a face and breaking it up, one would be much more aware of it than if you were looking at a pattern on the floor. By using my face one had much more a sense of intrusion.

JB: Could you talk about the transition that took place when you stopped flying and took up photography.

AN: I seem to have twice fallen into work that became my life. Flying was my life. On my day off I used to go to the airport. When I couldn't fly anymore, I needed something to fill that space in my life. But I don't know which came first, the need or photography. Flying and photography are both individual. I never did well working in a company, or even in the Air Force. I guess I've been sort of rebellious about having people dictate what I do and how I do it. So whatever you are comes out in your work and if you're good at it, as in flying, you live through it. It's a very completing thing because there is no other thing on this planet that's done totally alone where no one can help you or stop you. You are totally free and dependent on yourself for your own life. Flying is about that freedom and that responsibility to yourself. You simply strap the plane on you and it becomes an extension of you.

When I stopped flying it was that independence and freedom that I missed. It's actually more than freedom, it's a wild freedom and its wonderful! When I found photography, I found again that I depended solely on myself. The images came from me and no one else had any responsibility for them. You have to give yourself away and make the person that you are photographing be the most important thing in the world for that period of time. It makes them feel like a star, and allows you to concentrate on them. You're dealing with time and space, so philosophically there is a connection there between flying and photography.

I know I'm a workaholic and a perfectionist, which adds up to a lot more work in the darkroom and out. It's hard work and

you give up a social life when you are a photographer. It's a lot of time to be isolated in the darkroom. It makes a different person of you. It demands a lot of attention, but not so much that your thoughts can't stray. That to me is real isolation, when there is not enough to concentrate on to make the time pass. You do have time to think, but you can't do anything about the thinking. You just have to stand there in a great big bundle of thought. I sometimes look at the timer and say that second will never occur again. [laughter] Or, I know the world is moving around out there and I don't know anything about it.

JB: Do you feel that is a sacrifice?

AN: It's not one of the pleasures. The first print is a pleasure, but after that it's not a pleasure. I think photographers are actually hermits.

JB: What do you see as the connection between the way people look and their geographical location? Certainly, the people in east Texas look different from those in Seattle. Do you read peoples' faces as if they were maps or topographical charts?

AN: No, I don't read them as maps of their place in the world. I wouldn't generalize that way. I don't think that the age group that I am photographing is as affected by television and mass media as the younger people are. They didn't feel a need to all have the same things or react the same way that they've seen on television. You can't help but note that people that live away from the rush of city life are more in tune with the natural environment. They're never crowded onto a bus and never forced in the kind of social situation that you are in city just because there are a lot of people. Life is different for them and they react differently too. They haven't had to close up like we do on the street. We do have a self that is a street self into which we withdraw to present a noncommittal exterior. I don't see the people from east Texas doing that. They don't have the same kinds of pressures on them. They've known a lot of people since childhood a lot better than we even know our next-door neighbor.

They feel more at ease with their friends and their clubs that they've belonged to since they were young. Most of them have grown up there and gone to school within a hundred miles of where they live. They are very open when you call them, but they are suspicious in one way if they don't know you. They don't expect somebody to want to come to photograph them.

The city people, especially the wealthier people I photographed [in Seattle] expect that someone is going to want to take their picture. They attend a lot of social functions, are on the boards of museums, and are in a social strata where they've been photographed. Some of them so much so that they are a bit blasé. It's hard to find any other self but that. At first, I thought, I'm going to get to the bottom of this, I'm going to find the real person under that veneer of sophistication. But, I was unsuccessful. I tended not to use the photographs until recently when I realized that that is what they've turned into. If they want to present themselves that way, then there must be something that impels them to do that. So to show that is to show them as they are.

JB: Do you consider yourself a psychologist?

AN: No.

JB: I've heard people read your portraits very psychologically. The images seem to have that kind of an edge to them.

AN: I think I'm intuitive. I sometimes feel that I know people more than I want to because it makes me empathize too much. I don't want to know their psyche; they're very exposed to me which comes from watching people so much. I not only watch their gestures but their hands as they tighten up. But sometimes, I think, "Oh, God, that poor person," because I know something about them I would rather not know, and yet it is the very thing that allows me to make the photographs. My understanding comes by paying particular attention to gestures and nuances. Even as people talk you can see the subtle play of emotions across their faces. Sometimes I'll use whatever they were saying to try

to recreate that look. I like to photograph people in an intimate way, at ease with each other, and with a sense of timelessness. We talk about how I see them, but that depends upon the person.

JB: This must make one feel terribly self-conscious.

AN: At first, but they are fascinated. That's why it takes two hours. I get so far beyond it that I've made long-time friends in those two hours. It isn't as though I'm doing it to reveal you; it's more that I want this wonderful thing that I see in you. You have a way of presenting yourself at certain times that's marvelous, and I want it. This really summarizes my approach to portraits.

JB: You feel that you are celebrating a certain moment or aspect of someone's life as opposed to analyzing it.

AN: Yes, celebration is a good word for it.

JB: Could you talk about your recent work done using the wall of your garage?

AN: I've always coped with the environment, with other people's space and lighting, and I thought it would be wonderful to find a place where I could concentrate on the person. When I got this notion, I didn't have a place in my house to do it, so I had the garage wall cemented. I love the surface of cement, the texture is so fine that my video camera has a hard time focusing on it. People look incredible next to gray-card gray, they tend to be very etched against that surface. These days when I think I need something, I think, "You are going to be lucky if you can work until you are seventy, so go for it now." When I decided I wanted the cement on the wall, it had to happen immediately. I bought a jacuzzi and I hadn't ever been in one [laughter]. I'm doing these kinds of things because I don't want to wait one day. I suppose I can always be frugal some other time in my life. I feel a sense of time and immediacy. Right now I want to make images, I want to do it all.

JB: Some of the garage pictures have a movie-set quality, or the feeling of docudrama because they are staged. Is that a direction that your work is heading?

AN: Yes, very much so. I have been working a lot with a video camera and taking images off the video monitor. You expect drama off a video. Video images are strange because they exaggerate gesture and expression. The quality of the light is different and you have to squeeze people together to get them to fit in the frame, but when you look at it the space changes to look like a normal situation. The electronic media allows you to play with the drama. I have made tapes of myself where I work on gestures, and I've been directing other people so that I can have a portrait of them from the tape at a later date. I've insulated and vented the garage space, had a friend bring over lighting equipment, so there are several people working there. One night a week, called "Albuquerbuki Nights," we go to the studio to act and take turns at directing. It really affects the way that you work with a camera. It leaves you freer to do little dramas and tableaux. I've got some images from this group that I can't wait to finish.

Note

1. The biographical information in the introductory material, researched and written by me, appeared in *Facets of Modernism: Photographs from San Francisco Museum of Modern Art,* by Van Deren Coke with Diana C. du Pont (New York: Hudson Hills Press, 1986). Used by permission.

**AN
INTERVIEW
WITH
DIANA C.
DU PONT**

*April 25, 1988,
San Francisco*

Concerning
*Southern Visions:
Photographs by
Clarence John
Laughlin and
Ralph Eugene
Meatyard*

Southern Visions brings together the work of two photographers who share a regional sensibility, but whose working methods and metaphoric modes are separated by a generational shift in poetic expression. The South is palpably present in Laughlin's work—in the ruins of plantations or the confederation of specific emblems and symbolic forms. Laughlin's is a structured vision, one in which the contents and effects are consciously applied toward statement. His pictures, particularly the staged or fabricated ones, reveal a logic full of tropes whose figuration has faded along with the optimism of the Modernist period. One reads the pictures by accepting their historical context.

In Meatyard's pictures, the South is an allusion, a byproduct of his *mise en scène*. The decay and dilapidation, the masks and veiled figures speak directly of the inner life, the psyche, and the struggle of mind in overcoming matter. His pictures engage one in that process—so much so that at times the subject matter is dissolved into darkness, blur, or circles of confusion. Light becomes the metaphoric mechanism for the transubstantial.

In his essay "Ralph Eugene Meatyard," Guy Davenport examined the photographer's connection to light:

Light as it falls from the sun onto our random world defines everything perceptible to the eye by constant accident, relentlessly changing. A splendid spot of light on a fence is gone in a matter of seconds. A tone of light is frailer in essence than a whiff of roses. I have watched

Gene all of a day wandering around the ruined Whitehall photographing as diligently as if he were a newsreel cameraman in a battle. The old house was as quiet and still as eternity itself; to Gene it was as ephemeral in its shift of light and shade as a fitful moth.

The "fitful moth" is an extraordinarily significant and apt phrase for Meatyard's pictures. The greek word *psyche* has a double meaning: the soul and its physical metamorphic counterpart, the moth (or butterfly). The relations between light and dark, between the invisible, nearly visible, and the concrete in his pictures are translations of his inner struggle with photographing the ineffable.

In this interview with Diana C. du Pont, assistant curator in the Department of Photography at San Francisco Museum of Modern Art, Laughlin's and Meatyard's visions are explored as both regional and individual in an attempt to illuminate the character of their work from a curatorial and critical point of view.

JB: Is this show an argument for regional vision?

DduP: Yes, in part. I was fascinated by a region and culture that could produce two photographers like Ralph Eugene Meatyard and Clarence John Laughlin, and such major writers as Edgar Allen Poe, William Faulkner, Robert Penn Warren, Lillian Hellman, Carson McCullers, and Truman Capote. I was captivated by the southern Gothic imagination.

JB: What do you mean by a gothic imagination?

DduP: A penchant for the bizarre and the visionary. These artists developed a highly idiosyncratic imagery that was metaphorical and symbolic—imagery that went against the prevalence of photojournalism and documentary. A sense of history, of place, an interest in and penchant for the bizarre, and a sense of violence and mystery is something that characterizes the art of the region.

JB: Laughlin was a writer himself, and Meatyard was close to

literary figures such as Jonathan Williams and Wendell Berry. Do you think that has significance for their particular visions?

DduP: Definitely. Their work reflects it in its inherently dramatic and story-telling aspects. Their instinct is to deliberately place things together and invent characters.

JB: Do you consider them both directors, in a way?

DduP: Yes. They used the means of photography in a very plastic way. They made their pictures about imaginary worlds, but their vision embraced the world. They wanted to show what, within it, was strange and mysterious. They wanted to bring forth the bizarre in our everyday world if we would only care to look at it.

JB: Does Meatyard manipulate the medium more than Laughlin?

DduP: I would say the opposite. Laughlin, influenced by the practices of Surrealism, was drawn toward using multiple exposures, composite prints, collage techniques, and negative prints. Meatyard is as experimental in spirit as Laughlin, but as an optician by trade, he was more interested in camera or lens vision. He exploited pictorial elements like blurring, in-and-out of focus, and near-far relationships to achieve certain effects. The vanishing specter appears in both artists' works. Matter into spirit was also a concern for them. The out-of-focus effect creates haunting figures that approach abstraction in two works in the present exhibition. These images verge on this whole other side of Meatyard that really isn't explored in this show.

JB: What side do you mean?

DduP: The abstract side. He did slow, multiple exposures of water, for example, that are both influenced by the syncopated rhythms of jazz and are studies of pure light. This show only

brings together the work of Laughlin and Meatyard in which there's the greatest correspondence.

Meatyard's concern with abstraction indicates that he was a photographer of his time. He was extremely well-informed and literate about the world of photography and art. He was aware of Abstract Expressionism and of the achievements of Harry Callahan, Aaron Siskind, and Minor White. This connection will be made clearer when we complete a retrospective of his work.

Laughlin was an architectural photographer, but there are only a few examples of his architectural work that I've included in *Southern Visions*. The ones that are included refer to regional identity, to the "fallen grandeur of the South"—a preoccupation of the southern mind since the Civil War. Laughlin is concerned with the classical plantation, the grand southern tradition. The open door, the darkened hallway, the evidence of decay, and the neoclassical motifs are symbols. These pictures are more than architectural documentation. The unifying theme that holds them together is Laughlin's sense of history, and concern with his region's past. His work is imbued with a deep sense of melancholy. Meatyard is also preoccupied with the devastated, but his ravaged interiors are usually those of the rural, vernacular architecture of the South.

JB: Is there a difference in class sensibility in what they're doing? Between Laughlin's "grand old South," and Meatyard's more common places?

DduP: Perhaps. That is an interesting notion. Laughlin was born on a plantation so he has that connection, and in his work there is a sense of loss and a longing for the past. While death and decay are important themes for Meatyard, they are not related to this same kind of longing. The classic joke about Meatyard is that he was born in Normal, Illinois. His own name is also bizarre; it is very southern in character. Though Meatyard was born in Illinois, he might as well have been born in Kentucky, where he settled in 1950. His vision is as sympathetic with the southern sensibility as if he had been born there.

JB: What clues in the pictures tell us that these images are more than documents?

DduP: I think it's the free association that goes on in the pictures. They're laden with symbolism.

JB: Does it go on in the picture or is it suggested to the viewer?

DduP: Well, free association automatically calls upon the viewer to interact with the image in formulating his understanding of it. This kind of work is evocative rather than explicit. Nonetheless, these artists also had definite themes with which they were working.

JB: Do some of Laughlin's images suffer from being almost illustrative or too literal?

DduP: Laughlin directed or staged his scenes, to the extent that some of the figurative work is almost overdone. Laughlin really wanted to be a writer. He read Baudelaire and was influenced by the French Symbolist poets. Many of his pictures are accompanied by, at times, lengthy text, which was very important to him. But the problem with the text is (and why you don't see it here in the exhibition) that it actually explains the picture too readily. When you take it away, the picture has much greater mystery. Laughlin was decidedly more successful as a photographer.

JB: When I look at the Meatyard picture of the masked children sitting on the numbered steps, I wonder if he was, in any sense, a visionary or involved with the occult?

DduP: The vanishing specter is definitely a strain that runs through both of these artists' work. The use of the mirror, too, is an ethereal symbol. Both are concerned with the themes of personal identity. The idea of the spirit or a connection with the metaphysical or the occult is something that has a presence in Meat-

Clarence John Laughlin, *The Masks Grow to Us,* 1947, gelatin silver print.
Courtesy Clarence John Laughlin Collection, Historic New Orleans
Collection.

yard's work and is an issue that will be explored in preparing the retrospective.

JB: So, his notebooks, for example, have not been examined?

DduP: No. I am just beginning to do this kind of research with Barbara Tannenbaum of the Akron Art Museum.[1] And, I will be working with the artist's son Christopher Meatyard at the archives in Lexington, Kentucky. It will be an opportunity to put Meatyard in some kind of context. His work hasn't yet been gone through systematically to really understand what he was after. In addition to Abstract Expressionism, Callahan, Siskind, and White, I also want to explore connections with Frederick Sommer, for example. The insistence on death that occurs in some of Sommer's work is evident in Meatyard's photographs.

JB: Do you think Meatyard had a preference or particular reason for using children in his pictures? They occur far more often than adults, for example.

DduP: I think part of it has to do with a contrast between youth and innocence and maturity and monstrousness. That's how the masks are used—a contrast between what is pure and what is heinous. A further issue is what does the human being become in adulthood? Laughlin worked with anonymous female figures. They are shrouded and you don't know who they are. They are mythic in proportion and universal in identity. On the other hand, Meatyard's figures are specific and identifiable, because he drew on his immediate community of family and friends. He was very at home with that community, meaning that he didn't feel the need to go out and draw on other sources. Because of Meatyard's specificity, there is a much greater concreteness and palpability in his work than there is in Laughlin's. This idea of trying to find the bizarre and the mysterious within our everyday world is more convincing in a Meatyard.

Ralph Eugene Meatyard, Untitled, ca. 1959, gelatin silver print. Courtesy
San Francisco Museum of Modern Art, gift of Van Deren Coke.

JB: When you research Meatyard's work will you get access to his contact sheets?

DduP: Yes. He only printed once a year and even then didn't print extensively. So there are not very many prints, and they really are in one place, the estate. It's amazing that he would have had the patience to wait that long to see what his images looked like. But there are many contact sheets and other prints to be studied.

JB: Did he exhibit much during his lifetime?

DduP: When you go back and look at the records, there are a number of small exhibitions, but not anything that's been done in any great depth or with any scholarship.

JB: So, this exhibition is based on hunches.

DduP: (laughter). This one was done on intuition. As I said, any region that can produce two photographers like this and the writers that I mentioned earlier is worth looking into. Regionalism has an effect on the making of the imagery, whether it's the written word or in the form of photography.

JB: The image of Cranston Ritchie with the mannikin and mirror seems to be a kind of inventory. It's such a straightforward record.

DduP: You've hit on one of the leitmotifs of the Meatyard style. They give the impression of a snapshot that's gone awry. They have a familiarity that captivates you. You're drawn in and yet you're set adrift. The stagy quality is much more present in Laughlin's images.

JB: It's as if Laughlin's have their own built in proscenia.

DduP: The images with figures in abandoned, ruined architectural settings had to do with the cataclysmic events of World War II and even World War I. They have much broader ramifi-

cations for modern times, but I don't think we can underestimate the power of the past upon the southerner. His enigmatic picture made inside a burned building with a figurine and a fading photograph encapsulates this sense of history. It was taken when Edward Weston came and visited Laughlin during his project to illustrate Walt Whitman's *Leaves of Grass*. They went photographing together at the same place (the Meraux Plantation house), and, though they both used the same subject matter, the images were very different.

A melancholy about the past seems an overriding concern for Laughlin. And, though I would also say Laughlin is connected with a sense of the mysterious, Meatyard's vision is much darker, much more ominous. His imagery is charged with a deeply psychological ingredient. It has to do more with loneliness and the feelings of alienation, the terror that one can experience in modern times. This is the point where the two artists go in different directions.

Note

1. The project referred to was finally carried out solely by Tannenbaum and David Jacobs through the auspices of the Akron Art Museum. It became an exhibition and catalogue *Ralph Eugene Meatyard: An American Visionary* (New York: Rizzoli, 1991).

INTERIORS:
COLOR
PHOTOGRAPHS
BY LORIE NOVAK,
1978–85

*at Stanford
University
Museum of Art,
April 1986*

Two optical devices available in the eighteenth century, the camera obscura and the magic lantern, are both vehicles for the process of projection. The darkened room of the camera obscura, dependent upon the world before it, acted as a passive receiver of projections from the outside world. The magic lantern on the other hand was an active projector of painted images until the introduction of photographic transparencies in the nineteenth century. The projected image depended only upon a reflective surface for visibility.[1] As contemporary still photographers have turned to fabrication specifically for the camera, photographers and artists have combined projected imagery with other subject matter in carefully controlled environments, often the studio. In effect, they have brought together active and passive projection as an integral part of their image-making process. If, in this context, one views the studio as an arena and as an extension of the contained space of the camera obscura, one finds contemporary photographers standing at its perimeter with their cameras recording the events within while at the same time controlling what is projected from without. The resultant image can be as much about process as it reflects thought and imagination as it is about the fictive (magical) possibilities of illusion and representation.

Cindy Sherman adopted the early filmic technique of rear projecting, setting-appropriate images behind her self-performance in the studio in her *Film Still* (backscreen) series done in 1980. More recently Frank Majore has incorporated projected imagery

as a background or contextual element in his investigations of the advertising photography genre. Though others have made occasional use of the projected image, Lorie Novak was one of the earliest of this group to make extensive use of projected imagery as the central and poetic aspect of her work. An exhibition of Novak's color photographs curated by Anita V. Mozley at the Stanford Museum of Art, surveyed her ongoing series entitled *Interiors* begun in 1978. Throughout the series her basic methodology has been to create environments for the still camera by combining multidirectional photographic projections with colored lights in found rooms or studio spaces which include props.

In the earlier images she used the projections as part of a strategy to create a multifaceted space. In *Untitled (Hall)* (1981), sections of the transparent overlay of a white picket fence become integral with the hallway space and glass-paneled door. In other areas the subject matter defies logic, as in the top center where a dwarfed car floats at the top edge of the wall. She makes no attempt to hide the edges of the projected image; they are an essential part of her strategy similar to that used in Mannerist and Baroque paintings, wherein cherubim could be seen holding up a *trompe l'oeil* backdrop only to reveal another space beyond the scene of the painting. Novak intensifies this kind of spatial layering by defying conventional perspective. Visual elements like the repeated systemic forms of the fence posts, the framing in the door, and cabinets provide a compositional unity which weaves together the disparate projected elements. The coherence of the content arises from her use of plastic space primarily as a container. Her insistent ten-inch-square format reinforces the container-like quality of edge.

Novak's more recent work has shifted away from formalist strategies toward a more content-oriented approach. Many of the projected images come from her personal family history, including snapshots from her own childhood, of her relatives and of family outings and events. They are vernacular images elevated to significance by the process of projection within a new pictorial context. Rather than lived-in home-like rooms, she has used more neutral studio spaces. As a consequence, the rooms

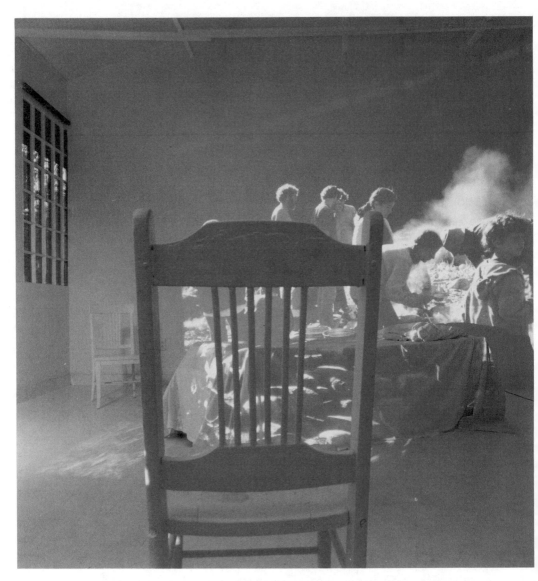

Lorie Novak, *The Barbecue,* 1983, original in color. Courtesy the artist.

themselves function more as containers (as is the camera obscura) which establish boundaries but do not define what transpires within. As Novak has emptied the spaces, the projections have become more prominent than the surfaces which reflect them. One becomes aware of their veil-like quality.

Projection as a concept is heavily laden with overtones of the psyche, and the titles of the images, such as *Childhood Dreams*

(1983) and *Company in the Dark* (1985), also suggest intentionally psychological statements. The recurring images of water, doorways, floating gossamer figures, shattered windows, hyperbolic shadows are all the stuff of dreams—and dream interpretation. This accretion of symbols gives the images a discursive or narrative framework within which the viewer can participate on a very personal level. One can equally apply Freudian interpretation. In *The Interpretation of Dreams* Freud wrote: "Rooms in dreams are usually women; if the various ways in and out of them are represented, this interpretation is scarcely open to doubt." He continues a catalogical analysis of room contents. The most salient of which in regard to Novak's work is: "The 'smooth' walls are men; in his fear the dreamer often clutches hold of 'projections' in the facades of houses." (Though Freud implies a more anatomical reference here, I am equating this use of projection with Novak's use on the understanding that both are based in illusion.) Gender issues aside, he has defined a model of dream space which is analogous to the camera obscura whose interior has meaning only when filled with projection.

The representation of dreams or memories of experiences raises some difficult problems for photographers since the camera photograph as a record of an object or event is a secondary source of experience. Stieglitz's concept and practice of Equivalence could work in a presynthetic period when the photographic process used nature as its transformative source. However, as fabrication, a synthetic process, has become the ascendant mode, subject matter has been taken yet another step away from accessible or verifiable experience (as in the extreme case of those like Novak who make objects or environments solely to be photographed before eliminating them). Dreams, too, are fabrications, fading when they have served their primary purpose. Since a dream occurs in the unconscious, its visualization is a *projection* of the unconscious. Like the shadow's relation to the higher forms in Plato's cave, the projection is a limited transmission to memory, which in turn serves as the vantage from which dreams can be reconstructed. We can only accept the pictured dream, then, as a form of fiction, as an analogue with objective qualities, notwithstanding the self of the dreamer. The reification of the

intangible dream or memory into a photographic image is at best a distillation process from the larger constellation of time (real or imagined) and conceptual space.

Chairs are a recurring presence throughout the *Interiors* series. In *Untitled (Blue chair, campfire)* (1983), the chair, facing the same direction as the viewer and placed in the center foreground serves both a graphic spatial purpose and as a surrogate observer of the campfire event projected within the picture. The chairs in *Shadows Cracked into Pieces* (1984), with their enlarged shadows, are far more ominous in feeling, as if they had assumed the roles of characters engaged in a power struggle, though the chair in the lower right corner offers the viewer a place in the picture. *Musical Chairs* (1984) is, of course, a reference to the childhood game in which there are always fewer chairs than participants. The goal of the game is to grab a seat as soon as the music stops; the potential terror of the game is exclusion or denial of place. It could also be seen as a metaphoric identity game—in finding one's place, one finds one's self. Chairs fit neatly as an authorial signature within a psychological schema of the *Interiors* series and function narratively as an allegorical self. Akin to what Virginia Woolf accomplished in her experiments with stream-of-consciousness in literary form, Novak has formalized an objective structure for auto-psychological content. In doing this she has borrowed not only from film but also theater as her *Interiors* take on the character of stage sets in which imaginary (projected) activities and characters "act out" dreams, memories, or fantasies.

Approaching Novak's work from without the psychological framework, one sees the images as records of process, of the conscious construction of imaginary forms. In this context the images become fictional autobiography based upon clearly accessible references to her personal life. Within her objective structure, Novak has defined a poetics of projection as an analogue to her own imagination. The result is kaleidoscopic. Forms overlap, colors become excitative, projected subject matter de- and re-materializes depending upon the contours and reflectance of the receiving surfaces, shapes become distorted because of oblique projection angles. Making reference to montage techniques investigated by European avant-garde film makers of the 1920s and

1930s, still montage imagery by photographers such as Val Tel-
berg, and Lucas Samaras's use of colored lights in his *Autopo-
laroids* and *Photo-Transformations*, Novak has developed a cohesive
body of work rich with psychological implications and over-
tones. Her photographs are also beautiful as objects with satu-
rated and sensitively managed colors. This optical quality
predominated throughout the entire exhibition.

Note

1. Owen Barfield, in his extraordinary essay "The Harp and the Camera,"
included in *The Rediscovery of Meaning and Other Essays*, (Middletown: Wesleyan
University Press, 1977) discusses the invention and implications of the camera
obscura and the magic lantern in the context of what he calls the "camera
sequence." He attributes to this sequence the radical change in our vision and
imagination since the Renaissance. ("The Harp and the Camera" is also re-
printed in *Reading into Photography: Selected Essays, 1959–1980,* edited by Thomas
F. Barrow, Shelley Armitage, and William Tydeman [Albuquerque: University
of New Mexico Press, 1982]).

PIERRE
MOLINIÈRE:
SIXTEEN EROTIC
PHOTOGRAPHS,
1967–76

at the*
Fraenkel Gallery,
August 1986

276

Eros was a fascinating god who governed the realm of sexual love. The tool of his trade, symbolic enough in psychological terms, was the bow and arrow with which he played endless games upon the gods and the multitude of mortals. Since he carried two kinds of arrows in his quiver—to engender physical attraction and, obversely, to engender repulsion—he had power to overwhelm and to frustrate, to instill inexplicable confusion. It was because of these powers that his mother, Aphrodite, sent him to avenge her anger with the mortal woman, Psyche (whose name literally translated as soul). Psyche had come to be revered and sanctified for her beauty, yet this reverence left her alienated from other mortals. Commanded to make sure that Psyche could procure no husband, Eros disobeyed his mother and instead took her as queen of his palace. It was his ironic destiny to be pierced with one of his own arrows. Thus ensued one of the great love stories of all time, charged with portent, and leaving carnal sexuality inextricably entwined with understanding of Psyche, psychology.

Both Sigmund Freud and Erich Neumann attached great mythopsychological significance to this tale, and concluded that mature sexuality in the developing consciousness of man and woman must have both physical (Eros) and psychic (Psyche or soul-oriented) components. Thus the erotic pertains primarily to physical (animal) sexuality and physical will, without soul-feeling or the consciousness bred of thought.

Western culture is conditioned by Eros's purveyance of sexuality, but it is important

to note how the myth translates into contemporary experience. The mischievousness with which Eros selected which of his two arrows to project has transformed into the potential for the simultaneous experience of attraction and repulsion. Either is possible at any given moment in response to the presence or representation of physical sexuality. This simultaneity constitutes a useful criterion for establishing the erotic in the pictorial arts, and, I suspect, is closely akin to the Surrealist proposition *La Beauté sera convulsive (convulsive beauty)*.

Pierre Molinière's small-scale penumbrated photographs currently at the Fraenkel Gallery are erotic by virtue of the above mentioned criterion. The pictures display sexual acts, exposed genitalia, masks and costumes, transvestism—the trappings and iconography of erotica, but with a peculiar twist. Molinière was an actor in the staging of his own sexual fantasies. This twist stirs a strong psychological current within the images. His artistic biography (written as a brief introduction to the exhibition by noted collector Robert Shapazian) would lead one to assume that the ascendence of Surrealism in the 1920s and 1930s had a profound influence upon his work. His association with André Breton's gallery during the 1950s and early 1960s bears out this assumption and would make him, in his use of photography, a second-generation Surrealist.

Born in France in 1900, Molinière began his artistic career as a painter, and by the 1940s his paintings included erotic elements along with his own semen (an act with behavioral but not visual implications). His first photographs were made in 1950, and shortly thereafter he made pictures of himself disguised as a woman. Because the representational immediacy of photography best served his aesthetic and, presumably, psychological needs, he abandoned painting by 1967. He then turned to photomontage and collage consisting of photographic fragments of himself, female models, and a mannequin. As if in response to the moral dilemma (attraction/repulsion) of his pictures, Molinière committed suicide in 1976. According to Jeffrey Fraenkel, the gallery's director, the stated reason for this final act was that the artist could no longer enjoy masturbation.

I sense the expression of extraordinary *angst* in these tightly

Pierre Molinière, Untitled (self-portrait), 1965, gelatin silver print. Courtesy Fraenkel Gallery, San Francisco.

circumscribed photographs—not just because of the biographical context. The first generation of Surrealist photographers used the nude female body as the functional basis for an expressive metaphor. Within the bounds of the metaphor, the images they produced ranged from the poetic at one extreme, through formalist, to pornographic at the other. Hans Bellmer exemplifies the latter, and is probably best known for his extended series using *La Poupée* (a doll constructed of sculpted body and organic-shaped pieces) in a variety of fabricated settings. Though these images touched on the issue of duplicity and hovered at the edge of a perverse fascination with the female, Bellmer also made images which were explicitly pornographic and overtly prurient. Molinière has engaged in more theatrical form what Bellmer

entered into the photographic-Surrealist-psychosexual dialogue, to reach into the realm of feeling from the physicality of animal instinct. In metaphoric terms, both photographers have searched for Psyche through the auspices of Eros. The search itself is born of separation or alienation.

The validity of that search as it is mediated by photography is ultimately the most important question. A photograph, as an aesthetic object, has physical properties which can be experienced and catalogued directly. Within the physical structure lies the photographic content which engenders a different level of response, generally associative. The viewer tends to focus primarily on one (certainly not to the exclusion of the other) depending upon the indications of the image. In Molinière's case, those images which are clearly montaged and illogical (such as *Untitled*, ca. 1965) make one aware of the process and the forming of the image. Those images which appear as direct records of staged situations (such as *Untitled [self-portrait and model]*, ca. 1965) tend to focus more on content. Molinière's work, or at least the present selection of his work, vacillates between these poles and, consequently, blurs this important distinction. In discussing sexuality in paintings, Stefan Morawski wrote: "We are reacting to artistic *mimesis*, that is to a quasi-world represented in the art object within the limits of its structure. Just as soon as the ideas plucked from the mimetic tapestry loom larger in our response than does the structure of the work taken as a whole, we pass to the sphere of nonaesthetic experiences, of which sex is one."[1] Despite the ever-present erotic iconography and sexuality, the psychological impact of Molinière's photographs is diluted as the images become more illogical. Just as his suicide seems an ironic end to his search for sexual pleasure, so too his illogical poetic of sexual fantasy tends to blunt the erotic.

With the recent release of the United States Justice Department report on the cultural impact of sex and violence, the issue of obscenity and pornography has received renewed attention. The document purportedly contains a distillation of some of the most prurient material generated within our culture—material which is republished as a context of evidence. Certainly, one could cite pornographic aspects within Molinière's work, though they are

nominal and, more important, incorporated within the context of art. The absurdity here (and this is certainly suitable material for a Surrealist novel) is that what is acceptable in one context (as indicated by the Government Printing Office publication) is deemed unacceptable in another. As Morawski wrote elsewhere in the same chapter: "Obscenity is—in a word—always dependent on idiosyncratic moral taboos; and since human sexuality is irrepressible, highly diversified, and volatile, the system of taboos is always shifting. Nevertheless, the act of transgression at any moment is labeled pornographic." Molinière's photographs are not masterworks and are unlikely to spark the level of controversy over the issue of pornography which attended the American publication of James Joyce's *Ulysses*. However, his images should be seen individually as psychic peregrinations and collectively as a document of how an artist is able to mediate his experience, regardless of the nature of that experience.

Note

1. See his chapter on "Art and Obscenity" included in *Inquiries into the Fundamentals of Aesthetics* (Cambridge, Mass.: MIT Press, 1974).

[Author's note: The italicized passages represent a second voice speaking from the vantage point of archetypes.]

Florence Henri, masculine surname, feminine given—an American name destined for Modernist Europe. As evinced in her work, this nominally implied polarity was in fact a real one for her. Throughout her artistic career, she sustained a struggle for hegemony between the polarities of gender. The issues of sexuality and social identity surface repeatedly as postulates and counterparts to her deeper particular concern with women's individualities. Despite the fact that she reached her creative apogee concurrently with the height of Modernism between the World Wars, and that much of the structure of her images flows out of Modernist tenets, she seems, in retrospect, to have carried on a Postmodern search for multiple selves. It was a struggle fought metaphorically on Freudian turf. Hers is a fascinating body of work, fascinating as much for the issues that it raises (and it may take the perspective of 1991 to deal with them) as it is for her connections to and understanding of a number of central Modernist schools and artists.

Whether named by accident or destiny, she participates in an archetypal recurrence in which the protagonist looks into a mirror only to see the reflection of an unexpected self. Her persistent research reaches far beyond formalistic incidence and reflection, though she certainly plays with the equation. Throughout her work, reflection carries the day, becomes more substantial than the quixotic presence which engenders it.

FLORENCE
HENRI

at the
San Francisco
Museum of
Modern Art,
February 1991

281

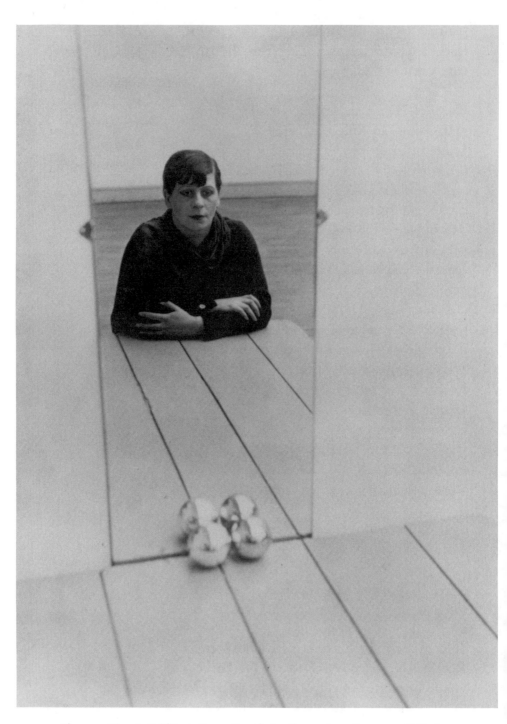

Florence Henri, *Self Portrait*, 1928, gelatin silver print. Courtesy Galleria Martini and Ronchetti, Genoa, Italy.

The Queen and Snow White—defiant vanity rules the game until the Queen is chased to the fires of hell by those seven Grimm planetary characters. Ever-goading intermediary, mirror mirror projects the errant truth. Narcissus pondered such a plot in the soul-depth of the still water. And Henri spent the bulk of her relatively short photographic career contemplating the mirror image as if the camera were not some mercurial presence interceding in the eye's behalf, but rather the eye itself. Narcissus had only Echo as a witness, and only the dangerous self-reflexiveness of psychic debate.

It is inconceivable to think of Florence Henri's work without seeing her residual presence in a mirror. The reflection for all its uncanny and multivalent revelations is still narcissistic at its root. This archetypal substrate at times seems a singular driving force behind Henri's images, most notably in the portraits and self-portraits; it also informs her more emblematic and formalized tableaux-mortes.

The contemporary French philosopher Malcolm de Chazal wrote: "A mirror has no heart but plenty of ideas." In this sense the mirror and the image overlap; he has encapsulated the central drift of the mediated experience. The photograph is pure concept, as is the mirror space. And Modernism has taught us the lesson of concept divorced from heart—the trick of mirror logic. Florence Henri did not, however, get it backwards. As a proto-feminist bringing soul-life into male formalism, as a bisexual searching for balance within while speculating on her identity without, Henri plays with the ambiguity of mirror space as a kind of *Zeitgeist*. She had plenty of ideas, but a recurring crisis of the heart.

Her work certainly mirrors her time. Constructivist and Surrealist references abound. This is one of the brilliant statements so carefully researched and presented by the exhibition's curator Diana C. du Pont. Henri socialized with the key figures of the time, Laszlo Moholy-Nagy at the Bauhaus or Ferdinand Leger and Amédée Ozenfant in Paris, to name a few. They provided her with a kind of anchor, a feeling of accepted value while her deeper searches, for which there was little precedent, continued. Ms. du Pont shows us Henri in context in galleries off both ends of the central gallery, no doubt a curatorial play on apparent

mirror-space symmetry. The central gallery itself is designed as a tip of the hat to De Stijl tenets with divider walls painted primary colors.

It is a striking if not stunning installation. The sequencing of Henri's pictures, both by chronology and idea or function (as in the advertising pieces), is sensitive to the pictures themselves, and, more important, to the flow of conceptual evolution. Graphic affinities abound, as does the peculiarly (in the visual realm at least) photographic attribute of close thematic development. While both of these are formal curatorial devices, Ms. du Pont has accomplished more in putting us, if we are willing and patient enough to work with her toward it, in touch with the artistic mind/body as much as is possible in a historically removed time. The result of her extensive penetrating research is a sense for Henri's contextual history and a character who, like all great literary characters, is as much renewed within the moral complexion of the experiential present as she is part of the past. In Henri's case it is the Modernist past. However, it has taken the consciousness brought about by the feminist debate of the last generation to glimpse the reality of Henri's inner life in an appropriate historical perspective, though there is little doubt (based upon Ms. du Pont's text) that her closest friends experienced that inner tension directly at the time.

The portraits, tightly constructed, direct, intense, flow from the interactive experience that was such an important part of Henri's life. This style, distinctly influenced by Lucia Moholy at the Bauhaus, serves an unabashed self-presence. No veiled, romanticized, pictorialized visages; instead a descriptive scrutiny which connects topography with the being behind it. Playful Narcissus turns the insularity of psychic debate into a directorial mode. *Think within, and if you dare look at the lens, don't look at me too in its periphery, don't look past with a distant stare. Study your reflection in the lens's smooth surface. The image an image. Let me see you from within the pool.*

Is the ethos of her portraits tied to those deep tones of gray which once had life in shining red lips? In life, the red flows from organic form, an attraction, a reference to someone's aesthetic ideal, a moving outline of occult sexuality. In dead-image, the

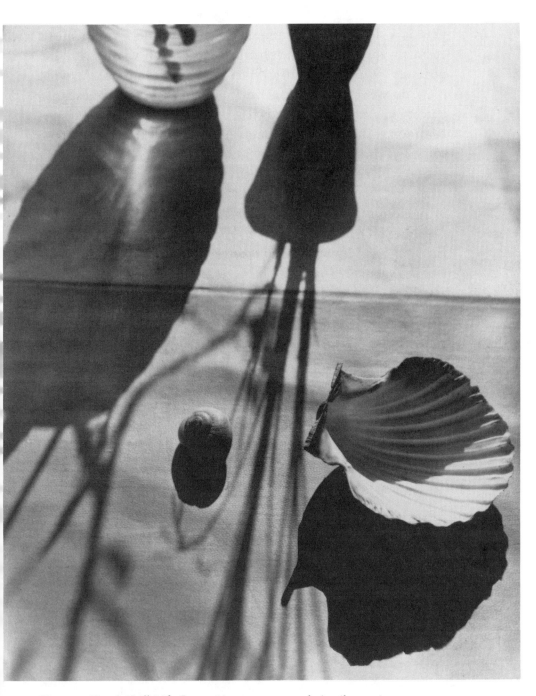

Florence Henri, *Still Life Composition,* ca. 1931, gelatin silver print.
Courtesy Paul F. Walter.

gray is a distortion, disconnected from organic form, a misfit cosmetic application which hardens rather than warms. Still life portraits. What is intended when they say becoming? At what point do we read identity, at what point crisis? Henri's heads are heroic, unafraid, unmasked; her women present in a way uncommon at the time, at least not commonly portrayed. I imagine some felt threatened by these presences.

The tableaux-mortes are a retreat to more poetic and formal strategies. Narcissus played with the water's surface, fractured image, diffused thought. *Let me play with my phantom, my beauty. Let me see if I return to whole through nature's will. Clarity in stillness. Even yet I will try my hand in the river flowing. My image-self must pass through time. I know it's there yet see it not.* The same themes are there played out allegorically as one traces the flower, the sphere, the fruit, the sea shell. All have long traditions in representation—traditions that in Henri's case burden the work, bring a self-conscious artistic intention that masks the deeper issues. This is old order feminine strategy, the one that was socially acceptable, the one that operates occasionally on the perimeters of her self-portraits and not at all in her portraits.

Ms. du Pont's exhibition and accompanying book *Florence Henri: Artist-Photographer of the Avant-Garde* make a long overdue case for Florence Henri's importance as one of many artists contributing to what is called Modernism in art historical terms. The advantage of hindsight allows one to see where in the past the most fruitful seeds of the present were sown. Culture needs the time-shift of developing consciousness to see past a prevailing mode; it needs its artists to sustain the risk of failing to be widely accepted to move that consciousness. One of the most important aspects of this exhibition is that it allows us to track how Henri negotiated with that risk.

Culture

and

Cultural

Constructs

The reductive view of Western dualism has been of opposites and contrasts. Significant couples such as rational and irrational, conscious and unconscious, representational and abstract have functioned as points of departure for explorations in form, expression, and their attendant criticism. However, dualism is a metaphor and the clarity which it implies, strives for, even depends upon, is actually a myth which has primarily served didactic purposes. As a metaphor or model of understanding, dualism seems exhausted, oversimplified, and continually discredited by the evidence of experience.

The critical writing of the Modernist period, if looked at collectively, has focused upon the tension between entropic and structural forces. This primary tension is the guiding principle underlying modern dualism. It remains a question whether this is still a useful principle. Now, it seems more important to focus on what can and cannot be known and, secondly, how we know what we know. Together these issues constitute a field of possibilities which embodies our constantly shifting or evolving sense of self and its relationship to the world. Within this field sense perception is the primary experience.

Ambiguity is the modern response to the breakdown of the metaphor of dualism. For ambiguity to be meaningful, one has to be excited about the prospects of grappling with it, and, more important, one has to have faith that the process will prove constructive. The optimism which fostered Modernism could support that process. But in this nascent Postmodern period, our think-

Thomas F. Barrow, *Tank Farm,* from the series "Modest Structures," 1981, reconstructed gelatin silver print with caulking, staples, and spray paint. Courtesy the artist.

ing has become indurate, threatened by the slowly emerging realization that it may not be possible to know or solve everything (or, anything). Appropriation or adoption is a form of cataloguing that confers authenticity upon the long-term accretion of culture-found images. There is little ambiguity if the present is simply a reflection of its precedents. In this sense Postmodernism has brought the development of imagination through art to a standstill, predicted (and perhaps justified) by the dictum found in Ecclesiastes, "there is no new thing under the sun."

In the face of a constant struggle with being overwhelmed by sense perception and the need to order life and understanding, perhaps the best one can do is simply catalogue unmediated experience and abandon the assumption that synthetic thought is inherently coherent, comprehensible, or immediately meaningful. Return instead to direct sense perception as the essential ingredient of and driving force behind imagination and thought. This is the ideal predisposition of mind with which to engage Thomas Barrow's work, to see the freshness in it. Art which asks the viewer to recast perception is both edgy and important. It may also seem inaccessible. In Barrow's most recent work one feels intimately and uncomfortably close to the shape, complexity, and, in some cases, obscurity of the artist's thought and thinking.

Throughout his career, Barrow has been concerned with the nature of contemporary culture. His work has become increasingly complex as it evolved from the singular images of the early documentary series *The Automobile* to the pairs of images in *Pink Stuff* and *Pink Dualities* to the *Caulked Reconstructions*. In this complexity and multiplicity each photographic image is a fragment, one perception out of many, regardless of whether it conforms to the camera rectangle or is altered by Barrow himself. When he brings those image-fragments into constellation (as in the *Fashion, Television Montages, Verifax Matrix* series, *Spray-Painted Photograms*, and recent sculptures), one is confronted with the tentative nature of order through the interrelation of images and the visibility which he affords them. The basis of the later work has shifted away from the pictorial quality of appearance to a relativistic approach toward what can and cannot be known. The

sheer density of content, whether conveyed through picture or materials, engenders a kind of metaphoric phantasmagoria of a culture assumed in its images.

Seen in an evolutionary context (as his recent retrospectives at San Francisco Museum of Modern Art and Los Angeles County Museum of Art and the accompanying monograph/catalogue *Inventories and Transformations: The Photographs of Thomas Barrow*, by Kathleen McCarthy Gauss have allowed) the evolution itself makes sense. But this does not make the work less challenging. It is difficult to get a hold on work that simultaneously celebrates and criticizes culture.

Barrow is an important intellectual force in contemporary photography—as an image-maker, writer, critic, curator, and teacher. As a photographer's photographer, he is a master at seeing through pretension and has been outspoken about his perceptions of the present state of the medium. Barrow is currently Presidential Professor of Art at the University of New Mexico.

JB: How did you get interested in photography? I know you were interested in design, cars, machines in general. I recently heard that you were also involved with airplanes.

TFB: I had an A.& E. (airframe and engine) mechanics license and was the youngest flight line mechanic they'd ever hired at TWA. What I did was taxi planes around the overhaul base (among other tasks). It was very interesting, but I also decided not to stay in that line of work. I was majoring in graphic design at the Kansas City Art Institute (KCAI) where I had a friend, Joe Guliano. He bought a camera and suggested that I try photography, so I bought a cheap 2¹/₄. I must say that, though my recent statements wouldn't indicate it, I was really taken. At KCAI, a fellow named Jameson taught printmaking and photography, almost as a hobby. I just picked it up and it seemed terrific. I was split at the time between filmmaking and photography. Joe and I made a couple of experimental 16mm films which were shown around in our local crowd and were well received. So, I didn't really decide until I applied to Northwestern University to work in film [as a graduate student]. But, I ended up at the

Institute of Design (of the Illinois Institute of Technology, Chicago) instead.

JB: Does your concern with and interest in film relate to your compositional use of still photographs, the compilation of imagery, and the shift of frames as in the *Dualities*?

TFB: I don't think so. The reason I didn't stay with film was that I was not very interested in how many people it takes to do it. Most film that I am interested in is narrative in nature and isn't very experimental—it doesn't investigate the syntax of film, it simply tells a story. I hardly ever think of film, except I'm using a lot of stills from films now in my most recent sculptural work. *Cabin on Fire* has film stills from *Rashomon, Hiroshima Mon Amour,* and two or three other images related to film. But that's still imagery really.

JB: You once mentioned that you got interested in art when you found a cheap paperback book on art in a drugstore. Is that true?

TFB: It is true. It's a classic story. I was still working on aircraft (long before I went to art school) and I found Sam Hunter's book on Impressionism. It was a fifty-cent Dell paperback with not very many black-and-white reproductions. I started reading it and couldn't believe what the author was writing about. Having grown up in the Midwest, I had no idea about art. My parents weren't interested; in fact, it wasn't even something they considered. It was so mysterious and interesting. Now I think (laughter), what if I had picked up Hal Foster's *After Modernism*, would that have inspired me to go into art? Or would it be absolutely impenetrable. Whatever anyone says about Sam Hunter, he made Impressionist painting sound terrific. I had never thought about art as something that someone did as life-work. I started thinking right then maybe I ought to go to art school. I had already started in college as a pharmacy major, because that is what my father did, and had dropped out. I was between things doing the aircraft job, then ended up at KCAI. So there you have the beginning.

JB: It was the words rather than the visuals that attracted you in Hunter's book.

TFB: Absolutely, the word. Aaron Siskind tells this great story which I can only paraphrase, but it was like this. He talked about his background with his Russian Jewish family. They read the Bible a lot, and in the Bible there is the Word. There is that great quotation from John: "I am the Word." Siskind used to tell it in his gravelly oracle-like voice. I think it was the word first, that's what seduced me. There weren't any reproductions of note really. I was probably twenty or twenty-one and I'd never been to (well, that's not completely true because I used to try to meet girls there) the Nelson-Atkins Museum, which has a pretty good collection. But at that I point I began to haunt the place, as much as one can, to try to see what was there. But it started with some very seductive writing. (If we get to the failure of criticism in photography that might be an interesting reference). I guess I was just very enthused and curious.

JB: You began photographing, then, while you were studying painting. What did you do with the photographs?

TFB: I just made prints. I was very excited about them. There was a librarian, Robert Billings, at KCAI who would call Joe and me up to say that he had bought another photography book. He would tell us to come see work by Walker Evans, Eugene Atget, or Robert Frank. That was my first introduction. Right away I had delusions of grandeur to photograph like these people, to do documentaries. For my senior project I did a group of pictures called *The Ghetto*. I spent several months photographing at 12th Street and Vine, which had fallen on hard times since the days of Duke Ellington and Count Basie. I worked with these crumbling tenements and felt I was doing something important. It looks pretty standard now, but that was what I did. It would be in the strongest sense of documentary, as we use it traditionally in photography.

JB: When you were photographing in graduate school at the

Institute of Design, were you still talking to painters and interested in the ideas that painters were dealing with.

TFB: There wasn't anybody painting there that I ever met. I guess Cosmo Compoli was there for sculpture. Beside Aaron (Siskind), the person I really got a tremendous amount from was the fine printmaker Misch Kohn. He was very well known at the time. He worked in etching with the complex *chine-collé* process of laying tissue down. Because we had so many photographers who were interested in photo-etching, he helped work out ways to use photo-sensitized materials with printing plates. We got a lot from that class. They didn't teach painting as I remember. It was all disciplines that related strongly to design. But, Aaron, with the graduate seminar of six or seven, would take us more frequently to painting shows than he did to shows of photography. Aaron was an important early influence that way. We didn't do just photo all the time, we looked at lots of things including painting. Aaron liked to talk about form. At that time, he never spoke about how close he had been involved with Rothko and Kline. He never name dropped. Perhaps he thought it wouldn't mean anything to students, or maybe it was a kind of interesting modesty.

JB: Is it possible that at that time he didn't realize how important the connection was?

TFB: Could be. He was an amazing man. That was in the early 1960s and they (Abstract Expressionists) were all still working. He talked extensively about Strand's work; he was very critical of the later work. He talked about what was missing in other people's work, and lot about Shakespeare and other literature. He was a profound teacher.

JB: Was it at that time that you did the series on the automobile?

TFB: Yes. There was a required graduate thesis with a short written introduction and a significant body of pictures. I really wanted to do some of the *Fashion* series and some of the "print

through" pieces which show both sides of the magazine page or paper. But, Aaron, as my advisor, said that because I always had such strong social interests I should do something more sociological. So, I did *The Automobile* series. I can't say how that series looks now because it is so far back that I don't have any perspective on it—except that it was based on my sophomoric ideas of the stages of Genesis, of the creation, the garden, then the fall. The wrecked cars were the fall. Typical graduate student thinking I guess . . . grand ideas of the creation. (laughter)

JB: On the other hand, without that idealism you don't get very far.

TFB: It was a reason to make pictures, which I did a lot of. I can remember going out on such cold winter days in Chicago that the shutter wouldn't work. I'd have to get back in the car, put the camera in front of the heater and wait for it. I thought I would do some view camera work of the junk yards, but the shutter always froze on the view camera. That was a lot of trouble. That finished me with the view camera forever.

What I learned, though, is that I wanted to find different ways to see the stuff. I had an idea while I was living in Evanston and working on the South side printing for a freelance commercial photographer. I spent so much time on Lakeshore Drive in traffic jams, morning and evening, that I began to think, "Why does everyone have to make photographs walking on the street?" I started making photographs from the car. It's nothing unusual now, Frank had already done it, but the pictures are of people stuck in their cars, lost in their worlds, in those little boxes. I like the idea in retrospect, and it represented a real breakthrough for me. I was so worried about that purist attitude toward the prints. I always wondered where that started in photography, anyway. As early as 1900, maybe earlier.

JB: Didn't it really start with daguerreotypes. Since it was such a direct plate process, you got what you got.

TFB: I suppose that's right. The only way to crop was with a

metal or glass cutter (laughter). One thing about discovering rules as a young artist was that certain of them were meant to be broken. Those pictures marked a turning point for me. That was about 1964.

JB: Didn't Aaron actually encourage using magazine imagery?

TFB: He thought it was a great idea as a way to explore form. He wasn't so interested in content. Interestingly, I first saw (Robert) Heinecken's work in *The Persistence of Vision* show at the Eastman House (now International Museum of Photography at the George Eastman House) in 1967, after I had been there a year or two. I was both angry and, I guess, excited, but more angry because I thought I had done all this great work in that area. Here was Heinecken with all this equally interesting stuff which he called the *Are You Rea* series.

JB: You're not territorial about that kind of stuff, are you?

TFB: Oh, of course not. (laughter) But I was a little then. It's what I've always said about guys like (Paul) Caponigro. Caponigro doesn't own those rocks. Who knows, the druids may have had cameras. There are an awful lot of good photographs of Stonehenge. I was exasperated because I wanted to show this work (I was about six years younger than Heinecken), but here he was having this great show. His were very different and had more content. Mine were following Aaron's original suggestion, which concentrated on form. Working with magazine imagery as a problem seems to have originated at the Institute of Design. What I like about it was that kind of accidental juxtaposition. Now, if you study my work, I still use it.

JB: It still seems very much within the realm of photography when you select that kind of imagery, whether you make it with a camera or not. Essentially, it is still a selection process that you go through.

TFB: There's no question that it really falls within the methodology of photography. The kinds of selections that one makes

as a painter, such as the color, or the kind of brush stroke are very different.

JB: In painting nothing comes complete, but in photography both the composition and the content come complete at the moment of exposure.

TFB: Exactly, but that's also one of the limitations of photography.

JB: Just to pick up on the notion of accidental juxtaposition, how much in the spray painted images is actually accidental? In making the photograms you are laying objects, negatives, and other things on the paper. Is it actually a process of building successive exposures or do you lay the whole construction on and expose it in one go?

TFB: I lay the whole thing out. It takes quite a while, up to twenty or thirty minutes working in the dark. Obviously, you can't build the thing and then slip the paper in underneath it. There are many failures because I use a lot of dense material for which I cannot predict how the light will penetrate. There's not only enlarger light, I also use a strobe and flashlights. Many of them are made with non–point-source light. I fire the strobe from the sides or from oblique angles. I have even put the light source under objects as well, so that whatever has been exposed by the original light will end up being overexposed. That of course is all accident. I don't know what it is going to look like until the print is processed.

JB: You say that you use accidental juxtaposition, but at the same time you are building them, which implies a conscious process.

TFB: And, some things work better than others as well. I know that if I take something about the bombing of Cambodia and I work it in with something else, I've loaded it. So I don't just reach into this pile of stuff I have (which is really probably a fire hazard) and pull something out with my eyes shut. I begin with something that I think has some real content or substance and

build on that. I move it around pretty carefully. The accident comes in with the lighting and maybe what gets emphasized by the nature of the printing process.

JB: That seems important because the accident is connected to the process rather than to the content. I think that is a very important distinction.

TFB: I've never quite thought of it that way. It is the kind of thinking that I like to believe I do in my work. I know where the things are, I know that a certain diagonal works better than another. There is an attempt at composition. That's probably not the right word, because some of them look really messy. But that's deliberate too.

JB: I would like to change the topic a bit, if I may. Do you feel that the distinction between theoretical and practical criticism is important?

TFB: I had a remarkable philosophy teacher, Raymond Bragg, when I was an undergraduate. He had been editor of *The Humanist* magazine for a number of years as well as a friend of Albert Schweitzer's. He used to say, "Let's not discuss aesthetics or read it because they can never give practical examples; no theory holds up under a practical test." I thought that was a very interesting thing to tell students and I have found it to be rather true. One of my colleagues at the university thinks that most of the writing that appears from the *October* [a critical art periodical] gang is really an excuse not to look at pictures. Their writing has very little to do with the original object. It is the presence of the original object or thing that should generate the response, not some attempt to invent artists or art to fit a preconceived thesis.

JB: Do you find that approach to the construction of meaning to be one of the major difficulties with criticism in photography?

TFB: Yes. I don't think it's generated from the work itself. I

think this is an extremely complex issue, which I would love to talk about at great length . . . but I won't. I would say that it is partly because there is such a paucity of interesting work in photography. As I often say, though I don't think I've said it in print, photography is the only contemporary art medium I know of where you're constantly rewarded for maintaining the status quo—through the granting agencies, etc. As long as that happens there will be a virtual vacuum of criticism from the work itself. Not much new in work gets generated. I see it as a matter of symbiosis. There is some very exciting writing about painting that is actually describing and looking at the painting. Sanford Schwartz comes to mind right away, and Arthur Danto.

Photography has cut across all of life—including a lot of the nineteenth century. I really don't like a lot of the contemporary photographic writing because I really don't think it is about photography or art, it's about social and political issues. To put it under the umbrella of photography actually reduces its impact. I'm truly interested in photography and how it fits in the realm of art. Unfortunately, much of photography is as Borges says in another context, "destined for oblivion." Painters like Rauschenberg and Kitaj really understood something about photography, its possibilities.

JB: What is it that they understood about the medium? I have heard it said often enough that painters understand photography better than photographers, but . . .

TFB: It's just that the majority of photographers have a resistance to most forms of art. They don't look at anything else. Painters really are looking at things visually, and I don't think photographers look at things that way. They are interested, if you look at Szarkowski's criteria in *The Photographer's Eye,* in that part of the syntax of the medium. They are looking at the frame, selection, and the content. Most contemporary photographers that I know really love the concept of the window on the world. They frame the window and they make the selection; the best of them think that they are leaving something for posterity. They also have a kind of reverence for the photographic

image that is out of proportion. That's why everybody loves to cite the Walter Benjamin article, "The Work of Art in the Age of Mechanical Reproduction." I would love to have a book burning of that particular article. The photograph in no way destroyed the aura. I know everybody loves the idea, but if anything it enhanced the aura. It made more people want to see the real thing. It made more people realize that stuff could be produced for very little (what does an 8 × 10 sheet of paper cost, 50 cents?)— and the aura was the value, so what? Rauschenberg and others see the photograph as a tool, a way of getting some kind of intensified reality.

JB: Are those artists dealing with content on a conceptual level that allows the object in the picture to be simultaneously both specific and universal as a sign?

TFB: They understand, though they probably couldn't express it, the sense of truth or veracity that the photograph carries. That's a useful thing to push against the abstract notions they might be adding in terms of drawing. Look at those little squiggly lines that Rauschenberg made. They don't seem to carry the weight that writers thought those kind of lines in Abstract Expressionist painting carried. They don't have the same kind of drama or heroic quality. To counter those almost meaningless marks, they coupled them with something which in our society has enormous implied meaning and power, the photograph.

If you really want to say something cynical today it seems the photograph can do it very well. We still seem to see the photograph as a talisman-like object. I don't believe all that stealing the soul thing, and the painters can get around that. They say, "Isn't this a funny way of making the three-dimensional world two-dimensional." They can look right through photography because they are not concerned with the technique. Of course I am speaking in very generalized terms.

JB: It seems that you are putting the artist more in an editorial rather than a producing role in relation to the photograph.

TFB: Rauschenberg generally found all his photographic imagery, but I think Baldessari acts more as an editor.

JB: Your recent sculptures seem very self-referential since you are using all your own books, or books that you are connected with.

TFB: They are autobiographical. I don't want them to be too didactic in any way, but I should explain them a little. In the *Reading into Photography* piece, the book itself is an anthology I did at the urging of and with a great amount of help from Shelley Armitage and Bill Tydeman. If you take the time to study it, many of the Polaroid photographs around it are from a book that has some particularly fine but rather obscure examples of high-Modernist architecture. I see that piece as almost Borgesian. I constantly cite him (as many people my age have); he was very seminal in the 1960s it seems to me. Photography has affected our thinking and knowledge since the halftone dot, because we are talking about reproduction. All of the images on that piece are from reproductions, and they are spilling out of the book titled *Reading into Photography*.

So we understand Modernist architecture through photographs. I was reading a book on 1930s British architecture that was done a couple of years ago. They explained that since most of the British architects knew German Modernist architecture of the Bauhaus sort, or International style, from reproductions, they felt that they understood the glaring white stucco very well. What happened is that they were never able to achieve that kind of brilliant white stucco in their Modernist buildings (of which there were not very many) because of the humidity and dampness in England. So what they did was make their buildings look like their brilliant white stucco German counterparts by retouching the photographs when they had them reproduced. That's what I'm commenting on, you see. We learn so much stuff through books and reproductions, and I accept it, I'm not criticizing it.

I wanted to use the book *The New Vision* in a sculpture because I still like that kind of dictum "make it new" as Ezra Pound and others have said. It was nice having my photograph chosen to

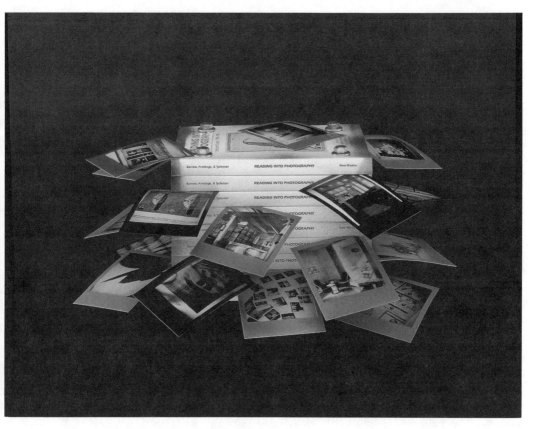

Thomas F. Barrow, *Reading into Photography*, 1985–86, construction with nine published books, bolts, and Polaroid prints. Courtesy the artist.

be on the cover of that book. I don't think I have a new vision, but I think I use photography in a somewhat fresh way. What I hope people will see is the very strange Polaroids around it. Those all seem to be elements that apply to new vision—Gumby off of a video tape, an odd-shaped amoeboid fiberglass sculpture, and two photographs of a Vermeer road grader. Vermeer is spelled exactly the same way as the Dutch painter. It is an asphalt paver, and I figured that if Vermeer had been a minimalist he might have done that. I would like it to be really dense in meaning.

JB: Density is an important issue in your recent work, isn't it? Not so much in the *Automobile* series or the *Dualities*.

TFB: The *Dualities* were the first attempt at increasing the density. The *Pink Stuff* were meant to be off-hand and 1960s. The images are almost identical, taken moments apart with slight movements of the camera. But in the ones called *Dualities*, I operated out of having read one of Pound's early literary essays where he talks about symbolist image-making. If you put two dissimilar words together, a new word or new poetic image may be formed in the mind. The essay, if you substitute in much of it the word *photograph* for *poem*, makes sense about how one could increase the possible levels of meaning. It doesn't work in many of them. They are not juvenilia, certainly, but it is early work. I enjoyed the way they looked hung in the museum, and I like them as objects. Where I really got the idea from was Alice Wells at the Eastman House. She was doing work with the double frame, as was [Robert] Fichter. All three of us were working that way, and then Donald Blumberg did it too. Everybody thought they had invented something, but it was in the air. That's the only way I can describe why things happen that way. That body of work is essentially completed for me.

One piece that is heavily autobiographical is called *Domestic Structure*. It has some subtle things about my life at the time that I made it. It was done at about the time that I guest curated the show *Self as Subject*. I like that kind of diaristic work. Eileen Cowin's work in the last two or three years is really powerful—the off-handedness of it, the sensitivity of relationships. It's a serious subject and she's wrestling with it pretty well.

JB: Some people have not seen past the soap opera quality of the images.

TFB: She's making objects, first of all, which soap opera isn't making. She's making those objects in a very astute manner. They are clumsy, but she understands the awkwardness of those situations. Yet, by making it an object, then we have it for longer contemplation. I don't think it is Cream of Wheat for the mind.

JB: Are you writing?

TFB: Not at all! Nothing more than occasional short reviews for *Choice*. I made a pact to stop trying to write. First of all I don't think I write very well, and even if it's readable it takes forever to achieve it. My wife said that I became such a difficult person to live with when I was writing that she asked me to reduce my output. Plus my visual work is going really well. I used to worry about running out of ideas, but now I have about five things started in my studio and I'm really excited about them. The sculptures are more exciting to me than anything that I might be doing with a camera right now. Some of them involve tremendous numbers of Polaroids, but somehow I never feel like that is using a camera. It's more like doodling. I'm copying things that I want in there and it does seem better to take the picture of it with the Polaroid, better than if I lettered it or sprayed it on with a stencil. Sometimes it's only the photographic piece that can work. And yet, because it's a Polaroid it seems notational and not as important as if I made a black and white or other careful picture.

One of the reasons I started caulking the *Caulked Pieces* was to add some body to them, to make sure they stayed together. Also, I wanted to cover the staples, but I used the transparent caulking because I thought one should see the staples there. It's a kind of honesty about how they are put together, and the staples have a character as well. Now I'm using a lot of sheet metal screws and those show too because I like to show how the pieces are assembled.

JB: You must be doing some writing to get the words on your photographs. It's pretty minimal, but how do you choose the words?

TFB: I have a collective list of all the words I've used typed on several pieces of paper. Someday I would like to see all the pieces that I've written on collected because I think it would be a catalogue not just of my thinking but also of terminology used in the 1970s. A kind of inventory.

JB: Would you call them key words?

TFB: That's good. Most of them have come from M.I.T.'s annotated catalogue of science books in print. There might be a topic called "stellar perturbation," which is about how they think things have moved in the heavens because of exploding comets. I learned what they mean because I don't want to use words that just sound good together. I already knew what "plate tectonics" meant. Recently, I have been using general book catalogues. There may be phrases which are part of longer titles. Some of the new pieces are on the theme of "sexual ecology." I have rented x-rated videos just to take the stills from. They have lots of Polaroids on them. I'm not sure what they are about yet, but I want to say something more about the Meese pornography report and in a sense respond to what Heinecken has done and the thinking behind his work. I think it's almost too inflammatory. I want to say something about living in my own time. I like to think of this work as highly documentary, partly because it is saturated with culturally related imagery from this moment in time.

JB: But you are creating primary documentation in the sense that though there are references to cultural things outside the work, the pieces are also objects of their time.

TFB: I would say that as documents, it will take someone with sensitivity to explicate them later on. They have a lot of iconographic references. I read a great line in a review of a book on science in the *New York Times*. It was about chaos and entropy and went: "Everything is winding down and ending up in chaos but we can only keep order for a certain time." I sort of think that way. The basic layer that I create in the darkroom is like what the author was talking about in terms of entropy. Then I put the overlay with the words and spray paint of reason—the mind of man over chaos.

Mark Alice Durant has written of his work that it is concerned with "ideas of public and private self, collective and personal history, faith in religious and/or secular ideologies, memory and reconciliation." In his search for expression of these heady concepts, Durant is actively participating in the broader movement toward rediscovery of meaning in the arts.

One difference between youth and maturity is the quality of experience. The ideals of youth become a life hypothesis which has to stand the practical tests of time. Maturity reflects the results of those tests, as the flaws in the original theory are resolved through adjustment. When a photographer, for example, has a body of work generated over sixty years, one can begin to encompass the whole of the life-theory, to see the questions asked in the early years, to see the resolutions. This comprehensive view does not exist when interviewing a younger photographer such as Mark Alice Durant. Instead, one feels like an intruder into the artist's search as he formulates his questions and philosophy.

This interview explores not only the kinds of guiding ideas behind Durant's work, but also how those ideas are given form and expression through photography as a medium. Rather than a photographer who suffers the presumed fetters of the medium, Durant is much more a poet, thinker, and tinkerer using photography as a medium because it has suited his aesthetic needs. Thus the work has to be considered in a context other than traditional photography—calling it not-photography suits it well—though its means of production are quite traditional.

AN INTERVIEW WITH MARK ALICE DURANT

May 6, 1987, San Francisco

307

Durant was born in Medford, Massachusetts, in 1955 and discovered his interest in photography when he was fifteen years old. With a friend's camera he photographed a rock concert. The incidence of a photographer's first conscious experience of photographing has a profound effect upon the development of his or her work. Given that this theory holds true, that Durant photographed within the context of the communal experience of a rock concert seems somehow connected to his ability to select images of significance from the pool of common published images. Durant's murals which are composites of media imagery with his own, demand a kind of patience from the viewer, patience to experience the struggle for coherence within the work, and then the coherence itself. What carries and rewards the viewer throughout this process is a refreshing, challenging conviction—an idealism of the hypothetical sort.

After graduating from high school, he studied history and anthropology at the University of Massachusetts, Boston, from 1975 to 1978. He then completed the B.F.A. degree in media and performing arts at Massachusetts College of Art in 1981. During the two-year period from 1981 to 1983, he served as staff photographer for *Boston Rock* magazine. He has lived in San Francisco since 1983 and completed an M.F.A. in photography at the San Francisco Art Institute in 1985. His large-scale works have been exhibited nationally.

JB: What interested you about photography rather than any of the other arts?

MD: I was just a punk kid hanging around the streets of Somerville, Massachusetts, in about 1970. There were a lot of liberal and radical students coming out of Harvard, Tufts, M.I.T., and other local colleges. They were all being social workers and were opening all kinds of media and drop-in centers.

JB: How old were you at that time?

MD: Fifteen. One person trusted me with his camera which I took to photograph a Led Zeppelin concert. I have always been

deeply involved in one thing or another, but photography just stuck . . . I'm not sure why.

JB: What other kinds of things were you involved in that would have led to photographing?

MD: I always wanted to be a writer from a very early age. When I was a kid I used to write short stories, but I was too afraid to show them to anyone. I never tried to get them published. I stopped writing when I was about twelve. I wrote about thirty short stories between the ages of ten and twelve.

JB: Have you gone back to read those stories?

MD: My Mom has them in her basement, but I haven't actually had the nerve to pull them out. They are buried under so much stuff I would have to dig for days to find them—if they are still there at all.

JB: Does your interest in writing and words explain the use of text in your images? It seems to me a logical extension.

MD: My way of looking at the world and my experience of photography were more than just visual. It never really occurred to me to put the things together until I was in East Berlin. I was photographing at nightfall. There were piles of tar lying in the middle of the street. I thought it was quite odd. Then a little boy came walking down the street. It was winter time so he was wrapped up in a hood. He was also very curious about the piles of tar—they were about six feet tall and steaming—it was in January. He was looking at it and touching it. I thought, "What a photo opportunity." So I started shooting away with a flash— and he was quite startled. He stood back and asked me something in German which I didn't understand. I continued to photograph until I realized that he was asking me if I was from the police. I just had a moment of shame, of abusing my power as a photographer for the sake of a good image.

When I finally printed that picture it didn't have any of the

Mark Alice Durant, *Temple of Bones,* 1986, gelatin silver print.
Courtesy the artist.

implications of what had actually happened. I printed up three
of them and scribbled the story underneath. Within a month
after that I was doing pieces with text included in the image.

JB: Is photography a good substitute for writing?

MD: I see them very differently. Image-making and words are
very important in everyone's life in a very personal way. I want
to use the power of both. I want to reflect the way that I've been
touched by words and images.

JB: You are implying that they touch one in different ways—
how does each one of them work? What is your own experience
of them? They are both connected to the imagination—a picture
is in a sense a preformed imagination, but one has to conjure the
image of a word. Does one hear things through the words, but
look at the picture, for example?

MD: They are opposite sides of the coin. I want to make images that have literary or historical references, so the images are attached to ideas and language. The way that I write is very imagistic, it evokes pictures. They are both trying to get at a resonance. The tension between the two can expand both of them. At times it can work against you when things become very obvious. My writing is pretty free form. My mind is so distracted that that is the only way that I can work. My mind is like cable TV sometimes, continually switching.

JB: But you write reviews.

MD: I've been doing that to become more disciplined. I thought that I should be able to write 600 words—if you can't there is something wrong with you. (laughter) It's a challenge. I've done some pretty evocative pieces of writing in stream-of-consciousness—pieces that evoked a sense of place, time, and events—all mixed up in a tumble where things happen simultaneously. Ever since Joyce, people have been working this way. I want to evoke the simultaneity of experiences that don't necessarily have any obvious relationship to one another, but work out of a tension between the words and pictures that forms a third entity.

JB: What you are describing to me in terms of the simultaneous experience of divergent elements really fits your work. The elements seem to hold together at first, then seem to fall apart, only to develop a newly found coherence that connects with the guiding idea. So your work really reflects the way that you think. Do you feel that kind of a connection to it, or should it seem completely resolved?

MD: No. I really see the work as process. I usually hate my work until it has been around for a while, then I can accept it. I am in the process of making work for a show in June—it's driving me crazy. I feel like the character in a Maya Deren film who is running down the beach picking up stones. The more she picks up the more she drops. I am trying to hold on to so many ideas, I end up having to let a lot of them go. Each work

has to be honed down some. I like it to have a presence that has some electricity—that the piece *might* be falling apart visually and as far as the ideas go, but hopefully they all come down to rest or resolution as well.

JB: You are appropriating imagery as well as including your own and text. Do you feel more like an assembler than a creator or originator?

MD: One can try to be pure in terms of one's own vision, but I don't want to deny all the input, that I have all my nerve endings open. Calling oneself a conduit sounds a bit pretentious, but, in fact, it's true. I've also thought that I've never had an original thought in my life! (laughter) I was once going to change my name to Mark Derivative—I still think it would be funny.

There are specific references, whether they are media images or some phrase that is used a lot (actually all the phrases are mine). I will use them somehow if they are powerful. Because I am so affected by imagery, and I look at a lot of it, I'm hungry for it, I want to respond to it, to have some kind of dialogue with it. I do that either through the text or by making an image in response to that image. It makes the matter more public because a lot of the pictures have been seen either in paintings, newspapers, or magazines, although the pictures that I have been using lately are a bit more obscure.

I don't see myself as an appropriator in the truly Postmodernist sense—deconstructing imagery or criticizing the media. My sources are much more medieval. I am trying to create worlds with each of the pieces that draw their inspiration from artists like Breughel or Grunewald.

JB: What seems important there is the notion of trying to create a world. That in itself is what fiction is about.

MD: I don't want the pieces to be didactic. I want them to be as simple and as distilled as a poem can be. I hone down the number of images until I have a few that I can respond to. Generally the pieces are planned and made for a specific show.

Mark Alice Durant, *History Soars/Flightless Wing,* 1987, photo mural.
Courtesy the artist.

JB: Do you mean they are made for a particular audience or
space?

MD: No. The last three shows I've had have been these philo-
sophical collaborations with the other people in the exhibition.
We all made our work around an idea. *Oh, What Ravenous Eyes
We Have* (with Mark Chambers and Mimi Plumb-Chambers) at
the Eye Gallery was about cynicism and nihilism. Another show,
The Loneliness of Not Being God (with Alan Rutberg), was more
about my or one's relationship to faith, God, and religion. The
upcoming show is called *Stories from an Anxious Childhood.* For
that show I am using a lot of imagery that walks a line between
faith and betrayal, innocence and cynicism.

JB: Who determines the themes for the shows?

MD: I like to name things first then go about finding the vi-
sualization for it. Though I authored the titles, the ideas are
actually arrived at through the process of collaboration.

JB: Why are you working in mural scale?

MD: Some of the original collages are more beautiful than the murals.

JB: How small are the original pieces?

MD: From 4 × 5 to 8 × 12 inches. I rephotograph them.

JB: So you work knowing that the small version will be reconstituted in large scale.

MD: Murals are not such an unusual size if you compare them to painting. I like the scale's presence in a space. I think they become more object-like. It is easier for the viewer to fall into the world of the work when they are large. Figures become life size and the pieces are more aggressive. Subtlety has never been my forte, I just don't have that kind of mind. I think I am basically a rock'n'roller at heart. I also get tired of seeing photographs in straight lines looking like little dots.

JB: You actually apply acrylic gel medium to the surface of your prints. What's the reason for that?

MD: Since the prints hang away from the wall, the gel medium makes them physically stronger as objects. I apply it thickly, it drips in places. They look wet hanging there and have more presence. If I am ever going to use color successfully I just need to explore it some more because it is a difficult issue. The strength of the murals is their austerity. The color detracts from that. The times I have used it, it has been deliberate. In *Captivated by an Unholy Light,* I used a yellow to convey a sense of sickliness or jaundice. It was also a play on a jaundiced view of mankind.

JB: Many of the themes in your more recent work have centered around issues of spirituality and culture, but I may be presuming upon the work. A more obvious theme is religion. Does that seem like a reasonable statement to you? If it is about religion, is it the political structure of religion or a more personal experience of it?

Mark Alice Durant, *Tierra del Fuego,* 1987, photo mural.
Courtesy the artist.

MD: On one level the work publicly decries the abuse of be-
lievers. Religion is not just a declared faith such as Catholicism,
it has to do with putting your belief in something. Agreeing to
believe something with a group of other people. That is what
fascinates me. I was an extremely devout Catholic when I was
a child. I was even much more religious than my parents, by
choice. I was an altar boy and wanted to study to be a priest. I
had a natural inclination to throw myself into this all-consuming
ideology. I felt sacred, something more than me which I yearned
for. Like every other kid fifteen or sixteen, I rebelled, grew my
hair, and turned away from "institutionalized" beliefs.

JB: It is interesting to me that it was at that time you were
entrusted with a camera. Was there a connection between the
rebellion and the use of the camera? After all, one of the ten
commandments is: "Thou shalt not create graven images."

MD: It was not a tool of rebellion, but it certainly became one
of the ways I could start talking about what I was dissatisfied

with. When you are that age, you feel betrayed by everything you've been taught, by all adults. You figure out that everything they've been telling you is lies. After that I became very involved in politics, union work, antiwar protests. Again I threw myself into it totally and after three years experienced the same disenchantment with that ideology. I wasn't so upset with the ideas as I was with myself for swallowing the ideology. I was very dogmatic about my beliefs. Personally, the ideas of politics and religion are inextricably related. If you need something to save you, Communism isn't all that different than some religions in terms of the promised payoff at the end of the road. Do we betray ourselves when we give up our power? Power is being abused by those that have it. It's a funny cycle because power is given by people then it gets taken away even more. I have tried to explore that in a very personal way, though it is also a public issue.

JB: Does your present work have an ideology?

MD: That's a good question. I wish I had a clever answer for it. I'm sure it does, I hang on to some opinions tenaciously. I think I'm very moral, very moralistic. Sometimes the work is very preachy. I'm more comfortable not being anchored to any one specific ideology now. What I see going on in my work right now is that it always addresses some conflict between declaring one's own power and feeling betrayed. In one of the pieces it says, "sing out, be afraid." This phrase really contains the contradiction.

JB: How is your work moral? How would I experience that in one of your pieces?

MD: A work won't end up being completed as a mural unless it has those qualities. If it doesn't have a moral integrity, then I will throw it away and start over again.

JB: What are your criteria?

MD: I don't think I've ever said this out loud, but I think a work has to have a sense of sanctity for what we try to be as human beings—not just the sanctity of human life though that's part of it. It is the sacredness of our dreams, of what we want to be and become. The work should have some sense of liberation. The very act of making something is an affirmation, it's antithetical to nihilism. Making art for me is a religious activity.

JB: Is art-making a ritual for you?

MD: It's like a chant. I begin with a vague idea, work with images and ideas, think about them over and over again, like the structure of a chant, until at a certain point all the excess syllables are gone. Then I stop and it's done. It is a long gestation period, but when the decisions are made I can act quickly.

Photography entered the history of picture-making when rendering in perspective was still the ideal of representation in Western culture. The medium, its practitioners and its processes, were so readily engaged in the service of that ideal that the process remained transparent to viewers taken by the content. By the turn of the twentieth century the photograph had lost its visual innocence; it could be viewed as a phenomenon evidencing its own means.

Critics of the proto-Modernist movement in photography, such as Sadakichi Hartmann, recognized a separation between photographic ideas and the Western ideal. Even as the photographers reinterpreted representation through manipulative processes, Hartmann discussed the abstract and structural aspects of the medium. The Dadaists, Constructivists, and Surrealists rediscovered cameraless techniques and explored other non-objective imagery with light. The key to understanding the content of these images is to examine their genesis or process first. In conjunction with this reappraisal of expressive forms during the early Modernist period, the traditional notion of representation, approximated best by the camera, was recognized for its lenticular abstraction of space. From another analytical point of view, the lens-image was a mathematical structure containing literal referents. It is this conceptual attitude which freed photographers from the medium's monocular vision and underscored a more plastic approach to photographically derived content.

Artists in the 1960s demonstrated a sim-

ilarly antimaterialistic approach to art-making as had been explored by their counterparts in the 1920s. In particular, process artists moved art further through the abstract into the conceptual. Photographers, fascinated with the newfound significance of and possibilities for process, rejuvenated forgotten photographic techniques, explored new imaging technologies, and crossed over traditional boundaries of the media. Content, often referring to aspects of the medium itself, became a vehicle for process and was relegated to secondary status. Means and processes became an integral and visible part of the photographic statement. More recently, structural and semiotic analysis of art has shifted the focus from process to content as message and has attempted, in a sense, to locate the concept within the tangible aspect of the image.

Artists and photographers, such as Betty Hahn, have met the challenge of content by questioning the assumptions through which we receive it while at the same time reasserting art's connection to the intangible, to implication and evocation. Hahn emerged in the late 1960s as one of the leading photographers concerned with the renewal of process as an idea in photography. Her early work using the gum bichromate process and multiple imagery was included in the seminal exhibition *Vision and Expression* held at the George Eastman House (now the International Museum of Photography) in Rochester, New York, in 1969. This exhibition was one of the first to survey uses of the photograph beyond the straight tradition. Since that time, she has continued to expand and deepen the range of her expression through the process-idea dialogue. A prolific artist, she has had over thirty one-person exhibitions and been included in countless group shows nationally and internationally.

Hahn's studies at the University of Indiana were to have a profound effect upon her career both as an artist and as a teacher. First as an undergraduate then as a graduate student, she met and worked with Henry Holmes Smith, one of the most highly regarded educators in and of photography. Smith himself was the first to explore nonobjective dye-transfer color photography, and was concerned with mythological themes throughout his life. He instilled in his students honesty, a willingness to question

and take risks—and, as Hahn points out in the interview, a faith in the flexibility and expansiveness of the photographic medium.

It is those two words which best characterize Hahn's work, with the important addition of a sense of playfulness. It is through the latter that she has satirized high seriousness in photography (witness her giant "soft" daguerreotypes, 1973), and, more recently, questioned the very nature of photographic representation as evidence (*Crimes in the Home*, 1982). Though her point of departure in photography was through process, her most recent works (*Shinjuku*, 1984, a still-photo installation, for example) have focused primarily on the issue of narrative content. In short, she has touched upon many nuances in the quadrivalent relationship between form and content, process and idea. Perhaps this entry drawn from artist Paul Klee's journal reflects what Hahn has done in photography: "The form occupies the foreground of our interest. It is the object of our efforts. It belongs in the first rank of our *metier*. But it would be wrong to conclude from this that the contents that it embraces are secondary."

Betty Hahn lives in Albuquerque where she is currently professor of art at the University of New Mexico.

JB: Your work has taken so many different directions, I wonder how you determine what you are going to do next? How do you treat such multidirectionality, does it make for some confusion or just a range of possibilities?

BH: To me it represents a range of possibilities at any given moment. To others it appears as some confusion. I don't work based on what I did before. I don't look for a linear progression at all. Consequently, I have made some radical shifts.

JB: Do you find your ideas resurfacing in different forms?

BH: I've just noticed that happening in the past two years and I have been working seriously for about twenty-two. Sometimes I feel like I have only six ideas in my head that just come out in different forms. What form they are going to take is really a

question of resolving the problem of form and content. I think a lot about that problem as well as how things are going to look.

JB: Is that a consequence of your long-standing interest in process?

BH: It is more connected to the background I had in design and film-making. In design one really approaches each problem as a discrete entity. I had a lot of training in that kind of thinking. One doesn't have to maintain a continuity of style in design, one can change from problem to problem.

JB: Do you feel that you bring an idea or problem to its temporary conclusion, then set it aside?

BH: I've noticed that a lot of those ideas I've set aside have begun to spill over into new work. I see myself returning to ideas that I worked with seventeen or eighteen years ago. Now I have a new big studio where I can lay out all of the work together, put pieces next to each other that are years apart and suddenly see connections.

JB: One clear connection occurred to me as I was looking at some of the early gum prints. There were a lot of strips of images that were very filmic. There is almost a narrative or at least a sequence of events. Your recent work *Arrival or Departure* reflects that. Is there something endemic to roll film and perhaps to photography as a whole that fosters extended linear thinking?

BH: The film strips that I am working with now are very much like the very first gum prints in which there are five or six variations of the same image with slight movement. I also noticed connections between the stitched pieces and the straight color photographs. I never really tried to do that, though now without trying it's happening anyway.

JB: Do you find it rewarding to discover the value of those earlier ideas, to see now what you were doing though it was not so evident then?

BH: It makes me feel more like other artists! [laughter] People are bothered by my succession of radical shifts. They look at those shifts and see a chameleon-like character operating. So the connections make me feel less like a chameleon and more like a solid citizen. I find that the changes are very refreshing and, more important, I don't do it on purpose. I just can't work any other way. I will do fifty to eighty prints within each group, so it's not as if I am simply jumping around from idea to idea.

JB: When you worked on the *Flowers* or *Lone Ranger* series what was the guiding principle? Though the subject matter remained fairly constant, you certainly varied the process. Was it an elaborative approach to the idea?

BH: Within those groups I would say that that is true. I would wear myself out within this rather narrow approach to an idea, if I only worked in that one way. It would limit my thinking, that's what makes me want to change to another idea. That's how I find freedom and flexibility. One of my major influences in that area was Henry Holmes Smith because his attitude was expansive. He was so open-minded and had enormous confidence in the medium, that it could handle anything. He was always questioning what it was capable of and it seemed that he felt it was always capable of more. He passed that confidence on to his students.

JB: Because you have a similar approach to that expansiveness, why photography, why not another medium?

BH: For me, it was Henry's influence. He made photography seem the absolute most important of all the media available. It was his belief system, his attitude toward it. I started out in painting and drawing, shifted to design, then into photography.

JB: It seems that few photographers approach the medium with that breadth of attitude and experience. Why is that?

BH: Painters see photography as just another way of making a

picture. I think a lot of photographers don't have the soul of an artist. Secondly, they are not really trained in the arts from childhood on—and that makes a big difference. I mean having art classes all the way from elementary school on; even bad art classes would allow them to make pictures. People come to photography from more academic disciplines and they feel most secure approaching photography in a very narrow way.

JB: How important is process in your work? What is your relationship to it?

BH: People ask me that all the time, because they assume that everything I do comes out of the process. I like all the various processes that I have used, but I have gotten to the point where I'm almost afraid to say so.

JB: Is that because it would verify people's assumptions?

BH: Exactly! They will just write the work off by saying that's just technique.

JB: People have often seen only one or two pieces from what you have described as much more elaborate series. That would seem to limit how they could perceive the full evolution of the idea. Is that a problem for you?

BH: I have only shown the pieces in small sections. What I try to do is show one or two groups at a time because I don't like to add to the confusion either. I also like the look of similarity.

JB: Would it be possible to show selections from different groups now that you have seen connections between them?

BH: If I had a lot of exhibition space, or a book published.

JB: Your recent work is filmic in that it includes subtitles within the sequenced still images. The series *Shinjuku* was done in Japan.

Another series and installation that you did was titled *Appearance*. What do the titles mean?

BH: Shinjuku is an area of Tokyo. *Appearance* has to do with a work that I have been evolving since 1978 on the idea of mystery and intrigue in photographs. I began working with text and captions as a way of dealing with the idea.

JB: Its final presentation, then, is an installation?

BH: As a sequence of photographs it's really better installed. You know that I live in the cracks of photography, so it's all right to call it an installation. The piece wouldn't work if you took out one of the eleven pieces.

JB: Is the sequence meant to be viewed as a puzzle?

BH: *Appearance* is not a puzzle, but the piece before it required that you had to match text with the images. *Shinjuku* is more like Japanese film with English subtitles—the text is within the photographs. In all the other series the text was separate from the image. *Appearance* has to do with the Lone Ranger, so there are eleven pictures of the Lone Ranger mounted above eleven pictures of typeset text. The text flows from one image to the next. Reproduction of incomplete parts of the series can be very misleading.

JB: In the development of these mysteries what kinds of rules are you using, what kind of logic?

BH: It's hard for me to think in terms of rules. It has been a real investigation for me and I have made some real mistakes doing it.

JB: What kinds of mistakes?

BH: Photographs that I have taken for certain purposes would sometimes go out of control and didn't go in the direction that

I wanted them to. For example, in the *Scene of the Crime* series, I hadn't worked out the ideas thoroughly enough and also exhibited them too soon—meaning that I received immediate feedback that told me that the pieces weren't working the way I wanted them to. I also learned a lot about the picture/caption relationship. The overriding idea that ties my work together is that I never do photographs that are complete statements in themselves. I'll take an essentially incomplete image, then complete it with a process, paint, drawing, fabric, and now text. My thinking is that the whole is equal to the sum of its parts. I look for incomplete or extremely simple photographs which provide an entry to play with the image as an idea or process.

JB: Do you consider these as criteria?

BH: Yes—I'd call them *modus operandi* [laughter]. That's the way I look at it. I don't think in terms of rules. I do think in terms of making sense, or is this logical—a picture logic or a language logic.

JB: How do those two logics relate?

BH: I don't know. I approach making the work as a balancing act, trying to get enough information coming from the picture and enough coming from the language. Context, simply placing a word next to a photograph, forces the instinctive response to want to make sense of them.

JB: Do you write all the words you use?

BH: Sometimes yes and sometimes no. I have appropriated (or stolen or cribbed) the words. In *Case of Dos XX*, I took them from a detective's training manual as well as from a sleazy detective novel. I just cut them out of the books with a razor blade, xeroxed them, and put them back together. Not only did I crib them, but also rearranged them. With the *Lone Ranger, Appearance*, I used the last paragraph from a 1949 children's novel. In

I can't remember.

Betty Hahn, *Frame #10,* from the sequence "Shinjuku," 1984, chromogenic print. Courtesy the artist.

Shinjuku, I wrote the words myself, and it is the shortest written piece.

JB: Was that because of the technical problem of fitting the words in the frame?

BH: No. I just got tired of reading so much text; I felt I could do more with less.

JB: That's your rule, isn't it?

BH: That's Mies van der Rohe.

JB: In speaking about *Shinjuku,* you mentioned the influence of

the *Wizard of Oz* because of the film's switching back and forth between black and white and color. Switching presents an interesting problem for still photography. In the filmic technique the purpose was a shift of reality. Does it work that way in the still?

BH: With the still photographs it works almost as a shift of perception, feeling, or mood because it is the same picture that changes. The picture which includes the shift is flanked by a black-and-white image on one side and a color one on the other. So it's a real melding together of the two techniques. The image looks a little like a hand-colored photograph because the color is mostly at the top, but they are type-C prints. The change is slow so you can see it evolve and contemplate it.

JB: The shifting mood is one of the key elements in the development of a mystery plot. Is there a mood of ambiguity or . . .

BH: What happens is that the ambiguity begins to fade away, it's like a dream when things become more clear. In the movement from black and white to color, the color presents more clarity.

JB: Is that because it seems more representational, more like the way we experience the world?

BH: I think so. There is also a shift of time in that the color looks contemporary and the black and white seems much older. In the sequence you go from past to present to past. There is also some soft focus going on in these pictures; my first gum prints also had that softness. I always had that kind of melting together of colors or partial color.

JB: Do you think the pictures and words work together through what they imply?

BH: I like the idea that things are there through implication. In

the newer works, implication creates a kind of coherence. The earlier pieces had more disparate elements, were choppier, but were united by context.

JB: In earlier sequences, such as *Case of Dos XX* or *Crime in the Home,* you were forcing the viewer to take some imaginative leaps.

BH: In the more recent pieces there's more of a flow. The viewer becomes conscious of the role of photography because I've made photography function in certain specific ways—but in different ways each time.

JB: What kinds of responses have you had to the language pieces?

BH: Initially I had some negative responses to the fact that I would do it at all—jump out of nonsilver processes to which I was obviously assigned! [laughter] Also people were upset that I chose murder and crime as themes, because they didn't relate to my earlier themes. Not just what are you doing but also, how dare you! Others were interested in the kind of logic of the pieces or the puzzle aspect, and some the humor and playfulness of it.

JB: Humor and wit have been constant threads beginning with your earliest work, haven't they? There has to be a sense of humor behind someone who will overlap several photographic images printed in different colors of gum. How else can one accept it as an image except on that basis? The humor seems to have taken different forms. The *Passing Shots* series was made with a Mick-A-Matic and is therefore based upon humorous and somewhat ironic assumption about the relationship between the mechanism and the vision. You had to be working tongue-in-cheek when you chose that camera.

BH: Well, it's an eighty-eight-cent camera. So it has a forty-four-cent lens and a forty-four-cent body.

JB: Do you agree that wit is a leitmotif in your work?

Betty Hahn, *Exhibit C, Cowboy Boot Assaulted*, from the series "Crimes in the Home," 1982, Cibachrome color print. Courtesy the artist.

BH: I would call it playfulness. I know there is humor because I have never been able to take all this stuff super seriously, nor have I ever been able to suffer—I never connected that with being an artist, I've always enjoyed it. That's the way I express my enjoyment. I know that sounds naive, but it's true.

JB: It doesn't sound naive coming from an artist with so many years experience. It's clearly an attitude or approach that works since it has allowed you the freedom to make the work that you feel is right to do.

BH: It has allowed me to maintain my interest. I have never lost my fascination with any part of art-making.

JB: Extending the notion of working with fiction or mystery, there are two schools of thought—one is that facts themselves are related to truth, the other is that when you build a believable fiction, regardless of fact, then it is closer to a "higher truth." This may seem like an antidotal question to the notion of wit and humor, but do you see working in mystery and drama (in such a fictional realm) as dealing with ideas that are of the "higher truth"?

BH: I wouldn't make the distinction or qualitative judgment between higher and lower; I have an enormous amount of respect for the truth and the facts. I prefer working in the fictional mode because it gives me a lot of freedom. A lot of writers have said that fiction gives them more freedom to deal with ideas. Fiction wants to be realistic, so it's not that you don't know what reality is, it is that you construct your own to get at purposes that would otherwise be limited by the facts or the truth. I just see working with fictional set-ups as access to freedom.

JB: So you feel that it is all right to treat facts in a plastic way.

BH: You mean things like docudramas that are partly fact and partly fiction? The *Lone Ranger* series works that way. I don't want to be dishonest about anything or trick anyone. I want to

expose rather than hide what I am doing. That attitude came from Henry Holmes Smith; he just abhorred anything dishonest.

JB: You show us everything, yet at the same time, the slight of hand is happening in our own minds, the mixing of the words and images. What are some of the clues in the work which tell the viewer that you are being honest?

BH: They can pick up the evidence of that first in the process itself, the attitude toward the process or how it is used, and from the titles or text.

JB: What do you mean how the process is used?

BH: When you look over all my work there are gum prints, cyanotypes, van dyke prints, some with paint, some without, type-C color, Cibachrome, black and white, and black and white with color mixed. I see process as the right tool for the right job. Decisions are made on how the image will appear to the viewer, that's a clue right there.

JB: You are saying that idea and process are completely integrated, and that there are certain images that work only in certain processes. Do you feel like you have pushed the limitations of what any process can do?

BH: No. I am sure there is a whole lot more in each of the processes. I can approach a problem from the point of view of the idea or of the process. It works either way for me, but most of the time I work from the idea first, know what is available, then work through the process.

JB: Did the first *Lone Ranger* series arise that way?

BH: That fell in the cracks again. That was an exercise in extension.

JB: If you see idea and process as integrated then it doesn't matter how you start. The words and images in the more recent work

would tend to be viewed as more conceptual or as idea oriented. The gum prints were process. Do you see them as unified?

BH: Fortunately, I am not a critic. I don't have to make sense out of those kinds of things. I'm not forced to unite them. I have just lately been surprised at ideas falling together. It's just not my problem. I always find it a great obstacle and a great burden to have to think in those terms.

JB: To return to the recent fictional pieces, how do you go about structuring and pacing the visual mystery or detective story?

BH: That poses an enormous problem of relationships and I'm still trying to work on what photography has to do with that. Maybe nothing, because detective novels have their own logic, form, and language. My question was, could I make a solvable piece photographically? Could I use puzzle parts and have it add up to something without falling into the use of abysmal cliches? I am not even sure what a solvable photographic piece might mean. I like thinking in those terms and about still life objects as clues. Each object would come with its own baggage, its own connotations and history. Context is important in that respect. I like to take the pictures at face value, as pictures *of.*

JB: Is there a strategy that you follow?

BH: I've considered it a lot, I just haven't found one that works perfectly to create a solvable puzzle. I've been able to deal with atmosphere and deceptive appearances—photographs and the building up of evidence tied to a certain character—but there is a lot I have to work out as well. I looked around me and there was evidence of breakfast on the breakfast table, evidence of traffic and activity in and on the street from skid marks, it's everywhere. You can look at your life and your route through the day as evidence. When people speak to you they are also giving testimony; they are witnesses and you are listening to their statements all the time. Once I could perceive that framework, everything fit into it.

I continue to return to the notion of the puzzle. I did all the pieces on story board first. I pinned up the frames and moved them around trying to make sense out of the puzzle parts.

JB: Are the *Flower* pieces feminist statements, or are they about the female aspect? Is it appropriate to discuss your work from a symbolic point of view?

BH: The *Flowers,* no. The *Stitched Pieces,* yes. They really had more feminist intent. I saw myself connected to a whole generation of women who expressed themselves through stitched pieces. They also were done on feminist themes, family and things close to home. I feel the flowers are much more universal. They arc around to all cultures—my favorite being the Edo period in Japanese art. Think of all the male artists and photographers who have done flowers.

JB: In the Edo period flowers were primarily a decorative theme. If you don't treat them as symbolic, though you have surrounded many of the flower images with fictional botanical information, then the beautiful saturated colors would put them in the decorative realm.

BH: I'm not afraid of the word *decorative.* I think the flowers are decorative, though I would tend toward the word *sensual.* Because of the tactile and visual qualities they appeal more to one's senses. But, I will find myself making a picture of just a luscious-looking flower. If I start thinking in symbolic terms, the burden would be such that I couldn't work any more. I like to lose myself in the sensuality of the picture. With the mystery work there is a chance to think and play. I don't see any connection between the *Flowers* and the *Mysteries.*

JB: The two groups seem to represent the difference between pictorial and linguistic logic. You did two particular series with flowers that also seem to demonstrate an analogous difference. The collotypes of flowers were overdrawn with richly gestural abstract marks. They were active and full of movement. Your

20 × 24-inch color Polaroids, on the other hand, were very still, pseudo-scientific.

BH: As I was working with the collotypes and the other non-silver processes—paint, tusche, and lithographic crayons—I kept those gestures in those processes. It was literally and virtually a flowing kind of working; I could watch things flow on the surface of the photographic image. When I went to Polaroid, I had to make an enormous concession to that relentless detail that the Polaroid materials were giving me. I shifted into the botanical mode so I could keep the flowers. Also while I was at Polaroid, I did some double exposures, including first a single crisp flower, then a second exposure with an overlay of very liquid paint. On that basis the two separate flower series [collotypes and Polaroids] came together. So, I could have my cake and eat it too at that point [laughter].

JB: What are you currently working on?

BH: I was in Australia for six weeks photographing landscapes. I've been working on landscapes for about a year. Prior to that, the only landscape that had I dealt with was in the background of the *Lone Ranger and Tonto* image. I started making some cloud images printed in cyanotype over a van dyke brown landscape. I thought I would do that with the Australian landscapes, as well as work in color and sequences—perhaps three, five, or seven adding up to one installation. The ideas, you see, are starting to flow together without me making them try to do it. I also want to paint on color photographs with an airbrush to destroy some of the color.

JB: Why did you choose the landscape? It has such a long and explored tradition.

BH: It came from working on the flowers so much. I like working with plant forms and I wanted more background, more context, so it quickly evolved into the landscape idea.

JB: Has your approach to teaching changed over the last fifteen years?

BH: My attitude toward the students and their work hasn't changed, but my personal style has changed. I am a lot more comfortable with the students and feel they need less and less teaching. I see some enormously talented students, and I just try to stay out of their way. A lot of them simply need the time and judicious encouragement and they will do fine. I have a lot more confidence in the students, but also I am dealing with better students now than I was when I began teaching. I am fascinated by the individuality which every student is capable of and I will do everything in my power to foster that.

JB: How do you recognize that individuality?

BH: You don't recognize it, you have to assume that it is there and work from that assumption. Challenge them, present them with alternatives, and hope for the best. You really can't teach art or artists. The individual has to have a longing inside them— the soul of an artist, an irrepressible impulse to make images.

ROBERT
FICHTER:
PHOTOGRAPHY
AND OTHER
QUESTIONS

*at the
San Francisco
Museum of
Modern Art,
October 1984*

Throughout the twenty-year period incorporated in this exhibition, 1962–82, Robert Fichter has evolved a methodology of fabrication which is wide-ranging both in content and technique, a methodology based on immediacy rather than formal strategy. It is immediate to the extent that one experiences the images as direct translation of his thought. His thinking, equally as concerned with the politics of experience as it is with sociopolitical issues, is nonlinear and intensely concentrated, reflected in the density of many of his pieces. Fichter's work is a visual analogy of stream-of-consciousness in literature. This technique, developed by such writers as Edouard Dujardin and James Joyce, is an impressionistic approach to character, a psychological portrayal, without regard for logic or narrative development. Subjective experience was the substance of objective reality. More often than not Fichter succeeds in transforming subjective experience into a vision of reality which is objective. Sometimes that vision is threatening: e.g., concern with nuclear disaster, militarism, and environmental destruction, but it is relieved with humor based upon ironic juxtaposition and a cartoon-like appearance.

The techniques he has used in the 180 images in the show range from silver gelatin prints to cyanotypes or gum bichromates to lithographs, etchings, and direct application of paint on paper. Though Fichter has respect for each, he demonstrates no compunction to keep them discrete; in fact, he combines them with a purposeful disregard for rules. This is emphasized in the exhibition by hanging together different images

in which similar subject matter, such as "Mr. Bass," a taxidermic wide-mouth fish, is repeated in altered perspectives, forms, contexts, and techniques. Content and technique are inextricably entwined. He has photographed drawings, drawn from photographs, collaged or transferred photographic information into drawings, painted on lithographs. . . . The list could go on, but the point is that technique, while at the service of content and statement, impresses the viewer with its own qualities. For example, cyanotype solution is treated as an aqueous paint medium as well as a carrier for photographic imagery. Fichter is not a master draughtsman, but the drawing, as sketchy and deliberately coarse as it is, is in apposition to photographic rendering. The camera is just a more optical tool for mark-making.

Fichter's characters, such as Flying Dog, Bones, and Baby Gene Pool, are convincing because they are repeated as elements of fictional development and because they express an aspect of the artist's personal mythology. Yet Bones is represented as a skeleton for its universal symbolic function. The transformation and recurrence of these symbols engage the viewer directly in the imagination and imaging process. Johann Wolfgang von Goethe, eighteenth-century scientist and poet, concluded in his correspondence with the philosopher Fichte: "I see my ideas." The implication of this statement is that the notion of idea is inseparable from imagination, a notion true of Fichter's work. The contexts which he creates for his characters, the imaginary landscapes or the tabletop settings of the photographs, contribute to the image statement by building upon symbolic content. Relationships and juxtapositions are sometimes intentionally humorous; at other times one can only assume they are arrived at intuitively. All of his charged information is coherent because Fichter is able to correlate vision and idea. Each fragment, though it may be indecipherable and illogical in terms of meaning to the viewer, has a reason for being there. Of the relationship between intuition and imagination William H. Gass wrote (from the essay "Philosophy and the Form of Fiction"):

The man who makes machines intuitively, the laws of heat and light and motion in his fingers, is inventive. Indeed, he

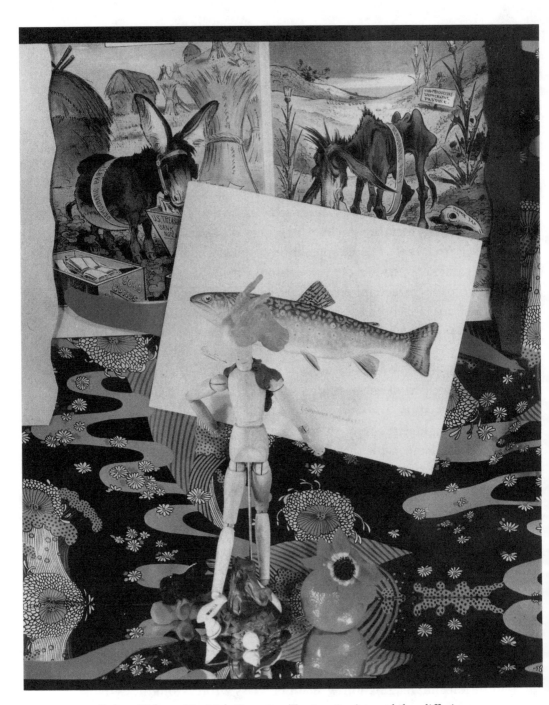

Robert Fichter, *Mr. Mule Presents a Trout*, 1980, internal dye diffusion-transfer (Polacolor) print. Courtesy the artist.

may invent, in the principles of its running, what science knows nothing of. The writer, similarly, thinks through the medium of which he is the master, and when his world arises, novel and complete—sometimes as arbitrary and remote from real things as the best formal games, sometimes as searchingly advanced and sharp to the fact as the gadget of the inspired tinker—his world displays that form of embodied thought which is imagination.

Images arrived at through the intuitive tinkering which characterizes Fichter's work defy explanation. But this, in turn, is their strength, their freshness.

Roast Beast/Weapon of War (1970) is a combination cyanotype and gum bichromate print in which an ad for a beef sale and a negative image of a military tank are vertically juxtaposed. The beef illustration shows a whole steer surrounded by various cuts of meat connected by lines to their physiological origins. Words above the tank read: "A New Photograph of a Successful Weapon of War." The loosely painted edges of directly exposed emulsion become the border for the comparative association of paired imagery. While the image seems completely accessible, there is a red gum overlay of vaguely discernible image. The seeming contradiction raised between photographic rendering and illegibility is an important issue in the earlier work shown. This issue is addressed in other ways such as partial sensitization of an image area or purposeful underexposure, and is reiterated in the *Damaged Negative* series from 1980. Large areas of the negatives were obliterated by abrasion before the images were printed.

The montaging and collaging of imagery has been incorporated in his fabrication of tabletop sets for the 20 × 24 Polaroid images. The frame of the camera defines the arena of action (a notion significant for the Abstract Expressionist use of the canvas). Within this arena, Fichter uses the illusionistic quality of the camera to play with perspectival ambiguity. This ambiguity contributes to the humorous effect of building an image such as *Jonah* (1980) out of fragments as disparate as Zen figurative illustrations and "Mr. Bass" reincarnated as a whale. The biblical theme of this image is given a political twist by the message

written on the sail of the sinking ship (lower left), "Political Honesty." In the large Polaroids, Fichter demonstrates that an intuitive method can be formed into narrative; the whole transcends its constituent elements. He succeeds in this because of his detached wit which borders on the absurd.

The exhibition represents the evolution of a body of work in which ideas and images resurface after being rethought, sustained through time, and given new significance. The influences or precedents found throughout the work could read like a short history of art and photography, but most prevalent is the attitude that art has sociopolitical importance. Leo Tolstoy, in his seminal essay "What is Art?", argued that there is a direct correlation between morality in art and its ability to address the situations of human existence with honesty and directness. Fichter has done that. One can forgive being confronted with truth when it is presented with ironic humor.

Fotografie aus Berlin is a selection of photographs produced at the Werkstatt für Photographie der VHS Kreuzberg in Berlin. Founded by Michael Schmidt, the Werkstatt is a highly regarded photographic workshop and education center in West Berlin. Despite its geographic isolation, Werkstatt participants remain informed of photographic activities in the rest of West Germany and the United States through guest instructors, periodicals, exhibitions, and travel experiences of its members. The idea for the present show was generated by Lewis Baltz, who traveled to Berlin in 1978 and again in 1980 for a showing of his *Park City* images. Impressed with the work he saw there, he contacted John Gossage, with whom he organized *Fotografie aus Berlin*. The show opened at Castelli Graphics in New York, traveled to the Jones/Troyer Gallery, Washington, D.C., and finally to the California Museum of Photography in Riverside. Not surprisingly, this itinerary reflects the bicoastal terrain of the organizers of the exhibition. Baltz lives and teaches on the West Coast, Gossage in the Washington area. Both are associated with Castelli Graphics in New York and have lectured or taught at the Werkstatt.

Based upon the range of work in the show, the organizers have had considerable input into the development of photography at the Werkstatt through their own work and their presentation of contemporary American photography. The question of their influence is difficult to qualify or isolate from their role as catalysts in releasing inherent potential within the Berlin photographers,

FOTOGRAFIE AUS BERLIN

at the California Museum of Photography, University of California, Riverside, May 1985

341

and it is certainly inseparable from their role as organizers of the exhibition. Perhaps the most immediate aspect of the installation was that all eight photographers work within the bounds of unmanipulated photography, though they achieve a range of statements from descriptive to conceptual. Thus the work takes two directions: first, a response to their awareness of American photography; second, a continuing exploration of ideas prevalent in the 1920s, such as middle European experiments with portraiture and photojournalism, which became a legitimate tool of expression in the German illustrated press. Collectively, they define photography as a recording medium.

The title of this exhibition is misleading; it is not an encompassing survey of all that is happening in Berlin. As the exhibition pamphlet states: "Though the Werkstatt is not the only institution to inspire important work in Berlin, it has developed as a primary nexus between the 1970s generation of Berlin photographers and their European and American counterparts." This connection is one of the reasons for the show which is a rather brief representative and informative survey of the work of eight photographers from the Werkstatt. They are: Gosbert Adler, Deiter Binder, Uschi Blume, Friedhelm Denkeler, Ulrich Gorlich, Wilmar Koenig, Michael Schmidt, and Klaus-Peter Voutta.

They break into three sometimes overlapping groups in their approaches to photography: documentary, journalistic, and conceptual. Of those involved with the document, Deiter Binder is perhaps the most traditional and the most subtle. He borrows the convention of distance necessary to establish a view from nineteenth-century landscape photographers. The images contain enough optically refined detail to form patterns which indicate conscious design; horizon lines and sky are textural counterpoint to the forms on the land. The poetics of this vision contrast sharply with the presence, in a number of the images, of groups of people who have gathered to inspect the landscape. Except in one picture in which a person viewing the landscape is photographed from fairly close behind, the people are small in scale, equal in visual weight with the rest of the details. The pictures hover on the edge between elegant landscapes and more political statements about the relationship between man and en-

vironment, akin to the work of Robert Adams. In Binder's images, the commentary revolves around tourists as view seekers and photographers as view takers. Despite having accepted an aesthetics of detachment, of psychological as well as physical distance, he has managed to implicate himself by the act of photographing.

Klaus-Peter Voutta, through an extensive series of photographs of a woman friend, has created a collective portrait whose obvious precedent is the evergreen model of Stieglitz/O'Keeffe. Voutta, however, concentrates on description rather than passion, more the way Edward Weston worked with the figure. He has photographed with a directness and forthrightness which virtually brings the viewer into the presence of the subject. Stark white backgrounds and diffuse light contribute to the sensuality of skin tone and fabric texture, which give the vision intimacy and formal credibility. The last image in the group, however, takes a rather different tack. Taken outdoors in brilliant sunlight, the photographer has included the hirsute leg of a male figure, presumably his own. This inclusion interrupts the directness of the other pictures. It makes the viewer aware of the image-making process and, in the guise of more honesty, speaks to the photographer's insecurity or immaturity about releasing his subject to the public. If there were more images in which we see the photographer's presence, perhaps this would not seem so. Introducing a new idea or approach in the last image of a sequence is editorially difficult, and a break in what otherwise is coherent pictorial metaphor.

Wilmar Koenig has done penetratingly intense close-up portraits. He has concentrated on faces and heads which range from the psychological intensity that Ingmar Bergman worked with in *Persona* to the casual detachment of Chuck Close's portraits. They are printed in life-size scale so that one is aware of every subtle facial gesture or tilt of the head. In this exhibition, the pictures have been installed in a tight grid which extends about ten feet high and about eight feet across. This format, because of its scale, transcends the portrait studio display; it intensifies the appearance of the individual despite the repetition of form.

The three photographers working in the journalistic mode are

Michael Schmidt, Uschi Blume, and Friedhelm Denkeler. Both Schmidt and Blume have used their cameras to take a personal look at two distinct environments. For Schmidt it is the neighborhood in which he has spent the majority of his life; for Blume the new wave clubs of Berlin. Schmidt works out of the tradition of photojournalism or social documentation which, though clear in its sympathies, also works with formal clarity. His image of a young man sitting on a store window seat shows Schmidt's sensitivity to the melancholic mood and expression of the person; he uses gray, overcast light and a wide-angle lens looking slightly down to reinforce the feeling, classic journalistic technique. Schmidt has consciously embraced the tradition within which he is working. I sense one does not get a full understanding of the depth of his work from such a limited selection of prints.

Uschi Blume's study of new wave nightlife shows a youth culture far from the *Jugendbewegung* of the early twentieth century. Theirs was certainly a culture of light as they traveled in bands across the countryside in search of the experience of nature. Her images are filled with darkness, partly as a consequence of the nightclub environment and her choice to use direct camera-mounted flash. Lee Friedlander used a similar technique in his New York City party pictures, but the mood is radically different. In Blume's photograph of a young woman, she is placed front and center in the frame, wrapped in a too large rain coat. The gesture of her right hand is the inverse of Leonardo's *John the Baptist,* the index finger points straight down. Blume's one study of the club environment without people is equally revealing. On the rear wall is a mural of Jimi Hendrix, seated with guitar, arms uplifted, a contemporary Orant figure. It is somewhat surprising to see this symbolic image transplanted, but its association with the incompatibility of altered consciousness and self-destruction seems appropriate to the setting. Blume's images lack stylistic strength, but she has certainly contributed to the collective image of cultural de-idealization which is antidotal to the mainstream media's sanitized view of the world.

Friedhelm Denkeler's work is far more personal and notational than Schmidt's or Blume's. The images are records of his observations of the curious juxtapositions, visual inconsistencies,

and irony of daily experience. This use of photography, the re-forming of our visual awareness of the world, was one of the most prevalent approaches to photography in Europe in the 1920s and 1930s. He sustains the earlier concern with the formal aspect of pictures, but has selected a group of images uneven in its freshness of perception, which is ultimately the criterion for working in a notational manner.

Gosbert Adler has incorporated the notational or diaristic mode into a larger conceptual framework. His piece is a fifteen-image installation which according to the catalogue is site specific. It is a continually evolving work in which color snapshots of his daily life and experiences, enlarged to slightly diffuse, grainy and sometimes off-color 11 × 14 prints, are assembled into associa-tively derived constellations. The sequence is accessible, clearly autobiographical, and open-ended. Perhaps because it is the only color photography in the exhibition and occupies an uninter-rupted stretch of wall, Adler's piece has a commanding presence. At the same time, he is the only exhibitor who has worked with a form which respects the inherent qualities of the photograph yet moves beyond the individual image to pictorial language for expression of personal statement and idea.

Ulrich Gorlich states that he has made photographs at the sites of Nazi war crimes, though there are no remaining edifices, and actually no proof in the images that they are made at the stated locations. The titles of the pieces, *Dachau, Gestapo-Hauptquartier,* and *Volksgerischtshof* (the court of justice responsible under Hitler for political executions), are typeset boldly onto the 7 × 6–foot canvases. He has mounted the pictures in grid form onto the canvas so that each presents a section of the whole with some overlap of content. The pieces have presence because of the scale; each is suspended like a banner from a pole across the top. The initial reaction is, of course, to the words which are heavily laden for any American familiar with the history of World War II. Stated by a German, however, they seem more like a confession. Gorlich is the only exhibitor to have studied in America, where he worked with John Baldessari at the California Institute of Arts. Baldessari was one of the primary conceptual artists to debunk the myth of veracity in photographs. He often did so

with a sense of ironic or black humor. Gorlich is also playing with the audience's notion of truth. However, his use of what could be arbitrarily derived photographs undermines the mnemonic function of his pieces. By allowing doubt about the authenticity of the photographs, he casts doubt upon the seriousness of his intentions with the words. And black humor seems inappropriate.

The photographers at the Werkstatt work with a range of ideas founded upon the photograph as a record, the world in front of the camera their primary resource. This is a fairly conservative position in the realm of the photographic medium. The Germans, since the Bauhaus and *Subjectif Photographie* have been noted for redefining the limits of photography. In recent years, the development of Neo-Expressionism has focused the attention of the art world on West Germany. From this, in conjunction with the emergence of Green politics one would expect a more radical and energized show. Nevertheless, *Fotografie aus Berlin* presents a group of photographers committed to the development of approaches to and ideas in photography through an open and evolving workshop.

When the Reverend Calvert Jones photographed the ruins at Pompeii in 1846, he included by convention a standing figure in the composition. Though the intention was to convey a sense of scale to a nineteenth-century audience whose vision was anthropocentric, he incidentally made a territorial claim upon the ruins. The figure is facing sideways, dressed in typical mid-century upper-class British clothing, including stovepipe hat and long-coat. His posture, as he leans casually on the historic wall, is borrowed from the tradition of illustrative lithography and has been imitated in many a cowboy movie since. It is a posture that implies prior (squatter's) rights, a character integral to the context. Jones's rudimentary image suggests how easy it is for the photograph to homogenize time and, without even a nod, artificially unify the specifics of place and historicity.

Three transparent nodes of time coexist in Jones's picture—the present, the past, and the past's past. In the process of tracing through these nodes, the imagination can easily lead into the realm of fantasy as we move from what we see in the picture to constructing what we think through it. In the 140 odd years since Jones visited Pompeii (he was one of the first to photograph it), that site and its tragic demise under Vesuvius's volcanic effluence have been a source for acts of reconstructive history (a rigorous, highly disciplined form of imagination) as well as forms of fantasy exploring its poetic and metaphoric potential.

Sharon Boysel's *Photographic Environments,* all set within the pictured confines of

347

Pompeii's ruins, are thematic fantasies through which she engages aspects of modern private and public ritual. Her superimposition of contemporary experiential politics and residual antiquity is analogous to that in Reverend Jones's photograph, but Boysel has subverted the notion of contextual unity by juxtaposing the photographic (virtual space) with objects and materials in real space. These works are miniature dioramas averaging 8 × 18 × 7 inches whose perimeter walls (and floor sections occasionally) are fabricated with photographs taken at various villas and temples from Pompeii. The artfully hand-colored photographs remain physically, though not visually or psychologically, peripheral to the tinsel-flocked animals, mounds of ash-like substance, and bits of miniature machinery that inhabit these boxes. Like Roland Reiss, the contemporary master of the sculptural micro-environment, Boysel has devised a part-humorous, part-critical narrative strategy which serves the dual purpose of message and unifying force. Her restatement of space serves narrative rather formal projective ends.

The photographic elements tie the constructions to place (though without the titles one would have difficulty knowing exactly which ruins were pictured) and set conditions for the narrative elements. But place itself is a rather abstract notion, especially when treated as Boysel has. The assumption that the images somehow convey the richness of their subjects' history, are fruitful emblems for it, is in Boysel's work as naive as it was for Reverend Jones. Yet this naiveté (postured or actual) is very much a part of the charm of these works. (I also wonder if Boysel is not another case of an artist using photography successfully because of an unfettered view of its limitations.)

The strongest pieces, such as *Pompeii #7, House of Mysteries,* in which a window shade made of window screen floats veil-like in front of a pedestal upon which is placed a miniature high-heeled shoe among other symbolic objects, and *Pompeii #6, Temple of Apollo,* with its artificial ever-blaze fire, suggest without telling. They somehow manage to bridge the absurdity engendered by the conjuncture of such elements disparate in time, scale, and origin. The date in the title *Pompeii #10, August 24, 79* A.D. refers to the fateful day of Vesuvius's eruption according

Sharon Boysel, *Pompeii #8, House of the Fawn,* 1987, photograph/mixed media. Courtesy the Allrich Gallery, San Francisco.

to Pliny's eyewitness account. The somewhat instantaneous pre-serving effect of the catastrophic event proffered archaeologists a cosmic snapshot, but Boysel has reduced the event to a simple still-glowing mound of ashes. Careful inspection reveals little shiny blue creatures crawling through the underbrush toward the mound—a tonic against taking the work too seriously and a kind of silliness from the realm of fantasy which is both questionable and refreshing.

In *Pompeii #1, Camera Ready,* a tripod-mounted camera stands front and center facing a ruin wall. Draped over the back of the camera blown by the prevailing wind is the proverbial dark cloth rendered in this version as a translucent veil. The only indication of human presence is a well-worn path between the camera and wall. I found this particular piece suffered from its own cuteness of concept; the self-reflexiveness of process is a hackneyed idea, though Boysel has offered an interpretation of it in keeping with her methodology. None of the other pieces in this exhibition were quite as literal as this one, though the more obvious so-

ciocultural commentaries, particularly pertaining to media or technology, seemed to me the weakest pieces.

Ms. Boysel has created an extraordinary arena, the diorama, in which to work out her ideas. And she has managed the difficult craft aspect of that arena through attention to detail, in hand-coloring the photographs, in the choice of various warm and cool white lights, and the restraint in selection of materials. As I walked into the darkened room where these *Photographic Environments* were installed, the glowing rectangles of the proscenia invited inspection and inquiry, both of which were rewarded. It is refreshing to see photography integrated into sculpture. This approach to crossing media was last surveyed in 1970 at the Museum of Modern Art, New York, by Peter Bunnell in an exhibition titled *Photography into Sculpture,* at a time when such explorations were afield throughout the media. Ms. Boysel's work is a reminder that ideas as well as fashions run in generational cycles, and that renewal of interest in photographic extensions probably will not come from within the conservative confines of photographic establishments.

The ancient Greek philosophers Plato and Aristotle established the theory of Mimesis, or imitation of what exists in nature, as the first principle governing the arts. Their legacy, though occasionally challenged, provided the criterion by which art would be judged by critics and aestheticians until the first half of the nineteenth century, a time coincident with the invention of photography. The artists of the Renaissance, though distant philosophical cousins to Aristotle, brought the mimetic visual principles to fruition with the development of systemic perspective and, particularly in northern Europe, a concern with everyday subject matter. Within this system, painters and sculptors worked toward realistic rendering of subject matter in a fictive context, constructing, for example, biblical narratives and metaphors in highly representational and often posed tableaux.

Photography, to the extent that its aesthetic was based upon the technology of optics, was treated from the start as a conclusive phase in the evolution of illusionistic representation. Lacking only a third dimension and real time (now realized in holography and film), camera photography became the bearer of high-level mimetic content within the visual arts. This was the whole point behind painter Paul Delaroche's oft-quoted remark made in 1839 upon the invention of the daguerreotype: "From this day painting is dead."

Clarity of informational presentation was an important issue for nineteenth-century photographers, at least until the Pictorialists reacted against it as a scientific rather than

**THE PAINTED
PHOTOGRAPH**

*at Robert Koch
Gallery and*

**THREE COLOR
PHOTOGRAPHERS**

*at Artspace,
June/July 1986*

artistic mode. The Modernists, on the other hand, opted for clarity but brought to it the "new vision" which further eroded photography's mimetic basis. The abstraction of subject matter into formalist statement or personal reverie still placed emphasis on representation regardless of its design function or symbolism. In the context of contemporary photography, however, the mimetic principle has regained importance but with an ironic twist. The photographically derived image (that is, the imitation) has become more significant than "nature" (source) as it has come to embody a world of ideas beyond the notion of representation. One of the primary and strongest arguments for Mimesis is that it provides a basis for credibility. That is, the closer an art object compares to our experience of the world, the more we can believe and rationalize its being. And it is around the issue of credibility that contemporary photographers have exploited the artifice of the camera's veristic, mimetic connection to subject.

We have been shown often enough by artist/photographers such as John Baldessari and Robert Cumming just how fallacious that connection between image and subject is. In a sense, they have purposefully put the audience on guard against its own credulity. More important, they have established a conceptual framework for the photograph's embodiment of idea that has moved photography beyond its elementary role of imitation. If one is aware of the camera's peculiarities as a rendering system, one can experience simultaneously in the photograph what is represented and the idea of representation. The underlying idea becomes tantamount to appearance as the criteria for establishing the image's credibility. Mimetic theory places the work of art in a secondary role to the primacy of direct experience. But this theory no longer works when the photographic image is treated as content or form untethered from its source. In this free-floating and ambiguous state, the photograph remains an open system of optically formed marks—marks which mediate between the photographer and the world and which can be considered, like drawings, primary experience.

Two current photographic exhibitions, *The Painted Photograph: Dennis Farber, Joan Myers, Holly Roberts, Gail Skoff* at Robert Koch Gallery and *Three Color Photographers: Marion Bulin, Bill Sanders,*

Petra Davis Storey at Artspace, explore a range of approaches to mimetic and postmimetic photography, some of which looks more like painting. Both exhibitions present photographers whose work is new to or not recently seen in the Bay Area, and who represent some of the major directions in contemporary photography. Rather than discussing the exhibitions separately, I will group the photographers by their affinities.

Bill Sanders and Marion Bulin (in her more recent work) have used the photographs as records of sites and situations which they have fabricated and found, respectively. Of the photographers under discussion they remain closest to the mimetic tradition. Into still lifes with painted backdrops and assembled objects, Sanders has placed panes of painted glass whose transparency allows for the layering of information and which creates an ambiguous spatial impression. His subject matter is highly personal and iconic, clear in its references to black culture. The range of color in his Type-C prints is carefully controlled to support the expressive current of the images. His work is challenging because of the world he creates, but somehow the photograph, though visually rich, seems a detached step away from that physical world.

Bulin has taken a more conceptual and dry-humored stance toward the recording process, akin to what Robert Cumming did in his *Found Sculptures* series. In her earlier black-and-white pieces, she hand-applied color to identify and highlight found, art-like objects in the urban and rural landscape. Her color *O Christmas Tree* series works on the same principle without the contrapuntal separation of object within context afforded by the hand-coloring. She has continued the search for ironic objects in her more recent color photographs such as *Modern Gardening, Death Valley, CA*, which portrays site as environmental sculpture. In this image, the imposition of the camera frame defines the "sculpture." One can grasp her attitude toward and perception of subject matter quickly. Consequently, the photographs seem based on taste and selection rather than a deeper philosophical concern.

Gail Skoff and Joan Myers use a traditional approach to hand-coloring in that they both respect the graphic boundaries estab-

lished by subject matter and composition to map their coloring. Myers posed nudes and children in stage-like architectural interior and exterior settings which she prints from paper negatives onto now-obsolete "tweed" surface Portralure paper. After toning them warm-brown, she applies delicate tinting which is integral with the surface and which brings out the flesh tones. Her work looks self-consciously pictorial, perhaps a reflection of and reference to late nineteenth-century Photo-Secessionist imagery. Skoff addresses more Modernist issues such as spatial ambiguity and the distorted perspective of a wide-angle lens. Her approach to the landscape, particularly the open expanses of the western terrain, is to create a toned black-and-white photograph as a receptive structure for the coloring process. While the pigment sits within the photographic surface, she has used the color theory of simultaneous contrast to give edges of shapes (such as a haystack or the horizon line) the appearance of lifting from the picture plane.

In the 1920s and 1930s, the Dadaists and Surrealists experimented with direct alteration of the photograph through expressive drawing and the application of sculpturally dimensional paint to the surface. Showing a renewed interest in this approach beginning in the early 1970s, a growing number of artist/photographers explored a wide range of techniques. Though they worked out of a postmimetic stance toward the photograph—disregarding edges or the continuity of surface, they tended to use portraits and, like Skoff, landscapes or site photographs as vehicles for experimentation. The structural simplicity of many landscapes, in particular, leaves the image open to manipulation. On the psychological level, these landscapes tend to be passive (or neutral) mediative receptors for both artist and audience.

This mediative approach to site characterizes Petra Davis Storey's altered photographs in the *Revisit* series. She makes contrasty, grainy black-and-white prints from purposefully scratched negatives of abandoned industrial landscapes. Guided by highlights and linear compositional elements, she adds spots, small patches, and lines of bright color. These marks make a playful and spontaneous, if a bit nervous, impression. After looking at

the series, however, it is her generative strategy or method, rather than developed idea, which governs the work.

Farber's work is also strategy-oriented in the choices that he makes in leaving or obliterating photographic information. Farber layers semitransparent acrylic glazes over the surface of color photographs of urban views. He allows some of the photographic information to remain by masking during the painting process or by cutting through the layers after the paint has set. The forms and shapes left by Farber tend toward the geometric and are brought together by the surface of the paint rather than by perspectival cohesion. One exception to his emphasis on the picture plane is *Unfriendly Persuasion,* 1984. In this image, he has cut through the paint to make a projective space which traps and truncates the figures emerging from the building.

To those who use the quantity and opacity of paint applied to the surface of the photograph as the prime criteria for classifying works of art by discipline, Farber's and Roberts's images have transgressed the photographic. Roberts has virtually obliterated most of the photographic information with the application of opaque oils. For her the photograph functions as an inspirational blueprint from which she develops her Neo-Expressionist, sometimes religious statements. By painting fantastic, almost childlike animals and figures, she is the only artist of the seven to supplant mimetic photographic content with painted subject matter. She has used the photograph as a deep structural element underlying each of the pieces. Her work makes it seem irrelevant to be concerned any longer with traditional classification, as it represents one logical extreme, perhaps conclusion, of postmimetic photography. Roberts's work points out how extractive photography is. While it is a medium of content, that content has symbolic rather than physical presence. In the interplay between the photographic symbol and the physicality of paint, a cohesion emerges which challenges and transcends the constituent elements.

**PLAYING IT
AGAIN:
STRATEGIES OF
APPROPRIATION**

*at San Francisco
Camerawork,
October 1985*

In his *Autobiography of Benjamin Franklin* written in 1757, Franklin provided an unintentional justification for Postmodernism when he recounted the story of a newly arrived priest in Philadelphia whose sermons Franklin thought stimulating. Unfortunately the priest was found out to be "borrowing" someone else's written sermons, and was consequently chastised and removed from his post. Franklin rose to his defense with the argument that it was far better to be giving someone else's interesting sermons than to be forced to give mediocre ones of one's own invention. Ranging from direct quotation to adaptation, "borrowing" or appropriation is an important contemporary issue in photography and is the central focus of *Playing It Again: Strategies of Appropriation* at San Francisco Camerawork. This exhibition, curated by Sam Samore and accompanied by an informative catalogue, includes images by twelve photographers who use appropriation as a mode for pictorial and linguistic statements through photography. The photographers are: Sarah Charlesworth, Patrick Clancy, Peter D'Agostino, Stephen Frailey, Suzanne Hellmuth/Jock Reynolds, Barbara Kruger, Mike Mandel/Larry Sultan, Richard Prince, Gwen Widmer, and Reese Williams. As one of the first surveys of Postmodernist photography to be seen in the Bay Area, the show affords an opportunity to engage both the visual and theoretical aspects of Postmodernist practice.

A brief recount of Postmodernism's development will provide a context for its application in photography. The term was first

applied in the field of architecture in which Modernism or the International Style, identified by its reductive geometry and sleek surfaces, had been predominant since the 1920s. Its principle architect/theoretician was Walter Gropius, who began at the Bauhaus in Germany, then came to the United States after the rise of the Nazis in the early 1930s. Modernism represented in its early phase a reformative energy for social transformation after the physical and psychological disaster of World War I. Artists and architects saw harnessing the developing technologies and material for the betterment of man as their responsibility. But as Modernism developed, it followed an evolutionary model characterized by three phases: formative, in which the ideas are initiated but not fully developed in form; classical, in which idea and form are in harmonious relationship; and decorative, in which form has become style devoid of idea. The latter phase, designated in critical terms as *formalism*, is but a pale reflection of the originating impulse. It was also this latter phase to which architects reacted by drawing upon the history of architectural styles and forms preceding Modernism. Architects such as Charles Moore and Michael Graves synthesized aspects of various styles into this "new" architecture and established an aesthetic based upon appropriation (sometimes quoting elements of past styles) and recontextualization (in which these elements are brought together in a new context). Thus Postmodernism can be seen as a direct reaction to the sterility of Modernism. By being based upon the extensive vocabulary of existing forms, Postmodernism spelled an end to the ideas of originality and invention which were central to Modernism.

Translating Postmodernism into photography has been more difficult from a critical stance for three reasons that are revealing in themselves. Criticism does not yet have a language in which to address Postmodernist theory and practice. One model might be a review entirely constructed of quotations from existing literary or critical sources. However, in order to avoid a suit for plagiarism, the footnotes could well exceed the constructed text. The notion of original research and the practice of acknowledging sources are built into the use of language by our current legal system. Such specific copyright laws do not exist in the visual

realm, though this has been tested by Sherrie Levine with her rephotographs of Edward Weston images to which she affixed her signature. In the middle of this moral dilemma one has to note the irony in Picasso's purported statement: "Bad artists borrow, good artists steal."

The second difficulty is that quotation and appropriation have had a place in the development of modern music as, for example, Mozart quoted Haydn, and Charles Ives appropriated themes from vernacular music. Synthetic Cubists Pablo Picasso and George Braque and Pop artists Robert Rauschenburg and Larry Rivers have borrowed freely from popular imagery as well as the history of art. How does the Postmodernist stance vary from the technique of these Modernists? (One answer to this question has been drafted by Douglas Crimp in his article "The Photographic Activity of Postmodernism," reprinted in this exhibition's catalogue.)

The third difficulty, and the one I find most problematic as a critic, is that Postmodernist photographers have coopted the critic's stance toward photography and photographs. By appropriating already existing imagery (from art, advertising, commercial, and illustrative photography) and recontextualizing it, these artist have created at least a commentary upon, and at most a scathing review of Modernist photographic tenets, including a moral posture toward process, equivalence, and lenticular clarity. The artists in this exhibition have also examined the photographic image as it has been used in the service of propaganda. One of the critic's roles, that of determining the meaning or hidden agendas of images, is assumed instead by the artist. Is the obvious remainder for the critic to begin writing criticism of criticism?

The photographers employ a range of devices to keep the viewer within an analytical rather than interpretive frame of mind. Patrick Clancy, Peter D'Agostino, Gwen Widmer, Barbara Kruger, and Sultan/Mandel use language as a reflexive and critical tool to subvert the "normal" relationship between words and images as they are used in cultural media such as newspapers and television. Clancy has used the format of a Hawaiian cruise brochure and reiterated fragments of the front piece throughout the sequence while using accompanying text (sometimes quoted)

to challenge the imagery from philosophical and conceptual points of view. D'Agostino has photographed the television screen on which are selected images from the Godard film *Alphaville*. These images are accompanied by subtitles which reflect the theme of the film—the relationship between government control of language and control of minds and behavior. Widmer is much more playful with her rephotographed images from instruction manuals for girls' behavior on which she has overwritten the text or told us through other written statements exactly how to react. Her images struggle to control the viewer's imagination and engagement with the endearing though absurd hand-colored images. Kruger (whose work is usually exhibited in larger scale which creates a greater presence) and Sultan/Mandel use typographically presented phrases to close the circuit of meaning/commentary within the image. Kruger's feminist imagery is brilliant in satirizing what she perceives as male-dominated imagery and cultural psyche. Mandel/Sultan's words address more directly the intended effects of advertising imagery as cigarette smoking heads are accompanied by the words "We Make You Us." Their billboard piece was located on 10th Street and is represented by record photographs in the gallery proper.

Suzanne Hellmuth and Jock Reynolds's collaborative sequential piece entitled *Carnage* is both a word play on car imagery and a look at violent aspects of car accidents. Humor arises from the juxtaposition of comic stock shots and film stills with images which seem drawn from police report files on automotive accidents. Reese Williams uses the same sequential filmic technique in his imagery drawn from military record photographs. Stephen Frailey has rephotographed peculiar illustrative images with everyday objects placed on them to play with the notion of photographic scale. The absurdity or arbitrariness of the objects brings the viewer's attention back to the mediation of process.

Sarah Charlesworth has imposed symbolic silhouette shapes over fragments of fashion and news imagery to present a conundrum of simultaneous pictures. The intense red backgrounds of the pieces extend the optical effect, but at the same time heighten the graphic rather than content aspect of the imagery. Richard Prince, who became known for his extractions from

jewelry and cigarette advertisements, has continued with straight rephotographic quotation from media imagery. His images in this show are notable for seeming to touch upon vague memories of long-ago-consumed images.

The work in *Playing It Again* and the articles in the catalogue go far in developing the precepts and theories of Postmodernism, but the structure of the show itself reflects a flicker of Modernism. Samore shows that through the various strategies, there is yet individuality and originality (two hallmarks of Modernism) in the artists' approach to the practice of appropriation. As rephotographers and assemblers of already existing imagery, the process of selection or organization embodies personal taste or critical stance.

But, the images in this show break from Modernism in one extraordinarily important aspect. Their critical posture preempts the primacy of expression. Postmodernism is a proclamation of the end of the self, an end of the ego which stood behind individual Modernist achievements. In retreating from the ideals of originality and invention, Postmodernism represents an admission that the self has been appropriated by the media and that it is primarily experienced as fiction outside one's own imagination. By recycling cultural (pre-existing) imagery, Postmodernists have removed imagination to secondary status, and instead collaborate with culture in an attempt to redefine the self in cultural (rather than psychological) terms.

Postmodernism in photography raises some important and difficult questions about our relation to imagery which surrounds us on a daily basis. It questions our consumptions and assumptions, and forces us to look at the sources, construction, and processing of our own imagination. The most salient effect of artist/photographers' work with appropriation is to make us intensely aware of the witting (in the sense that we are participants) pollution of the eye which comes as a consequence of ubiquitous imagery. As Marshall McLuhan wrote in his introduction to the second edition of *Understanding Media: the Extensions of Man* : "Art as a radar environment takes on the function of indispensable perceptual training rather than the role of a privileged diet for the elite." The work in this exhibition is antidotal in varying

strengths to pollution of the eye, yet it seems wasted on an already attuned gallery audience. Only Mandel/Sultan, with the public presence of their billboard (the premature removal of which serves as a measure of the tolerance our culture has for looking honestly at itself) have fulfilled the role which McLuhan foresaw for the art which we now call Postmodern.

**NATURE AND
CULTURE:
CONFLICT AND
RECONCILIATION
IN RECENT
PHOTOGRAPHY**

*at the
Ansel Adams
Center of The
Friends of
Photography,
San Francisco*

[I had the honor of curating this inaugural exhibition for the opening of the new Ansel Adams Center in San Francisco in the fall of 1989. The exhibition ran from September 14 through November 26, 1989, and included the work of sixty-four photographers. Virtually all of the works included had been made within the five years prior to the exhibition, though the majority were quite recent and came from artists across the United States. The following is my exhibition text.]

I

Nature and culture are so integral to our daily existence, and we are so dependent upon them, that they remain unnoticed until some critical event compels us to reckon with them. Nature and culture embrace the breadth of experience, yet they defy definitions other than poetic or metaphoric ones. However, as phenomena and as philosophical concepts, both evoke powerful images. Consequently they are not only the stuff of existence but also the stuff of science, of fiction, and of myth.

The intent of this exhibition is to survey recent portrayals of nature and culture, to offer viewers an intensified dialogue with these phenomena as they have been engaged by the artists and mediated through the artifice of the photographic image. The artists grapple with problems of appearance and presentation through the camera, and with the notion that the image rather than the original subject matter will be the lasting record. While the images inform us of the texture and complexity of Postmodernist

vision, they portray nature and culture in conflict and reconciliation. Visual records of the ravages of scientific culture are a stark contrast to the rendering of mythological themes, yet both speak to aspects of contemporary experience. Both center upon and spring from human nature; we, in a sense, are the jugglers keeping nature and culture from crashing upon us.

Nature and Culture: Conflict and Reconciliation in Recent Photography is framed around four guiding themes that reflect the artists' modes of working:

- the recorded effects of scientific culture upon nature
- construction of subject matter to be photographed in order to manifest a highly personal or culturally conditioned response to nature
- images, language and text as the character of culture
- nature and culture reconciled through mythic or ritualistic forms.

The installation is designed to encourage the contemplation of the exhibition's themes in the form of an unfolding dialogue among the images rather than in discrete categories. All four themes are interwoven in each gallery.

II

Nature has spawned culture, an aspect of the world formed from the social, political, and aesthetic response to nature. As producers and consumers of culture and participants in nature, we trade in images. In a sense, they chart human nature. By virtue of their quantity and their persuasive representation, images have become an essential ingredient and broadly accessible measure of experience.

As a medium ideally suited to modern scientific thinking, photography has been a significant contributor to our growing detachment from nature. The scientific method demands a dispassionate and objective observer. The camera's convincing and powerful mimetic capacity leads one to consider the image as evidence taken out of context. This separation from original context is emblematic of a profound conflict between nature and a culture driven by the needs and benefits of technology.

Historically, the photographer's attitude, and sometimes pas-

Larry Sultan/Mike Mandel, *Trouble Spots, White Corn Meal,* 1988, dye-transfer print, billboard. Courtesy the artists.

sion, has been masked within photography's scientific or technological mode of presentation. The photographers included in *Nature and Culture*, however, have used this mode to make clear their positions about the conflict between nature and culture. They present us not only with visual evidence, but more importantly with cultural and informational context. Sometimes the subject speaks for itself, sometimes accompanying text counters what might otherwise be visually attractive.

III

Camera vision and its images have proliferated so extensively in modern culture that they have assumed a near incontrovertible importance and presence in daily life—witness the fascination with image in the realms of fashion, style, and their scripted companion, television soap operas. This wave of images has overemphasized appearance at the expense of the inner voice of human nature. Examining and decoding appearance has been one of the critical issues of Postmodernism.

Postmodern experience has been highlighted by a fascination with spectacle—the notion that everything is there for our entertainment and is awaiting its realization in being photographed. The camera has homogenized experience and defined it as happening within the framework of the image. Nature has been recast as an object of culture and desire.

Nic Nicosia, *Real Pictures #11*, 1988, gelatin silver print. Courtesy the artist and Linda Cathcart Gallery, Santa Monica, California, and Texas Gallery, Houston.

As the camera has been pointed away from nature toward culture's images, a powerful and highly significant substitution has occurred: image has replaced nature as the touchstone of experience.

This substitution is one of the essential issues addressed by the artists who have constructed realities for the camera or who have used the techniques of appropriation to create new contexts for the images. What becomes most apparent is a candor of artifice, a willingness to inform the viewer, however subtly, of the presence of the artist's hand. When elements of nature are brought into the studio and used to create an imitation of a natural occurrence, or an event is staged to make a point, culture—through the mediated statement—subverts nature.

IV

As we approach the closing decade of the twentieth century, artists have sharpened their attitudes about nature and culture in coming to terms with the politics of contemporary experience. It seems only appropriate that, through the photographic medium, artists have reconciled nature and culture. Photography, the medium of scientific perception and metaphor, can also be used to reinvest the image with symbolic, mythologic, and ritualistic meaning.

When artists bring together images—some reflecting archetypes, others elevating seemingly mundane events—through assemblage or installation, they ask the viewer to participate in their process, in the way they use picture language to achieve a new order. The result is a synthesis that transcends what is portrayed in any of the image parts.

By reaching further within as well as outside the conventional boundaries of artistic media, the artists in this exhibition represent new modes and attitudes toward Nature and Culture. Whether they portray the residual conflict between the demands of technology and the survival of nature as a resource, or whether they achieve a poetic reconciliation between nature and culture, the artists awaken us to a more active and critical reconnection to experience through their images.

If one accepts the notion that there is an economy of ideas, then it may be possible to consider that economy as systemic, seeking balance, and perhaps limited. As one idea rises to cultural consciousness another must fade away or be transformed—made new in the words of Paul Klee. This life cycle within the ideational macroeconomy occurs over time and is traced superficially by shifts in fashion, and more substantially in the stress points of sociopolitical dialogue. As history attests, religion has long been one of those stress points, a focus of debate, existential questioning, and war. I was once told in earnest that one should never discuss religion in social conversation. Such a topic polarizes feelings. Yet, it is time to address those feelings, those connections to what may be, culturally speaking, bred in the bone. Denial of a religiously specific value structure in a socially diverse culture has placed some of the key functions of religion in the arena of politics—a disastrous state of affairs.

Cycles and shifts in the idea economy are reflected linguistically by art terms such as *Renaissance, neo-, late,* or *post,* and echoed more simplistically, for example, in the opening strains of the popular 1960s television show *Ben Casey:* man, woman, birth, life, death, infinity. The last figure of speech leaves room for the uncertain in the larger pool of certainties. The post- or after-life hints at some other unnamed secular dimension made seemingly acceptable without a tip of the hat to formal religion. Science coopted the spiritual. The packagers of *Ben*

BEYOND BELIEF

at San Francisco Camerawork, August 1991

367

Casey were right in the mainstream by treating the infinite as a stylish gesture.

The late 1950s and early 1960s were a low point in the presence of religious and spiritual concepts in American culture. The separation of church and state was also a denial of the connection between faith and politics on an individual sentient level. God was repronounced dead, and authority questioned. Since that time those questions about authority (or just whose value structure should we operate under) have become more precipitous, but the tools for constructing answers are pluralistic and scattered.

Presently, the politics of world and individual experience are in a state of flux and transformation. Something is dying away and something must be rising. As we edge toward the middle of the 1990s, culture seems bored with what seemed so certain for *Ben Casey*'s writers and, instead, has become increasingly fascinated with a range of other realities from the demonic to the godly. It is *almost* as if, having come to the conclusion of the Renaissance, we are returning to the bestiality and high scholastic spiritualism of the Gothic paradigm. Something happened in the Renaissance: the disappearance of blind faith that pervaded the Middle Ages; an unabashed commencement of Western commercial culture; and a rebirth of ancient Greek or classical ideals minus a spiritual or mythological hierarchy, replaced of course by the political structure of the church.

One of the emergent by-products of commercial culture was the specialist—the microeconomist, the Modernist. With this concept in mind, it no longer seems important to argue the origins of Modernism since its assumptions are intimately connected to those of the Renaissance and are also late and post— connected to a fading idea. Whether one accepts the technological model of human progress in the name of science or one reads the flip side of that same record as the withering of spiritual capacities, there seems to be little question that art, religion, and science, which had remained in the Middle Ages aspects of an integrated vision (for better or worse), came unraveled in the Renaissance. As individuals competed for dominion in specialized areas of knowledge, the imbalance created the circumstances surrounding Galileo, to cite one example. He came to his un-

derstanding technologically and intuitively (read artistically). What he postulated stood at odds with the religiously acceptable. That fracas in one form or another, from political repression to self-censorship, continues to this day over the hum of commerce—in an age not of reformation but of deformation.

So, it is not surprising to come upon an exhibition such as *Beyond Belief*, which collectively addresses questions of religion, the significance of its iconography, the cogency of religious symbolism as a vehicle for personal expression, and the role of the artist as an arbiter of religious experience—all of this in the context of a progressive temple of art and photography. The seven artists included proclaim a certain faith that their objects are religiously inclined, in their statements of intent and in the quality and craft present in those objects. Curated by Rupert Jenkins with a text written by Jessica Chiswick, the show's assumption seems to be that a degree of satire mixed with the enigmatic will at least inspire a reconsideration of Judeo-Christian religious values if not religious practices.

To a limited extent, that assumption seems to hold true. Pondering the conceptual humor behind Anne Rowland's rendition of *God's Brain* or that of *The Twelve Apostles*, the process of picturing a supreme being is brought into question. Graven images in comic posture. The rest of her work seems to play more on the language—the image as imposter—than on deeper cultural imprints or referents. Therein lies the limitation. True religious or spiritual experience has never been pictured directly. It is experiential, not pictorial. Its telling has been in analogy or parable, metaphoric figures of speech whose purpose is *equivalence.* Any direct renditions tend to be illustrations whose business it is to tell us, not engage us. The potential and potent act of imagination evoked through these poetic devices is short-circuited. Lewis Toby's clever, color-rich restagings of biblical scenes, and J. John Priola's installation *A Mantle of Charity Thrown Over the Failures of Other Men* fall into this illustrational category.

If one treats the exhibition as a religious-based metaphoric exploration of some deeply personal and honest questions about meaningful experience, then much more of the work makes sense. Kim Stringfellow's intricate mixed-media boxes pay homage to

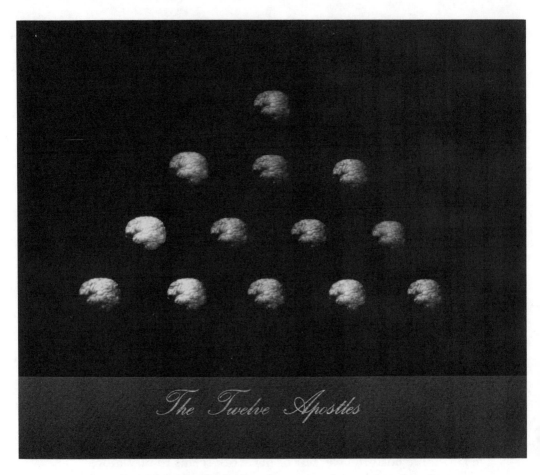

Anne Rowland, *The Twelve Apostles,* 1990, color coupler print. Courtesy the Tartt Gallery, Washington, D.C.

Joseph Cornell and Olivia Parker, and are, more important, excursions into the visual-literary mode. She has chosen to adopt and portray others' mythologized experiences such as in *Self Portrait as St. Lucy.* This is an intellectual path which she shares with Alan Rutberg, whose installation *The Violence of the Hyphen* calls up tragic memories from Jewish history. It is his selection of charged found imagery rather than the random placement of Hebrew characters across them that gives the piece its cogency.

Kathryn Eldredge's multimedia shrines examine a range of contemporary experience from a woman's view. Religion is seen

as a political rather than spiritual structure, one about power and the *Passion of the Purse*—her title which is ever so delicately a triple entendre engaging religion, economics, and physiognomy. Much of what she has portrayed with the purses placed centrally in the image-laden three-panel construction feels autobiographical. As one passes through her installation, the collective muttering of all the separate soundtracks, each of which runs on a continuous loop, creates the feel of walking into some immense cathedral in which no two people are saying the same prayer. The pieces and artifacts demand audience participation and are engaging and suggestive when one explores them. However, the scripts that one hears with each lack the same sense of clarity that one gets from the visual aspects of the presentation.

Participation in the historicity of religious imagery is taken to its extreme by Cristina Emmanuel's installation *Choose Your Pain, Stand to Gain*. This larger-than-life carnival-like "mugging" altarpiece, including candles and other sacramental paraphernalia, greets one at the gallery entrance. Like the reductive wit of Anne Rowland's pieces, Emmanuel's allows one to make a quick transition of reality. Participating means having one's face recorded in the work as either the head of John the Baptist, St. Sebastian, or Our Lady of Sorrows—a strange menu of projective transference. (I understand there were long lines to have pictures made in this manner during the opening.) But the immediate experience of the installation, with the absence of faces from the reproduced imagery, is like that of finding daguerreotypes and tintypes with faces scratched out—the death mark, identity removed—the indicator of an empty metaphoric shell.

Religion carries with it an emotional and barbed hook, which is one reason why it is never discussed at table, but a good reason to engage this exhibition. Amidst the righteous debates about religion and its grace of state, is some serious searching in the realm of faith and spirit—even within the hierarchy of the Catholic church. The general movement, if I read it correctly, is toward a reintegration of the three forms of knowledge characterized separately as art, religion, and science—or, by way of parallel analogy, the realms of soul, spirit, and intellect. As the latitude of expression in *Beyond Belief* indicates, even in its un-

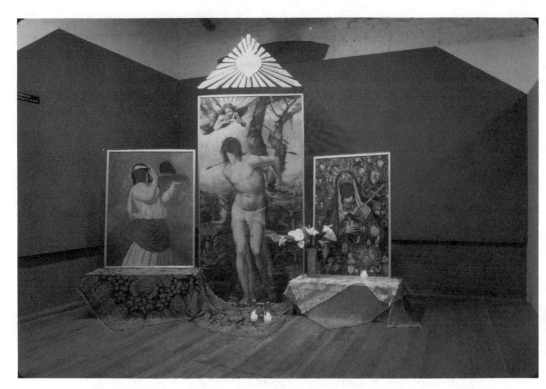

Cristina Emmanuel, *Choose your Pain, Stand to Gain,* 1991, mixed media installation. Courtesy the artist.

evenness, it does not matter which of the three directions one comes from, an artist dealing with religion, for example, if the movement is toward some balance of the three. The strength of this exhibition is the cathartic position it takes toward the past. The artists have taken gospel or what is just bred in the bone and raised those personal experiences and questions for public dialogue. Toward the future of religion and religious experience, the artists and the exhibition as a whole remain tentative. It would seem important to find belief present before considering going beyond it.

AFTERWORD:
NORTHERN
CALIFORNIA:
AN OCCASIONAL
ACCOUNT OF ITS
PHOTOGENIC
CHARACTER

October 1992

[Written in honor of *Photo Metro's* tenth anniversary]

The psyche's projected need for a paradisiacal vision and nature's late attempt to announce itself as a violated being have met most pointedly in the exactitude of photographic representation. And, rarely in the history of photography have the natural landscape and the camera had such a long-standing case of mutual admiration than in northern California. Chronologically framed by the earliest portrayals of pristine Yosemite in the later middle decades of the nineteenth century and the most recent attempts to reconnect human consciousness with environmental sanctity, the photograph has served as the arbiter of the imagination of nature—first as evidence, later as its definition.

The poetry of light, a phenomenon reflected, for example, in Edward Weston's kelp beds at Point Lobos, seems antithetical to the prosaic depiction of Lewis Baltz's images of the trash-strewn San Quentin area. Both sets of images are alive to the vagaries of nature; both are inflected translations, though the former comes out of the intuitive, the latter the conceptual; both are sensitive to the aesthetic/cultural needs of their time; both operate within the broad definition of straight photography; both are models, among many others, of northern California vision. The experiential, whether flowing through the will (in Weston's expressive forms) or the intellect (in Baltz's ordered chaos), is the central issue. Camera, view, image—all aspects of the spiritualized machine.

373

Technology, a materialistic counterpart to the experiential and phenomenal, has a center in the San Francisco Bay area. So do venture capital, the human potential movement and its later expression in eco-consciousness, and, of course, a cultural milieu including opera, ballet, symphony, and museums, which exceeds what one might expect with just a glance at the area's demographics. There must be a reason for all of this reflected in the area's history.

The peaceful hunter-gatherers, who had the wherewithal to find nourishment in the acorn, never formed anything approaching a nation-state, as had happened with the Iroquois in upstate New York. The indigenous Bay Area cultures were too easily supplanted by a gold culture which thrived on the consumption rather than the support of human beings. (Prospecting is a term equally applicable to photographing and mining—territory and claims withstanding. The rate of return is about the same.) Where does the gold culture's history figure in the geographic ecology of the area? The consciousness is somewhere in the land and sea, both mined for their riches and subjugated for transportation. It is an unfortunately familiar mix to find ministries of the spirit following at the heels of seekers of wealth and domain. The San Francisco Bay is full of riptides and swirling currents. Navigating its waters is a bit like penetrating the fog of current culture.

Technology is critical to (and is perhaps the defining element of) the Bay Area. Its capacity to create an artificial unity is counter to the disintegrative historical/natural forces whose proclivity has been to separate tribes. Commercial culture is served far more by technology than by nature; technology's capacity is a necessary adjunct. To understand a natural phenomenon one first has to experience awe and wonder. The same can be said of technology, but with a cautionary note that the experience itself may be an intentional illusion. This intention is an essential problem in most forms of representation—add to that the camera's ability to condense perceptual experience into 8 × 10-inch scale. The grander the scale of nature (and it does not come much grander than in the Wild West), the greater its susceptibility to technological means. One of the technology's key functions is to quantify, measure, delineate, represent, and otherwise fossilize.

There must also be a reason that the California School of Art (now San Francisco Art Institute) had one of the first programs in photography founded by a native son, Ansel Adams, and an assistant transplanted from the Northwest, Minor White. Adams chose the more modern technology (camera rather than piano) as his public medium of expression. His crossing with Paul Strand in New Mexico was an act of destiny. But he remained rooted in his natural California element, though his work was certainly shown by Stieglitz at An American Place in New York and was well received by a northeastern audience. Adams has certainly been a redwood in photographic and environmental history— majestically tall, evergreen, and resistant to fire.

His Yosemite became the Yosemite that everyone expects to see. Tourists often prefer the photographs. Lesser known are his important contributions to the stylistic development of commercial tabletop photography. Whole California institutions are founded upon and partially financed by *nature as it appeared to him*—or at least its technological facsimile. Interestingly enough, he belonged to one of the only groups of artists in the history of art to name itself by a strictly technical term. Group f.64 treated technological terminology as poetry and created the northern California paradigm for photographic practice. While there has been an evolving conceptual and political consciousness on the part of more recent work (Richard Misrach's and Robert Dawson's come to mind), the photographs as technically produced objects still fit within that paradigm.

At its inception, the paradigm fit neatly into modernist strategies of defining means of image-making by their technological particularities. Stieglitz, Strand, and Group f.64 evolved a critical language for which *separate but equal* was the goal. Postmodern artists tend to be trans–tribal boundary crossers concerned (in the best of cases) more with generative concept and idea than with specific technology. This is not antitechnology, just a wish to bypass the homogenizing effects of technical applications which tend to reduce art to style and look.

The Bay Area certainly witnessed a burgeoning of this kind of activity just prior to the founding of *Photo Metro* in 1982. At that time the Bay Area received a dose of Van Deren Coke's

adrenaline. The long-term effect of his tenure at San Francisco Museum of Modern Art has been to make clear that photography and photographers were as much plugged into the ideas and currents of their times as any painter, and that there are no preset conditions for the technique or look of the work. Though Joel-Peter Witkin is not a northern Californian, it was here that his first major retrospective opened to raving and fascinated audiences. His darkness, manipulated and psychosexual, was a partial answer to the metaphoric light landscape. Paralleling the transforming modes of expression of photographers, such as Judy Dater, whose work began in the f.64 vein, Coke's adventurous and aggressive exhibition program energized the photographic community and freed it from the tyranny of the northern California modernist paradigm.

Such a release allows for use of the old paradigm, but with a renewed consciousness. Water resources, nuclear test sites, the qualities of the human condition are all concerns which beg the question of technology, and perhaps more important, the capacities of heart, mind, and community. There was and still is a bull (too bad bear means the opposite—another postmodern linguistic quirk) market for the earliest images of northern California. The nineteenth-century mind still felt the tug of paradise. Mammoth views of Mt. Shasta and Yosemite hung on the walls of Ralph Waldo Emerson's house, souvenirs of his journey west.

There was and still is a bull market for Ansel Adams's images. They define an environmentally concerned community whose focus is preservation of the undisturbed. There is now a burgeoning marketplace for those contemporary images and book projects whose purpose is to mobilize a community of conscience around ecological and physiological disasters. But, one wonders how sanitized the images need to be to pass through the marketing maze. Technology serves commercial culture well when it plays to the more romantic (including the dark) side of imagination. Turned to portray the downside of its own consequences it is more about betrayal and meant to awaken a sense of morality. Northern California certainly has a history of political activism transformed by the media into morality plays. Witness, for ex-

ample, the photographs from the underground press made during the Berkeley protests of the 1960s.

With photography as the emblematic representative of technology and nature standing as a victim, images produced in northern California are a useful measure of conscience and consciousness. So long as we are not ruled by technology, our natures will survive the marketplace.